THE FLOWERING

THE AUTOBIOGRAPHY
OF JUDY CHICAGO

To the friends who have stood by me;
to the history that has sustained me;
and to my wonderful husband,
photographer Donald Woodman,
who has been the best partner imaginable

First published in the United States of America in 2021 by Thames & Hudson Inc.,
500 Fifth Avenue, New York, New York 10110

First published in the United Kingdom in 2021 by Thames & Hudson Ltd,
181A High Holborn, London WC1V 7QX

Designed by Anne DeMarinis

JUDY CHICAGO is a registered trademark of Chicago/Woodman LLC

British Library Cataloguing-in-Publication Data
A catalogue record for this book is available from the British Library

Library of Congress Control Number: 2020950371

ISBN 978-0-500-09438-9

Printed and bound in China

Be the first to know about our new releases,
exclusive content and author events by visiting
thamesandhudson.com
thamesandhudsonusa.com
thamesandhudson.com.au

v FOREWORD BY GLORIA STEINEM

1 INTRODUCTION

7 COMING OF AGE

23 MAKING A PROFESSIONAL LIFE

42 BECOMING JUDY CHICAGO

57 CREATING FEMINIST ART

73 LEARNING FROM THE PAST

92 BACK TO L.A. AND *WOMANHOUSE*

117 DREAMING UP *THE DINNER PARTY*

151 CONTROVERSY? *WHAT* CONTROVERSY?

175 GIVING BIRTH TO THE *BIRTH PROJECT*

194 IS THERE AN ALTERNATIVE TO THE ART WORLD?

216 EXPANDING MY GAZE

239 IF YOU DON'T HAVE, YOU CAN'T LOSE

265 WHY THE HOLOCAUST?

298 *THE DINNER PARTY* GOES TO CONGRESS

332 LOST IN ALBUQUERQUE! FOUND IN BELEN?

356 AFTERWORD

401 ENDNOTES

402 INDEX

407 ACKNOWLEDGMENTS

FOREWORD

I can divide my life into before and after Judy Chicago.

In 1972 when I was in San Francisco, I happened to hear about something called *Womanhouse*, an art project that was part of the exploding women's liberation movement.

I was attracted to it by the word "movement" more than "art." I still thought of art as something confined to paintings and sculptures in museums and galleries. Even the Guerrilla Girls, each one an artist herself, had not yet put on gorilla masks and carried such protest signs as "Do women have to be naked to get into the Met. Museum?" That was a decade away. Art was still what men did in a European tradition, and was exhibited in galleries, museums, and the homes of those few who could afford it. What women and non-European men did was called crafts, and their popularity and usefulness only demoted them.

Since I had a few hours free, I decided to take a flyer on this event created by a woman with the great name of Judy Chicago. She was aided by New York artist Miriam Schapiro, and also by some of their art students.

When I entered this old-fashioned, seventeen-room house, the first thing I saw was a hall leading to circular stairs, and halfway up them was a mannequin in a white bridal gown with a long train. Its fabric became grayer as it led down the stairs to a door. When I opened the door, I was in a kitchen where every surface was painted pink, with fried eggs on the ceiling and breasts on the walls.

Upstairs in one of the bedrooms, a young woman sat in front of a vanity mirror, slowly and perpetually brushing her long hair, as if in a trance. In a bathroom, a tub was filled to the brim with sand so fine that it looked like water. A sign warned, "Do not touch." If a visitor touched anyway, the

marks could not be erased. It was the perfect symbol of touching without permission and the permanent results of abuse.

There were many more such experiences in this big house that included a porch and a garden. I cite these because I remember them as if they were yesterday.

Altogether, I spent hours walking through *Womanhouse*. I remember thinking with surprise: *Women have symbols, too.*

This was my first experience of an inclusive art. I was no longer just the object of a painting or a sculpture, but a female human being with a life of growing up, bleeding, birth, nurturing, empathizing, learning, succeeding, failing, bonding with other women, and being equal to men. Instead of trying to change women to fit the world, this was a world that fit women.

And then I saw *The Dinner Party*, an installation with a huge and beautiful triangular table at which thirty-nine places were set for historical and mythical women. Judy Chicago was giving us back not only our lives, but our history.

I first saw this life-changing creation at the San Francisco Museum of Modern Art, then worried as it was stored and homeless for years. Finally, a large room was built for it in the Brooklyn Museum in New York, all thanks to Elizabeth Sackler, who founded and maintains this first, and so far the world's only, Center for Feminist Art. There *The Dinner Party* reigns, with its huge table set with elaborate plates and place mats unique to each woman. As in *Womanhouse*, everything was created under Judy Chicago's direction by a team of women artists, from makers of china to creators of embroidery.

You might say that Judy Chicago has spent her life not only inventing Feminist Art, but inventing a feminist way of creating art.

How did she grow up to be this miracle? There are clues in her parents, whose working-class socialism included everyone, even a daughter who began asking to go to museums every day when she was a child of eight.

She also began making art young, and had the courage to call herself an artist when few women did. In her twenties and thirties, she survived the New York art world of abstract expressionists, whose designs were devoid of anything recognizable as human. Its masters were almost all white men

who reigned in galleries and museums as well as the legendary bars that were their hangouts. They did not understand her work, much less welcome or praise her, yet she survived.

Perhaps we can best honor Judy Chicago by honoring the uniqueness in each of us. She is a combination of millennia of environment and heredity that has never happened before, and could never happen again, and so are we.

Yet at the same time, we share a common humanity that cannot be divided by race or gender or class. The shortest way I can think of to say this is: *We are linked, we are not ranked.*

Now, we need Judy Chicago more than ever.

Because she survived earlier and very macho art worlds from New York to Los Angeles, she can help us survive backlash and resistance to the successful majority consciousness-raising that feminists have achieved in this country, from reproductive rights to electoral office.

Because she remembers when there was no such thing as Feminist Art, when it was ridiculed and resisted, she can give us hope when our ideas of democracy are resisted, from the family to the nation.

And because there is no accounting for the miracle that is Judy Chicago, we can honor her by honoring the miracle within each of us.

—Gloria Steinem

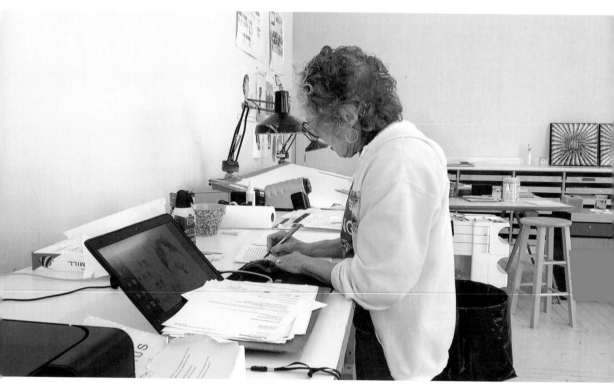

Working on *The Flowering* 2020

INTRODUCTION

On May 28, 2020, *The New York Times* published my essay about why art matters as part of their online series entitled "The Big Ideas," and it was subsequently printed a few days later in their international edition. As the paper states, this forum brings together "the world's leading thinkers to contemplate one theme." To be viewed this way by the *Times* presents quite a contrast from forty years earlier. On October 17, 1980, in that same publication, Hilton Kramer, one of the most important art critics in the country, pronounced *The Dinner Party* (my monumental, symbolic history of women in Western civilization, which launched me into public visibility) to be "crass," "very bad art," "failed art," thereby relegating me and my work to the margins of the art world, where I remained for many decades.

The first volume of my autobiography, *Through the Flower: My Struggle as a Woman Artist*, appeared in 1975. Over the years, it was put out in multiple languages, which helped to bring my work to thousands of people, bypassing the ongoing hostility of the art community. In 1996, I published *Beyond the Flower: The Autobiography of a Feminist Artist*, which continued my tale. At the end of that book, my husband, the photographer Donald Woodman, and I had barely managed to scrape together enough money to buy, renovate, and move into the Belen Hotel in a small town south of Albuquerque. My career was in tatters. I had no gallery representation, few opportunities, and *The Dinner Party* was facing an uncertain future. In addition, even though the *Holocaust Project* (which Donald and I had created together over a grueling eight years) traveled to eight venues and was embraced by the general public and the Jewish community, it also received scathing reviews from art critics.

Despite the ongoing controversy surrounding *The Dinner Party* (which I will discuss later), my lifelong goal was for it to be permanently housed, which was finally realized at the Brooklyn Museum in 2007. This started a slow turnaround of the art-world perception of the piece which—according to the museum—has become one of the most beloved in its collection. It accounts for 20 percent of their audience as viewers come to see it from all over the world. As gratified as I was by all the attention *The Dinner Party* has garnered over the years, I often said "I hope I live long enough to see the large body of my work emerge from the shadow of *The Dinner Party*," which defined me in the eyes of the world for far too long.

This objective took several decades to achieve, during which time I continued to make art, publish books, and lead a busy life. It was not until a few years ago that the breakthrough occurred, one that was supposed to culminate in 2020 when my first retrospective was to open at the de Young Museum in San Francisco. By then, *Time* magazine had named me one of the 100 most influential people in the world; *The New York Times* featured me in a major profile; and "Artsy" named me one of the 20 most influential artists. How can these momentous changes be explained? Is it because, as many writers have claimed in the abundance of recent articles about me, the culture has finally "caught up" with me? Does the #MeToo movement have anything to do with it, as some people have suggested? Or perhaps it's simply the result of women having gained a sufficient foothold in the art and art history worlds and, in the process, discovered that my work speaks to them.

Of course, everything had to be put on hold because of the COVID-19 pandemic, which turned the world upside down. It was during this period that I worked on this book. Also, along with Jane Fonda and her organization, Fire Drill Fridays; Greenpeace; the wonderful street artist Swoon; the National Museum of Women in the Arts; and Hans Ulrich Obrist, artistic director of the Serpentine Galleries in London, I helped launch an international project, Create Art for Earth, which is aimed at stimulating artists to create work that might contribute to social change. This is what I had advocated for in my *New York Times* piece: that artists concentrate on making art that matters about some of the challenges we are facing.

Just as the United States began to slowly emerge from the lockdowns that wreaked economic havoc and upended the lives of millions of people, there was a momentous public uprising in reaction to the ongoing racism in this country and its manifestation in unrelenting police brutality against people of color. As my life and work have been devoted to fighting for justice and equity through my art, I fervently hoped that these protests would lead to substantive changes, not only in America but around the globe. However, even as people all over the world were protesting, our president was continuing to turn back decades of progress through executive orders.

I am often asked, What is Feminist Art? My answer seems relevant at a time when patriarchal values are fighting to maintain their dominance. From my perspective, one that has broadened over time, the purpose of Feminist Art is to challenge patriarchy, which oppresses not only women and people of color but animals as well. In my *New York Times* essay, I tried to point out that the origins of the coronavirus were in our utter disregard for the well-being of the planet and our hideous treatment of other creatures. They are being made to suffer because of one of the underlying assumptions of patriarchy, which involves privileging human life over all others. This is as much an extension of white male privilege as the racism that underlies our society. As one of my *PowerPlay* paintings suggests, patriarchy is literally "Driving the World to Destruction."

In the 1970s, when I was working on *The Dinner Party* and discovering the ongoing cycle of erasure that repeatedly obscured, marginalized, or diminished the achievements of so many of my foremothers (another manifestation of patriarchal control), I was part of a social movement by women and some sympathetic men aimed at overthrowing male-dominated societies and replacing them with a more equitable world. Our efforts were part of a long, historic struggle for change, one that—unfortunately—is agonizingly slow. At the same time as I am heartened by the outpouring of justified rage on the streets, I worry that it will not be transformed into lasting institutional change, which is what my generation of activists was unable to accomplish. Thus we see history repeating itself; for instance, who could have imagined that the fight for reproductive freedom would have to be battled all over again or that police brutality would be as prevalent today as it has been in the past?

I have always stood somewhat apart from my career, viewing it as possessing a larger, symbolic significance in that I believe it reveals what many women—as well as members of other marginalized communities—can expect to encounter as they practice their talents to the best of their abilities. If that is indeed the case, perhaps it is a good time to offer *The Flowering*, an answer to and reflection upon the first two volumes of my autobiography which also updates my story, describing these last twenty-five years. Perhaps my experience might offer some hope to younger generations.

Having recently reread *Through the Flower* and *Beyond the Flower* in preparation for this new publication, I must admit to being somewhat taken aback by their unabashed honesty. It is not that I don't intend to be equally candid in these pages; I do. It's just that the confessions of a mature artist will, I am sure, be somewhat more discreet and deferential in regard to the feelings of some of the people with whom I've been close. Moreover, now that I am more of a public figure, I have come to cherish the intimacy of my private life. I shall therefore ask for the indulgence of my readers if I do not disclose all my intellectual detours or numerous romances. If I have omitted something that is known to have occurred, it is because I decided that it would have distracted from the more important task of examining what has happened to me in order to understand something of where we women are in history.

Along similar lines, I must ask for understanding regarding these earlier volumes, which were written at a time very different (in some respects) from the present. When I was coming of age as an artist, while it was clear to some of us that gender involved roles to be performed—and that these roles were based on sociocultural expectations—we understood gender and sex to be binary, rather than a spectrum as we do today. To a certain extent, my recollections are shaped by how I viewed the world at an earlier time, one that blinded me to both this issue and the intersectionality of identities that shapes the experiences of so many. Nor was I aware of the various ways in which the oppression of women and people of color is related to our exploitation of other creatures and the planet. In this text, I have tried to indicate how my thinking has changed.

The Flowering chronicles my journey as a white, cis, middle-class Jewish woman who learned about the potential power of art through the widespread positive response to her work despite art-critical scorn; who had to build a community of support when there was none; who never swerved from her vision, no matter how difficult her life became; and who ultimately triumphed by *not giving up*. My struggle has sometimes been overwhelming and dispiriting but in the end it was worth it. I hope my readers will find my tale as inspiring as I did when I first discovered the long struggle of my foremothers, who paved the way for so many of the freedoms we enjoy today.

UNTITLED fingerpainting created at age four 1943
Fingerpaint on paper, 15 × 19 in (38.1 × 48.26 cm)

Collection of Elizabeth Sackler

COMING OF AGE

I was born at the Michael Reese Hospital in Chicago, Illinois, in 1939 at the end of the Great Depression. From the time I was a child, I always had a burning desire to make art. In fact, I started to draw when I was barely able to talk. My preschool teacher told my mother that I was gifted, and when I look at some of my childhood drawings—which were prized and saved by my mom—I can see what prompted the teacher to make this assessment. At a stage in which most children are making stick figures and colored blobs, I was doing drawings such as a finger-painted landscape that demonstrated a talent for conceptual thinking that would be considered unusual for any four-year-old child.

My mother, who had been a dancer and maintained a lifelong interest in the arts, encouraged my artistic ambitions. She told me colorful tales about her life prior to her marriage, when she went to the Jewish People's Institute and mingled with musicians, poets, and other creative types. These stories contributed to my developing interest in art. When I was five, she borrowed a friend's membership card to the Art Institute of Chicago so that I could attend the free classes held in the museum auditorium. Later, despite my family's fluctuating and often limited finances, my mom always managed to find a way to pay for the more rarefied classes at the Art Institute's Junior School, where I went every Saturday until I left Chicago to go to college in California.

Almost from childhood, my artistic life felt more real to me than any other aspect of my existence. Each week, I would take the number 53 bus from our home on the North Side, near the lakefront, and it would drop me off right near the stone lions that flanked the steps to the museum. I always felt as if I were entering another world, one in which I could totally

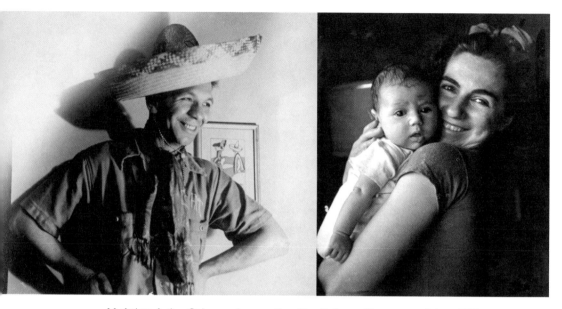

My father, Arthur Cohen and my mother, May Cohen, with me as an infant 1939

lose myself in the creative process. I would emerge from the cramped classes in the basement with a sense of satisfaction that I came to crave. Then I would walk up the wide stairway leading to the light-filled galleries, often spending the rest of the day there.

I loved wandering among the paintings and sculptures to study the millions of colored dots that together form Seurat's *A Sunday on La Grande Jatte* or to marvel at the luminosity of Monet's paintings of haystacks in the changing light. Standing in front of the ribald images by Toulouse-Lautrec, I traced his use of reds and noticed how the viewer's eye is made to move around the entire canvas. As observant as I was, however, the one thing that I failed to notice was that nearly all of the art at the museum was by men. But even if I had noticed, I doubt if that would have deterred me from my aspirations.

I cannot remember when I first decided that I would be an artist when I grew up. I know that I spent countless hours by myself drawing, and I became the official school artist almost as soon as I entered grammar

school. I illustrated yearbooks and decorated the gym for dances, activities that continued in high school, though by my teens my life circumstances were quite different. The one constant throughout these years was my ambition, which was to become a famous artist and to be part of the glorious art history I saw represented at the museum.

I have always, from my earliest days, had a strong sense of myself, which was encouraged by my parents. Years later, my mother told me she had always known that I was different. For in addition to being artistically talented, I was also, apparently, extremely bright. In the environment in which I was raised, these twin traits somehow afforded me such special treatment—from family, friends, and at school—that I never once encountered the notion that, given my gender, my aspirations were either peculiar or unobtainable.

My parents were Jewish liberals, with a passion for the intellectual life and seemingly endless energy for political activism. Some of my earliest memories include going to the union hall with my father, where I'd eat hot dogs (something I no longer do) while listening to him deliver some rousing political speech. He was a Marxist and a labor organizer, and I derived from him a lifelong passion for social justice, the belief that the world could be changed, and, equally profoundly, that I could trust and be unconditionally loved by a man. I also learned that the purpose of life is to make a difference, a goal that has shaped my existence.

I can still see my mother and father dancing together in our living room, for theirs was a love marriage, which was quite evident in the way they interacted. Music, especially blues and jazz, forms a backdrop for many of my childhood memories because my parents had a vast record collection. I was raised amid record parties for various progressive causes. People of all races mingled in our second-floor apartment to engage in near-constant political arguments. Moreover, there was an expressed commitment to equal rights for women, something I not only heard stated but saw demonstrated by the way in which my father always made sure to include the women in these lively discussions. And I saw it manifested in the way he treated me.

To say that my father adored me would be an inadequate description for all the love and attention he showered upon me, and I cannot emphasize

enough the pivotal role he played in my development. Because my mother was employed full-time as an administrative assistant and later as a medical secretary, it was my father, who worked nights at the post office, who was home when I awoke from my afternoon naps. He would gently place me on his lap and begin to play a series of games that he had invented to train me in logic, in mathematics, and, most important, in values.

I can vividly recall my dad at the center of the many conversations that raged in our house, patiently explaining one or another political theory to the assembled group. To make him happy, I had to perform intellectually, which I started doing as soon as I could talk. For years, family members and friends from this period would remind me of certain "Judyisms," the precocious comments I produced in order to gain my father's approval, which he repeated to anyone who would listen.

There is a common misconception that females are severely discriminated against in traditional Jewish families, but this was not my experience. Because my mother was employed and because I saw women participating fully in the discussions that went on in the house, I grew up with the sense that I could do what I wanted and be what I wanted. As a child, I was encouraged to be honest and direct, affectionate and trusting. I had two female cousins, both ten years older than me, who came to the house frequently, were intellectually engaged, and provided role models for me.

My father, Arthur, was the youngest of ten children, "nine of whom were living," as his mother, my Grandma Cohen, used to put it. Her husband, my grandfather—who died the year I was born—had been a practicing rabbi, the twenty-third in an unbroken chain. It had been expected that my father would follow in his footsteps, but he rebelled against this assumption even as a child, when he refused to go to *cheder*, or religious school.

My mother came from a small family, one that was scattered and lacking in presence during my early years. But my childhood was punctuated by many raucous Cohen family affairs. Given that his family was so large and that most of the relatives lived in and around the Chicago area, there were numerous opportunities for sizable and noisy get-togethers, especially on the Jewish holidays and, oddly enough, on Christmas, which was usually celebrated at our house. Though there was never a tree, various aunts, uncles, and cousins

would bring stacks of inexpensive presents, which I would excitedly hand out to people in our front room as my father called out their names.

The Cohen family seemed to speak to and about each other constantly. Because my own household was one in which the life of the mind held sway, I felt somewhat separated from what appeared to me mostly trivial concerns, although I definitely enjoyed the love and connection engendered by family events. My father was particularly close to his sister Enid, the one nearest in age to him. She and her husband, Willy, who first drove a taxi and later opened a liquor store, lived nearby when I was born. We spent a lot of time with them and their two children, Corinne and Howard, both of whom were a decade or more older than me. Many years later, Howard, who would become like a brother to me, would often remind me that he had known me since the time I was only a bow on my mother's pregnant stomach.

My father's various siblings all had differing relationships to their Jewish heritage, a few maintaining religious observances but most turning their backs on the Orthodoxy in which they were raised. My mother once told me that she'd asked my father if he wanted her to learn how to "cook kosher" like his mother, whose food he would eat on Friday nights at her house. He shuddered and replied that Jewish food made him sick. This response may be said to be an apt metaphor for his relationship to Judaism generally, for like many second-generation Jews, he (and my mother) basically rejected all things Jewish. As a result, I learned less than nothing about Jewish history and culture from my parents.

However, they were always quite clear that we were Jewish and that this was something to be proud of, though they never explained exactly why, except for my father's frequent references to the long tradition of rabbinical service in his family. He also spoke of an ancestor so illustrious—the Vilna Gaon—that he had bequeathed his "blue blood" to all of his descendants, including me (though of course my father made no mention of women's traditional exclusion from the rabbinate).

The Vilna Gaon was named for the Lithuanian town in which he had lived in the eighteenth century. I would later discover that Vilna had at one time been referred to as the "Eastern Jerusalem" because of the

long tradition of Jewish life and learning that had flourished there. It was part of the Pale, a section of Eastern Europe that had gone back and forth between Polish and Russian control. All of my grandparents had come to America from this area, which included Latvia, birthplace of my maternal grandfather. As a child, I asked my father about these countries, only to be told that "they didn't exist anymore." This declaration came back to me and made me both angry and sad when, many years later, I traveled there in search of the Jewish heritage that I had been denied.

But even if I was ignorant about my Jewish background—knowledge that I would one day yearn for—with hindsight, it becomes obvious that I was raised in a household shaped by what might be called Jewish ethical values, particularly the concept of *tikkun olam*, the healing or repairing of the world. I was taught to believe that working to achieve this transformation is what life is all about and that material possessions are unimportant. I can still remember my father pointing to all the books and records in our house and saying, "See these, these are the only riches that count."

I am convinced that my father really didn't want another child, but my mother became pregnant despite his stated objections. My brother, Ben, was born in 1945, when I was five and a half years old. I remember the day my mother brought him home from the hospital. There he lay, red-faced and screaming on my parents' big bed, which, every Sunday afternoon, I claimed for my own when my father and I listened to radio programs. Ben was born with a vestigial stomach, which meant that he had trouble ingesting food. He cried a lot, and it seemed that his arrival introduced strife into our household. I did not realize that there were other factors creating tension in my parents' lives.

When I was still in grammar school, my father was investigated for his political beliefs. It was in the early days of the Red Scare and McCarthyism. A cloud of despair settled over our household as my father, forced out of the post office and the union work that he loved, began searching for a way to make a living. Though he worked for a while as an insurance agent, it was the start of what would be a slow but steady decline.

Sometime later, I began coming home from school in the middle of the afternoon to find my dad sitting in the living room in his favorite

rust-colored velvet chair, smoking Chesterfields, listening to music, and staring vacantly into space. When my mother came home from work she would become furious, but instead of saying anything, she would put on blue jeans and begin to clean the house. She never explained what was going on; all she would say was that my father was at home because he didn't feel well. But I would often hear them arguing, usually about money.

By the time I entered puberty, I felt as if I were living several different lives. There was school, which was always easy for me. In fact, most of the time I was bored, so I consoled myself by reading the contemporary fiction that lined our household bookshelves. I had become well acquainted with such American writers as Dos Passos, Fitzgerald, and Hemingway, and then moved on to the Russians, beginning with Dostoevsky, though my English teacher would not accept book reports on their work. Instead I cribbed from synopses of unimportant books in popular magazines.

Then there was the private drama at home that was so baffling to me. I could see my father failing but I didn't know why. I sensed my mother's anger, which she refused to talk about. My recollections of Ben are that we were not that close, though my brother later reminded me of the many hours we had spent together contentedly playing Monopoly. Certainly, there were some times when our family life became what it had once been: for example, all four of us would visit my Grandma Cohen, and my father, Ben, and I would play games on the streetcar on the way there—identifying objects on the street, counting different kinds of animals—games that, in my father's estimation, would help build our powers of observation.

Finally, there was my art life, which, as mentioned, was already more real to me than anything else. Certainly it provided a retreat from the events in my life that I found so confusing, especially since it was at about this time that I began to be classically trained, which was quite time-consuming. Manuel Jacobson, my teacher for many of the years I spent at the Junior School, did not believe in starting such training until a child was at least eleven years old, so as not to inhibit the creative impulse. But once this age had been reached, one began rigorous training in anatomy, still-life drawing, and study of both human and animal bones, the latter through regular drawing trips to the Field Museum of Natural History. Mr. Jacobson was

encouraging, although he often pointed out—with some quiet frustration in his voice—that my drawings never seemed to fit on the page.

When I was thirteen, my father, who had been suffering from a mysterious and painful stomach ailment, went to the hospital for an operation. Ben and I were sent to stay with Aunt Shirley, another of my father's sisters. We remained there for several days, with no word from our mother. Finally, our Aunt Enid came over to tell me that my father was "very sick." "He couldn't die, could he?" I asked tremulously, thinking that she would answer, "Of course not." Instead she said, "Yes," and walked away. A few days later he died, apparently from kidney failure after an operation to remove part of his stomach, which had been eaten away by ulcers.

Over the years, relatives have insisted that my father actually died from cancer, and that no one would admit it. But according to my mother, my father died of a combination of unpredictable circumstances, not the least of which was the peritonitis he'd had as a ten-year-old, causing him to spend almost an entire year in bed; he was supposedly the first person to have recovered from this disease before the advent of penicillin. Unfortunately, one of the consequences of his many supine months was that his organs had become matted together with adhesions, a discovery that was made only on the operating table. At that point there was no choice but to go ahead with the surgery, even though there was some doubt that he had enough healthy tissue to withstand the stress of the operation.

There was never any discussion of my father's death, and Ben and I were not allowed to go to the funeral; it was not for us to weep together as a family. It was as if my father simply walked out of our life and, with his departure, the three of us became alienated from each other. At night we would sit down to dinner together, my father's palpable absence filling the room, my mother's refusal to discuss his death a wall between us. To this day I cannot understand what possessed her to shut us out like she did. Who knows? Maybe her own grief was so unendurable that she felt she would be destroyed—or would hurt her children even more—if she allowed herself to express her own feelings or ask us about ours.

Perhaps she was attempting to protect us, though there was probably no real way of shielding either of us from the trauma of our father's

death. I was left grief-stricken and totally dazed by the loss of my beloved parent. But I believe that Ben was affected even more, though the full and paralyzing effects would not become apparent for many decades. He and I became even more distant, perhaps separated by the sorrow we could not share. And for many, many years, I was deeply and bitterly enraged at my mother because I felt she had failed both my brother and me at this terrible time.

Moreover, not only had we lost our father, but most of the Cohen family members seemed to disappear from our lives. Some of my aunts apparently blamed my mother for my father's death, primarily (and irrationally) because it had been her doctor who'd performed the operation. In fact, this might have been the reason for my mother's decision that Ben and I not attend the funeral. Perhaps she'd been afraid we would be forced to witness something unpleasant—like an aunt accusing my mother of "murder" (which actually occurred).

BITTERSWEET STREET ca. 1948. Oil on canvas board, 11 × 16 in (27.94 × 40.64 cm)

This dramatic alteration in our extended family structure was also precipitated by my Uncle Willy being shot to death during a robbery at his liquor store a mere eight months after my father's death. My poor Aunt Enid lost the two people closest to her within such a short period. As I tell this story I find myself thinking about my mother, and I feel my heart breaking for her. Not only was she widowed at forty, left with little money and two young children to support, but as the result of a botched administration of anesthesia during a hysterectomy she had around this time, she began to have epileptic seizures. These could only (and barely) be controlled with phenobarbital, since she was allergic to all other medications on the market. I wish I had not been so young and so unable to feel sympathy for her at the time. I understand now that she must have been suffering even more than her children.

Shortly before my father's death, he and I had a conversation that left an indelible impression upon me. He had apparently promised my mother that he would never tell me that he was a Communist. (Earlier I labeled him a Marxist, which is more accurate, as he ceased to be a party member in 1939.) I do not know why my mother extracted this pledge from him, though I would imagine that, as this was the 1950s and anti-Communist fervor was at a high pitch, she was probably frightened.

Perhaps my father, with some sense of how ill he was, wanted to be sure that he would be the one to explain his political views to me. Even though I distinctly remember talking with him, I cannot completely recall everything we discussed, most likely because, even now, I still become quite choked up when I think about it. At one point he asked if I knew what a Communist was, to which I replied, "I think so." Then, despite his vow to my mother, he told me that he himself was a Communist and asked whether I believed that all Communists were "bad," as I was being taught in school. (The Weekly Reader at this time featured comic strips in which monstrous yellow Communists were pictured bayoneting handsome American boys.)

I cast about for an answer and finally replied that people like him couldn't be bad because they were only trying to make the world a better place. He smiled, which made me feel that my reply had satisfied him— though later, after his death, I went over this conversation again and again

to see if I had somehow failed him and that was the reason he had died. With a child's logic, I believed I was somehow responsible, a conviction that lodged deep within me for quite some time.

Another—and ultimately more far-reaching—effect of this interchange was that from then on, when it was time to look at the Weekly Reader in school, I found myself in possession of a secret: my father was one of these dreaded Communists. This was something I puzzled over for a long time, and I eventually concluded that I would have to choose between my own experience of my father and what the world would have me believe about him. I shall always be grateful for my dad's wisdom in initiating that conversation with me. As a result, I learned a crucial lesson: I had best trust my own judgment, because other people's assessments could be very, very wrong.

After my father's death I was an extremely confused teenager. Although outwardly I seemed to be functioning well—continuing with my art classes and doing fine in school—my life was a mess. My mother and I were fighting almost constantly, the consequence of some teenage rebellion on my part, made worse by her continued refusal to discuss anything related to my father's death. Any attempt on my part to broach this subject seemed to result in her having a seizure, which (I am chagrined to admit) used to embarrass me terribly, especially if it took place in public.

I took refuge in my art life and also with my cousin Peggy, the daughter of one of my father's sisters. She and her husband lived near the University of Chicago, where they attended classes and taught part-time. Peggy would meet me after class at the Art Institute, and we would take the train to her house on the South Side, where I would spend the weekend. We would engage in intense discussions about my father, by whom she, like some other cousins, had been inspired. For some reason I found these talks comforting, if only because, at least for short periods of time, they brought him back to life.

One other strong memory I hold from my teens is of my boyfriend, Tommy Mitchell, a sweet and good-looking guy. He had a fantastic car, a '53 turquoise-and-white Chevy, in which he would pick me up after my Saturday classes at the Art Institute. It seems somewhat remarkable that, though this was the mid-1950s, he never uttered a word of protest at my

insistence that I couldn't see him until after class since my work came first. Tommy was also memorable because it was with him that I first experienced orgasms. Being well-behaved, middle-class teenagers, intercourse was unthinkable to us. Instead, we would pet and dry-hump on whatever sofa we could find. The then-prevalent idea that women didn't *need* to come was one with which I was unacquainted. I took my right to sexual pleasure for granted and was shocked when future boyfriends were not always so accommodating as Tommy.

Most of my high school years were a blur. Much later, some classmates (encountered by chance) mentioned their impression that I had thought myself "too good" for them, what with my artistic passion and seemingly advanced intellectual interests. Had they only known how mixed-up and sorrowful young Judy Cohen actually was, perhaps their perceptions would have been different. For my part, the most important aspect of high school was getting through it in order to go to college.

I had been debating whether to attend the Art Institute, the University of Chicago (which had a joint program with the Institute), or UCLA, which was known to have a good art program. My mom's sister, Dorothy, who lived in Los Angeles, had offered to let me live with her and her husband, Herman, should I choose to go to school there. Had I received a scholarship to the Art Institute—which I expected and thought I deserved—I would probably have chosen to go there. Instead, I decided it might be a good idea to head west, if only to escape my troubled family life.

Shortly before my departure for California, Paula Levine, a girl who lived across the street from me, was killed, along with most of her family, when their car was hit by a train at a blind crossing. Two years my elder, Paula had been my best friend throughout our childhood. It was with her that I had many frank discussions about sex, beyond the rather technical explanation my mother had given me when I was six. As a result of this tragedy, when I left Chicago I took with me two important traits: the determination to make something of myself and an acute awareness of the fickleness of fate.

If I were to meet this young Judy Cohen today, say, on the train taking her west, how would she appear to me? She was small, not more than five

feet three, slim but with a slightly stocky build, the result of her father's genes, which seemed to produce a body type featuring a somewhat thick midriff along with negligible hips and backside. She had cropped hair (common then for people with overly curly tresses) and wore glasses, which she often removed in an effort to avoid being viewed as "four-eyed." Her earnest manner and direct mode of expression gave little indication of her troubled heart. Somehow, the free spirit she had been as a young child had managed to survive the traumas of the intervening years. She still breathed the rarefied air of the "higher purpose" and had little patience for mundane concerns. All that was important to her was to become a famous artist and to make a difference in the world.

Soon after starting college at UCLA, I met Lloyd Hamrol, a fellow art student two years ahead of me. He was my first date in California and he was soon quite smitten with me, possibly because he had never met any female who seemed so sure of herself, nor so determined on a future as a successful artist. We dated on and off, though in my somewhat snobbish view, he was not intellectual enough. My tastes ran more toward the black-turtleneck type, commonly referred to as "beatniks." I also liked tall, lanky, smart Black men, like Leslie Lacy, a philosophy student at USC whom I met at an NAACP meeting. I had joined the organization and become its secretary. It was with him that—after some awkward attempts—I lost my virginity.

After six months at the home of my aunt and uncle, whose extremely right-wing politics provoked many arguments, I moved into a succession of apartments with a changing roster of female roommates. I adored college and benefited from having been placed into a gifted students' program, which allowed me to substitute stimulating upper-division courses for the less challenging survey classes.

At the end of my sophomore year, my mother and brother moved to L.A. They settled in the Fairfax area of the city, which is full of modest Spanish-style residences and apartment buildings. My mother got a job as a medical secretary and my brother enrolled in Fairfax High School. I was furious about their arrival, thinking that they had followed me when all I had wanted was to get away from my family. Years later, my mom told

me they had moved out west in order to establish residency so that my brother would be eligible for the low-cost but high-quality education of the California university system.

By then I was living with Jerry Gerowitz, a charming, brilliant, though self-destructive and rebellious young man, whom I would later end up marrying. Soon after my mother and brother got settled, I announced that I was leaving with Jerry for New York. After hitchhiking the whole way, we ended up living in a cockroach-infested apartment on East Sixth Street.

I painted every day between eight in the morning and two in the afternoon, establishing my work hours as an inviolate time, a pattern I have maintained ever since. In the afternoon I taught art, first at the Henry Street Settlement, then at the Police Athletic League in the early evening. After work, Jerry, who had a succession of part-time jobs, and I would hang around with artists and musicians, as the area in which we were living (the East Village) was filled with numerous creative people. Unfortunately, too many of them seemed to spend more time discussing their respective crafts than practicing them. I tired of this scene after just a year and decided to return to California and resume my studies. Jerry followed several weeks later.

I had begun to have stomach attacks in New York and had seen several doctors, all of whom dismissed the pains that doubled me up. I never associated the terrible stomach pains I was experiencing with my father's condition, although they were identical. Shortly after our return to L.A., I was diagnosed with a bleeding ulcer that had perforated my duodenum, which forced me to spend almost a month in the hospital. This experience scared me so much I decided to go into therapy, which was an uphill battle that lasted two and a half years. While I was working through my personal problems in therapy, Jerry and I began to struggle with the issues that kept us in a pattern of coming together and then breaking up. I wanted him to become more responsible, to find regular employment and a direction for his life. He loved me and wanted to make the relationship work and agreed to make some changes. We got married in the spring of 1961. I believe that my mother and brother attended the ceremony at the county courthouse but, to be honest, I do not remember. I visited them on a regular basis, though relations between us were less than wonderful.

In 1962, I received my undergraduate degree Phi Beta Kappa, having taken so many philosophy and literature classes that I qualified for this honor, which was apparently unusual for art students. Jerry and I were relatively happy together by then, having established an equalized relationship at a time when such a thing was still unusual. I assumed that he should do half the housework, and he complied. We had one argument about it when he left his dirty socks on the floor. I flipped out, yelling something about how my having a cunt did not mean that I was his maid.

After we were married for about a year, we got a house in Topanga Canyon, one of the lush, mountainous canyons in Los Angeles. I used the garage for my studio and carved stone in the large area behind the house. I had become a teaching assistant at UCLA in sculpture. Jerry started therapy and went back to school. He had decided he wanted to be a writer, and he was working at it. That year was really good, though I got pregnant twice. We never discussed having children and I never wanted them, because I was focused on my ambitions as an artist. I got abortions both times even though they were illegal; if you could afford it, there were cooperative doctors. At one point, the FBI visited and asked me to testify against the doctor who had performed my abortions as they wanted to charge him with a crime. Of course, I refused, because even then I knew that women should have control over their own bodies, a right that continues to be contested.

One Friday night in June 1963, Jerry and I came home to find our four-month-old Labrador retriever dead on the road, hit by a car. We were very upset, especially Jerry, who as a six-year-old had been traumatized when his puppy was hit by a car in front of his eyes. Our dog's death brought that experience back. We buried her behind the house and cried together for a long time. For some reason, Cleo's death seemed like an omen.

Two days later, Jerry was killed when his car went over a cliff on the twisting road leading to our house in Topanga Canyon. Our friend Janice Johnson found his body. She reported that it was covered with ants, which left me with a lifelong aversion to this particular insect. Jerry's death precipitated a period of deep mourning, which, thanks to my therapy, helped me openly grieve for my young husband and, at long last, for my dad. It

also helped me uncover and then recover from the guilt I had internalized about my father's death ten years earlier.

After Jerry died, I moved into a small house in Santa Monica, which had a separate building that I used as a studio. I spent most of the next year—my second in graduate school at UCLA—trying to translate my sorrow into images and coming to terms with what was an exceedingly premature awareness of the fragility of life and my own mortality. I was all of twenty-three but it was then that I resolved to build my life on the basis of my own identity, my own work, my own needs—those few things I knew that I could never lose. My art became my focus, my solace, and my reason for living. At the time I still had absolutely no idea that building such a life was at all unusual for a woman.

MAKING A
PROFESSIONAL LIFE

After Jerry's death, I worked in my studio constantly, trying to make images out of my feelings. I did drawings that contained shapes tumbling down the page, like Jerry's body falling through the air and down the cliff. I made images of death and resurrection and frozen contact; shapes trying to touch, forever held in the agony of separation. I wasn't always conscious of the meaning of these images, but in the process of struggling to come to terms with my circumstances, I made myself into the artist I was always determined to be.

When I was an undergraduate, I had noticed that most of the serious students were men, and because I wanted to be taken seriously, I sought the friendship of these men. They would often put other women down, calling them "chicks" and "cunts." Occasionally, I joined in, feeling a little guilty, but wanting to be "in" with them. I didn't understand why other women weren't interested in the things I was, and unknowingly I began to absorb the culture's contempt for women, rationalizing my own female identity, as my male colleagues seemed to do, with the idea that I was somehow "different."

I had had female teachers before I went to college, but at the university the respected members of the studio faculty were all male. By the time I entered graduate school, I was becoming more conscious of my situation as a woman. The continuing hostile comments from men and the absence of other serious women students made me conclude that some men didn't seem to like women who had aspirations as artists. While discussing teaching assistantships with Oliver Andrews, my sculpture teacher, I commented that I was afraid my gender would disqualify me, having heard that the

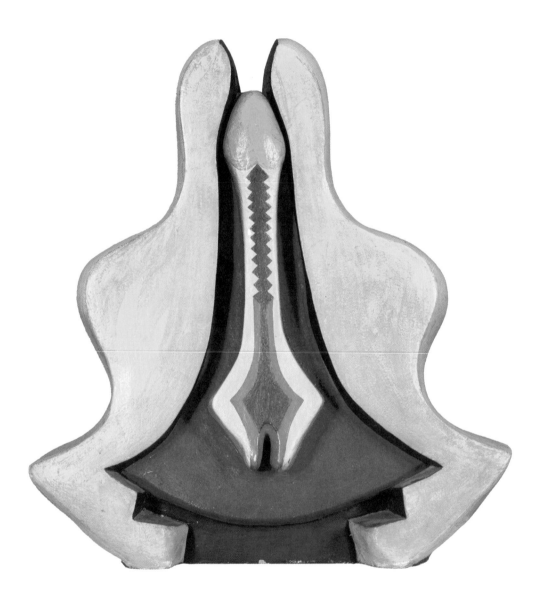

IN MY MOTHER'S HOUSE ca. 1964

Acrylic on stoneware, 24 × 18 × 6 in (60.96 × 45.72 × 15.24 cm)

Collection of the Monterey Museum of Art, Monterey, CA

department didn't give teaching assistantships to women. He assured me that although there was discrimination in the Painting Department, he did not practice it, and he was sure that I could get an assistantship in sculpture (an unusual event in 1962). As I remember this period of my life, I realize that there was a knowing and a not-knowing going on within me simultaneously. I was coming to recognize that there was a serious gap between the way I saw myself and the way I was seen by the world. At the same time, I tried to deny the significance of that gap, because I did not want to feel how alienated I really was as a woman who took herself seriously. I was having enough trouble, first coping with the struggle to recover from my father's death, and then, after Jerry died, trying to put my life back together.

Fortunately, I had a tendency to pursue my own objectives regardless of the societal messages I received. This came partly from my irrepressible confidence that whatever I did was "terrific," partly from my drive and determination, and partly as a result of my childhood. I had learned early on that the world's perceptions of a person are not necessarily accurate, so I tended to discount comments and attitudes that conflicted with my own sense of what was true.

Several years after I left college, a school friend told me that she and most of the other young women we knew always felt that the discussions that took place in academic classes were intended to be between male faculty and male students. I had often noticed that most of the other female students were quiet in class, but I had no idea why. I was annoyed that other women didn't take an active role, but I attributed it to the fact that I was "different" and acted as I wished. As we talked, I remembered that when I raised my hand to speak, I often wasn't called on right away, but I just figured that the instructor hadn't seen my hand, so I kept on waving it around until he called on me. It suddenly dawned upon me, in the context of this conversation, that I had been oblivious to the message being telegraphed: women were supposed to be "good girls" and accept the inevitable second-class status of our gender. Since I never got this message, I continued to behave according to the standards of equality I had absorbed from my family.

Nonetheless, I couldn't entirely escape the realization that my ambition and dedication were somewhat unusual in women of my generation. I had what seemed at the time to be good friendships with some of the male students, but even those ultimately forced me into greater consciousness of my situation as a developing woman artist.

One day in 1963, I visited my friend Lloyd, whom I had met as an undergraduate. We had not seen each other in a while, and when I entered his studio, I was shocked. He had changed his way of working and had built a series of large sculptures using techniques I didn't realize he knew. All that time together at school—drawing, taking classes, sharing ideas—and now he had begun to work in a way that I knew nothing about. As a male, he had grown up learning to put things together, to use tools, processes, and techniques that were not in the realm of my cultural orientation as a woman. When he showed the work in a gallery, people continually commented on his good craftsmanship.

I didn't even understand why "craft" was important. The whole idea of artmaking as an involvement with materials, process, forms, or "craft" was entirely foreign to me. When, in sculpture class, the teacher had given long lectures on elaborate technical processes, I had barely been able to contain my boredom. My male friends, although equally bored, took voluminous notes—preparations, I later discovered, for the time when they would get jobs teaching sculpture and setting up sculpture shops. No one had ever suggested that I would have to "make a living," so I was not involved with "preparing" myself for a job. (I suppose I just assumed that somehow it would happen.) Besides, as far as I knew, there were no women who ran sculpture departments, so it seemed clear that the lectures were of no value to me.

Also, it was very confusing that something could be considered "good" just because it was well-made, independent of its meaning. Yet, in the world of art galleries, museums, and art magazines, there seemed to be a set of standards by which art was measured that were very different from anything I had ever encountered, standards that had to do not only with craft and process but with "newness," "issues," and the "formal properties of the work," whatever that meant. Since I wanted to do "important" work, I felt obliged to internalize these foreign standards.

I began to realize that I would have to develop some knowledge of craft, process, and technique. I felt extremely uncomfortable with the tools and machines of sculpture, given my lack of exposure to them along with my upbringing, which stressed the Jewish intellectual's disdain for physical work. But in an effort to be taken seriously as an artist, I forced myself to learn how to use tools that I had never even seen before. I didn't want to admit that I didn't know the first thing about the mechanical world, because I knew that my status in the Art Department depended upon the fact that I was "different" from other women, who were "weak" or "dumb." I couldn't exhibit either of those traits or I would be just "another cunt." So I pretended to know what I was doing in the shop. Even when I almost lost a breast in the table saw, I wouldn't ask for help. Instead, I just maintained a brave front and bumbled my way through.

In my second year in graduate school, I had a confrontation with my male painting instructors. Although I was primarily working in the sculpture department, I was also still painting. The work I did in the summer after Jerry died had led me to a series of paintings on Masonite. As I had begun to learn something about tools by then, I built some large panels to paint on. Lloyd's success had influenced me, and I copied the symmetrical frontal format he was using and stuffed all my falling, tumbling shapes into a position of stasis and formal organization. But I was filling the framework with images that came out of my deepest emotions.

These images were biomorphic and referred to phalluses, vaginas, testicles, wombs, hearts, ovaries, and other body parts. The first one, *Bigamy*, held a double vagina/heart form, with a broken heart below and a frozen phallus above. The subject matter was the double death of my father and my husband, and the phallus was stopped in flight and prevented from uniting with the vaginal form by an inert space. Another of the paintings, *Birth*, had an abstract body form composed of reproductive parts that hunched over, as in the birth process. The other paintings were similar in imagery and, although abstract, were very graphic in their expression.

When I showed the work to the two male painting instructors on my thesis committee, they became irate and began to make irrational objections to the paintings. I didn't understand why they were upset, and

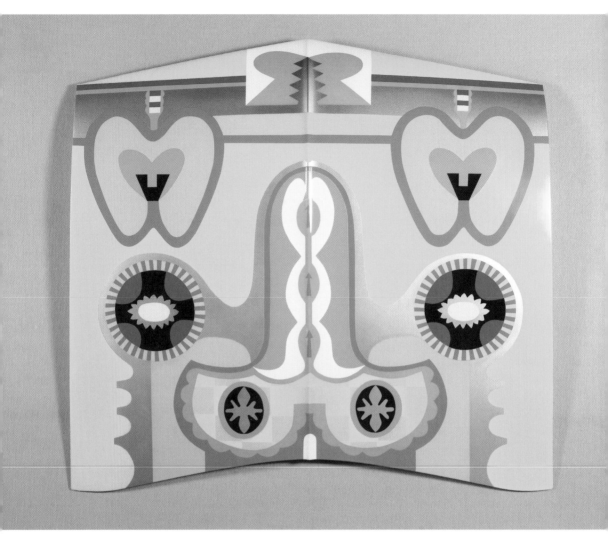

BIGAMY HOOD 1965/2011. Sprayed automotive lacquer on car hood
42.9 × 42.9 × 4.3 in (108.97 × 108.97 × 10.92 cm)
Collection of the Longlati Foundation, China

obviously, judging by their reactions, neither did they. They threatened to
withdraw their support if I continued to make works like these. One sput-
tered something about not being able to show the paintings to his family
and then left, leaving me more confused than ever about standards in art.
However, I was getting one message loud and clear: there was something
in my work that wasn't supposed to be there. Other male instructors had
made comments about some of my earlier drawings and sketches that

contained references to female anatomy. "Icc-ch," one man had said, "those look like wombs or breasts." Perhaps, I thought, they didn't like work that appeared too womanly.

Looking at the work of graduate candidates that the faculty admired, and whose work bore some relation to mine, I could see that it tended to be more abstract and less graphic in its description of emotional or sexual subject matter, like the work at the better galleries around town, which seemed to be more about painting itself and less about any internal or personal reality. I made some pieces in which the subject matter was less obvious, and my teachers were pleased. I soon became intimidated and began to hide my subject matter from them, trying to find a way to still be involved with my own content without making it so straightforward that my male teachers would respond negatively.

Halfway through my last year in graduate school, I became involved with one of the best galleries in town, run by a man named Rolf Nelson. He used to take me to the artists' bar Barney's Beanery, where all the "important" artists hung out, most of whom showed at Ferus Gallery. They were all men, of course, and they spent most of their time talking about cars, motorcycles, women, and their "joints." I knew nothing about cars or motorcycles, couldn't really join in on their discussions about women, and didn't have a joint. They made a lot of cracks about my being a woman, but I was determined to convince them, as I had convinced the men at school, that I was serious. In an effort to be accepted, I began to wear boots and smoke cigars. I went to the motorcycle races and tried to act tough whenever I saw them.

By the time I left school, I had incorporated many of the attitudes that had been brought to bear on me and my work, both in school and in the art scene. I had abandoned the paintings that my graduate advisers disliked so intensely, leaving them in a garage to be destroyed. I used to have dreams about being on a battlefield with bullets zinging across the field in front of me. I needed to get across, but I didn't know how, having never been trained for warfare. I was terrified. Finally, an anonymous hand reached out and helped me across the field safely. The dream obviously symbolized my need to learn how to survive in the rough-and-tumble male-dominated

world in order to become visible as an artist. I didn't want to run away or hide in a closet, pursuing my work in isolation, even though many nights, after hanging out at Barney's, I'd go home and cry.

After I finished college, I decided to go to auto-body school to learn to spray-paint, something several of the male artists—specifically the sculptor John Chamberlain, whom I had gotten to know—had discussed doing in order to improve their artmaking techniques. I was the only woman among 250 men, all of whom lined up to see me do my final project, which was spraying an old Ford truck with metallic chartreuse paint. Despite the inhospitable environment, I learned quite a bit that was beneficial to me as an artist, the most important skill being the technique of spray painting, which provided me with the ability to fuse color and surface in many media (and became one of the hallmarks of my work).

I am sure that one of the reasons I took up spray painting was to prove myself to the guys, who were influenced in their work by the gorgeous lacquered surfaces that grace motorcycles and race cars. This was the time when the "finish fetish" style dominated L.A. art, especially as it was practiced by an artist named Billy Al Bengston, who became something of an unacknowledged mentor to me. It was from him that I learned not to pay much attention to reviews. His advice was to count the column inches and the number of pictures, disregard whatever the critics wrote, and go on working, a practice I would follow for most of my career.

Although Billy Al and his colleagues were not exactly supportive of women artists, they treated me with a modicum of respect, probably because they could see that I was talented, worked extremely hard, and was determined to be taken seriously as an artist. That was my goal, and everything else was secondary, including my personal life. (For example, if I was not finished with my studio work at the end of the day, I would cancel whatever social plans I had made for the evening in order to complete the task at hand.)

Early on I had been introduced by the Ferus boys to the idea that being taken seriously as an artist was more important than anything else, even economic success. Since my upbringing had instilled in me the idea of working for a higher purpose, it was easy for me to accept this canon,

which was highly promoted among artists then, before marketplace values came to dominate the art world (one consequence of which has been that the notion of art as a spiritual pursuit is now considered quaint). But higher pursuits aside, how did I earn a living?

Even though I was as poor as a church mouse, I looked around at my male artist friends to see how they made do, discovering that they lived by the "something will happen" school of thought. This meant becoming accustomed to never knowing how you would pay the next month's rent, all the while hoping either that your gallery would ring up to say a work of art had been sold or that some other equally providential event might occur. As it was considerably easier to get along on next to nothing back then, I was able to scrape by, supplemented by part-time teaching on weekends or at night, so as not to interfere with my studio hours. My male colleagues also taught me that you have to generate the money you need in order to create. This means that, unless you are wealthy, some form of patronage is essential. I have been extremely fortunate in that I have been able to acquire a number of patrons, though of differing means, and many of them have remained loyal for decades.

What I have been describing is the voyage I was forced to make out of what is considered the female world and into a male-centered environment where "real" art is made. Not long after I finished auto-body school, a male artist told me that he had held me up as an example to his female students, saying: "You see, if you want to be taken seriously, you've really got to dig in there, like Judy." What a shame that I was made to feel that "digging in" could only be measured in terms of "tough talk," spray paint, and motorcycles. One of the best compliments a woman artist could receive then was that her work "looked like it was made by a man." A sculpture like *In My Mother's House*, done while I was in graduate school, was smilingly referred to as "one of Judy's cunts" by male artists. In *Car Hood*, one of the painted hoods I worked on when I was at auto-body school, the vaginal form, penetrated by a phallic arrow, was mounted on the "masculine" hood of a car, a perfect symbol of my state of mind at this time.

In 2011–12, my early work was included in a number of exhibitions related to the Getty-funded initiative Pacific Standard Time, which

documented and celebrated Southern California art from 1945 to 1980, twenty years of which I was in Los Angeles. In preparation for these exhibitions, I went through this work and discovered I had laid out three other car hoods that I had never actually finished as a result of so many rejections. I decided to finish them, and when they were done, I realized that there was never anything wrong with my imagery; it was the misogynist attitudes that were brought to bear on it that were wrong.

However, the next few years of my life were extremely baffling to me in terms of both my life as an artist and my relationships with men, both in and out of the art world. As I mentioned earlier, I started having orgasms when I was a teenager, and my sexual relationship with Jerry was relatively satisfying. We had sex almost every night and came simultaneously. But after he died, I had several affairs, all of which depressed me enormously and made me think that I would have to spend the rest of my life alone. The men with whom I became involved either used me sexually, expected me to "take care" of them, were threatened by my work, or, if they could relate to my work, were unable to relate to me personally. Lloyd seemed to be the only man I knew who cared about *me* and who could relate to my work. It was probably loneliness that caused me to move with him into a loft in Pasadena.

In terms of the art world, one man, an art critic, used to bring me paint and canvas, mention my work occasionally in his articles, and take me out to dinner. But then he would say, in the middle of a discussion, "You know, Judy, you have to decide whether you're going to be a woman or an artist." His words echoed comments made by the male artists at Barney's: "You have to have balls to make art."

In Pasadena, there were a number of male artists living nearby, as space was extremely cheap. When they visited, they made it clear that they were interested in Lloyd, not me. It seemed that as my work got better, the resistance to acknowledging that a woman could be an artist grew stronger. It was at this time that I did a piece called *Rainbow Pickett*, a series of multi-hued forms that rested against the wall to create a spectrum of color bars (later shown in *Primary Structures*, which was the first major minimalist show and was held at the Jewish Museum in New York). Shortly after the

work was completed, Walter Hopps, one of the most important curators in the Southern California art world, stopped by our studio. I invited him to see the sculpture, of which I was quite proud. But as soon as we got into my space, he deliberately turned his head, refusing to even look at the piece—and, worse, going over to a work of Lloyd's that he'd seen numerous times.

RAINBOW PICKETT 1965 (re-created 2004)
Latex paint on canvas-covered plywood, 118.79 × 119.79 × 132 in
Collection of David and Diane Waldman

Years later, I ran into Walter at an art event and we somehow got into a conversation about this exchange. He tried to defend his response by telling me he had been disconcerted that my art seemed considerably stronger than what was being done by many of my male peers. As he said, at that time women in the art world were assumed to be either wives or groupies, devoted to the care of the men. Therefore, he explained, when confronted with my work—and my expectation that both it and the artist should be dealt with in the same way he would have related to my male colleagues—he felt compelled to avert his eyes, adding that it was as if he had seen a lady publicly lift her skirt and display her bare thighs.

During the next few years, I was continually made to feel by men in the art world that there was something wrong with me. They'd say things like "Gee, Judy, I like your work, but I just can't cut it that you're a woman." Or male artists who lived in the neighborhood would come over and be astonished that I wouldn't cook for them or cater to their needs. I heard stories from people about how someone said that I was a "bitch" or a "castrater," which hurt me deeply. If my work appeared in a show and Lloyd's didn't, I was held responsible and accused of having "cut his balls off." I couldn't win. I knew that what I was confronting came out of the fact that I was a woman, but whenever I tried to talk about it, I would be put down with statements like "Come on, Judy, what are you, some kind of suffragette?"—a precursor to the same scorn that was later heaped on the word "feminist."

My earlier naïveté about my situation as a woman artist was giving way to a clear understanding that my career was going to be a long, hard struggle. And because I felt that I had to hide my gender and be tough in both my personality and my work, my imagery was becoming increasingly more neutralized and minimal. But I was never interested in minimalism as such. Rather, the formal composition of my work was something that my content had to be hidden behind in order for my art to be taken seriously. Because of this duplicity, something always appeared "not quite right" about my pieces, according to the prevailing aesthetic. I was caught in a bind. In order to be myself, I had to express those things that were most real to me, and those included the struggles I was having as a woman, both

personally and professionally. At the same time, if I wanted to be taken seriously as an artist, I had to suppress anything in my work that would mark it as having been made by a woman. I was trying to find a way to be myself, still function within the framework of the art community, and be recognized as an artist.

This required focusing upon issues that were essentially derived from what men had designated as being important, while still trying to make my own way. However, I certainly do not wish to repudiate the work that I made in this period, because much of it was good within the confines of what was permissible. Moreover, this was the time when I developed my own color systems and forged the formal building blocks of my career.

On New Year's Eve, 1965, I had my first one-woman show at Rolf's gallery. By that point, I had been in several group and museum shows and had made a lot of work that could be classified as minimal, although, as I mentioned, hidden behind that facade were a whole series of concerns that I did not know how to deal with openly. Lloyd and I had ongoing conflicts, especially around sex, and he soon moved into another studio on the same street, leaving me with a 5,000 square-foot studio to myself. He and I had been having a lot of trouble working in the same space, and we decided it would be better if we each had our own place. This need was particularly strong on my part because I felt that when people came to the loft, they would be less apt to see me in relation to Lloyd if I were alone. I remained convinced that the only way to make any progress in the art world was to stay unmarried, without children, live in a large loft, and present myself in such a way that I would have to be taken seriously.

In 1967, I was working on a piece for a big sculpture show. Called *10 Part Cylinders*, it was made from the forms in which freeway pillars are cast. I needed a large amount of money to finish the piece, and a collector friend of mine introduced me to a man who, he said, was interested in helping me. This man owned a large company that dealt in plastics, and I thought his involvement in plastics was the reason for his interest in my sculpture, which was to be finished with fiberglass. We went to lunch, where I discovered the real reason for his offer: he felt that women "needed help" from men because they were inferior, and he "liked to help women." He

went on to say that if a male artist were to ask him for help, it would be degrading to the artist and he would refuse, because "men should take care of themselves."

My throat constricted and my stomach became tight. Though this man was willing to give me all the money I needed to finish my piece, it meant that I would have to live with the fact that I accepted help from a person who considered me inferior. What's more, his assistance only highlighted my inferiority, because by accepting the money I would be reinforcing his belief.

Perhaps today I would tell him off and walk out. Then, because I had internalized the idea that I had to be "tough enough" to do whatever was necessary in order to get my work done, I accepted his offer while feeling terrible about it. Was it any wonder that in my work I was trying to move as far away as possible from revealing that I was a woman? Being a woman and an artist spelled only one thing: pain.

Although I was trying to deny anything in my work that could mark me as a woman, some aspects of my gender were intrinsically involved with both my day-to-day activity as an artist and my developing aesthetic. In fighting for my rights in the art world, I was acting out of a feminist consciousness before I knew what to call it. At the same time, when I worked in my studio I came into contact with those areas of my personality structure that had been crippled by what we used to call "female role" and is now described as the construct of femininity. Even though one could say that I had been imperfectly socialized as a woman in that I was extremely ambitious and assertive, I still came to realize that certain aspects of my personality were the result of internalized gender expectations.

This was particularly true in relation to my interactions with male art authorities, whom I tended to see as a child sees a parent. I kept expecting to gain approval from them, particularly since I had grown up being loved for whatever I did. It was shocking to encounter hostility and rejection instead. Slowly and painfully I began to realize that I had to change my expectations. Instead of looking to the male world for approval, I had to learn to rely on my own instincts. In some strange way, the rejections I faced strengthened me, but only because they forced me to learn to live as I saw fit and to use my values and judgment as my guides.

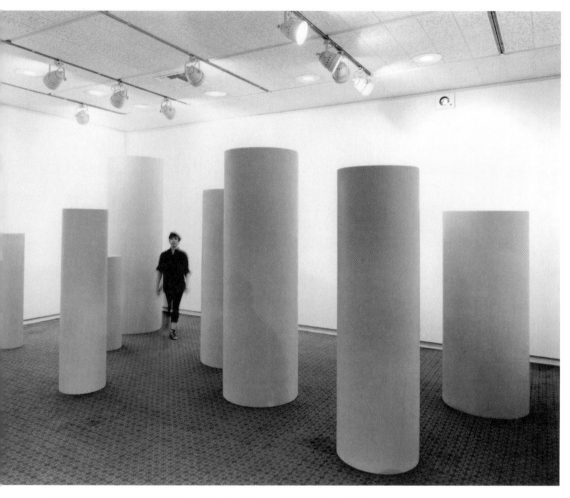

With **10 PART CYLINDERS** from the *Sculpture of the Sixties* exhibition
at Los Angeles County Museum of Art, CA 1967

Despite my efforts to eliminate content from my work, my art reflected
my struggles, albeit indirectly. The hard materials (plastics and metals),
perfect finishes, and minimal forms in my work of 1966 and 1967 were
"containers" for my hidden feelings, which flashed in the polished surfaces,
shone in the light reflections, and disappeared in the mirrored bases. By
1965, I had stopped painting and was entirely focused on sculpture. My
pieces were either very small and rearrangeable, which made the viewer

With **MOVABLE CYLINDERS** Pasadena, CA 1968

huge in relation to them, or were large, simple pieces that one walked through and was dwarfed by.

This duality paralleled my own experience. In my studio, I felt large and able to manipulate my own circumstances. In the world, I was continually made to feel small by men and their attitudes. Consequently, I could get lost in values and opinions that were hostile and foreign to me. Moreover, I realized that my rearrangeable sculptures had another dimension that was directly related to my socialization as a woman. By 1967, Lloyd had gotten a teaching job in San Diego and was away three days a week. During his absence, I lived my life in terms of my own needs, but as soon as he returned, I "put down" my life and changed my schedule to suit him. I realized that I had been taught to think that I should "rearrange" my life to meet the needs of a male partner and that this was reflected in my decision to make sculptures that could be moved about. The problem was that this behavior was unconsciously shaping my aesthetic choices.

I worked through most of these issues alone in my studio and through my work. In going to auto-body school, learning to use tools and machines,

facing and overcoming rejection and difficulties in the world, and build-
ing large-scale pieces, I was moving beyond the limits of what women are
expected to do and be, which was healthy. Although aspects of my work
process were still being shaped by male pressure, my own desire to grow
and be a whole and functioning artist also motivated me. When I made
the small, rearrangeable pieces and the large sculptures through which
one walked, I was also trying to give voice to my own feelings of "moving
through" and "out into" an unfamiliar world, trying to gain control over
my life, trying to expand my capacities. The years 1965–67 were spent
exploring those aspects of my personality that this culture calls masculine:
my strength (both physical and mental), my assertiveness, my ability to
conceptualize. It is interesting that it was during this period that I encoun-
tered hostile statements to the effect that I was trying to be a man and that
I was "castrating" Lloyd.

In truth, my relationship with Lloyd was somewhat incomprehensible
to the people around us. We never had any problems about housework.
Lloyd simply assumed that he would do half and, because by that time I felt
threatened by the idea of being seen doing "female" chores, sometimes he
did more than half. However, during the Pasadena years, I think Lloyd was
often torn between his feelings for me and his own need for recognition,
because male art-establishment visitors liked to extol him while putting
me down, which must have put him in a no-win situation.

At the same time, the more I experienced myself as a "person" in my
studio, the more unbearable it became to deal with the fact that I was being
treated as a "woman" in the world. Additionally, I had come to realize that
whenever I showed a male artist or curator my work, his perceptions were
inevitably filtered through his attitudes toward women. So by 1968, I had
ceased showing my work to many people, had become particular about
where and under what circumstances I would show, and was living in virtual
isolation. I wasn't even seeing Lloyd too often.

I could no longer pretend in my art that being a woman had no meaning
in my life; my entire experience was being shaped by it. I decided to try and
deal with it in my art. I also wanted to explore the nature of my sexuality.
Having been brought up with 1950s sexual mores, I had been taught that

mutual orgasm was the ultimate in sexual satisfaction. It had been continually puzzling to me why a single orgasm left me unsatisfied. This was before the publication of the report by groundbreaking sex researchers Masters and Johnson, which demonstrated that many women are multi-orgasmic. I had already had experiences that suggested this was the case for me. I felt that if I could somehow symbolize my true sexual nature, I could open up the issue of the nature of my identity as a woman through my art.

As I was still trying to "slip by" in the male world and express myself without losing validation from men, I decided to use three abstracted dome shapes, the simplest forms I could think of that had reference to my own body, breasts, and fecundity while maintaining the necessary neutrality for the art world. Each of the three domes was made of a transparent material and had layers inside that could not be clearly seen, an interesting metaphor for my own hidden depths. These multiple half-spheres were sprayed with softly changing colors, which overlaid inside the forms. In order to make these pieces, I had to slowly and painstakingly develop technical skills. I had not sprayed since auto-body school, and now I wanted to spray on

BRONZE DOMES 1968
Sprayed acrylic lacquer on clear acrylic domes on mirrored base, 43 × 30 × 30 in

plastic, which was difficult to do (and which no one on the West Coast had yet done, certainly not in the scale that I ultimately used).

I began working on color systems that would make the forms feel as if they were dissolving. I was trying to invent a format for expressing what it was like to be female and multi-orgasmic. In addition, I was struggling to resolve my ongoing sense of loss and my still unclear self-image. The dome shapes stood for the essential family unit of mother, father, and child as well as my sexuality. One could walk around the domes and see them from all sides, which allowed them to be examined for their constantly changing relationships. The color in the domes was contained, trapped inside the swollen breast or belly form.

Even though I had attempted to neutralize the subject matter of this work, apparently my femaleness was still evident. At one point, Irving Blum, the director of the Ferus Gallery, visited my studio. When he saw the domes, which were set up in a room I had turned into a gallery space, he remarked scornfully, "Ah, the Venus of Willendorf," a reference to the ancient stone statuette of a woman with pronounced breasts, stomach, and vulva and, by extension, early goddess figures. I was devastated. It was one thing to approach issues about my identity as a woman, no matter how indirectly. It was quite another to be identified as doing so.

Finally I realized that whether my work would be accepted or not, I had to work through these issues. Whether I liked it or not, on one level I was the Venus of Willendorf and all that she symbolized. Rather than running away from having been born female, in that—like the effigy—I have a belly, breasts, and a vagina, perhaps it was necessary to accept it and affirm myself and my own identity as a woman artist. But could I do that and still maintain my status as an artist in the "outside" world? After all, I did not want to relinquish the professional identity I had fought so hard to secure.

BECOMING JUDY CHICAGO

The domes led me back to painting. I began working on a series of images on small sheets of clear acrylic, spraying them with an airbrush and using them as studies for the color layouts in the domes. Then I became interested in the two-dimensional forms independent from the domes, because it seemed that a flat format worked better than a sculptural one for the issues with which I was dealing. One thing working in two dimensions seemed to allow more easily was a body identification between me and the painted forms. This was hard to achieve in sculpture, which seemed to exist outside of oneself so much more.

At first the forms—three round shapes, one above the other two—were blobby, undefined, as if to say that my own self-image was still undefined. Then I did some drawings in which the centers of the forms were dark. I felt the darkness in my stomach as a sense of wrongness, as if there were something wrong with *me*, and I knew that I was going into the place inside me that had been made to feel foul by my experiences in the male-dominated world.

I opened the forms and let them stand for my body experience instead of my internalized shame. The closed forms slowly transmuted into dough-nuts, stars, and revolving mounds, which—for me—represented cunts. (I use that word deliberately, as it is that word that has often embodied society's contempt for women. By symbolically turning the word around, I hoped to turn around society's negative definition of the female.) I chose that format because I wanted to express what it was like to be physically organized around a central core, my vagina, which is so connected to the social definition of womanhood. I was interested in portraying a dissolving sensation, like one experiences in orgasm. It seemed that my situation as

a woman had a dual nature. On the one hand, as a heterosexual woman it was through my cunt that I made contact with men, who could affirm me and give me great pleasure, especially at the moment of orgasm, when I was totally vulnerable. At the same time, because I had a cunt, I was despised by male-dominated society.

I made shapes where the central holes contracted and expanded, clicked around in a circle, twisted, turned, dissolved, thrust forward, and became soft, both consecutively and simultaneously. I repeated the forms in an effort to establish a continuum of sensation. As I went along, the paintings became increasingly difficult technically. But that difficulty seemed to be a parallel to the emotional risks they represented for me as I openly confronted my feelings as a woman. The color systems I had been developing allowed me to establish a method of representing emotional states through color: assertiveness could be represented by harsh colors, receptiveness through softer, swirling color, the state of orgasm through color that dissolved. I began to combine these various color systems with the forms I was evolving in order to try to convey the multiple aspects of my personality and my sexuality. Again, I was working within a male-oriented form language, which inherently limited the degree to which all this information could be perceived by others, but I did not fully appreciate that at the time.

In 1969, I began a series of paintings entitled *Pasadena Lifesavers*. They embodied all the emotional work I had been doing in the past year, reflecting the range of my own sexuality and identity, as symbolized through form and color, albeit still in a somewhat neutralized format. By then, I had become secretive in my process, sliding the acrylic sheets into specially built painting racks and showing them to no one until they were done, which took a year and a half. The series involved fifteen paintings, $5' \times 5'$, sprayed on the back of clear acrylic sheets, then framed with a sheet of white Plexiglas behind each clear sheet.

The first five paintings were hinged on red/green opposition, a combination that caused the forms to gray out. I was frightened by the images, by their strength, their aggressiveness. I had obviously internalized parts of society's dictum that women should not be aggressive, and when I expressed that aspect of myself through forms that were assertive, I thought

PASADENA LIFESAVERS *Pasadena Lifesavers Red Series #2*, *Pasadena Yellow Series #2*,
and *Pasadena Blue Series #2*, 1969–1970. Sprayed acrylic lacquer on acrylic
each 60 × 60 in (152.4 × 152.4 cm). Collection of Elizabeth Sackler

there was something "wrong" with the paintings. Gradually, I accepted the images and, in so doing, also accepted myself more fully. But I was unable to explain my intentions to anyone.

The next group was softer; the paintings were based on what I called spectral color—that is, starting with one color and moving on to one close to that color in the spectrum until I arrived back at the beginning color. The images and ground interplayed as I carried the segments of color over into the background, which I had not done in the first group. The third sequence was blue-green-purple in color and bleached out when looked at for any length of time. Looking back, I now understand that the three groups represented my "masculine" aggressive side, my "feminine" receptive side, and the hiding of myself that I was still doing at the time. But the paintings function on many levels and, as well as possessing layers of symbolic meanings, they are also intended to be visually engaging. They were a first step in my struggle to bring together my point of view as a

woman with a visual form language that allows for transformation and multiple connotations.

While I worked on *Pasadena Lifesavers*, I also executed a series of smoke pieces in which the color inside the domes and the paintings was freed from its rigid structures and allowed to gush into the air. My *Atmospheres* could be seen as a gesture of liberation and also an effort to "feminize" the landscape. Additionally, they reflected the release that I felt in the process of creating *Pasadena Lifesavers*. As I symbolized the various emotional states that comprised my personality in the fifteen paintings, I gave myself permission to experience and express more aspects of myself. When I finished the series, I felt like icebergs were breaking up inside me. By making images of my feelings, I was able to liberate myself from the guilt about my needs, my aggressiveness, my power as a person. Although I was feeling increasingly free within my artistic and personal life, I was still discovering that this freedom did not necessarily extend to the outside world.

When I began working on the *Atmospheres*, I became involved with the only fireworks company on the West Coast capable of producing the smoke devices I needed. The company, located near San Bernardino, was run by a man who, like other men in the business world, was intrigued by the idea of a woman entering a male preserve, as there were no female pyrotechnicians in California at that time. At first he was very nice, although he occasionally made sexist cracks, which I tried to ignore. In order to be in control of the process of setting off the smoke devices, I had decided to become a licensed pyrotechnician. To accomplish this, it was necessary

Performing **SMOKE GUN ATMOSPHERE**
Brookside Park, Pasadena, CA 1968

for me to "shoot" three fireworks shows, and I needed the support of the fireworks company, not only for the production of the material but also for show dates, help with the state tests, and authorization for buying and detonating the smoke devices.

All went well during the year I was ordering materials and doing my pieces around California. I fended off the fireworks guy, ignoring his gradually more insistent remarks about women, sex, and me. Finally, when I was in San Diego to shoot a Fourth of July show in the stadium, the man became aggressive and tried to get me to go to his motel after we finished working. I resisted, and at one point he threw himself down on the grass and began humping the ground, saying, "I could do it to you right here." Then he got up and began rubbing himself against me. I kept trying to push him away. Finally he gave up, but not until he had made me feel like I never wanted to go near him again.

As a result of this experience, I did something I had never done before: I gave up on what I wanted to do. I stopped studying to become a pyrotechnician and I didn't do another *Atmosphere* for several years. Occasionally, someone who saw the slides of the smoke pieces asked me if I'd be interested in doing another one. I always hemmed and hawed because I was too embarrassed to say that I stopped doing them because I couldn't deal with this man who ran the fireworks company. Finally I met a woman who had succeeded in becoming a pyrotechnician, and this encouraged me to resume working with fireworks.

After that scene in San Diego, I retreated still further into my studio, trying to pursue my work the best I could. Then the first material from the slowly developing women's movement reached the West Coast. I couldn't believe it. Here were women saying the things I had been feeling. I shook as I read their words, remembering the put-downs I encountered whenever I had tried to express the facts of my life as a female artist. Reading Valerie Solanas's book, *SCUM Manifesto,* and some of the early writings of the women's movement was mind-blowing. Even though I thought Solanas extreme, I recognized the truth of many of her observations. Rereading her text recently, I realized that her words crystallized my own rage at men, their lack of attentiveness to my sexual needs and the open disdain

for women evidenced in so many of my interactions with them. Moreover, her text anticipates recent theory about the construct of toxic masculinity and how it is destroying the planet. As Solanas pointed out, "The male is completely egocentric, trapped inside himself…Proving his manhood is worth an endless amount of mutilation and suffering and an endless number of lives."[1]

As I read, I slowly allowed the information to seep into my pores, realizing that at last there was an alternative to the isolation, the silence, the repressed anger, the rejections, the depreciation, and the denial I had been facing. If these women could say how they felt, so could I. Coincidentally, I had been invited by several colleges in the area to speak about my work. I decided to use these opportunities to express my real feelings, to reveal what I had been going through. But I was so scared. My voice quivered, and I could hardly talk. I spoke about my experiences in the art world and my anger toward men because they had used me sexually and were oblivious to my needs. Everyone was shocked; there were furious reactions from some of the men. I felt sure that I would be punished for speaking up, that someone would break into my studio and destroy all my paintings or shoot me or beat me up.

For an entire year, I lived in terror. I recognized that my fears reflected how deeply I had internalized society's taboos about honestly revealing my feelings, especially anger. I had been told that if I spoke the truth about how I perceived men, I would "castrate" them, and I was afraid that they would retaliate. But I felt I *had* to reach out and take this opportunity to be myself, offered implicitly by the women's movement, despite being afraid.

Throughout this period, the only person I had to depend on was Lloyd—at least, that's what I thought at the time. Even though he was often unable to express his real feelings, he tried to support me, and by the beginning of 1969, it seemed that we had worked through many of our problems. That spring, we decided to get married. In retrospect, it was probably a mistake, one that I didn't recognize for some time.

By the end of that year, I felt I was in a new place. I had not shown my work in Los Angeles recently and decided that it was important to do so, if only to try to establish my range as an artist. I felt strongly that I was

not seen in the art world in a way that was commensurate with the quality of my work, and I still hoped I could change that. I had been creating coherent bodies of work for some time, was working across various media, including painting, sculpture, and process art, was dealing with the subject matter of my own identity as a woman, and had developed technical procedures in spraying and in fireworks that were seemingly unprecedented. I arranged to have a show of the domes, the *Atmospheres* (in photo and film form), and the entire *Pasadena Lifesavers* series. Also, in order to identify myself as an independent woman, I decided to change my name from Judy Gerowitz to Judy Chicago.

When Jerry and I were wed, young proto-feminist that I was, I had kept my original surname, altering it only after noticing—while doing the Saturday-afternoon gallery stroll along with all the other "cool" art

Name-change and exhibition announcement, *Artforum* October 1970

49

people—that there seemed to be too many artists named Cohen. I soon exchanged one patriarchal name for another, since my then-young husband's last name seemed less common. But after Jerry died, people kept mistaking me for the daughter of his parents. Not that I didn't like them; I did. It was just that less than two years of marriage hardly seemed sufficient reason to carry someone else's name for the rest of my life.

Why that last name: Chicago? Rolf Nelson, whose gallery had shown my work from when I was in graduate school until he closed in 1966, used to call me Judy Chicago, in part because of the strong Windy City accent I had retained, but also because he thought it suited the tough and aggressive stance I had felt obliged to adopt in order to make my way in the macho art scene that was Los Angeles in the 1960s. Rolf had tried to convince me to take this name professionally, but I had gone only so far as to list it in the phone book. This was, in fact, an "in" thing to do at the time, as there were several artists with underground names (for example, Larry Bell was Ben Luxe and Ed Ruscha was Eddie Russia).

My name change took place in conjunction with two exhibitions, both in Orange County. Jack Glenn, the owner of a prominent gallery in the area, was planning to hold a show concurrent with one at California State Fullerton, directed by Dextra Frankel. Her exhibition included all fifteen *Pasadena Lifesavers* and a group of *Domes*, along with one gallery full of photographs of my *Atmospheres*. Dextra's installation was excellent, and the notice about my name change was positioned on the wall directly across from the entrance. It said:

> *Judy Gerowitz* hereby divests herself of all names imposed upon her through male social dominance and freely chooses her own name: *Judy Chicago*.

During this period, my male artist peers in L.A. were prone to macho announcements and posters in relation to their shows, something Jack suggested spoofing with a picture of me in a boxing ring, the very one in which Muhammad Ali had trained. Jack had a sweatshirt made that was emblazoned with my new name, rented boxing gloves, and somehow got hold of some small but mannish athletic boots. We trooped down over to a

downtown gym, where we were greeted by some shocked boxers who were training there, as female boxers were rare or nonexistent.

The resulting picture, which was printed and sent out to supporters of the gallery, ended up as a full-page piece in *Artforum*, then the most influential of all art magazines. One result was that for many years, pugnacious male artists asked me if I wanted to fight. I would also see this image posted in the studios of many women artists I visited during the 1970s. Although I was unaware of it at the time, numerous female artists were having experiences similar to my own. I guess that the boxing-ring ad marked the moment when women came out fighting in an effort to somehow effect a change in the art world.

In 2018, Hanya Yanagihara, the editor of the *New York Times T Magazine*, would re-create this ad for the cover and commission an article by Sasha Weiss (now the culture editor of the *Times Magazine*) that would challenge all the dismissive things that had ever been written about me and chronicle my influence on subsequent generations of women, which was thrilling, to say the least.

I do not know how Lloyd felt about my name change, as we never discussed it. I expected him to be supportive, and he seemed to be. Ironically, as my husband, he had to sign the legal papers, which he did uncomplainingly while I rather vocally protested such sexist laws. My family said nothing at all about it.

My position was visibly stated in the wall sign (not to mention the ad): my work was intimately connected to my gender. Admittedly, the content of the work was not altogether clear, but it seems that people could have made an effort to see the show in relation to the statement I had chosen to include. No one even dealt with the range of ideas expressed or with the discrepancy between my status as an artist in the world and the obvious level of my development. Instead, there was very little writing and no sales from the gallery show. At that time, there was no recognition in the art community that a woman might have a different point of view than a man, and if difference was acknowledged, that difference meant inferiority.

As I look back on this, I realize that the situation was complicated. I had come out of a formalist background and had learned how to neutralize

my subject matter. In order to be considered a "serious" artist, I had had to suppress any hint of gender in my work. Although I was trying to make my images clearer, I was still working in a frame of reference that people had learned to perceive in a particular, non-content-oriented way. But what other frame of reference existed then for abstract art? I was expecting the art community to "see" my work differently, to look at it in new terms, to respond to it on an emotional level. I realize that most people didn't know how to "read form" as I did.

But when Miriam Schapiro, a well-known painter from the East Coast who had recently moved to L.A., brought her class to the show, it was obvious that she could "see" my work, identify with it, and affirm it. On the other hand, the sculptor Mark di Suvero told me: "Judy, I could look at these paintings for twenty years and it would never occur to me that they were cunts." Of course, the idea that my forms were cunts was an oversimplification, but even a greatly simplified understanding of the relationship between my gender and my art seemed better than no understanding at all.

When the level of achievement and meaning of my shows went so completely unrecognized, I was very upset. Not only had the exhibitions failed to result in any art-critical understanding of my intentions as an artist, but they ended up generating a host of accusations regarding my integrity. I was accused of "mixing up" politics and art, "taking advantage" of the women's movement; of being "rigid" because I used a structure in my paintings; and of copying a male artist in my domes. I wanted my shows to speak to people, to send the message that society's conception of the female was distorted and that other values in the culture that grew out of that distortion were also questionable. Fundamental to my work was an attempt to challenge the values of the society, but either my work was not speaking clearly, society didn't know how to hear it, or both.

The full impact of my alienation struck me. I had tried to challenge society's conception of what it is to be a woman. At the same time, I had—in trying to make myself into an artist who was taken seriously in a male-dominated art community—submerged the very aspects of myself that could make my work intelligible. How could I make my voice heard, have access to the channels of the society that allow one's work to be visible, and be myself as

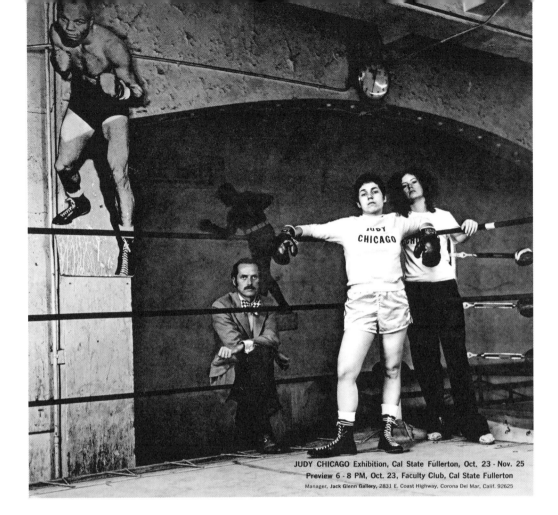

JUDY CHICAGO Exhibition, Cal State Fullerton, Oct. 23 - Nov. 25
Preview 6 - 8 PM, Oct. 23, Faculty Club, Cal State Fullerton
Manager, **Jack Glenn Gallery**, 2831 E. Coast Highway, Corona Del Mar, Calif. 92625

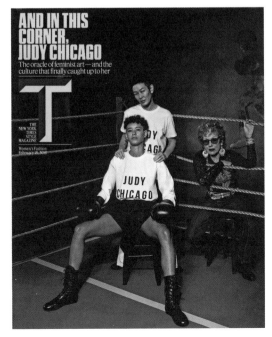

Boxing-ring advertisement, *Artforum* 1971,
Jack Glenn Gallery, Corona Del Mar, CA
and *The New York Times, T Magazine* cover 2019

Photo by Collier Schorr

a woman? I had tried to deal with the issues that were crucial to me within the structure of a male-centered art language and a male-oriented art community, a group whose values reflected the patriarchal culture in which we live. My accommodation had been self-defeating, however, for I could see by the results of my show and the evidence of my life as an artist that the male-dominated art world, by its very nature, could not give me what I wanted and deserved. To honor a woman *in her own terms* would require a fundamental shift in the culture and in cultural values as they are expressed in art.

I slowly came to the realization that there was absolutely no frame of reference in the early 1970s to understand a woman artist's struggle, to value it, or to read and respond to imagery that grew out of it. What did men know or care about how difficult it was for a woman to overcome her social conditioning or to find her own voice? I could not be content with having my work seen as trivial, limited, or "unimportant" if it dealt openly with my experiences as a woman, something I had seen happen to women who had not neutralized their subject matter. And I could no longer accept denying my experiences as a woman in order to be considered a "serious" artist, especially if my stature was going to be diminished anyway by the male-dominated art community.

I realized that if the art world as it existed could not provide me with what I needed, then I would have to commit myself to creating an alternative. And with the advent of the women's movement, there was, probably for the first time in history, a chance to do just that. Perhaps, working with other women artists, I would be able to develop all aspects of an art infrastructure—making art, showing art, selling and distributing it, teaching other women artmaking skills, writing about art, and establishing our own art history, one that allowed us to discover the contributions of women artists past and present. I had been reading women's novels for several years, having given up male literature because I couldn't relate to most of the female characters. I had found a wealth of work by women I never knew existed, work with which I identified, and I was sure there must likewise be unknown visual art by women. If creating art according to male standards had resulted in making my subject matter unintelligible, perhaps looking at the work of women artists would give me clues about how to

communicate my point of view more directly. But first, I would have to go back to the point where I had begun to hide my content and learn how to expose rather than cover up that content.

The problem was that I didn't know how to do that in Los Angeles, where the values of the male-centered art community pervaded the environment—values asserting form over content, protection over exposure, toughness over vulnerability. I decided to go away from the city for a year, to look for a job at a university, something I had never done before, having supported myself by teaching extension classes part-time along with occasional sales of art. When I graduated from college I had vowed not to become involved with full-time teaching, as I didn't want to be like my art professors who had become more invested in their teaching than their artmaking. Now I wanted to teach—but I wanted to teach only women. I wanted to try to communicate to female students, to tell them what I had gone through in making myself into an artist. I felt that by externalizing the process I had gone through, I could examine it, which could be the first step in turning it around, and a women's art class might also be the first step in building an alternative female art community.

Of course, I didn't know for sure if my struggle was relevant to other women. I had to discover if my own needs as an artist, my desire to build a new context, and the needs of other women interested in art could merge to become the basis for a viable female art community. Also, I wanted to be in a place where male-centered values were not as pervasive, and that meant going to a place where the art scene had less power. I wanted to feel safe to open myself up, to try to reverse the toughening process I had undergone in order to make a place for myself in the art world. After having dealt with issues about the nature of my own identity as a woman, I wanted to go beyond the construct of femininity to an identity that embraced my full humanity. I wanted to make paintings that were vulnerable, delicate, and feminine, but that also reflected the skills I had developed in the male-dominated world. But I recognized that I needed the support of a female environment to expose myself more than I had been able to at that point, and I hoped, by establishing a class for women, I could provide a context for my students and for me that could serve us all.

At that time, a number of schools in California were hiring Los Angeles artists with name recognition, and although my reputation was not altogether consistent with my development, I had made something of a name for myself as an artist. Because of that, I found it fairly easy to get a job. I simply put out the word that I was looking and sent a few notes to places that, I had been informed, were hiring. I received a telephone call from Fresno State College (now Cal State–Fresno), which I had never heard of. They were eager to have me come there—so eager, in fact, that they were willing to accommodate me in any way, especially after they received a recommendation from Oliver Andrews, my former sculpture teacher, that "the best way to work with Judy was to let her do what she wanted." They agreed to let me teach in the late afternoons to preserve my studio time.

Lloyd and I discussed it. We went up there to look around, and as soon as we drove into the city, I knew it was the perfect place for me to be for a year. In addition to the other reasons for wanting to go away, I felt that I should learn to live without Lloyd close by, as his presence still sometimes precluded me from acting independently. Although we never really talked about it, I guess Lloyd resented my absence, but the full consequences of my decision to go to Fresno would only become apparent later. However, that year allowed me to examine my ambitions and make plans for my life in terms of my own needs, goals, and desires. It gave me the space that I needed to think, to dream, to experiment, and to change.

CREATING FEMINIST ART

In 1970, by the time of my name change, I had moved two hundred miles north of Los Angeles to teach at Fresno State College. I wanted a chance to test my ideas about establishing what I called Feminist Art education, a term that didn't exist until I invented it. My intention was to see if such an educational process might lead to a new kind of art—Feminist Art—in which distinctly female-centered subject matter could be both central and unabashedly expressed.

At the time, I was operating out of the naïve assumption that women shared a common experience; in some ways this is true, in that gender continues to shape and constrict many women's lives. But I would later come to appreciate that women's experiences are often shaped by a multiplicity of factors, including race, ethnicity, sexual orientation, religion, and a myriad of other things—and more importantly, not all women view their experiences through a gender lens.

The main point, however, is that I had decided I wanted my art to look like it had been created by a woman, however that might be defined. My presumption was that young students at the beginning of their college art training would not yet have gone through the same process of disconnecting from their natural tendencies that I had. I hoped that by providing them with the permission to develop as artists without having to deny their gender, I would be able to offer them a unique type of education while also being able to recapture this same ability for myself. The main explanation for my insistence upon an all-female environment was that the teacher as well as her students would thereby feel safe to pursue what was an entirely unprecedented undertaking.

Another reason I wanted to teach only women was that I wanted to address a problem that was prevalent at the time. The preponderance of undergraduate art classes were filled with female students, although few of them were successfully completing graduate school and making their way into professional life. Thinking that perhaps my own experiences might be of some value, I wanted to offer an opportunity for young women to develop away from the presence and, hence, the expectations of men.

For my own quarters, I rented an old supermarket in Kingsburg, a nearby town of 3,000 people, and turned its main room into a clean white studio, the back space into a spray booth, the meat locker into my office, and a small storage area into my living quarters. It was here that I would create two series of large sprayed paintings, the *Fresno Fans* and *Flesh Gardens*. In these images I would attempt to fuse flesh and landscape references, trying to make my almost entirely abstract form language more intelligible. At the same time, I would also experiment with other, more overt types of imagery—both abstract and representational—and various media, including photography, film, video, and printmaking.

I also planned to undertake a more focused research project into women's history. I had already begun studying women's art, literature, and autobiographical writings in an effort to discover whether any of my predecessors had experienced and/or documented struggles similar to what I was then going through. The next step was to be a systematic, yet totally self-guided investigation, including the ferreting out of all the information I could find about women artists and some major women writers. I also wanted to investigate the history of feminist thought.

At that time there were no Women's Studies courses, no body of contemporary theory, and little analysis, except what had been generated by the first wave of feminism, which had basically subsided after World War I. When I started teaching, I began to receive invitations to lecture about my work at various places around the country. On such trips I always tried to arrange some extra hours to visit used bookstores. Judging from the heaps of inexpensive volumes I found by and about women, there was little or no interest in this subject then. I also discovered an abundance of material in

local libraries, including some insightful feminist writings from the end of the nineteenth century that had never even been checked out.

Though Kingsburg was only a three-hour drive from L.A., it seemed a million miles away, which is one reason it had attracted me. Its small-town atmosphere provided me an almost unimaginable level of psychic space for what might be described as a risky vision quest (risky in that I was pretty much on my own and doing something unheard-of). It was there, in that converted supermarket, surrounded by the unmistakable odor of cottonseed oil from the nearby processing plant, that I painted and studied and realized that women have a heritage so rich it took my breath away.

What a source of amazement—and a relief—to uncover the lives, words, images, and ideas of so many talented women. I felt extremely validated by learning about their experiences, reading their words, seeing even inadequate black-and-white reproductions of their art, and studying their ideas and philosophies. It seemed that countless women before me had stumbled over similar dilemmas, had asked the same and sometimes even more profound questions, and had arrived at answers that were not only illuminating for me but would, I was convinced, be vitally useful to others.

Although this information inspired me, it also enraged me, because I could not believe that all these important contributions of women had been omitted from the mainstream of culture, be it in art, literature, history, or philosophy. My discoveries intersected with the values of my upbringing—which had emphasized the possibility of radical transformation—and led me to conclude that the only real solution to the problems I was facing lay in the creation of an entirely new framework for art: one that included, rather than excluded, women, along with women's ways of being and doing, which, I was convinced, could be quite different from men's. I would soon come to realize that numerous women throughout history had espoused this same philosophy. The problem seemed to lie in the fact that women through the centuries were under the thumb of men and therefore had no possibility to be completely themselves, in their lives or in their art.

To solicit students for my class, I posted signs in the halls of the school's Art Department, inviting young women who wanted to be artists

to come to a meeting where I discussed my ideas. From this group, I ended up selecting fifteen students. They came from diverse backgrounds though they were all white, a reflection of the student body at that time, when Fresno had a smaller minority population than they do today. My teaching methods evolved out of the part-time teaching I had done during the 1960s, which was based on the way in which my father had conducted political discussions that involved engaging everyone, including women.

Even then, my definition of a teacher was akin to that of a facilitator: one who facilitates the growth and empowerment of students. This required making a real connection with my students, which I accomplished by encouraging them to reveal where they were intellectually, aesthetically, and personally. It seemed that only then could we forge an intersection between what they as individuals needed and what I as a particular person had to give. But making this type of connection required shedding the traditional teacher role in favor of a more humanized interaction with the students.

It had always been extremely important to me that all of my students actively participate, whether by asking questions or engaging in discussion. In my earlier classes, I had noticed a tendency for some students (usually, but not always, the men) to dominate the classroom, while others (often, but not exclusively, the women) remained silent. To counteract this, I had developed a technique of going around the room, asking everyone to speak about the subject at hand (one fascinating result being my discovery that the quietest people were sometimes the most interesting).

This was before consciousness-raising groups became widespread. My pedagogical process has a lot in common with that practice, though with one important exception: because I was the teacher, I could interrupt in order to make comments or suggestions that seemed appropriate. Moreover, the goal of consciousness-raising was exactly that, the raising of political consciousness. Although this was inevitably what happened in my classes, my goals were quite different in that they involved finding subject matter for art in one's personal experiences.

My pedagogical methods proved to be an effective way of combining education and empowerment—the most desirable goal for teaching,

in my opinion. One without the other seems to lead to only partial growth for students: the amassing of information without the ability to apply it in any meaningful way, or self-development at the expense of specific skills. One reason for my staunch and abiding commitment to feminism is that I believe its principles provide valuable tools for empowerment—and not only for women. In my view, feminist values are rooted in an alternative to the prevailing paradigm of power, which is power *over* others. By contrast, feminism promotes *personal* empowerment, something that, when connected to education, becomes a potent tool for change.

I brought these values and aims to my teaching, along with the patience to remain silent while students either summoned the courage to express themselves honestly or tested me to see if I would let them off the hook by resuming the teacher-student relationship to which they were accustomed. Too often, there emerged a level of passivity on the part of the students—particularly the women if it was a mixed class, which they all were in my earlier years of teaching—that was unacceptable to me. I soon encountered an almost stubborn refusal on the part of the students to assert themselves in any real way.

In order to have a space in which the Fresno students could explore themselves without the intimidating presence of men, I felt that we should have a studio away from the school. Besides, being an artist meant having a studio, and if I wanted the students to experience themselves as artists, I thought the first step would be for them to do what artists do—find a studio, fix it up, then begin to work in it. The fixing-up process seemed a natural way for the women to learn to use tools, develop building skills, and gain confidence in themselves physically. I remembered my own phony bravado in the industrial arts shop and felt committed to providing a way for my students to learn craft without either having to appear "tough" or feel embarrassed about their awkwardness.

I also thought that, once the studio was complete, we would get an old car and fix it up, thus further expanding their mechanical skills and also helping the women build a sense of independence. I wanted them to see that they could take care of themselves—a feeling, it turned out, few of them had. Only after these processes had taken place did I expect to

move into artmaking, but my plans changed and adapted themselves to the natural flow of the group (we never did fix up a car).

The first meeting of the class freaked me out, but it also revealed an important truth. The fifteen students and I were sitting around at the home of one of the women. They were chitchatting, talking about clothes and boyfriends in a superficial manner. I sat quietly for a while, waiting for them to start talking about their feelings about the class, their excitement or fear, their ideas about art, a book one of them had read, anything that would indicate some intellectual interest. But the conversation never altered from its course—clothes, boyfriends, casual experiences, food. I couldn't believe it. I had been with art students before. There was generally *some* discussion about something having to do with art. I suddenly panicked. What had I gotten myself into?

This was just like the high-school experiences I had run away from. I didn't want to be identified with women like these "chicks" who concerned themselves with trivial issues. I didn't know what to do; I wanted to escape. I forced myself to stay, to take responsibility for my feelings. Right then, I made the most important step in my commitment to women: to always be honest. I said, "You know, you are boring the hell out of me. You're supposed to be art students. Art students talk about art and books and movies and ideas. You're not talking about anything."

Dead silence. I thought, "It's only the first day, and already me and my big mouth have blown it." Then I heard a soft voice saying, "Well, maybe the reason we don't talk about anything is that nobody ever asked us what we thought." Even today, as I read these words, I get emotional. I realized that no one had ever demanded of these young women that they reach their potential. They slowly began to tell me about their lives and relationships, about how, when they went to parties, the men did most of the "serious" talking. True, many of them had been pressured by their parents into getting good grades, but getting good grades was one thing, and establishing personal goals and identities was quite another.

It seems that they were accustomed to always being introduced by their first names, just "girls" who were expected to go along with the men. (Later, I instituted a practice of always introducing themselves and each

other by their full names and shaking hands, looking full into the face of the person to whom they were being introduced.) We discussed the idea of making demands upon each other, and talked about learning to exchange ideas, feelings, and thoughts. Soon the room was filled with discussion and excitement. However, it would not be until the following year that I would begin to understand the full implications of making demands upon personalities that were more accustomed to being protected than pushed.

As the students gradually opened up, it became clear that many of them suffered from a significant lack of self-esteem, expressed most poignantly in their personal relationships. Our meetings were very intense. We talked a lot about sex and parents and being independent. It has always been my contention that sexual behavior is a mirror of the total behavior of a person, and I have never, for example, been able to understand how someone can say that he or she has a terrible relationship with someone but "great sex." If you cannot act on your needs, articulate your real feelings to another person, and feel good about your wants, how can you do those same things in bed? These are things that seem fundamental to having a good sexual experience. At any rate, discussing sex illuminated some of my students' intimate problems and also opened up ideas for art sooner than I had thought possible.

When they went to their other art classes, my students were supposed to focus on "form and shape and color and line" and other formal issues that had little to do with their actual day-to-day experiences or their real aesthetic interests. For example, one of my students, Nancy Youdelman—who was very gifted with needle and thread and went on to have a successful career—avoided all sculpture classes even though sculpture was what she wanted to do. As she told me many years later, she had no interest in making plaster cubes, which was one of the exercises assigned to students, a perfect example of male-centered art education.

Since the women's real concerns revolved around their sexual anxieties, their problems with their boyfriends and parents, possible pregnancies, or the impossibility of getting enough money for food by working at the degrading and low-paying jobs available to them, I decided to see what would happen if I encouraged them to make art out of the issues on which

they were really focused. At one point, the students began to talk about how they felt when they walked down the street and were harassed by men. Everyone had very strong opinions about these experiences, and I asked them to try to make images that represented the sensation or experience of being psychically invaded by a man or men. There was no media restriction. They were free to paint, draw, write, make a film, or do a performance.

On the day the work was presented, everyone was trembling because no one (myself included) had ever seen such images before: paintings and drawings, poems, performances, and ideas for films, all revealing the way these young women saw men and how they behave. Until the #MeToo movement, women did not dare to publicly share their many negative experiences with men. And as has recently been seen, even when this taboo began to be broken, many women were punished for their honesty. One arena where it became possible to express their feelings, as my students and I would discover, as did other women artists, was through art.

Although I had never been as reticent or lacking in self-confidence as some of my students, I could still relate to many of the issues they were facing, some of them resolvable (in my estimation) through personal empowerment. I had gone through this same process all alone in my studio: slowly struggling past my own limitations, which included learning to stand up to men's often misguided perceptions and expectations of me. I tried to help the women gain greater understanding of their experiences along with more self-confidence.

But weren't you teaching art? you might ask. The process I am describing might best be described as twofold: dealing with self-esteem issues while also doing what could be called a content search. Out of these discussions about what was of greatest concern to the students—issues related to independence, relationships, and sex—I helped them to make art. I must point out that this is not at all the way in which art was customarily taught, certainly not at the college level (where "content" is still a dirty word), and when I went back to teaching in 1999, I discovered that not much had changed.

As the class continued, the students gradually became more aware of their situation as women in the culture. I felt that it was important for

them to understand and be able to cope with their circumstances, instead of simply assuming, when they came up against societal pressure, that there was something "wrong" with them. Their growing consciousness was a result, not only of our sessions but also of their efforts to move out into the world. Looking for a studio proved to be an educational process in itself. When they went to real-estate offices in search of commercial buildings, the realtors refused to take them seriously and were incredulous when informed that these young women were looking for studio space. Many male real-estate agents refused to believe that women would want to work and insisted that they must want the place for parties.

We spent a great deal of time discussing how to present oneself in order to be taken seriously (which included stating their whole names clearly and shaking hands). We also did some role-playing, the women alternately taking the parts of the realtors and themselves, acting out their experiences, trying to find new ways to respond to the realtors' doubts. Instead of feeling intimidated and just slinking away, through these performative methods the students learned to challenge the men, demand the right to rent the place of their choice, and struggle to get what they wanted.

My strategy for the year had been to first help the women open up, then encourage them to turn to each other for support (instead of to me), and, finally, to begin to demand that they relate to me as younger artists to an older artist—through work. This was important because women do not ordinarily relate to each other on this basis; the personal tends to prevail. The students soon become quite skilled at discussing their problems in depth and exposing their real feelings, but they were not nearly as good at translating those feelings into a work ethic—putting in regular hours, setting work goals for themselves, and helping each other as much in their art problems as in their life problems.

Although all the students agreed that it was a good idea to begin to concentrate on work, there was a great deal of insecurity manifested in the group at this time. Crying jags, depressions, and self-deprecating remarks were rampant, as they weren't at all sure that they could make the necessary changes. Many of them became extremely angry with me for making demands upon them that they were afraid they couldn't meet. This lasted

for about a month, during which time I tried to ignore most of their expressions of anxiety. Gradually, they began to feel more sure of themselves.

By the end of the first semester, the women were beginning to take charge of the class, which was something I encouraged. They set up work requirements for themselves and each other. All of them wanted more time to focus on their art and to be in the studio. I arranged with the school that they could have flexible credit, from six to fifteen units, depending upon how much art they made. The students set up the following system: six units of credit required four hours of daily work in the studio; nine units required six hours' daily work; and if you asked for twelve to fifteen units, you had to work at the studio eight hours a day.

The schedule for the second semester was arranged almost completely by the students themselves. On Wednesday evenings we had dinner meetings, which everyone attended. During the week, the students came and went as they wanted and made appointments with me for critiques as needed. One of my most important discoveries that year was that informal performance seemed to provide the women with an effective method of reaching personal subject matter. They all seemed naturally good at this. In fact, the most powerful work of that first year was the performances.

Given what I learned in Fresno in 1970 about educating young women to be artists, it seems appropriate to raise the fact that neither formal art training nor apprenticeships were available to them for many decades. It was only toward the end of the nineteenth century that this began to change. At the time I started my program, I do not recall ever reading anything about whether the art education women were finally able to enjoy was shaped to their needs. Do art classes for women have to be structured differently because they have been socialized differently? For centuries, they had been raised to focus on housekeeping, raising children, quilting, sewing, cooking, weaving, nurturing, pleasing men, and remaining in the background, while men ran the world. Also, since most women are raised to value feelings over abstract ideas, responsiveness over assertiveness, and small scale over large, does it not seem ludicrous to ask women to move out of their familiar frame of reference and into another without so much as a gulp?

At any rate, my class continued; each of the students paid twenty-five dollars per month toward studio rent, equipment, and materials. At the beginning of the year, we had a lengthy discussion about buying tools, which I had urged the women to do. Many of them objected, saying that if they wanted a hammer, they'd go borrow one; if they needed some wood, they'd find a house that was being torn down. I tried to explain to them that if you had a hammer at your disposal, it suggested the building of something. If you had a tape recorder, it led to recording something. If you had a movie camera, you ended up making a film.

Although they were unconvinced, they went along with the plan. By the second half of the year, they were all making frequent use of their tools, cameras, and equipment, and had come to realize the necessity of having things easily obtainable. One of the women built a darkroom and was teaching other women how to take, develop, and print their own pictures, while others were crewing for each other's films, helping one another with their projects, and exchanging skills with one another.

I had managed to structure the Fresno program so that the students worked almost exclusively with me for a year. This allowed a kind of intensity of purpose that would be hard to achieve in traditional teaching, when people move from subject to subject and teacher to teacher, sometimes on an hourly basis. The resulting explosion of energy was probably a combination of this concentrated course of study and the fact that I gave my students permission to bring their real concerns to their artmaking. As a result, it felt almost as if I had lifted a lid off a kettle of boiling water—too quickly, in fact, because it frightened me. I was still a relatively young artist, not yet all that mature myself. Suddenly, I found myself in the position of teacher, mentor, and surrogate parent all at once.

There were several occasions when I found my students' youthful— and somewhat radical—exuberance disconcerting (to say the least). At one point, I arranged for Ti-Grace Atkinson, a prominent feminist theorist, to present a lecture at the college and visit the studio. The young women decided she should be welcomed with flair and put together a "Cuntleaders" group, complete with costumes and a "Cunt" cheer that they presented at

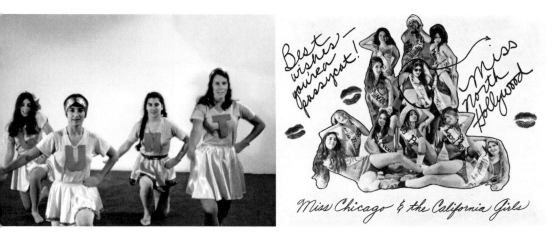

CUNT CHEERLEADERS and "Judy Chicago and the California Girls," photograph by Dori Atlantis. Feminist Art Program California State University at Fresno, CA 1970

the airport when she arrived, much to the chagrin of a group of Shriners who were apparently on the plane with Ti-Grace.

My discomfort with what I had unleashed was one reason I was so eager to make contact with the artist Miriam Schapiro. She and her husband, Paul Brach, also an artist, had moved to L.A. to work at the new Disney-sponsored California Institute of the Arts (CalArts) where Paul was to be chairman of the Art Department and Mimi a faculty member. The new campus was being constructed at the north end of the San Fernando Valley in a small, mostly residential suburb called Valencia. Meanwhile, classes were being held in a converted convent in Burbank, many miles to the east.

Mimi was a zaftig, middle-aged, dark-haired, attractive, though somewhat brooding woman, while Paul, who always seemed to be sucking on a large, aromatic cigar, was small, wiry, and intense. They were a lively couple and a dramatic study in contrasts, positively reeking of the New York art scene and full of juicy gossip about its complex political intrigues, about which I knew little. What I did know was that I felt an immediate identification with Mimi and thought that, in light of her own experiences as an artist, she might be sympathetic to my ideas and aims.

I had heard that she'd been one of the few women who had managed to become visible in New York during the heyday of abstract expressionism, which could be said to have personified macho attitudes, what with its emphasis on muscular "action" paintings, heavy drinking, and late-night arguments at the then-popular Cedar Bar. I admired her work, particularly a large canvas entitled *OX*, the abstract form and open gesture of which seemed reminiscent of my own imagery, particularly that of *Pasadena Lifesavers*. I sensed that, like me, Mimi might be forcing what was actually female-centered subject matter into a formal abstract visual structure. I thought she might respond to my desire to make my imagery clearer and establish a new form of art education suitable to women's needs. (As it turned out, my intuition about her proved correct.)

I arranged for Mimi to give a slide lecture at the college about her career. She was very nervous because it turned out that she had never spoken publicly about her work. In fact, before her talk she confessed to me that she was worried that by asserting herself in public she would "grow a penis," which gives some indication of how readily even professional women internalize the ways society genders qualities like "assertiveness" and "ambition."

Afterward, the students and I held a party for her at our studio, where they presented a few of their performances as well as their paintings and sculptures. Some of the work might have appeared somewhat simplistic; after all, it was the work of young women at the beginning of their development as artists. And there was not a great deal of iconography to draw upon in terms of their chosen subject matter, which largely had to do with their experiences as women. But what it was lacking in visual sophistication it more than made up for through its authenticity.

The aim of Feminist Art, which is what my program was intended to instigate, was empowerment and social change. This was to be accomplished by educating viewers about women's real feelings, experiences, and history through art. From the beginning of the program, I shared my own discoveries about women's history with my students, believing that it would inspire them, as it had me. In fact, I had them read and look at nothing but women's work throughout that year. As most of the students

had gone through the usual form of education, I knew that most were probably already grounded in men's history; in my program, they would become educated about their own.

To my mind, the study of women's art, literature, and ideas was important because it provided information that could be a foundation for personal and artistic growth. This growth would take place primarily through translating one's own empowerment into works of art that could facilitate the same process for others. This required that the art be accessible to many viewers, not so coded as to be intelligible only to the tiny, elitist art world, as is so much of contemporary art. Moreover, Feminist Art would in no way be singular in style but, rather, pluralistic in both form and content in order to reflect the diversity of women's experiences. The one unifying factor was that it would be openly female-centered and geared toward a broad and diverse audience.

I imagined that the primary audience for Feminist Art would be women, at least at first, in that they'd be the ones most able to relate to imagery that reflected their own experiences and also to evaluate its authenticity. Another seemingly important reason for addressing a female, rather than a male, audience was that I believed it would be liberating for women artists to direct their work to viewers of their own gender instead of trying to please men or conform to male definitions of what constitutes worthwhile subject matter for art. But it never occurred to me that men might not be interested in art made by women that openly addressed female concerns.

I cannot remember what Mimi said to me after seeing my students' work, although I know she provided them with some valuable feedback (she had a remarkable talent for critiquing art). But not too long after her lecture, Mimi proposed that I bring my program to CalArts, where we would expand it into the Feminist Art Program, which we would team-teach. I was extremely excited about this idea, most of all because I really needed an ally in this somewhat frightening effort to give birth to Feminist Art. I looked to Mimi—as someone more mature—to provide me some level of support and understanding, such as I was giving to my students. I simply assumed that her goals were similar to mine, otherwise why would she be inviting me to work with her?

Mimi had obtained the full backing of Paul, who assured us that the Feminist Art Program would have its own studio space, tools, equipment, and money for materials and projects. In addition, we were to have a trained art historian who'd bring professional skills to bear on the rather ragtag slide library that I had begun, then expanded with my students as a first step in assembling a real Feminist Art history. After Mimi's visit, she also began searching for and collecting slides of art by women and sending them to us. Let me reiterate that at that time there was an almost total absence of knowledge about or interest in female artists, past and present.

For instance, before Rolf Nelson closed his gallery, he hung a beautiful 24-foot *Cloud* painting by Georgia O'Keeffe. Although it was for sale for only $35,000, no one was even interested in looking at, much less acquiring it. This might help explain why I was so thrilled that a major art school was offering to provide a trained art historian and devote so many resources to the needs of its women students.

The year in Fresno was almost over. Before we closed the studio, we held a weekend rap session and invited women artists from Fresno, Los Angeles, and San Francisco to the studio who put up their drawings, paintings, and photographs alongside those of my students. Many of the images were filled with biomorphic forms—vaginas, uteruses, ovaries, and breasts—as my early work had been. But there was no one to make the artists feel uncomfortable about dealing with their sexuality. In addition to showing their own work, my students performed some of their pieces and showed their films.

The women in attendance were generally very excited by what they saw in both each other's work and that of my students. The weekend was filled with so much laughter, tears, and warmth that I wept. What I had set out to do all alone was now out in the open. Other people were seeing it and sharing it. It was like being at the moment of birth, the birth of a new kind of community of women, a new kind of art made by women.

Moreover, in one year, many of my students had been able to change their lives, find their personal voices, build confidence, develop leadership skills, make art, write about their experiences, speak and perform publicly, and learn building and filmmaking skills. They did costuming, makeup,

and sewing one day, construction work the next, and art-history research in the evening, moving easily from one discipline to another, regardless of their previous experience in that discipline.

Out of the fifteen students in the Fresno program, nine went on to become professional artists, an astounding statistic when one successful student out of one hundred is the norm. My experiences in Fresno called into question some of my assumptions about *who* can be an artist. For example, Suzanne Lacy, who became an important performance artist. During our initial interview, I almost didn't let her into my class because when I asked her why she wanted to be part of it, she replied that, despite having no painting or drawing skills, she wanted to "learn to be creative," words that are anathema to the ears of most professional artists. Still, she had a strong feminist consciousness along with an intense desire to express her ideas; eventually, she would create empowering performances for audiences worldwide.

Fresno also illuminated the shortcomings of studio-art classes in terms of women. In 1999, after a twenty-five-year absence, I went back to teaching and discovered that the art-educational system was still failing many women. This was very distressing, especially because I found that my content-based pedagogical methods still worked and could be applied to men and students of color, too. It is disheartening that art-history classes still privilege white men; that students learn little about the history and struggle of women artists; and that they generally come out of art school utterly unprepared for professional life. Even worse, instead of having been helped to find their own voices, most of them lost those along the way, the reason being that even today, the emphasis is primarily on the formal, conceptual, and theoretical, with personal content a distant fourth, if it's even discussed at all.

LEARNING FROM THE PAST

During my time in Fresno, as mentioned earlier, I created two series of large sprayed paintings on white acrylic, *Fresno Fans* and *Flesh Gardens*. My Kingsburg studio was set up specifically for these works, with specially built painting racks to store first the blank acrylic sheets and then the finished paintings, which I moved in and out of my spray booth on a large easel with wheels. It required many hours of taping and painting to create the images. After all the color was applied, I turned the easel on its back so I could spray successive layers of clear acrylic lacquer. Because the lacquer and the acrylic sheets were made of the same material, I was able to achieve the fusion of color and surface that was my aim.

The *Fresno Fans* were $5' \times 10'$ and were structured on a system of boxes, each painted so that they fanned in or out. This made the sections appear to breathe, open and close, expand and contract. The centers were bars, slits, or squares. The structure of the paintings was based upon a body gesture that extended from the center to the edges of the image. The *Flesh Gardens* were eight feet by eight feet and were also based on a series of squares. Although the visual format of these paintings was rigid, strong, and assertive, the color was soft, fleshy, and vulnerable. Both series were related to my desire to "reach out" from my sense of myself as a female into something larger and beyond gender and sex. Thus, while the centers of the paintings referred to my body through its central core imagery, the paintings also referenced landscape: sky, sun, grass.

The Prismacolor studies for the paintings included a number of written notations: "How can I make a hard shape soft?" and "How can I fit a soft shape into a hard framework?" I had been educated in the tradition of male-centered art, and while some of that type of practice was important

to me, much of it now felt restrictive. My consciousness as a woman had developed still further in Fresno, yet my art didn't seem to reveal that clearly. I began to feel trapped by the minimalist framework I was using in my paintings. On the one hand, the structure allowed me to establish a format against which my intuition could play; but I was struggling to put together my own impulses with the art background that I knew.

At the same time, I had been preparing to paint those pieces for a long time—first developing the technical skills that would allow me to work so large, then establishing color systems that could speak of hard and soft, open and closed, strong and receptive. When I started the first *Fan* painting, I had to paint it three times. I began by making the center very bare and exposed. Each time, I became frightened and covered it up again, "coming on strong," as I had learned to do in the male-oriented art community, in

DESERT FAN 1971
Sprayed acrylic on acrylic
60 × 120 in (152.4 × 304.8 cm)
Collection of the Rose Art Museum,
Brandeis University. Gift of MaryRoss Taylor

order to protect that vulnerable-looking center. Now I wanted to allow that openness, though I didn't seem able to do so without becoming terrified.

As the months passed and I helped my students open themselves, I absorbed some of the permission I was giving them. They were building their art directly out of their experiences as women. I could hardly even reveal my subject matter openly, much less find a way to make it speak clearly. I had sophisticated artmaking skills but no ability to directly connect with my impulses. In contrast, my students had the freedom to be themselves but limited skills to convey their information.

At one point in the year, I began to work in the women's studio. The group had developed a sense of community, which I had helped to create, and still I felt alienated from it. My age alienated me. My experience alienated me. My professionalism alienated me. I was jealous of my students,

SKY FLESH 1971. Sprayed acrylic lacquer on acrylic, 96 × 96 in (243.84 × 243.84 cm)
Collection of Elizabeth Sackler

jealous that they were being given an opportunity that I had not had. I had painted these large, technically formidable paintings, and although they were beautiful, they still did not speak the language of my real self.

I wanted to bring my art and feminism together but could not envision how to do it with the artmaking methods I had developed. I could see all these roads stretching out from my developing consciousness toward a new art, a new literature, a new theater, new kinds of collaborations among artists,

perhaps even a new relationship between art and society. I wanted to start all over again. For the first time in my life, I had no new ideas for art—only a desire to move beyond anything I had done. I couldn't fit my forms into a rigid structure. That was the answer: I would have to abandon the structure.

By this time, Mimi and I were becoming close. She confided that she had also been struggling to make paintings out of her feelings as a woman. Like me, she had constructed her images around a central cavity, which both of us viewed as referencing our bodies. Then we looked at other contemporary artists' work, examining abstract painting and sculptures by women, both known and unknown. What we discovered in our inquiry, and later through studio visits to other women artists, reinforced my own aesthetic impulses. We found a frequent use of a central image, often an abstracted flower form, sometimes surrounded by folds or undulations, like the structure of the vulva.

There was an abundance of sexual forms—breasts, buttocks, female organs—and, based on our own imagery, we surmised that what we were seeing was a reflection of each artist's need to explore her own identity, to assert her own sexuality. We wrote about it in *Womanspace Journal*, a publication that started in Los Angeles, arguing that "the visual symbology… must not be seen in a simplistic sense as 'vaginal art.' Rather [a number of] women artists have used the central cavity…for an imagery which allows for the complete reversal of the way in which women are seen in the culture. That is: to be a woman is to be an object of contempt and the vagina, stamp of femaleness, is despised. The woman artist, seeing herself as loathed, takes that very mark of her otherness and by asserting it as the hallmark of her iconography, establishes a [visual] vehicle by which to state the…beauty of her identity."[2]

It is difficult to express the way I felt when I realized that—like me—so many other artists had tried to deal with their feelings as women through an abstract form language. And my perceptions were reinforced by reading statements like one made by the sculptor Barbara Hepworth, who said: "The woman's approach presents a different emphasis. I think that women will contribute a great deal to…the visual arts, and perhaps especially to sculpture, for there is a whole range of…perception belonging to feminine experience."[3]

THROUGH THE FLOWER 1973. Sprayed acrylic on canvas, 60 × 60 in (152.4 × 152.4 cm)
Collection of Elizabeth Sackler

However, women's art (including my own) had always been looked at in relation to men's work, rarely in relation to that of other women. In some ways, this was appropriate, as the few women artists who were included in art history had worked in a male milieu. But within the framework of the dominant form of art criticism at that time—which focused on the formalist while being oblivious to content—this "difference" cited by Hepworth could not even be perceived, much less appreciated. At one point, Mimi

and I did a few slide talks together in which we discussed the fact that we had found that many women artists seemed to have done what both of us had done, that is, hidden personal subject matter in an abstract artmaking style that was close to what the men around them were doing. In many cases, the stylistic differences among the women's work were striking, but the content came through to us nonetheless.

When we presented our ideas to a group of women artists in New York, some of them reacted with hostility, some recognized their own impulses in the work we showed, and still others realized that they were seeing the first step in a new kind of art history, one that sought out women's art looking for a female perspective. At the time, I had no idea that a few years later, long after my relationship with Mimi had broken down, she would move back to New York and spread lies about me and my work that would affect my career for many years. But during the short time we worked together, we found solace in each other's struggles.

In *Womanspace Journal*, we commented that once a woman (artist) has challenged the basic values that supposedly define her as a woman, "She will inevitably challenge others as she discovers in her creative journey that most of what she has been taught to believe about herself is inaccurate and distorted. It is with this differing self-perception that the woman artist moves into the world and begins to define all aspects of experience through her own modes of perception, which, at their very base, differ from the society's."[4]

Throughout my time in Fresno and for several years after Mimi and I went our separate ways, I continued with my self-guided research project. I was amazed to realize that nuns had often worked on medieval manuscript illuminations side by side with monks, but of course this wasn't ever mentioned in my college class on medieval art. I also learned that in numerous historical periods, women artists I had never heard of had flourished, often in the face of overwhelming difficulties, only to have their work forgotten. Some gained honor and recognition in their own time and supported themselves handsomely. Others earned the patronage of various monarchs. I kept discovering more and more: Catharina van Hemessen (1528–after 1565), Artemisia Gentileschi (1593–1652/3), and Rosalba Carriera (1675–1757); Judith Leyster (1609–1660) and Rachel Ruysch (1664–1750); Angelica

Kauffmann (1741–1807) and Marguerite Gérard (1761–1837); Adélaïde Labille-Guiard (1749–1803) and Elisabeth Vigée Le Brun (1755–1842).

Even in the early days of America, there were women artists. Anna Claypoole (1791–1878) and Sarah Peale (1800–1885) were part of the famous nineteenth-century Peale painting family. Yet their work was hardly ever mentioned when the family was discussed. The same was true of the more contemporary Wyeth family, which included several women artists. For women artists of color, like Edmonia Lewis (ca. 1844–1907) or Elizabeth Catlett (1915–2012), their race combined with their gender to render their artistic paths even more challenging, but many still had successful careers. Earlier, it would have been impossible to even find records of African American women artists due to their enslaved status. We know that many of them made quilts for their owners, sometimes piecing into these scraps of fabric from their countries of origin that they had managed to bring with them. However, the gendered nature of craft, even beyond their enslaved status, would have disqualified their work as art.

The more I learned, the more upset I became at having been deprived of this information, as it would have helped me immensely. Many of these artists struggled with obstacles similar to those I had encountered: negative attitudes toward women; not being taken seriously; and, most grievous, being deprived of the opportunities and rewards that allow one's career to flourish. Even in the face of innumerable impediments, including a lack of formal art training, they had carved out lives for themselves in a world where only male artists had the support of the culture.

Unfortunately, the accomplishments of one generation did not necessarily guarantee greater ease to the women artists of the next. Instead, women artists' achievements would repeatedly be left out of recorded history (presumably the work of male historians), and young women could not model themselves upon their artistic foremothers. In each century, women artists had to repeat the efforts of their predecessors in order to try to make a place for themselves, without benefit of the information that should have been their natural heritage.

When I examined their art for hidden subject matter, I found that, until the late nineteenth century, only a few works could be said to possess

any clear reflection of women's experiences. One exception was Artemisia Gentileschi, who did a great number of paintings on the theme of "Judith Beheading Holofernes." She represented this subject in a way that seemed quite distinct from that of her male contemporaries. In the men's pictures, Judith is usually depicted as standing passively by while the maid does the honors, or else the gory deed is not even shown. Male artists often painted Judith with slender, reedlike arms that were hardly capable of being lifted to cover a yawn, much less undertake a beheading. Artemisia's Judith, however, performs the bloody act herself, hacking off Holofernes's head with arms that are muscular and powerful, arms meant for action, an image of a woman quite different from those created by men.

More significant—as would be demonstrated in the new feminist art-historical approach (that barely existed when I was engaged in my research)—in paintings by male artists, men were almost always presented as the artist or the primary figure, while women were the models, generally seen as passive or in secondary roles. It was a great relief to find alternatives to what has become known as "the male gaze," notably, self-portraits by women artists that had rarely been seen or reproduced. The first one I saw was by Judith Leyster in the National Gallery of Art, Washington, D.C., along with another by Rosalba Carriera, both depicting themselves as artists, holding brushes or palettes. Here at last were women defining *themselves* by saying, "Look here, I am an artist."

In stark contrast was a work by a male contemporary of Carriera, which hung beneath hers. A game of cards had just been played. The card table, on the left, had been overturned, as if after a fit of passion by one of the players. In the center was a swooning woman, her bosom heaving, supported by two men who were holding her aloft lest she faint from the effects of having just lost at cards. The stern, strong face of Carriera stared out above the fatuous painting below it. Why, oh why, it seemed to ask, has *my* face been hidden away for so long, while this false image of woman has been publicly displayed?

Two decades later, the British art historian Frances Borzello would publish a book of women artists' self-portraits, *Seeing Ourselves: Women's Self-Portraits*. This collection of images was one of the first to delve into the

history of female self-portraiture and was so inspiring to me that during my subsequent visit to London, I called Frances without ever having met her. Thus began a long friendship, one that includes our collaboration on a book about Frida Kahlo (1907–1954), which taught me that Kahlo's work prefigured the Feminist Art movement of the 1970s in that she opened up a range of subjects that had not previously been part of the art discourse.

But in order to perceive this, we had to look at her work separately from that of her husband, Diego Rivera (1886–1957), especially because some art writers have gone so far as to describe her paintings as emotional reactions to his behavior, thereby completely denying her artistic agency. Examining women's art on its own or in relation to other women allowed me to see it in new ways: for example, the work of Mary Cassatt (1844–1926), who has traditionally been viewed as a minor member of the Impressionists.

In contrast to the paintings of many of her male contemporaries, Cassatt's female figures are usually engaged in "doing" something: bathing, caring for or playing with a child, pouring tea, going for a boat ride or a trot in the carriage. Perhaps her lesser art-historical position has to do with scorn for her "female" subject matter rather than being an accurate assessment of her painting skills. This idea is something that occurred to me a few years ago when I saw *The Great Mother*, curated by Massimiliano Gioni, at the Trussardi Foundation in Milan, the first major exhibition to examine birth and motherhood in modern and contemporary art.

When I later took up the subject of birth (in the *Birth Project*, 1980–85), I was under the impression that there were very few images of birth in Western art. Because art usually grows from art, I therefore felt obliged to create my iconography from personal testimony. Since I never had children, I consulted other women, watched a live birth, and studied photos and videos; I also researched birth historically, as research is part of my artistic practice. I was amazed to learn from Massimiliano's show that there is an abundance of art on this subject that has not been included in the artistic canon, probably because it is *what women do*, which apparently has rendered it unimportant from an art-historical point of view.

To realize that birth, a seemingly universal experience, has been neglected as important subject matter for art is to recognize that not only

have women's achievements been erased from history but also that what has been viewed as "women's sphere" has been equally ignored or devalued. It is with this understanding that I recently viewed a retrospective of Berthe Morisot (1841–1895) at the Dallas Museum of Art. Her oeuvre has also been relegated to a minor status, a position that has been reinforced by the fact that her work has rarely been seen as a whole, a consistent method of sidelining women artists, including—until recently—me. As the show made eminently clear, Morisot was a radical artist who also created images of women that are a startling contrast to the romanticized figures devised by her far more prominent male peers.

Examining women's work separately made it possible to see that the representation of women in the work of many modern and contemporary women artists can be best understood from the point of view of a dialogue in which the artists ask: What is it to be a woman? The answers are diverse, but together they constitute a perspective that is in opposition to male iconography and a challenge to society's definitions of women. Unfortunately, even today, when a great deal of art-historical work has been accomplished by feminist art historians, the contributions of many female artists continue to be marginalized rather than fully integrated into the history of art, which would require that art by men and women be equitably hung side by side in every museum in the world, with all art history texts following suit.

My research revealed that most female artists had worked within the prevailing aesthetic modes of their times; until recently, there were simply no other options. Until the advent of abstraction in art, it would not be possible for women artists to invent forms to express their own subject matter. This was something that I realized early on in my investigation of abstract art by women and that was reinforced by my own experience of creating *Pasadena Lifesavers*. I had basically invented the forms and developed the color systems to explore my own sexuality.

Although I had come to this conclusion earlier, I only began to articulate it recently in relation to the work of such twentieth-century pioneers as the Swedish painter Hilma af Klint (1862–1944) and Agnes Pelton (1881–1961), both abstract painters, whose work has recently become prominent. However, the ongoing need to somehow dismiss women artists'

historical significance is evident in the rapidity with which the notion has taken hold that both artists were somehow "agents" of an outside spirituality. It is true that they were interested in the realm of the spiritual, but so was Kandinsky, and the same description is never applied to him.

This is not only another demonstration of denying female agency but also reveals a complete lack of understanding of the struggles that creative women—including myself—often go through in terms of internalized fears of their own power, which was all too evident in Miriam Schapiro's dread that if she asserted herself publicly, she would "grow a penis."

As I said, until abstraction was invented (generally attributed to a triad of male artists, a theory that Hilma af Klint's work upends because it preceded theirs), female creators had to fit their content into the prevailing aesthetic modes. Another ongoing problem is that the history of women's art and Feminist Art in particular continues to be sidelined by major museums and art-history programs. As a result, female artists continue to be dealt with critically almost exclusively in relation to the concerns of their male peers, meaning the content of their work is often unperceived, ignored, or reviled.

A quick review of some of the vitriolic writing about my own work will make this eminently clear—"Ah, vaginas on plates," one male critic opined about *The Dinner Party*, thereby reiterating the same disgust my male art professors had expressed about my early work. And it was not only men who expressed this view; a number of supposedly feminist critics were guilty of a similar revulsion in the face of a work of art that asserts female agency in a fairly direct way. As the influential theorist bell hooks has pointed out in *Feminism Is for Everybody*, "All of us, female and male, have been socialized from birth on to accept sexist thought and action. As a consequence, females can be just as sexist as men…We need to be clear that we are all participants in perpetuating sexism."[5] Which, I might add, is a close companion to patriarchy and in fact helps to maintain it.

At the same time I began looking at women's art in its historical context, I also took up a study of women's literature to see if a comparable oppositional viewpoint might be present in their writings. Over the next few years, I read systematically, selecting the books of twelve female novelists whose

work spanned two hundred years: Jane Austen (1775–1817), George Sand (1804–1876), Charlotte Brontë (1816–1855), George Eliot (1819–1880), Edith Wharton (1862–1937), Colette (1873–1954), Gertrude Stein (1874–1946), Virginia Woolf (1882–1941), Willa Cather (1873–1947), Anaïs Nin (1903–1977), Simone de Beauvoir (1908–1986), and Doris Lessing (1919–2013).

Unfortunately, I had to abandon my plan to examine George Sand's work because I could not find enough of her books in translation or in print, despite the fact that she wrote 120 books and was a major literary and political force in her own time. Still, my study of women's history laid the groundwork for some of my subsequent art.

I am sorry to admit that I was so focused on issues of gender, I neglected to explore the work of women writers of color, which was definitely an unforgivable omission on my part. Since that time, I have tried to compensate for this by expanding my readings, especially after the advent of #BlackLivesMatter, which led me to try to expand my understanding of the pernicious and ongoing effects of racism.

I approached women's literature as I did women's art—in terms of its subject matter—and read in search of information that could be relevant to my own life and focus. Did these authors concern themselves with their lives and feelings as women? If so, what did they have to say on the topic? Did their work reflect their own struggles as women? I was not surprised to discover that, like many female artists, women writers had faced ongoing discrimination. How did they deal with it? What record had they left that could help me and others? Was there any development in ideas that could be traced throughout their work?

In almost all the literary work I studied, the female authors openly cried out against the pain they had seen women suffer and had experienced themselves, the result of lives dominated and circumscribed by patriarchal attitudes. Moreover, my reading taught me that—like a number of women artists—what many female writers had been trying to say about themselves as women actually constitutes a fundamental challenge to patriarchal perceptions and representations of women. In content, if not in style, these female creators had all confronted similar dilemmas; their sense of themselves did not correspond to society's narrow definitions of women. Asserting their

wrote 120 books, 80 of which are novels, few of which are in print. She strikes me as a woman of great energy. George Sand – 19th century writer, feminist, political activist. She deeply conflicted, whose drama was never fully realized.

GEORGE SAND from the **REINCARNATION TRIPTYCH** 1973
Sprayed acrylic on canvas, 60 × 60 in (152.4 × 152.4 cm)
Collection of Lynda Resnick. Photograph by Silvia Ros

own self-definitions through their work was, in part, an implicit demand that society adjust its views of women to correspond to the reality of women's lives, a demand that—even now—has barely been apprehended, much less met in terms of the larger literary world.

For example, Siri Hustvedt's 2018 novel, *The Blazing World*, explores the glass ceiling that continues to limit women. In a recent *Harper's Bazaar*

interview, she mentions that still today, one finds lists of great writers in which almost no women are cited. Closer to home, I read mysteries with female protagonists. In the Sunday *New York Times*, there is a column about new books that is written by a woman. Every time I read it, I notice that three out of the four thrillers discussed are by men. I am often tempted to write and complain, but something stops me. Maybe the response will be that many books by men feature female detectives, but those I have read do not have convincing characters (or the women are portrayed as helpmates to men). Perhaps it is because I am steeped in literature by women in which the female characters seem more believable than those penned by men.

In order to learn more about the contexts in which these successful female writers had lived, I began to read biographies. These books told the same story again and again: a woman of genius, talent, and aspiration, forced, like Eliot or Brontë, to publish under men's names or, like Austen, to hide their work. In fact, Eliot edited a magazine in which, for a long time, she could not publish. Colette, whose early work was published under her husband's name, had to sue him for title to her own writing.

After reading biographies, I turned to women's political and social history in an effort to understand the historical context in which these women had written. It was then that I made the discovery that female writing (as well as women's art) had emerged against the background of two hundred years of women's struggle for freedom. The women whose work I studied did not emerge singly, as popular mythology would have it (the "if you're really good, you'll make it" story). Rather, they wrote either during or after a period of active feminist struggle, or if spirited political battles were not actually taking place, they generally had the support of a small group of women or were sustained by the companionship of one woman.

Beginning around the 1830s, women started to openly contend for political rights. For the next half-century, all over the Western world, they challenged the restrictions men had placed upon them. The suffrage movement overlapped with the abolitionist movement. Even though recent scholarship has decried the lack of focus on race in the early suffrage movement, from the beginning there were African American women who saw the connections between race and gender. This is not to say that there wasn't racism in the

suffrage movement; there definitely was. But it is also not accurate to deny the insights of those women—both black and white—who fought on two fronts.

It was during this time that Eliot, Brontë, and Sand wrote, and all three of them reflected the growing consciousness spawned by the nineteenth-century feminist revolution. As this struggle for equity continued, more female writers and artists emerged. Virginia Woolf, for example, wrote during a time when there was a violent fight for women's rights in England. While female activists were battling the society to a standstill and obtaining the right to hold property, to speak publicly, to divorce, to receive higher education, to enter more of the professions, to control their own earnings, to practice contraception, to have some authority in relation to their children, and, finally, to vote, women writers were articulating the feelings of women caught between old values and new aspirations.

Often, political writers and novelists expressed the same ideas. Some years after Sarah (1792–1873) and Angelina Grimké (1805–1879) began to fight for women's rights in America, Elisabet Ney (1833–1907) began struggling to be admitted to the Munich Academy of Art, and Elizabeth Barrett Browning (1806–1861) was pleading for the rights of female creators in her epic poem *Aurora Leigh*. Not only were women writers and political activists expressing similar ideas, but one woman's work often directly inspired another's.

In America, a man named Timothy Fuller read Mary Wollstonecraft's radical book, *A Vindication of the Rights of Woman* (1792), and decided to educate his daughter, Margaret. She later wrote the first feminist document in this country, *Woman in the Nineteenth Century* (1845). She also set up a series of conversations for women. She felt that, as women were then still deprived of higher education, the best method of informing them was through dialogue.

These discussions, aimed at educating the women of Boston, were attended by a number of women later active in the feminist movement, including Elizabeth Cady Stanton (1815–1902). Fuller herself was influenced by both Madame de Staël (1766–1817) and George Sand. Another woman, Harriet Beecher Stowe (1811–1896), read and was inspired by de Staël, Sand, and Fuller, as well as Harriet Martineau, an Englishwoman who wrote on

religion, political economy, property, taxes, and labor, and who, as early as 1837, advocated suffrage for women. Stowe's book *Uncle Tom's Cabin* (1852) had such a profound effect on her generation that when Abraham Lincoln met her, shortly after the start of the Civil War, he took her hand in his and is supposed to have said: "So this is the little lady who made this big war."[6] And, of course, it was the abolition movement that was the stepping-stone to the feminist campaign that erupted at the end of the nineteenth century.

Some of these women even managed to make contact with each other. When Margaret Fuller went to Europe, she visited George Sand. Fuller was announced by the maid. At first, Sand did not recognize her name. When she came downstairs, she realized this was the woman who had written *Woman in the Nineteenth Century*. Sand threw her arms around her and cried, "My sister." Then the two women went into the study and closed the door. Ostensibly, they did not emerge for twenty-four hours.

There were also great female crusades in the last half of the nineteenth century—not only the feminist movement but also the temperance movement, the missionary movement, and the women's club movement. Women were organizing, writing, speaking, painting, sculpting, and pushing into all the professions. Elizabeth Blackwell (1821–1910) became the first female physician in America. Earlier, Victoria Woodhull (1838–1927) and her sister had become the first female stockbrokers; then, later, Woodhull became the first woman to run for the presidency. In England, Florence Nightingale (1820–1910) was beginning her lonely battle to establish nursing as a profession, not only training women but establishing schools and methodology. Everywhere, women were challenging male culture and its assumptions about "woman's place," and women writers were articulating similar challenges in their books.

There was almost no aspect of society that was left untouched by the radical efforts of women. Kate Chopin's appropriately titled book *The Awakening* (1899) speaks poignantly of the new sense of freedom women were experiencing:

> When she was there beside the sea, absolutely alone, she cast the
> unpleasant, pricking garments from her, and for the first time in her
> life she stood naked in the open air, at the mercy of the sun, the breeze

that beat upon her, and the waves that invited her. How strange and awful it seemed to stand naked under the sky! How delicious! She felt like some newborn creature, opening its eyes in a familiar world that it had never known.[7]

I read this book after I had been studying women's art, literature, and history for a number of years. But only recently have I seen any references to the importance of her writing in that it encapsulated the incredible changes that were taking place around the Western world. How different her book appeared to me than it might have, had I not seen it in the context of women's social, political, and aesthetic rebellion against male-dominated society. I thought about my experiences in school. I had read some work by nineteenth-century women writers, but their work had never been discussed in relation to this great "awakening" of female consciousness and the radical political activities of hundreds of thousands of women in the nineteenth and early twentieth centuries.

There has been a great deal of speculation as to the reason for the decline of this transformative revolution and its subsequent absence from history. I myself feel that, even after the laws were changed through political agitation, the values and attitudes that had shaped women's personalities and behavior remained the same. Even though nineteenth-century women altered many of the legal restrictions against women and forced open many of the professions, they were still expected to conform to the concept of what a woman was supposed to be. Moreover, even though women made inroads into the professions, they did not have sufficient control over the mechanisms of those professions—the recording of history, the disseminating of information, the transmitting of new values.

In her writings, Virginia Woolf argued that the feminist challenge of the nineteenth and early twentieth centuries was met with a mounting reaction from men as that confrontation began to affect the concept of masculinity and all the privileges and power that go along with it. A parallel can be seen today in the furious response to the #MeToo movement and contemporary feminist activism, specifically in the worldwide rise of misogyny, especially in the digital world.

One might argue that the 1970s Feminist Art movement represented the moment when female artists began to realize that the *form of art itself* would have to be different if it was to communicate a female-centered point of view, an idea that was first espoused by Woolf.

However, the fact that women's cultural production has not been viewed as a coherent body of information has significantly lessened its ability to transmit the new values it espouses. It left us with the legacy of political freedom that the nineteenth-century feminists achieved, but without a necessary redefinition of gender or an understanding of the crucial importance of our history. This meant that women born in the mid-twentieth century were deprived not only of an understanding of their political and social history but also of the insights about women's lives contained in women's books and new images of female agency in women's art.

It is essential to recognize that the erasing, obscuring, or minimizing of women's cultural contributions—or viewing them only in relation to what's important to men—has allowed patriarchal attitudes to prevail for both women and men. Consequently, women learn to identify themselves and their relationship to the world only through men's eyes, which assumes that male-centered views constitute not only the real but the universal.

The ongoing silence surrounding women in history, about women's accomplishments, and most importantly, about women's perspectives as expressed in art and literature, is not an accident of history. Like the erasure of the history of many other groups, it is a primary means of preventing us from seeing that work together; seen as a whole, women's work can change the ways in which we see ourselves, each other, and the world. Investigating women's art, literature, and biographies helped me see my circumstances and frustration as an artist as a social and political dilemma that could only be solved by fundamental changes in the nature of society and the histories it values. Being denied the recognition I deserved, being rejected by the male art community, and having my achievements and point of view as an artist diminished were all symptoms of my situation as a woman in a male-dominated culture. With the hubris of youth, I believed that I could single-handedly change this through art.

BACK TO L.A.
AND *WOMANHOUSE*

As my self-imposed exile in Fresno drew to a close, it was clear that my time away had allowed me much-needed solitude to develop my ideas. And my program seemed to have been an incredible success. Still, it was somewhat scary to return to Los Angeles in the early summer of 1971. In Fresno, there had not been much of an art community, and the women's program had existed in somewhat of a vacuum. In contrast, the Los Angeles art world had sophisticated art standards, and I had no idea how I, my new work, or what was now officially called the Feminist Art Program would be received. My own return to L.A. was followed shortly thereafter by quite a caravan down the highway: cars and trucks full of those students whom Mimi and I had helped get into the CalArts program, along with a variety of significant others, pets, and furnishings.

Before we decamped to L.A., my students and I put out an issue of a feminist magazine, *Everywoman*, and it had circulated widely, even making its way into the hands of the writer Anaïs Nin, who lived there. We met at a party where she commented on my article titled "My Struggle as a Woman Artist." At that time, Anaïs was coming into prominence after years of having her work ignored. I had read her first diary, which chronicled her slow, solitary struggle against the social construct of femininity. It had only been published because of her relationships with Henry Miller and Lawrence Durrell but—much to the surprise of her publishers—had been seized upon by thousands of women who were eager for guidance, including me.

Anaïs invited me to visit her in her airy house in the Silver Lake district where she lived with her second husband, Rupert Pole, who was the stepson of Lloyd Wright. (In the 1990s, it would be revealed that, at the time I met her, Anaïs had not divorced her first husband, which for

some reason infuriated feminists, who attacked her for duplicity. My own reaction was amazement that she could have managed two husbands, one on each coast.)

As soon as I arrived, I explained in a rush of words that the women's movement had opened up options that had never been available to me when I was young, and that I desperately wanted to be myself as a woman artist but didn't know how to integrate my artistic and female selves. The only thing I could imagine was that I would have to give up painting to pursue other artmaking forms that seemed more conducive to personal subject matter.

I then explained that I had been studying the history of women's art and literature, not only looking for personal reinforcement, but also to see if there was such a thing as a uniquely female perspective, something we discussed extensively at this and subsequent meetings. During our initial conversation, Anaïs suggested that I use writing to "try out" all the various paths I could see myself taking, adding that—based on my essay—I definitely had literary talent.

Other people had mentioned this in the past, but it had always frightened me. It was difficult for me to absorb the idea of being able to write as well as paint. An "artist," I had learned, was generally mute and inarticulate. I will be forever grateful to Anaïs, who became my mentor. It was because of her encouragement that I wrote my first book, *Through the Flower: My Struggle as a Woman Artist*. She was correct: writing helped me to clarify my aims and allowed me to share my somewhat confusing experiences as a woman artist. The book also brought my work to thousands of people around the world, as it was eventually published in multiple languages.

I started writing the manuscript by hand on index cards in the summer of 1972, when I was working at Tamarind, the lithography workshop founded by the artist June Wayne, which had recently moved to Albuquerque to become part of the University of New Mexico. I wrote from 5:30 to 7:30 a.m., then walked to the printshop, where I worked from 8 a.m. to 5 p.m. When the book was published in 1975, Anaïs generously wrote the introduction.

About the same time that I visited Anaïs (in the fall of 1971), I started working at a printshop owned by Sam Francis, who used to visit me when

I lived in Pasadena. As I've indicated, although the Los Angeles art scene was singularly inhospitable to women, there were always some male artists who were supportive, including Sam. Another source of backing came from Elyse and Stanley Grinstein, a husband-and-wife collecting team in Los Angeles and my first patrons. I initially met them in 1965 at an art party. I can still see Stanley in his horn-rimmed glasses and pleated pants, yelling to Elyse to come over to meet me.

Apparently, they had admired one of my small game-board pieces but balked at the price. As I had used commercial toy blocks, Elyse was convinced she could emulate my work. But, Stanley confided, she couldn't seem to achieve my surfaces, a confession that embarrassed Elyse. Soon afterward, they visited me in Pasadena, where I served them snacks on mismatched plates, which was all I could afford. Three weeks later, a huge box arrived at my studio containing eight complete place settings of white Japanese porcelain. The Grinsteins stood by me through thick and thin over the vicissitudes of my career. And I wasn't the only artist to whom they provided support; without them, a lot of L.A. artists would have had a much harder time.

I made lithographs at Sam's printshop, inspired by a conversation at a friend's house. Four of us, all women in our early thirties, were talking about menstruation. Suddenly, we realized that none of us had ever discussed this subject in any depth before. Moreover, there was a complete absence of menstruation images in literature or art. I decided to address this void by creating what would be the first image of menstruation in Western art. Titled *Red Flag*, it was a photo-image of a woman's hand pulling a bloody Tampax out of her vagina.

I was nervous when I first brought the project to the litho shop, where I was to work with a Japanese male printer. I had no idea how he would react, especially because I was still uncomfortable about exposing my point of view as a woman around men. Working on the litho helped me considerably. The printer and I calmly talked about adjusting the blood color and making sure that the Tampax looked like it was really emerging from the vagina. He introduced me to a technique called a rainbow roll, which involves blending more than one color on the roller that is used to apply the ink, a process I would use throughout my career.

RED FLAG 1971. Photo-lithograph on paper, 20 × 24 in (50.8 × 60.96 cm)

But there were definitely some funny moments. When we put up the first proof, I asked him for his response and he demurred, meaning that it was up to me to decide—or he could have been so mortified that he felt compelled to hide his feelings behind a professional facade. I made the print for two reasons: first, I wanted to validate female subject matter by using a "high art" process—like hand lithography—and second, I was trying to test male reaction to overt female subject matter. In fact, as I think back about the months after I returned to L.A. from Fresno, I can see that I was actively testing my limits and my talents, was searching for a method of integrating my art and my feminism, and was also trying to gauge the potential response to my new work.

After the lithograph was finished, I brought it home and hung it in the same room as *Desert Fan*, one of the paintings I had created in Fresno. I looked at both of them for a long time. *Desert Fan* was beautiful, but its content was submerged. *Red Flag* was clear in its subject matter but did not possess the layers of meaning that the *Fan* painting had. Could I bring those attributes together? At that point I was convinced it could be done, but I wasn't yet sure how.

Shortly before I began working at the printshop, Lloyd and I were reunited in Pacoima, a nondescript town in the San Fernando Valley, right off the San Diego Freeway, which was not far from where the new CalArts campus would be. We rented a rather odd place that had once been the home and office of a chiropractor. The sprawling, one-story building had a long string of rooms that were easily turned into studios, offices, and living spaces. It was on a large, barren, fenced lot covered with gravel, where I took up running, circling the property numerous times each morning before doing my daily calisthenics.

At that time, women artists all over the country were starting to get together. The same spirit that had touched me seemed to be inspiring other women to come out of the isolation that had made too many of us feel separate and self-despairing. There was a good deal of discussion beginning then about a female sensibility in art, partly stimulated by the slide talks Mimi and I had given together about some of the commonalities in contemporary women's art. I decided that it would be a good idea to gather a group of women artists to talk about our needs and our feelings about our art.

It happened that a curator friend, Dextra Frankel, was interested in doing a women's show, which was quite radical in the early 1970s. Like me, she had come to realize that she didn't know the work of very many women artists. She asked me to help her put the exhibition together, which created a perfect opportunity to meet with women artists on the West Coast, some of whom I knew, others whom I had never heard of. Over the summer of 1971, shortly after my return from Fresno, we visited about fifty studios. Sometimes, Mimi went with us.

One thing we discovered was that we all had certain notions about what a studio was. We were shocked that our visits took us to bedrooms, dining

rooms, and porches more often than to the 2,000-plus square feet of white space that defined the work areas of many male artists. Some women made studios in the midst of their homes and developed an artmaking process that was compatible with their lifestyles. Others worked in the back rooms of their male partners' studios, having internalized the idea that their work was less important.

At first I found it difficult to "see" their work because it was not in the kind of clean white space that seemed to designate importance and seriousness. As we traveled to more studios, we observed that a number of women artists had an attitude toward artmaking that was strikingly different from both our own and the men's. Objects, toiletries, children's toys, pets, old postcards and curios, paintings, and drawings all intermingled in a rich, womanly environment. Although there were male artists who lived in similar surroundings, they were usually considered eccentrics and unusual, whereas this art/lifestyle was common to a great number of women, who fit their artmaking into a multiplicity of activities that included making breakfast, getting the children off to school, doing the laundry, painting; then, while waiting for the paint to dry, doing the dishes, after which it was back into the studio until the children came home.

I observed two clear patterns. Some women worked in almost total isolation; generally, they dealt with subject matter connected to their home lives or their experiences as women and were not part of the art world. Another group—whose work was more visually neutralized, as Mimi's and mine had been—often had stores and lofts for studios. But their relationship to the art world was peripheral, and many of them complained of blatant discrimination. We heard repeated stories of struggling to be taken seriously by male partners or recognized by male peers.

The range of art that we chose for Dextra's show reflected these two alternative artmaking paths. One involved art that was highly formalized. (If there was female-centered content, it was, like mine, buried.) Other work was more explicit, dealing with kitchens, costumes, curtains. There was, however, a consistent softness and an antiheroic attitude in most of the show. *Twenty-One Artists: Invisible/Visible*, held in 1972, was probably one of the earliest feminist exhibits in the country. It was definitely the

first time my work appeared in an all-female context, which helped my submerged subject matter become more visible. I felt proud to be a part of the rapidly developing women artists' movement in America, though it was disheartening that so few male artists appeared at the opening, something that would continue to be the case for many years at all-female exhibitions.

In the fall of 1971, Mimi and I had organized a Conference for Women Artists, one of the first in the United States. Over two hundred women showed up, and it was just like our Fresno art marathon. We all cried and laughed and shared our work and were overwhelmed at the number of artists there were and how good the work was. (Out of this conference came plans for Womanspace, an exhibition space for women and a community art gallery, which opened in Los Angeles in January 1973.)

Meanwhile, things were coming together for the Feminist Art Program, which formally started at the California Institute of the Arts in the early fall of 1971, even though the new campus in Valencia was not yet ready, and classes were still being held in the old convent in Burbank. As a result, Mimi and I met with our students in various living rooms. Still, what a difference from Fresno! This was the first time that a school of art was addressing itself specifically to the needs of its female students by incorporating an educational program designed and run by women.

From the start, Mimi and I were interested in the possibility of doing a large-scale project. Paula Harper, the Stanford-educated art historian hired for the program, suggested transforming a house into an art instal-lation. After all, women had quilted, sewn, decorated, baked, and focused their creative energies on their homes for centuries. What would happen if these same activities were brought to bear on the process of creating art?

Our students were as excited as Mimi and I were about this project. They broke up into teams and scoured Los Angeles for an appropriate space. Three of the young women spotted an old, run-down mansion near downtown, found the owner's name in the Hall of Records, contacted her, and secured permission to use the house for three months. On a bright November morning, Mimi and I and twenty-one students, along with a few interested local women artists, all arrived at Mariposa Avenue armed with mops, brooms, saws, ladders, hammers, and nails to begin transforming

the dilapidated two-story building into the first openly feminist art instal-
lation to be seen in the United States.

We looked around the seventeen rooms and began to dream. The
first job was to get the house into shape for the metamorphosis that would
occur. The building had been unoccupied for twenty years and had been
repeatedly vandalized. The staircase railing had been ripped out, windows
were broken, the toilets were stuffed up, dirt and grime were everywhere.
We set to work: cleaning, scrubbing, tearing up carpets, repairing broken
doors. Some of the students had plans for rooms that required the building
of walls and furniture, plastering, wallpapering, and painting. Many of the
new participants had to learn how to use power tools, plaster walls, and
run power sanders. We used fifty gallons of white paint on the walls, and
by the end of the month, the house was beginning to shape up.

At first it was difficult to get everyone working at a consistent pace.
Several students, used to coming and going in classes and unobserved
by male teachers, had to learn that they were needed by the group and
that their absence was noticed. Some of them thought that an eight-hour
workday was outrageous, even though we had made it clear at the begin-
ning of the year that this was one of the demands of the program. Those
who had come from Fresno were accustomed to the schedule. But some
of the other women were used to working only when they felt like it. Mimi
and I believed that keeping regular working hours was important training
for professional life. We also agreed that the students needed to learn about
a continuity of work.

Few of the students had ever been involved in anything as overwhelming
in scale or concept before. They complained about being tired, of having
various aches and pains. Some were concerned about their bodies in an
overprotective way and were afraid of the strenuous activity required. As the
weeks went on and the work became more frustrating—such is the nature
of a large-scale project—many of the students grew angrier and angrier,
particularly those from privileged backgrounds, who were accustomed to
being pampered rather than pushed.

The lack of gratification was difficult for everyone to handle, including
the Fresno women. Some of the anger and anxiety that were manifest during

that period grew out of the fear that the house project would be a failure. Most of the students didn't have the necessary confidence in themselves or in each other. They began to talk about how Mimi and I were on "power trips," using them to gain some mysterious private glory. There were tears and accusations: "This project is terrible. I'm not getting what I want from the program." "I never do anything anymore but work." "I thought that all women were equal. We're not all equal. You and Mimi have more authority than we do. Why do *you* get to make all the decisions?"

There was a big confrontation. Why were they angry at Mimi and me? I asked. They should be angry at the society that had never demanded that they reach their potential. Looking back, I see why the students became confused. The rhetoric of the 1970s women's movement insisted that all women are equal, and so they are, on the basis of their humanity. But in reference to talents, abilities, and achievements, not everyone is equal. The reality was that Mimi and I were professional artists, and the students in the program wanted to learn about being artists. Hence, we were authorities *in that situation.* (I wish to make a clear distinction between authority figures and authoritarianism. To be an authority figure is to have amassed a body of knowledge about a given subject and to have information that is valuable to others. This can be given without the misuse of power that so often characterizes the behavior of many male authorities.)

One thing that really upset me was that even the Fresno women, who had been through a similar experience with me before, became carried away in the frenzy of anger that overtook our students. As I became more aware of these patterns of behavior, I realized that this rejection mechanism often kicks in when a woman feels that she is becoming stronger. One way of demonstrating that new strength—which, though negative, is still an assertive act—is to reject the female figure who helped her become strong. By saying "I don't need you anymore," she feels a sense of power.

Regrettably, during the 1970s, many strong women in the women's movement were devastated by this dynamic, as it is deeply hurtful when a woman you've helped rewards you with hate instead of love. Over time, I would experience both sides of this dynamic. In the meantime, my energies were focused on the creation of *Womanhouse.* After the initial house

repairs, the students turned their attention to the development of their respective projects. Some women worked alone; others collaborated. At no point did Mimi or I dictate subject matter. In fact, the same thing happened that had taken place in Fresno. As soon as the constraints against their working openly from their experiences as women were lifted, their ideas poured forth: One woman made a crocheted environment, another a lipstick bathroom painted entirely red.

Two women made a bridal staircase in which the bride was pictured, radiant and beautiful, at the top of the stairs, her train covering the carpet

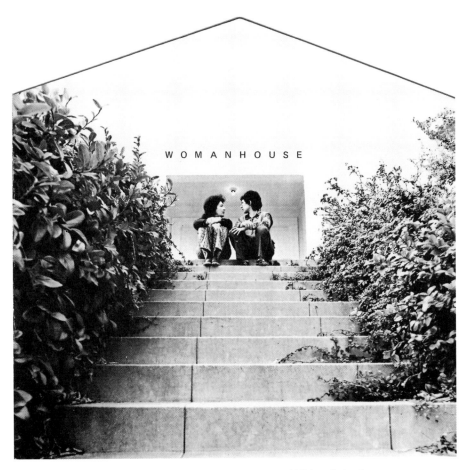

WOMANHOUSE catalog cover featuring Judy Chicago and Miriam Schapiro
Designed by Sheila de Bretteville 1972

and going up the back of a mannequin that was attached to the bottom wall, headed into the seeming obscurity of marriage and domestic life. Another woman created a nursery in large scale that made adults feel like children again. There was a shoe closet, crammed full of footwear to match every conceivable outfit, and a private, personal space, all pink and soft and feminine, hidden inside a dirty, messy room.

For some reason, the three students collaborating on the kitchen were not having much success. Mimi suggested that we have a group discussion about kitchens and what they meant to everyone. As we went around the circle and the women talked about their memories of the kitchens in their homes, it became clear that this room was often the battlefield of the house. What kind of food was prepared, who made it, and when it could and could not be eaten frequently became the means for a power struggle between mother and father, mother and children. The historical associations of women and the preparation of food finally led to the idea of a "nurturant" kitchen in which the walls, floors, and objects were covered with flesh-colored skin tone (Caucasian like the artists), and plastic eggs transmuting into breasts cascaded down from the ceiling onto the walls.

My own contribution to *Womanhouse* was the *Menstruation Bathroom*. Although Mimi and I had not originally planned to make art—as we felt it might be inappropriate, given our role as facilitators—we both changed our minds. I decided that it was important to include some reference to menstruation, particularly because it was so unrepresented in the history of art. I used one of the non-working bathrooms, painted it white, built a shelf that featured various menstrual products, and filled a white garbage can with what looked like bloodstained tampons and menstrual pads. But the blood was actually paint, which I applied as I sat on the floor with some of the students around me, all commenting on the shade of red.

The *Menstruation Bathroom* turned out to be one of the more shocking installations as viewers stared aghast at the small room through a layer of white scrim that covered the doorway. Only the menstrual products and the blood on the menstrual products interrupted the sterile bathroom environment. And when I did a reinstallation twenty years later at the Los Angeles Museum of Contemporary Art, I was amazed that it caused a similar level

MENSTRUATION BATHROOM
from **WOMANHOUSE** 1972
Multi-media installation

of shock. Since that time, however, there has been quite a bit of art on the subject of menstruation, including some by men.

Early in the semester, I had initiated a Performance Workshop with the idea of using the living room of the Womanspace house as a theater. The central space would be used for the performances, and the spectators would be seated on the floor, less than a foot from the actresses. While the house was still being repaired, the students met regularly at my house in Pacoima in order to develop some new pieces. We began by experimenting with an

array of feelings: crying, groaning, screaming, making animal noises, always trying to focus on an emotion and connect with it and with one another.

As a piece grew out of one of these informal exercises, we would work together, rehearsing and improving it until we felt it was ready to perform. Everyone took turns acting, directing, costuming, and stage-managing. This exchange of roles provided a fluid working environment and meant that everyone had a chance to express herself. Sometimes, several students would try out a role until we identified the one who was best qualified.

Once, spontaneously, two of the students lined up the others and began to inspect their bodies, as men often do to women on the street. They chose several to stand on chairs, then proceeded to comment on the physical faults of each woman, intuitively focusing on the things that had plagued them all their lives: fat thighs, acne, bulging stomachs. We all thought the sketch was good, but because it involved female nudity, we decided it should be presented to women-only audiences.

Occasionally, one of the women would have a clear idea about something she wanted to do—for instance, Faith Wilding (another student who had come with me from Fresno and went on to a successful career). She wanted to deal with the subject of female passivity. One night, Faith and I went to a mutual friend's house for dinner, where her concept came up for discussion.

Soon we were writing down all the things we had ever waited for in our lives, particularly in adolescence, when we "waited for boys to call, waited for boys to ask us to dance," waited for boys to take the initiative in just about everything, never daring to ask a boy out for fear of being thought "unfeminine." Faith took the long list home with her and revised it, bringing it back to the performance workshop, where we went over it, working on the lines, the emotional tone, and the rhythm until it felt right to everyone.

Other pieces included the *Cock and Cunt* play—which I had written in a fit of passion the previous year and used as a pedagogical exercise about gender roles—and two acts that we called "duration" performances because they demonstrated the length of time it actually took to do such "woman's work" as ironing a sheet or scrubbing a floor. Recently, I read an article about a 2019 Andy Warhol show at the Whitney Museum in New York. It

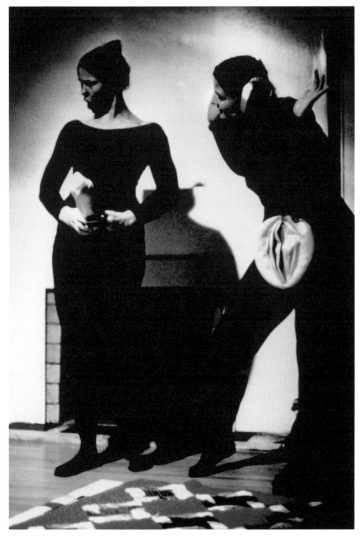

COCK AND CUNT PLAY from **WOMANHOUSE**
Performed by Faith Wilding and Jan Lester 1972

included photographs of his 1973 piece involving the vacuuming of a gallery rug. Of course, there was no mention of the *Womanhouse* performances that preceded this.

On the first night that *Womanhouse* was open, we performed only for women. The response was overwhelming. As one woman said, it was the first

work of art she completely understood. *Womanhouse* proved to be historically important because it allowed women to feel that their lives had meaning, that their experiences were rich, and that they had something of value to contribute to the world. After that first all-female evening, we performed most nights for an audience of both women and men. Gone was the raucous laughter and rapt attention that had existed when the audience was only women. It was disheartening to note how different the response was, particularly to the ironing piece. Some nights, everyone would be bored and start talking; other times, the audience sat there, rapt and silent. Sometimes viewers left, angry that they should have to watch a woman iron, unwilling to look at what many women really do with their time. There was often inappropriate silence, embarrassed laughter, or muffled applause, which upset me.

I expressed my distress to Lloyd. He listened to my rant about how the men hated the performances, how we should never perform for mixed groups, and on and on. Lloyd had a different explanation; he thought that, while there were some men who didn't like the house or the performances, many of them were so overwhelmed by what they'd seen that they didn't know *how* to respond. They were receiving new information and were not so much hostile as unknowing.

His comments made me reflect on something that had happened in Fresno, which I realized might explain some of the male responses. The chairman of the Art Department—a sophisticated, liberal man—came to visit our studio. One of the works on display was an installation by Faith Wilding, full of religious imagery implying the Crucifixion, death, and destruction of the feminine. The symbolism was pretty overt. For example, hanging around the walls were bloody Kotexes, which he perceived as "white material with red spots." I was flabbergasted by his inability to recognize imagery that did not grow out of *his* cultural experience.

However, it is not only men whose perception is impaired in terms of women's experiences. When I showed *Red Flag* to an audience of women, one woman jumped up and accused me of representing a bloody penis. It astonished me that she was unable to "see" something that many women do every month, that is, remove bloody tampons from their vaginas. What this taught me is that *what is not imaged is not real*; what I mean is that because

women's experiences are not part of the cultural dialogue, they are literally invisible, even when they are represented in art.

More importantly, from *Hamlet* to *Waiting for Godot*, not to mention the figure of Jesus Christ, the struggles of humanity have been primarily embodied in male characters and male-centered art, created by men, reflecting themselves and one another. Perhaps it was at this time that I first began to think about whether women's experiences could also be made to represent the universal, something that slowly began to shape my artistic path.

In *Womanhouse*, men were spectators to our lives, to our art, to our points of view, just as we had been the observers of male activities and their art for centuries; in our environment, they were the "other." Whatever prejudices men had toward women, they brought them to *Womanhouse* and interpreted it accordingly. For example, one man thought the house was a wonderful parody of women, despite the fact that there was nothing but compassion and empathy in the whole environment. I pointed out to him that it was *he* who saw women's lives, concerns, and paraphernalia as amusing, and that he was not seeing *Womanhouse* at all, only his own attitudes.

An issue that came up repeatedly was that of anger: "Why are women so angry?" was a recurrent question, one that was repeated frequently by the media. One of the subjects Anaïs and I had discussed during our many conversations was anger, which she felt was an inappropriate emotion. I disagreed, arguing that anger could be productive and healthy: anger against one's limits, against oppression, against the facts of the human condition. Also, anger can lead to creative growth, and its suppression can be especially damaging to women artists because censoring one's emotions can inhibit the artmaking process.

Unfortunately, even today—as evidenced by recent books on this topic—women are frequently made to feel guilty about any direct expression of anger, have few socially accepted outlets, and when we try to express anger verbally, too often are accused of being "bitches" or "loudmouths." Consequently, women are allowed only covert displays of anger: silence, passive withdrawal, manipulative behavior, and the use of "feminine wiles." Moreover, many women have internalized male attitudes and are afraid of

ambitious or strong women, seeing them as monstrous, which was sadly played out in the 2016 election when so many white women rejected Clinton.

Historically, numerous female writers channeled their rage through characters like Madame Deronda in George Eliot's 1876 novel, *Daniel Deronda*:

> You are not a woman. You may try—but you can never imagine what it is to have a man's force of genius in you, and yet to suffer the slavery of being a girl. To have a pattern cut out—"this is the… woman; this is what you must be; this is what you are wanted for; a woman's heart must be of such a size and no larger, else it must be pressed small, like Chinese feet."

Similarly, *Womanhouse*, particularly the performances, allowed the participants to express a whole range of emotions, including anger. Some of the anxieties *Womanhouse* induced in viewers (especially men) might have grown out of the fact that it brought so much of the "private" sphere—which has traditionally been the domain of women—into the public. One of the discussions in 1970s consciousness-raising groups involved men's fears about their partners openly discussing their sexual abilities—or lack thereof. The possibility that women would reveal such "private" information seemed to drive some men to distraction.

As Nancy Reeves observed in her 1971 book, *Womankind*:

> The gap between male and female…is not a universal constant, but rather the distance between public and private that developed with the first industrial revolution…Today the hemisphere of the public has been assigned to the male and the hemisphere of the private to the female.[8]

In *Womanhouse*, men were the "others." For some fellows, this was a real eye-opener. Never before had they had the opportunity to see women's lives from within a female perspective, and in some cases their initial discomfort changed into real fascination. Others felt threatened by the experience of not being in control since, in general, men are encouraged by the culture to "take charge" and often develop an unfortunate

tendency to *have* to be in control all the time. But for men whose identity was deeply invested in male dominance, the environment was so threatening that they hurried out.

If men related to the work, that was fine, but it was to a female audience that the house was primarily directed, and it was to women that we looked for evaluations, criticisms, and responses. For me, the response to *Womanhouse* was deeply reinforcing. During the month that it was open, almost ten thousand people came to see it, mostly through word of mouth. I had sensed that art that reflected women's experiences could have a profound impact, but to think that and to see it actualized were two different things.

In addition to its immediate impact, *Womanhouse* reverberated for years, in part because of the marvelous documentary (which would be seen around the world) by a filmmaker named Johanna Demetrakas, whose decision to document the installation seemed perfectly timed. Over the years, there has been a steady succession of *Womanhouse*-inspired projects, including one in 2001 at Western Kentucky University in Bowling Green that I helped facilitate. (Many of these are archived in the Special Collections Library at Penn State University, which, in 2011, became the site of my art-education files.)

By the time *Womanhouse* closed, the Valencia campus was ready and the Feminist Art Program could officially take up residence. Being in a high-tech, state-of-the-art building might have been stimulating to some, but from the first moment we arrived, I hated it. The sterile white corridors and multicolored though otherwise identical doors stood in stark contrast to the homey feeling and independent nature of *Womanhouse* and the earlier Fresno studio.

Not only that, but to my mind, the values of the Fresno and Feminist Art programs were basically opposed to the values of CalArts, which was male-dominated, hierarchical in structure, and directed exclusively toward the small, elitist art community. When the Fresno program came into CalArts as the Feminist Art Program, I was extremely excited about the fact that a major art school was addressing itself specifically to the needs of its female students. But after we began working on the campus, I became aware that something was going wrong. Yes, we had private quarters, our

own equipment, access to cutting-edge technical processes and funding for art-historical research; but what we did not have was freedom from patriarchy.

My program had become a women's program in an institution whose values were shaped by men. Even though they had made space for us, they were not prepared to restructure the school so that it was equalized on all levels. Once the students walked out the door of the Feminist Studio Workshop, they were confronted with a set of values that promoted standards of art derived from the male-dominated art community, along with the pressure to be "professional," whether that was real or merely a posture. All of the issues I had encountered when I was a student at UCLA were present at CalArts, despite its support of a feminist program.

In Fresno and during the *Womanhouse* project, there were no men around to fight against, so the women were liberated from that circumscribed area of either submitting to men or rebelling against them. They were able to act on their own impulses, something that became increasingly difficult once the program was installed at CalArts. Because male-centered values and attitudes pervaded the institution, the students often became confused. When they acted on their own behalf, they violated the standards of the school. If they conformed to the artmaking values of the institution, they denied themselves as women, which must have been difficult, especially for young students at the beginning of their careers.

Moreover, there was another issue, one of class, that I only became aware of many years later. Nancy Youdelman, another of the original Fresno students, told me about her experiences at CalArts, where there were many privileged students. Because Nancy had economic challenges, she had to work in the school cafeteria to support herself. One night, she went out on a date with a male student and had an enjoyable time. The next day, he saw her wearing a hairnet and dishing out food at the cafeteria and never spoke to her again.

Although I wasn't aware of class questions at the time, there were enough contradictions at play that I was forced to ask myself why I had brought the program into this institution in the first place. As ridiculous as the answer was, I had to recognize that I still entertained fantasies that the

male-dominated art world would reward me for challenging its values. I also realized that the Fresno program had worked so well precisely because it existed *outside* the sphere of patriarchy; having a space that was not regulated by masculine values made it possible to be ourselves as women.

Later, I concluded that it was not so much an issue of separatism as it was the simple fact of being away from male control. If there were an institution that was coeducational and not male-centered, the Feminist Art Program could have functioned in it. Had CalArts been willing to equalize its administration, its courses, its teaching staff, and its curriculum, I could have continued to operate within its walls. But even if CalArts had been willing, someday, to equalize its staff, it would never have equalized its perception of reality.

What I mean is that no institution seems ready to surrender the deeply held notion that men's history *is* history. If I had learned anything from my ongoing investigation of women's contributions, it was that we have our *own* history, and *to me*, it is as significant as men's history is to them. Although there was an ongoing effort to include a few women, the art history classes at CalArts focused primarily on a white, male, Eurocentric lineage. Thus, women artists were presented in the context of men's ideas, men's values, and men's past.

Even later, after Women's Studies courses were introduced around the country, there was Art History and then there was "Women in Art," which by its very nature trivialized female work because it emphasized the idea that there was an *important* art history and then, as a sideshow to the main attraction, women's art. But if women's work is studied as a side issue, it cannot challenge the fundamental dominance of a male-centered worldview. So I was right back where I had started. I had moved forward and then slid backward.

It was difficult for me to face the fact that I would have to leave CalArts, but my intense discomfort in such an institutional setting was complicated by the problems that developed between Mimi and me, which were both personal and philosophical. Things started going downhill shortly after *Womanhouse* closed. By then, there was a burgeoning movement of women in the arts across the country, and the Corcoran museum in Washington, D.C.,

had made the wonderful mistake of inviting all of us to get together. Several hundred artists, curators, critics, and historians assembled, only to become energized by the realization that most of us had been experiencing rather heinous forms of discrimination.

Mimi and I were invited to do a joint presentation about *Womanhouse*. I don't even remember what caused her to become so angry at me, but apparently, at some point in our talk, I said something that caused a groundswell of applause for my remarks. Afterward, Mimi accused me of having "manipulated the audience" so that they liked me better than her, which left me dumbfounded. I may be flawed, but being manipulative is not among my deficiencies; it's more like "what you see is what you get."

From that moment forward, our relationship began to unravel. Despite my reputation for being confrontational ("direct" would be more accurate), I have always been somewhat conflict averse. Thus, when Mimi would call me up early in the morning to castigate me about something I had done, I would become intimidated. Instead of challenging her, I basically ran away, tendering my resignation at the end of my two-year contract, which meant that I had to stay at CalArts until spring of 1973.

At the beginning of my second year, I was in a basement studio with those students who had remained loyal to me. In hindsight, I recognize that there were other factors at play that I did not appreciate at the time. Suffice it to say that I do not think Miriam and I had the same goals. I think she was committed to CalArts, whereas I wanted to develop an alternative female-centered art community. Although I was reluctant to give up the first financial security I had ever had, I felt I had no choice, even though it meant leaving my program, the Feminist Art history we had compiled through slides and books, along with my students, and starting all over again.

However, if I had ever entertained doubts about my decision, they were ended in the 1990s when young female students at CalArts found themselves facing many of the same challenges I had started my program to overcome. Somehow, they had discovered the archives of the Feminist Art Program in a dumpster on campus, which made it eminently clear that we had actually been unwelcome visitors at an institution that had no real interest in changing. Moreover, for several decades and despite the

worldwide influence of *Womanhouse*, CalArts distanced itself from even acknowledging that the project had been supported by the school.

As for me, I soon began making plans to start an independent art school with two other women: the graphic designer Sheila de Bretteville and Arlene Raven, an art historian who moved west from Baltimore not long after we met at the Corcoran. One day, she showed up unannounced at my doorstep in Pacoima, saying she felt that the West Coast was a more exciting place to be because of the developing Feminist Art movement. I helped her select a new name in response to her request for help, suggesting that she change her birth name of Rubin to Raven, which—given her long, dark hair—seemed to suit her perfectly.

Sheila, a gifted graphic designer, had come to California with her architect husband, Peter, both of them to teach at the new Disney school. Stimulated in part by the Feminist Art Program, Sheila had instituted a comparable program in the CalArts design school. Neither she nor Arlene (who had been hired by CalArts soon after she relocated to California) was unhappy at the Valencia campus, and both would continue to teach there even after we had instituted the Feminist Studio Workshop. Though our plan was based upon the principles of my Fresno program, our intention was to expand beyond what I had done by fusing our three disciplines into an educational program whose aim was the expansion of the role of art and artist, in particular a broadening of the relationship between art and the wider community.

At first we met in Sheila's living room with an enthusiastic group of young women from around the country who had been drawn to enroll in what was to be the first-ever independent (though unaccredited) Feminist Art institution. The Feminist Studio Workshop soon decided to join forces with a number of other women's organizations to create a common home, in which, in addition to the FSW, there were to be several women's co-op galleries, a feminist bookstore, and other female-run businesses and organizations. Each of these was to be financially self-sufficient, with everyone pooling resources to cover the rent, utilities, and maintenance.

One day, while we were still working in *Womanhouse*, one of the students had returned from a thrift-shop expedition carrying an old book. It

was an out-of-print edition about something called the Woman's Building, which none of us knew anything about. Opening the faded, gold-trimmed volume, we excitedly discovered that there had been a building in the 1893 World's Columbian Exposition in Chicago designed by a woman architect, established and run by a Board of Lady Managers, and filled with work by women from around the world, including a large mural by "our" Mary Cassatt, as she was referred to by the women who organized the building and commissioned her mural. As we examined the book, I was struck by the level of feminist consciousness evidenced by the women involved and by the fact that they had apparently unearthed a good deal of historical material about women artists. The writer of the book referred to many artists with whom I was unfamiliar, not only from Europe and America but also from ancient Egyptian, Cretan, and Greco-Roman times.

Cassatt's mural was a three-part painting entitled *Modern Woman*. In it, she portrayed women as independent, self-sufficient, and devoted to learning. The central panel depicted women plucking the fruits of knowledge from trees in an orchard and handing them down to their daughters. On the left, three women pursued the allegorical figure of Fame, while on the right, several female figures were involved in the various arts. It was a symbolic painting showing women struggling to move out into the world. Cassatt worked on plans for the mural for a long time; there are a number of studies around. Unfortunately, the mural was lost sometime after it was removed from the exhibition, a fitting symbol for our own lost heritage.

Based upon the model of the 1893 Woman's Building and, like its predecessor, run by a Board of Lady Managers (in this case representing the various organizations), our Woman's Building was set up in the somewhat seedy MacArthur Park area of Los Angeles, in what had formerly been the Chouinard art school, where numerous prominent L.A. artists had gone. Walt Disney sent many of his animators to the school and later took it over, converting it into CalArts, which eventually became a somewhat different institution from the one he had envisioned. The old Chouinard building was abandoned, which is how we were able to rent it very cheaply. The irony of leaving CalArts only to take up residence in its ghostly predecessor was amusing to us.

In the fall of 1973, the Woman's Building opened to an excited crowd of many thousands, drawn by what was then a rapidly expanding and vibrant West Coast women's culture. That night and for many months to come, there were exhibitions, performances, music, and other events taking place all over the building. In conjunction with the opening, I held a show at Grandview Gallery, one of the co-ops I had helped to organize. My exhibition featured a series of airbrushed paintings called *The Great Ladies*. My intention in these abstract portraits of women culled from my historical research was to communicate something about each of the figures and why they were so important, both historically and personally.

Although I felt quite joyous about what proved to be an overwhelmingly positive response to the opening of the building and my own show, before the end of the year I had decided to resign, both from the school and from the institution I had helped to establish. The explanation for this decision is complicated; the short version is that I wanted to get back to the solitude of my studio.

By the time the Woman's Building opened, I had identified the content in which I was most interested—women's history. I was determined to challenge the overriding presumption that women had no history to speak of, an attitude that had first been presented to me when I was an undergraduate at UCLA, by no less an authority than one of the most respected members of the History Department. I also wanted to call into question the assumption that there had never been any great women artists, an assessment that I realized was simply prejudice elevated to the level of unquestioned belief.

In addition to having found the subject matter that interested me, I had also been developing what I had determined were the required technical skills. One reason I have worked in so many different media is that I firmly believe certain techniques are most appropriate to specific intentions. For example, during the late 1960s I began to work with fireworks, primarily because I wanted to create ephemeral images. Plastics—my chosen medium for much of my work during that same decade—allowed for transparency, a layering of coloring, and a fusion of color and surface, something I had also achieved in my sprayed-canvas paintings. I was dissatisfied with these, however, because the forms seemed too generalized. I wanted to effect a

Installation of the **GREAT LADIES**, left to right: *Queen Victoria, Christine of Sweden, Elizabeth in Honor of Elizabeth (formerly titled Catherine the Great)*, and *Marie Antoinette.* Grandview Gallery, Woman's Building, Los Angeles, CA 1973

more precise rendering of the images while still retaining the integration of color and surface that these works demonstrated.

Arlene and Sheila were amazingly sympathetic to my announcement that I was going to resign, probably far more so than I would have been in their place. After I left, both the Feminist Studio Workshop and the Woman's Building continued to operate until the early 1990s, though by that time at another location. Arlene taught until the start of the 1980s, then moved to New York, where she would become a prominent art critic. Sheila remained for some years longer, before going on to become director of the Yale University Program in Graphic Design and the first woman to receive tenure at the Yale School of Art. As for me, although I didn't realize it at the time, I was about to start down the long path that would eventually take me "beyond the flower," a metaphor for my desire to find my way to personal and aesthetic liberation.

DREAMING UP
THE DINNER PARTY

By the time the Woman's Building opened in fall 1973, Lloyd and I had moved into a spacious, 5,000-square-foot industrial space in Santa Monica, about a mile and a half from the beach. We rented it from a husband-and-wife design team who owned the building and worked in the front. Lloyd and I divided our studio equally, erecting a wall between us that was almost eighteen feet high in order to accommodate the lofty ceiling. I also built a drawing loft with a small clean room beneath it that included good ventilation, something I had never had before. Our tiny living space was in the back and barely had enough room for a small kitchen, a bed, and a bathroom.

When I think back on this period, I have no idea how we paid for all the construction. Lloyd was still teaching and I was receiving a small paycheck from the Feminist Studio Workshop, but that ended the following spring when I quit. As discussed earlier, for most of my life I've lived without any financial security. Moreover, I have no recollection of how I supported myself, having continued to live by the "something's going to happen" dictum I learned from Billy Al Bengston. Fortunately, that always seemed to transpire, though I cannot remember any specifics, primarily because I was usually so focused on my studio life.

Two years earlier, in the summer of 1971, shortly before I left Kingsburg, Lloyd and I had taken a long drive up the Northwest Coast. At some point along the way, I saw a hand-painted porcelain plate in the window of an antique store. I was fascinated by how its effects had been achieved, presumably through a technique called china painting, which I knew absolutely nothing about. I would soon learn that this technique involves the application of specific paints onto a glazed ceramic surface, then firing the piece

until the colors meld with the surface. Although I loved my airbrush, I was becoming dissatisfied with aspects of that process. In addition to providing the kind of visual fusion I liked, china painting seemed to offer a precision of form that I thought my sprayed paintings were lacking.

In 1972, I took up the study of this technique. After looking up "Porcelain" in the yellow pages, I located a nearby class, in which I enrolled. I soon learned that, traditionally, one does not so much learn to china-paint as, for example, to paint a baby rose. The teacher was quite insistent that I spend my time mastering the "dots and dashes" essential to produce such a result, something I was not interested in doing. Rather, I was intent upon developing an understanding of the overall method of porcelain painting, which I would discover was quite a difficult skill to master.

Finally, I found a teacher named Mim Silinsky, who was sympathetic to my desire to extract china painting from where it was embedded in the world of craft and apply it to my imagery. One could say that the main historical distinction between art and craft is that in art, techniques are customarily put in the service of personal subject matter, whereas in craft they are generally employed for other purposes, including the simple demonstration of skill.

Even though I have used many media on the fringes of the art world (think spray painting and plastics), no one ever questioned my adopting them, perhaps because they are associated with the masculine world. Hence, I was moving upward by incorporating them. In contrast, over the years, many people would comment on my decision to take up china painting, which—when I encountered it—was a hobbyist technique generally associated with women, though this has not always been the case.

Over the course of the last few centuries, painting on porcelain went from being the province of highly skilled male artisans who produced gorgeous dinner services for royalty and moved into the hands of women who basically kept the technique alive for many decades (it is now in danger of decline as younger generations of women reject their mothers' hobbies). As soon as china painting was taken over by women, its aesthetic status was diminished. (Over the years since I began using the technique, countless china painters have asked me why porcelain painting wasn't considered art.)

The answer, of course, has to do with gender. As Elissa Auther put it in her 2009 book, *String, Felt, Thread*, "In the history of art…there is a matching up of gender and aesthetic hierarchies: art, associated with the mind and the idea, is implicitly coded as masculine, while craft, associated with materials as ends in themselves…is implicitly coded as feminine."[9] Personally, I think it is ridiculous to associate techniques with particular genders. The artists who employ a technique may be gendered, and the audience may have gendered expectations. But painting is simply painting, whether it is done with an airbrush and acrylic lacquer or a paintbrush and china paint. My perspective has allowed me to go back and forth across what has traditionally been a closely guarded gender spectrum in art.

Between 1972 and 1974, I basically apprenticed myself to Mim Silinsky. Under her supervision, I analyzed and sampled the range of colors, their respective firing temperatures, and the potential variety of visual effects attainable. In addition to doing innumerable samples, I also worked on a series of test plates that demonstrated the basic components and techniques

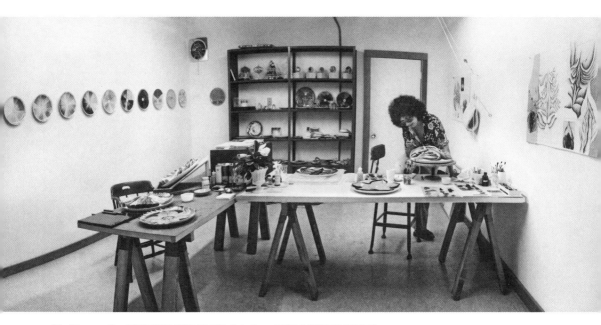

Working on the **GEORGIA O'KEEFFE** plate from **THE DINNER PARTY** in the china-painting studio, Santa Monica, CA 1972

of china painting. Throughout the course of my apprenticeship, I attended many china-painting exhibitions. In addition to being impressed by the crowds (far larger than those at most contemporary art galleries), I was struck by the array of domestic objects upon which many of the china painters worked.

During this same time, I worked on a series of sprayed paintings on canvas, including the *Great Ladies*. I decided that I wanted to expand this series by painting the images on plates, to imply that the women's achievements had been "consumed" rather than honored by history, an implication I thought would be best conveyed by the plate format. At the same time, I viewed the plate as a visually neutral surface, assuming that when these pieces were finished I would display them, like any other paintings, on gallery walls. Early in 1974, while finishing up my china-painting tutelage, I became engrossed in trying to break through the formal visual structure I had been using in my work, something I finally achieved in a series entitled *Rejection Quintet*, five drawings created in one of my favorite media, Prismacolor pencils. Step-by-step, in five successive images, I "peeled back" the highly abstract forms I had been using to reveal what I viewed then as a mutable vulval form.

Given the changes in our concept of gender since the 1970s, when I first wrote this text, it might be important to explore this idea in a contemporary context. It was clear to me even then—before we had the language to describe it—that the "feminine" was the result of both nature and culture; that is, as Simone de Beauvoir put it, one *learns* to be a woman. For my generation, *unlearning* these lessons was an important step in emancipating oneself, a process that Anaïs Nin described in detail in her writing—both her diaries and her novels.

In *A Spy in the House of Love*, Nin describes Sabina, a woman who continually "acts," trying on one feminine role after another:

> She was like an actress who must compose a face, an attitude to meet the day…She must redesign the face, smooth the anxious brows, separate the crushed eyelashes, wash off the traces of secret interior tears, accentuate the mouth as upon a canvas, so it will hold

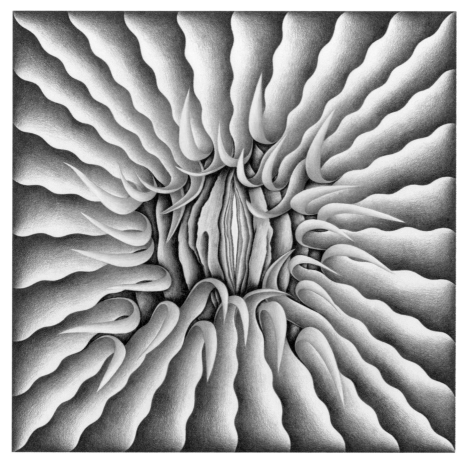

FEMALE REJECTION DRAWING from the **REJECTION QUINTET** detail 1974
Prismacolor and graphite on paper, 40 × 30 in (101.6 × 76.2 cm)
Collection of the San Francisco Museum of Modern Art

its luxuriant smile. Inner chaos, like those secret volcanoes which suddenly lift the neat furrows of a peacefully plowed field, awaited behind all disorders of face, hair, and costume.[10]

What Nin is discussing is *artifice*, something that many generations of feminists struggled to cast off because it was so personally imprisoning, whether it involved whale-bone corsets, constricting clothing and brutal shoes, cosmetic surgeries, excessive makeup, or any number of uncomfortable practices that women were expected to adopt in order to be attractive

to men. More pernicious aspects of these same types of expectations, of course, involve extremely painful and permanently disfiguring processes.

Two examples: first, foot binding, the practice of compressing girls' feet with tight bandages so as to prevent them from being over three or four inches long. Even though this rendered women unable to walk properly, it was considered sexually alluring to men. Or female genital mutilation, in which the genitals are partly or entirely removed with the aim of inhibiting a woman's sexual feelings, which, because it is done when girls are young, creates a lifelong association between the genitals and pain. Moreover, it renders the vulva nothing but an inert passage for male ejaculation. Both forms of torture were instituted by men to accentuate their own pleasure. But they have been primarily implemented by women and demonstrate some of the ways in which women have upheld and enabled patriarchal practices.

What does this have to do with your vulval imagery? one might ask. Social expectations, cultural patterns, and behavioral conventions contribute to and help to shape one's gender consciousness. One might experience oneself one way but discover that when one enters the world, there is a whole different reality. For instance, when I go into my studio, I do not think, "I am a woman." I approach art as a whole human being whose sex and gender make up part of my identity. But when my art goes into the world, it collides with social attitudes toward the female person. It is *because I have a vulva* that this happens.

Wanting to understand how this physical characteristic has shaped women's lives across history helped to fuel my research into women's history and also influenced my decision to start with the *vulval form*. Basically, I was trying to create a new visual language, one that could speak of my own experiences as a woman and what being female has meant across time. It seems important for my viewers and readers to realize all that this has meant, including some of the grotesque consequences, which include rape, sexual violence, and most of all, the intellectual, physical, and emotional stunting of one's potential as a human being.

Returning to the *Rejection Quintet* (the five Prismacolor drawings), I felt I had finally begun to forge an iconography that could be the basis for

my next series of abstract portraits of women. I wanted the vulval image to act as a visual symbol for the physically defining characteristic of the female in an almost metaphysical sense; that is, as an entryway into an aesthetic exploration of what it has meant to be a woman experientially, historically, and philosophically. Moreover, I hoped that my choice of this form would allow me to challenge some of the prevailing definitions of the vagina as being inherently passive (which is achieved in its most ghastly form through genital mutilation). But this required figuring out how to configure the vulval form into an energetic shape, one that could symbolize female agency, something that took many years to achieve. In the final drawings, I was able to transmute this image into a myriad of evocative organic associations to suggest the possibility that the female experience could be construed to be every bit as central to the larger human condition as the male, which, historically, has been singularly identified with the universal.

To put it another way, I was looking for a way of openly working from what might be called a female form base in order to remake the world in women's own image and likeness. In the final transmutation of this form, it turned into a winged butterfly, thereby providing me with the beginnings of a dynamic feminine iconography. Only later would I learn that the butterfly was not only an ancient symbol of the Goddess but also of liberation, a fitting association for this moment in my aesthetic development.

The butterfly motif had been quite prominent in my early work, those paintings I had felt compelled not only to repudiate but actually to abandon in an effort to put aside anything suggesting the feminine. In reclaiming this form, it was almost as if I were reconnecting with my younger, more authentic self and thereby finally achieving what I had set out to do when I first went to Fresno. At this point I recognized that I would have to stop teaching and also leave the Woman's Building. I *had* to have uninterrupted studio time in order to concentrate on combining my chosen subject matter—women's history—my newly developed skills at china painting, and now this potentially rich visual language.

For much of the time I was working on these drawings, Lloyd was away, doing an artist-in-residence stint at Western Washington University

How does it feel to expose your real identity?

 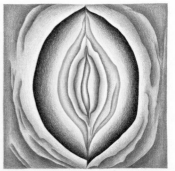

These images are what I've been dealing with all along in my work and hiding behind a formalized structure. Not only was I afraid to reveal the real subject matter of my work, but I didn't know how to draw these images before. I could only draw a vaginal form or symbolize that form. In this drawing, the cunt transmutes into a cave and then into a metamorphosing butterfly, wanting to be born and wriggle out of its old skin. For the last two weeks, I barely left my studio. I worked 12-14 hours a day on this picture.

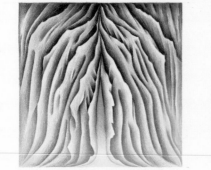 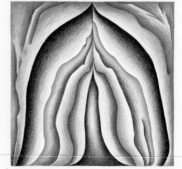

During the time I was working, I went deeper inside than I have ever been. At the end of each day, I was exhausted and shaken by the struggle to go beyond the "cunt" that I revealed in the "peeling back" drawing. In these images, I discarded my formalized structure for the first time and in so doing, broke through into a new form language, one that will allow me to make clear images of my experience as a woman. But, in breaking through, I became frightened by the prospect of my new loneliness and the difficulty of going on from here.

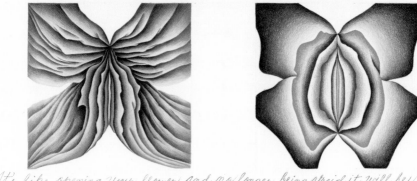

It's like opening your flower and no longer being afraid it will be rejected.

Rejection Breakthrough Drawing

Judy Chicago 1974

REJECTION BREAKTHROUGH DRAWING from the **REJECTION QUINTET** 1974

Prismacolor and graphite on paper, 40 × 30 in (101.6 × 76.2 cm)

Collection of the San Francisco Museum of Modern Art

in Bellingham, which I had arranged after my own stint there in 1973. He had been traveling quite a bit, teaching and doing site-specific installations. Although we spent a lot of time apart, I thought our relationship was in good shape. In fact, people often referred to us as an ideal couple in that we were pursuing our own careers while also seeming to maintain a viable relationship.

I had planned to join Lloyd for several weeks, intending to use the time to start the drawings for the first plates, which were to represent various ancient goddesses and historical personages. Because I wanted these to be more specific in both form and visual references than the *Great Ladies* had been, I had decided to infuse my evolving imagery with particular symbols related to the lives or mythology of each of these female figures. After many months of research and technical and aesthetic preparation, I finally felt ready to begin. Each plate was to be 14 inches in diameter and painted in successive layers, then fired multiple times in order to achieve both a density and a luminosity of color. Because this was to be a complex process, I felt that I needed detailed studies.

At the end of June, as planned, I flew up to Seattle with some clothes, lots of drawing paper, and my colored pencils. I had been looking forward to seeing my husband. But almost from the moment I arrived, Lloyd acted strangely toward me, exhibiting considerable hostility. I couldn't figure out what was going on, and he wouldn't explain. Then things seemed to settle down. We were living in a rented apartment, where I spent many hours alone drawing while Lloyd worked on finishing his outdoor installation. Toward the end of our stay, he came home one evening to announce that he had something to tell me, something that he felt horribly guilty about, adding that it was these unbearable guilt feelings that had caused him to act so angrily toward me.

With a sinking heart, I listened while Lloyd confessed that through-out the years of our relationship, including after we were married, he had engaged in a series of short affairs. Many of these interludes had been with his female students at the various schools where he had been teach-ing. Even now, I find it painful and humiliating to discuss this, primarily because his words hurt so much, especially his disclosure that a number of

these liaisons had gone on at the very time I was teaching young women. While I had been listening to their bitter complaints about how their male art professors seemed to be more interested in seducing than educating them, my own husband had been involved in such behavior. This realization horrified me because, in addition to feeling betrayed, it made me seem like a hypocrite.

Looking back, I recognize that I probably should have ended our marriage right then, because I never really recovered from this devastating experience. Regardless, after Bellingham it was never the same between Lloyd and me. I do not know why we did not seek marital counseling when we returned to L.A., or at least try to talk things out instead of just glossing things over and attempting to go on, which is what we did. Perhaps I was still frightened of confrontation, and Lloyd was too unwilling to examine the reasons for his infidelity and be honest about whatever unhappiness he felt in our relationship. Maybe I was too occupied with my work to pay sufficient attention to my marriage. All I know is that the minute we got home I went to see Anaïs, but certainly not to discuss my marital difficulties.

The drawings I had done in Bellingham emerged with so much force that I became terrified. I could hardly wait to discuss this with her, saying that while I was working on them I had felt "almost as though there was a malignant tumor growing in my womb." By then, Anaïs was visibly ill with the cancer that would kill her within three years, and as soon as these words escaped my lips I felt altogether mortified. I still cannot imagine how she was able to discuss my fantasy concerning cancer when a real malignancy was consuming her body. But the grace with which she handled my thoughtlessness and the generosity with which she put aside her own problems to offer comfort to me are additional reasons why I continue to feel such reverence for her.

Many people might find it difficult to accept that a woman can be so driven by her creative needs that she could be as oblivious as I was—and to some extent, still am. For example, one day while I was drawing in my loft, Arlene Raven came to my door. She was crying, but instead of asking what was wrong, I told her I was working and that she would have to leave. In retrospect, I feel embarrassed about my response while also understanding

that there is an implicit expectation that women will always stop what they are doing to minister to the emotional needs of others. More recently, I've altered my behavior to make room for personal emergencies, but I still set strict work hours and try to avoid all distractions. My artistic drive has always been so intense that I have simply put aside all personal concerns. Whether such behavior is right or wrong, I have no idea. I only know that this is how I have lived most of my life. Nonetheless, Anaïs believed women to be incapable of the same level of disconnection from emotional relationships and situations that male artists so often exhibit.

Anaïs also told me that the fear I had experienced was not unusual for a woman artist and that she herself had felt such distress. It was probably no accident that such terror began to engulf me at precisely this time, because I was on the brink of an extremely fertile creative period. Who knows? Perhaps Lloyd's behavior was subconsciously intended to send a message that he, too, experienced my growing expressive freedom as threatening. If so, how sad for both of us that his actions would ultimately force me to choose between my artistic growth and our marriage.

This and future conversations with Anaïs would help me to work through some of these irrational feelings. Although the anxieties I first experienced in Bellingham no longer plague me as they did then, for many years, whenever I expressed myself too freely in the studio, at my computer, or in public, I would become consumed with terror that I had suddenly become grotesque or that some great harm would immediately befall me or those I care about. This dread accompanied me almost continuously as I pushed on with my plans for the plates.

The studies I did in Bellingham became the basis for a series of china-painted plates, which fused the vulval/butterfly forms with symbolic motifs based on art-historical references. Another reason that I used this visual form language was that I wanted to suggest that—despite the fact of their different countries of origin, races, religions, sexual orientations, social class, or professions, and all that separated them—the one thing these different personages had in common was that they were born female. In fact, this was the main reason that their names and historical importance were unknown to most people.

More and more, I was considering the idea of trying to convey women's rich heritage through art as a way of sharing the incredible sense of empowerment I was deriving from my study of women's history. At first, I conceived of a series of plates that would be entitled *Twenty-Five Women Who Were Eaten Alive*, a reference to the seemingly deliberate erasure of women's achievements. Then I started thinking about doing one hundred abstract portraits of women, also on plates, with the idea that they would hang on the wall. Most of all, I was contemplating the problem of how to teach a society that believed women "had no history" (as my college professor had insisted) that this was absolutely wrong.

I began to cast about for a model by which I might reach a wide audience, at one point looking back to medieval art, which I had always admired. I found it instructive that the Church had taught Christian doctrine to an illiterate population through understandable visual symbols, and I thought to make my own iconography even clearer in order to accomplish a comparable goal. I do not remember when I visited the china painter who had spent three years executing complete place settings for sixteen. But my enduring memory is of exquisitely painted plates (including dinner, salad, and dessert), matching bowls (both soup and serving), similarly treated coffee cups and saucers, as well as a companion creamer and sugar-bowl set. These were all arranged upon her dining room table, where she kept them as a sort of permanent exhibition. While admiring the fine quality of the painting, I experienced an epiphany of sorts, realizing that plates are meant to be presented on a table rather than on the wall.

This was probably the moment when *The Dinner Party* was born, because once I decided to present my abstract portraits of women within the context of a table setting, I began to think about art-historical antecedents for such a tableau, notably the Last Supper. It seemed as though the female counterpart of this religious meal would have to be a dinner party, a title that seemed appropriate to my desire to point out the way in which women's achievements—like the endless meals they had prepared throughout history—had been "consumed" rather than acknowledged and honored. In fact, when I thought about paintings of the Last Supper, I became amused by the notion of doing a sort of reinterpretation of that

all-male event from the point of view of those who had traditionally been expected to prepare the food, then silently disappear from the picture or, in this case, the picture plane.

Before long, I became focused upon creating a series of plates that could constitute a visual narrative of Western civilization as seen through women's accomplishments. Like most folks educated in Western history, I had been taught to view this record in a linear progression, which is how I approached my chronicle of women's history. Whether this is, in fact, an appropriate or accurate way to present history is debatable. But at the time I was engaged in conceptualizing *The Dinner Party*, I chose to work within this traditional framework.

In this conventional historical narrative, native people are not introduced until "Columbus discovered America," an approach that has now been thoroughly discounted. Similarly, African Americans do not appear until the time when they were brought in slave ships to establish the foundations of a nation that repaid them with centuries of second-class citizenship even after they were "freed." The reason I bring this is up is that within this structure, I tried to be as representative as possible. Also, the limited scholarship available in the 1970s on people of color throughout history presented formidable obstacles.

Still, in a contemporary context, I can understand that *The Dinner Party* may not appear to be sufficiently inclusive, particularly for those who do not see their experiences primarily through a gender lens, as I did in the 1970s. At the same time, I was heartened by the fact that, in 2020, the Alvin Ailey school of dance was able to look beyond the limits of *The Dinner Party* and chose to celebrate International Women's Day with an all-female dance around the table, having recognized that the story of erasure it recounts is, sadly, still relevant today and continues to benefit white men.

In creating *The Dinner Party*, my intention was to challenge the male-centered view of history—traditionally presented through the accomplishments or exploits of men like Plato or Richard the Lionhearted—by focusing on female heroines who could stand for these same periods; Eleanor of Aquitaine, for example, would take the place of Richard as a

symbol for the High Middle Ages. This substitution in the context of a dinner party was intended to commemorate the unacknowledged contributions of women to Western civilization while simultaneously alluding to and protesting their oppression through the metaphor of plates set upon and thus "contained" by the table.

Then I decided that I would like the plate images to physically rise up as a metaphor for women's long struggle for liberation. As I did not then have a high level of ceramics skills, I thought I had best look for an assistant who could help me figure out how to make such dimensional plates. In the fall of 1975 I met Leonard Skuro, a graduate student in ceramics at UCLA, who agreed to work with me. While I concentrated on researching and developing the next series of images, he set up a ceramics area on the first floor of my studio, adjacent to the clean room I'd installed, which I had turned into my china-painting studio.

Leonard's task was to devise a system for producing plates that could be reliefed, then painted as richly as the early plates. They would also have to possess a visual quality comparable to those first flat plates, while being strong enough to sustain the multiple firings that would be necessary to achieve a similar density of color and luminosity of surface. This undertaking would prove far more daunting than either of us ever imagined.

I cannot recall the precise moment when I decided to place the table on a floor made of porcelain tiles, although I do know what brought me to this idea. My ongoing studies of women's history, guided by my search for the women I wished to represent, were teaching me that there were far more women deserving of honor than I could possibly depict. Moreover, I had discovered that the then-popular notion that anyone could pull themselves up by their bootstraps simply did not hold up to intellectual scrutiny.

Actually, there had to be some form of support in order for women to be able to realize their aspirations. Of course, race and class had a great deal to do with it—notably, access to education as well as the financial means to realize one's ambitions. It is also crucial to remember that, for many centuries, history was focused on the upper classes, so most of the women I found were from that segment of society. Still, even wealthy women had to find a means of emotional support, be it their family, the

convent (which often nurtured female talent, particularly in the Middle Ages), a group of like-minded friends (for instance, the Blue Stockings, an informal women's social and educational movement in eighteenth-century England), or personal companions.

Also important was that I wanted to signify that *The Dinner Party* was a *symbolic* history of women, in that there were thousands of worthy contenders for what I called the *Heritage Floor*, which would be inscribed with the names of hundreds of other women. My intention was to suggest that the accomplishments of each individual female figure on the table were best understood against the background of a much larger history. At some point, I decided to create groupings of names around the individual plates, to imply that each one exemplified a particular historical pattern. For example, I would position the *Elizabeth R* (1533–1603) plate in relation to the long history of female rulers.

Criteria for choosing the women on the table included the following: their contributions or circumstances rendered them representatives of a particular historical epoch; their lives embodied some type of significant achievement; they had to have worked toward the betterment of conditions for women; and there had to be enough information about them to provide the basis for visually cogent images. In terms of the names on the floor, at that exact moment I had not yet arrived at definite criteria for inclusion, but I was busily gathering material about dozens of women.

Obviously, such an ambitious project would require an enormous amount of funding. By this time, I had internalized the understanding that every idea carries with it the obligation to find the necessary financing. Certainly, I never thought, "I am going to need $250,000" ($1.2 million today), the approximate amount *The Dinner Party* would end up costing, or I would have been stopped before I even began. What I have always done is to figure out how to pay for a specific piece of equipment or material, and I've usually been able to accomplish this. But my ability to come up with money for my art was always tied to my willingness to pour everything I earned into my work, with no thought of my personal financial security.

Around this time I began to run into a young feminist activist and art-history graduate student named Diane Gelon (whom I always called

Gelon). She seemed to turn up at some of my lectures or openings around the country, and whenever I asked her what she was doing there, she would answer blithely that she was "a Judy Chicago groupie," a reply I did not take seriously. One day late in the fall of 1975, when she again appeared at some event, I asked her a different question: What was she doing with herself? When she responded, "Not much," I inquired as to whether she might like to volunteer for a project I had started on women's history.

Soon afterward, she came to the studio, having demonstrated considerable enthusiasm about the prospect of working with me. I showed her the card file I was assembling for the *Heritage Floor*, which at this time contained information on some three hundred women. I asked her how long she estimated it would take her to triple this amount of information. "That should take about six weeks," she announced, a statement that would

Diane Gelon (LEFT) and
Judy Chicago (RIGHT) in
the **DINNER PARTY** studio,
Santa Monica, CA
1978

prove to fall into the category of famous last words. Gelon sat down at the table, put on her glasses, and commenced work. Within short order, she was not only doing a significant amount of research but also providing me with a level of personal support I had never before enjoyed.

Even now, I do not know why she made the decision to offer this type of valuable assistance. Perhaps she realized that one of the primary reasons women artists have had such difficulty achieving at the same level of accomplishment as some of their male peers is that they have not had access to a comparable level of support. Maybe, as she told me, she just admired my work and also liked the idea of doing something to challenge the notion that women have no significant history, which was one of my primary aims.

Of course, the social and political climate might have had something to do with her decision. It was the height of the women's movement, a time when women all over the country were coming together, joining consciousness-raising groups, organizing, and generally making trouble in an effort to effect some level of change. Add to this my own rather trusting nature, and it should come as no surprise that I accepted her assistance at face value. At any rate, she changed my life, primarily by freeing me to concentrate on artmaking, especially as the project grew, resulting in innumerable administrative and organizational responsibilities.

Around this same time, it occurred to me that the tables on which the plates were to be presented should be covered with tablecloths. I had also been puzzling over how to identify each of the women to be represented, deciding that their names should be embroidered on the tablecloths. Initially, I thought to stitch identifying phrases about the woman in circles around each plate. I purchased a Bernina embroidery machine (I have no memory of how I paid for it) and began experimenting to see if I could use the different cams to achieve the dazzling array of stitches promised by the manufacturer. Then I received a letter from a woman named Susan Hill. She had been inspired by reading *Through the Flower* and was writing to inquire if I ever accepted assistants. I invited her to the studio and introduced her to Gelon, with the suggestion that she might be able to help with the research.

I am often asked how I felt about the 1975 publication of *Through the Flower*, which was put out in hardcover by Doubleday. To tell the truth, I do not remember having any reaction at all, except that I was glad to see so much of my art reproduced in the accompanying illustrations. As stated earlier, my motivation in writing it had been to work through my confusion about what was happening to me as an artist, and it had helped to get me back on track. I had always taken it for granted that I was destined to become famous, and the attention the book received seemed like just one more step toward that goal. In short, I did not pay all that much attention to its publication, although I did appreciate the fact that the book produced an expanded audience for my art and numerous offers of assistance, Susan's being the first.

It turned out that research was not Susan's forte. Many years later, she told me that it was because she was so determined to work with me that she somewhat jokingly suggested that she could "always cook or sew." I have no idea if she even knew that I was then thinking about incorporating embroidery, but I immediately responded by inquiring whether she might have needlework skills. She confessed that even though hers weren't all that good, many of the women in her family had been extremely skilled. This instantly made her seem far more qualified than me, who can barely sew a button on a shirt, which prompted me to appoint her "head of needlework." I set her up with the Bernina embroidery machine, and she soon enrolled in an embroidery class in order to expand her skills. Then she invited me to an exhibition of some of the other students' work, and off we went to something called (as I remember it) the Episcopalian Embroidery Guild.

I can still remember entering the dim, slightly claustrophobic exhibition hall filled with displays of vestments and church furnishings. Although I had no idea what most of these ecclesiastical objects were used for, I could see that the embroidery embellishing them was superb. Many of the needlewomen were proudly standing nearby or demonstrating the techniques by which they had rendered these objects so exquisite, seemingly oblivious to the fact that their talents were being lavished upon a religious system that was essentially oppressive to women. Even more unsettling was the

fact that the needleworkers received no credit for their work; they were not even allowed to stitch their names on the pieces they had spent months and sometimes years creating. As I commented to Susan, it was almost as if we were seeing women's overall historical and social circumstances being displayed right along with their splendid array of needle skills.

Sometime after visiting this exhibition—which prompted me to start researching the history of needlework—Susan informed me that it would be impossible to embroider the names directly onto the tablecloth in the manner I had envisioned, as it would have involved the manipulation of a long piece of fabric through the sewing machine. Instead, she suggested placing individual cloths or runners under each plate and on top of the tablecloth. I thought about the elaborately embellished altar cloths we had seen at the ecclesiastical embroidery show and realized that adopting this approach would solve some of the logistical problems. But even more, I recognized that this might actually open up whole new expressive avenues.

Runners connoting altar cloths might lend a sacramental quality to the table, which I found appealing in that I might thereby be able to suggest the table as a dual metaphor, encompassing both the domestic and the sacred spheres. Also, the runners could be designed to drop over the front and back of the table, allowing the women's names to be embroidered on the front while leaving an area that could be stitched in order to provide a visual context for the plate. This seemed like a good idea for several reasons. I was already worrying about what to do with the large expanse of white that would be established by the tablecloths; embroidering the runners might provide an aesthetically satisfying break. Then it dawned on me that if the plate was each woman's symbolic portrait, the runner could provide a space that could be used to convey something about each person's life and historical circumstance.

I started out by taking those plates that I'd already completed and placing them on the white-hemmed cloths that Susan had prepared, just extending the plate imagery onto the cloth. At first my ideas were fairly simple, but even so, it became apparent that we would need a team of skilled stitchers to produce these designs. This seemed to present no problem, as

we quickly found many interested volunteers. In fact, throughout the course of work on *The Dinner Party*, people seemed to come forward at precisely the moment they were needed.

Before long, numerous stitchers were vying with one another to see who could best achieve the types of color blends that typify my work and characterize the designs I had painted somewhat crudely on the cloths to create what we described as mockups. As these became transformed into brilliantly hued and subtly stitched fades, I discovered that, despite my ineptitude with a needle, I seemed to have an unaccountable talent for designing for the needle arts. I also learned that thread could be thought of almost as a brushstroke. And I wanted to know more about ecclesiastical embroidery, whose opulent quality appealed to me.

At one point I had the opportunity to try on an elaborately stitched bishop's glove. As I drew the jeweled and gold-encrusted object onto my hand, I could literally *feel* the hours of human labor that had gone into creating it, which seemed to be one reason that ecclesiastical objects appeared to bestow so much importance upon their wearer. It suddenly occurred to me that it might be fascinating to take the same needle techniques that had been lavished upon such vestments and bring them to bear on the honoring of women and our own history.

I soon decided that, in addition to raiding art history for the plate imagery, I would also turn around needle techniques on behalf of women by incorporating the needlework style of each woman's time for the runner designs. My aim was to imply that history should be seen as belonging just as much to women as to men, while also paying homage to needlework, which, like china painting, was—by this time—primarily a female craft. In addition, I very much liked the idea of telling "herstory" through techniques that were considered "womanly."

My studio was becoming quite crowded, and my assistants—Leonard, Gelon, and Susan—each had his or her own helper. People kept popping up, apparently drawn by my passion for communicating women's history through art. The only real problem was that the plates were going at an agonizingly slow pace. Somehow, we couldn't seem to get any of the reliefed plates (which required endless hours of carving) out of the kiln. Toward the

end of the summer of 1976, Leonard began to bring a friend, Ken Gilliam, to the studio. Kenny was an industrial designer and technically clever, so Leonard thought he might be able to help solve the plate problems. He was also incredibly attractive.

Throughout much of 1976, Lloyd was away, teaching and doing sculptural installations elsewhere. Certainly, my side of our shared space was becoming considerably different from the quiet tandem studios we had originally set up. As I think about this period, I am astounded that Lloyd and I never discussed this rather dramatic change. But he acted supportive of what was happening, and since I was so engrossed in *The Dinner Party*, I let it go at that.

As Kenny had a full-time job, he came to the studio at night, where we were frequently alone. From the start there was a strong attraction between us, and before long Ken had begun to actively court me. In retrospect, I guess it was probably inevitable that something like this would happen. Lloyd's confession in Bellingham about his infidelities had dealt a severe blow to our relationship. He was away so much, and even when he was around, there seemed to be a growing distance between us.

Then there was the fact that Kenny had a capacity for intimacy that I had never before experienced with a man, possibly a consequence of his being of a younger generation (there were almost twelve years between us). I found myself responding to it with an eagerness that suggested I was terribly parched for such a connection. *The Dinner Party* was also the toughest work I had ever undertaken, and perhaps I needed a romance in order to take the edge off what was an increasingly long and arduous task. But I do not wish to qualify my relationship with Kenny in any way, because during the period it went on (well into 1978) I would find most of our time together quite wonderful.

Moreover, Kenny made a rather substantial contribution to the project. The involvement of an industrial designer provided the opportunity to develop specific systems to meet various needs, such as the special runner frames he devised that allowed the needleworkers to see the overall designs stretched out like paintings, rather than rolled up on small frames and worked in their laps. This helped to bring the rigor of a fine-art approach to what

can sometimes be the rather wonky craft of embroidery. Even though much would be made of my homage to such crafts, it was the intersection of what have been called "male" and "female" techniques that would contribute to *The Dinner Party*'s originality and also serves to prove my earlier point that the often arbitrary gendering of specific art or craft methods generally serves only to hobble the imagination.

In November 1976, I told Lloyd about my relationship with Kenny, to which he responded by saying that he already knew about it. Given his own behavior, I imagine he didn't feel he had any right to become irate. Nonetheless, there were scenes and arguments, culminating in our decision to separate, though we agreed that we would view this as temporary and leave the door open for a reconciliation. As it turned out, it was not all that easy to make the break. We had known each other for a long time, and even though our marriage was clearly not all that satisfying, at least to me, ending it was like ripping up the fabric of much of my adult life. By New Year's Day, however, Lloyd had moved out, and Kenny had moved in; shortly thereafter, *The Dinner Party* expanded to fill the entire 5,000-square-foot space.

My mother was very upset about our breakup, so much so that she did something that enraged me. Without asking me anything about the circumstances of our separation, she invited Lloyd over to find out what had happened. Exactly what transpired during their conversation is unknown to me, though I made it clear that I felt betrayed by her having done this. My relationship with my mom had somewhat improved, though just under the surface lurked the same unresolved issues. Nevertheless, I tried to make a practice of seeing her regularly, sometimes flying her to one of my openings, which she loved.

Around this time, my mother retired from her full-time job, and she started coming to the studio two afternoons a week to type research cards for the steadily expanding file of names for the *Heritage Floor*. Even her sister, my Aunt Do (with whom I had lived when I first went to California), became involved in *The Dinner Party*, bringing both her embroidery skills and an extremely shy temperament to the needlework loft (formerly my drawing studio). There, she had an experience that she said changed her

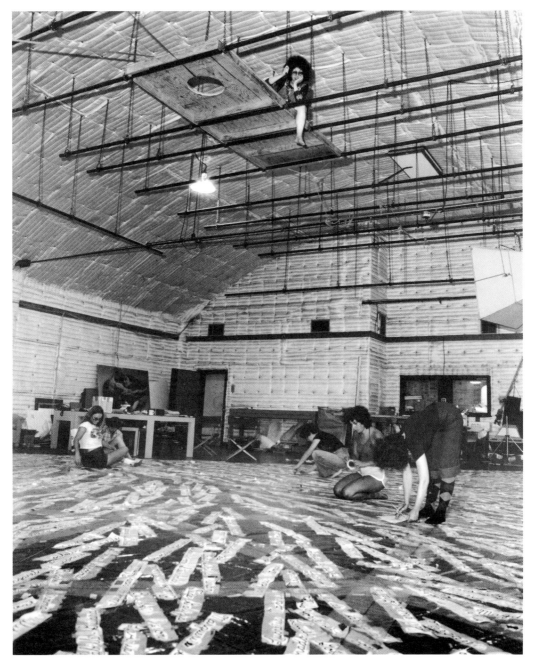

Laying out the names for the **HERITAGE FLOOR** from **THE DINNER PARTY** 1979

life, because she felt appreciated by the other studio members in a way that had never happened to her before. This same life-changing experience was reported by many other volunteers, some of whom were even relocating from other parts of the country in order to work at 1651B Eighteenth Street, the studio's address.

As more and more people came to work on the project, they often went through the same experience I had in the early days of my research: first, an incredible sense of wonder that women had such a rich history, followed by rage that it was still so unknown. Perhaps it was the almost indescribable excitement of participating in uncovering this heritage that caused them to find the studio so compelling. Or maybe it was the chance to help translate this information into art. Whatever the reason, the energy that developed there would sustain me even when I was so tired that I could barely force myself to take up my paintbrush or my carving tools. I have sometimes described this period as a process of discovery for all of us (the research was ongoing and ever expanding) almost akin to the opening of King—or, one could say, Queen—Tut's tomb. I was beginning to realize that there was too much material for one work of art to convey, even one as large as *The Dinner Party* was to become.

In 1977, *Through the Flower* had been released in paperback by Anchor Books, which was run by Loretta Barrett. At the time of its issuance, she informed me that she was interested in a long-term relationship with her authors. She came to visit the studio, and when she saw what I was working on, she urged me to think about doing a companion book in order to deal with all the emerging historical information, some of which seemed more suitable to a literary than a visual presentation.

Loretta also commented on the unusual nature of the studio environment, which she insisted was unlike anything else anywhere in the country. To me, it felt entirely natural; in fact, it was a lot like the boisterous family environment of my childhood, which I had lost so abruptly and had probably always continued to crave. By early 1977, there were anywhere from twenty to thirty people working in the studio at any given time, generally in teams focused on particular tasks. Each team had a leader, selected on the basis of talent, commitment, and the ability to take responsibility.

Most of the workers were women, but there were usually a few men, not just Leonard and Kenny but others who worked in research and even needlework. By this time, Johanna Demetrakas, who had made the *Womanhouse* film, had decided that what I was doing should be documented. She had assembled a crew—which included several men—and was filming on a regular basis, particularly on Thursday nights, when we had group potlucks.

Early on, Gelon and I had instituted these weekly sessions, primarily so that any problems could be openly aired and resolved. Our discussions were an important part of the studio process, which was set up according to the same principles by which I had run my Feminist Art programs, with one fundamental difference: I was not a teacher, but an artist. Rather than a consequence of my acting as teacher, the education that took place was primarily the result of everyone's working on an artmaking project that brought them into a sense of being in the service of a larger vision, something that has motivated me throughout most of my life.

It was this mutual commitment to the higher purpose of conveying the crucial importance of women's history that probably most shaped the studio environment. This shared perspective allowed us to leapfrog over our individual egos in order to support whatever idea would seem to most benefit the project, no matter who suggested it. I am often asked whether the process of creating *The Dinner Party* was even more important than the final work of art, and my answer has always been no. It is not that I considered this process unimportant. On the contrary, I tried to structure the studio so that the people involved could become empowered. But this growth happened through work, and it was around work that the studio was organized. Except for Thursday nights, people were discouraged from engaging in personal conversations or emotional exchanges, because these distracted from focusing on the tasks at hand. The studio was set up this way because I believe that the empowerment process—facilitated by both the studio environment and the nature of the project itself—had to be translated into a concrete result, which in this instance was *The Dinner Party*.

If people had difficulty working, we made an effort to help them, but if what they wanted was the opportunity for endless dialogue or seemingly fruitless arguments, Gelon would politely ask them to leave. Sometimes, the

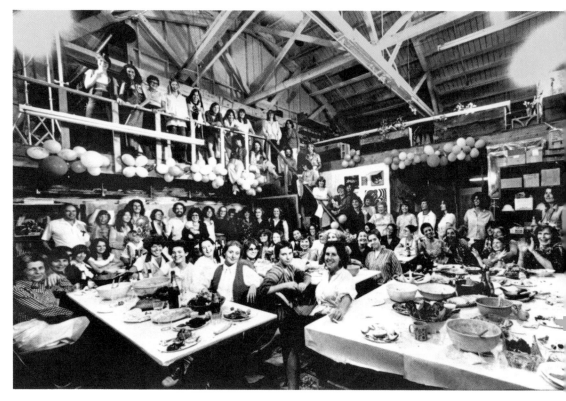

THE DINNER PARTY participants celebrating my 39th birthday in the studio, Santa Monica, CA 1978

person would denounce the studio structure as hierarchical and authoritarian, usually during the Thursday-night sessions that Johanna and her crew so liked to film. She seemed to intuit when there was going to be an intense session (and some of them got pretty hairy) and would often arrive unannounced. After a while, everyone seemed to become accustomed to being filmed, though I have no way of knowing whether the film crew's presence acted as a stimulus for the expression of anger or frustration.

It is true that the studio was a hierarchy, but not in the way this accusation implied. From the beginning, people worked within the framework of my concept. Moreover, they relied on my aesthetic guidance. Within the parameters of my vision, there was plenty of room for active participation and some degree of collaboration. But the authorship of the concept and

the images, along with final visual approval of the work, were always mine. Some confusion about this was probably inevitable, given the fact that this was the 1970s, when many women's collectives were operating. From the beginning, however, *The Dinner Party* was my piece, though it embodied information that belongs to everyone and seemed particularly meaningful to women. Working on it cooperatively would forge bonds among the participants that connect us even now.

The intensity of the studio environment and the demands of the work were such that I would spend most of 1977 and 1978 within the white walls of my space, except for running, which became increasingly important to me. Leonard and Kenny were both distance runners, and the miles they covered seemed staggering to me. But as the project continued, I found myself craving the glow of the afternoon light and the adrenaline rush that results from pushing one's body over long runs. The first time I ran six miles—three in the morning and another three in the late afternoon—I was ecstatic.

I rarely ran with the guys, as they were too fast for me. Instead, I would run with some of the women from the studio. We would pace and push each other along a path that parallels the beach in Santa Monica, enjoying the shared rhythm of our matched steps. But as my work hours began to increasingly stretch through the day and late into the night, my running became more solitary. This provided some sense of escape from the pressures of the project and my ever-more-crowded studio space. Even more important, the running path gave me a place to deal with my ongoing fear of my own power.

Each time I descended from the slope of the park onto the beach, I would experience a sense of freedom that was both exhilarating and addictive. Reveling in the pleasure that can come from challenging one's body, I soon began to do longer and longer runs. Inevitably, at a certain point, often just as I reached full stride, I would clutch up with terror as the sense of running freely and strongly somehow triggered the anxiety that there was something wrong with a woman being so vigorous. It was on the running path that I began to accustom myself to these still-frightening feelings, a process that took many months.

Slowly, I was able to translate what I was accomplishing on the running path into my studio life, a process that allowed me to reach an increasing level of aesthetic freedom. Subsequent generations of women have reportedly found their own paths from the strengthening of their bodies through exercise to greater confidence and empowerment. The studio environment aided this transformation greatly, because within it I felt accurately perceived and completely supported.

Most of the studio members had a similar experience. We were all able to transcend our creative limits, one result of which was that we were able to successfully complete *The Dinner Party*. Additionally, some of us became attached to one another and the work in a way that is inexplicable to anyone who wasn't there. In terms of the piece itself, I eventually decided on thirty-nine plates, to be presented in place settings that would include not only an embellished runner but a ceramic chalice and flatware, along with a napkin edged with gold. A corresponding gold edging embellished the tablecloth as a way of extending the sacramental associations of the table settings.

The thirty-nine place settings were configured on an open, triangular table resting on the *Heritage Floor*. Nine hundred and ninety-nine names were selected from a larger assemblage of nearly three thousand, culled by a team of twenty researchers under the leadership of Gelon and an artist named Anne Isolde. These names, chosen according to the previously described criteria, were hand-inscribed in gold china paint onto the 2,300 porcelain tiles that comprised the triangular floor, then lustered to create a luminous foundation for the table. (For more information about *The Dinner Party*, I must refer readers to the many art books in which it is now featured, including my own, and also to Johanna Demetrakas's film, *Right Out of History: The Making of Judy Chicago's "Dinner Party,"* or else I will never be able to finish the story of the ensuing years.)

The Dinner Party was scheduled for exhibition at the San Francisco Museum of Modern Art thanks to Henry Hopkins, the museum director, who had followed my work for many years. About midway through the project, he had come to the studio and offered to premiere and tour the work if I finished it (which he apparently considered a dubious prospect,

given how much financial and volunteer support I would have to muster). He offered to set up a fund at the museum so that we could accept donations to cover the costs of materials, which were becoming ever-more expensive as the concept of the piece expanded. By this time, Gelon had taken over much of the fundraising, supplementing what I brought in from lectures, sales, and book royalties with private contributions and a few grants. But we were always on the verge of running out of money, and the project account that Henry set up was extremely helpful, as it allowed people to make tax-deductible donations. Sometime in 1978, Henry came to Gelon and me to say that the museum comptroller was tearing out his hair.

Instead of receiving the large contributions to which they were accustomed, they were getting a seemingly endless stream of small checks from the various grassroots efforts that had sprung up around the country in support of *The Dinner Party*. Much of this activity was a result of Gelon's constant lectures about the piece, which were building considerable interest. "What should we do?" Gelon and I asked rather plaintively, to which Henry responded by advising us to start our own nonprofit organization.

I didn't even know what a "nonprofit" was, nor was I at all patient during the many hours Gelon and I spent with a newly established lawyer named Susan Grode, who offered to charter such a structure for us. She explained that the educational mission of *The Dinner Party*, along with its participatory nature, qualified us for 501(c)(3) status, which would allow the ongoing tax-deductible contributions upon which we were increasingly dependent. Needless to say, at that point I would have done anything in order to complete the piece, even sit in a lawyer's office or take out a loan, which Gelon and I were forced to do in 1978, the last year of the project. As we had no collateral, this was only made possible through the generosity of the collector and patron Joan Palevsky, who basically co-signed for us at the bank.

We decided to call the corporation Through the Flower, after the title of my 1973 landmark painting as well as my first book. A number of the studio people and I had begun discussing the idea that if *The Dinner Party* proved successful, we might be able to build an ongoing organization that could support other projects whose values and aims were consistent with

both the piece and the principles of Feminist Art. The existence of the corporation also suggested a way of accomplishing what I began to think about once the concept of *The Dinner Party* was finalized and we were in the last stages of production on the piece: its future.

By that time, there were dozens of people working day and night in the studio, and there was a steady stream of visitors, including such august personages as Joan Mondale, the wife of then–Vice President Walter Mondale. She toured the studio, guarded by a phalanx of Secret Service men, and particularly liked the plates, probably because she herself was a ceramicist. I thought that if *The Dinner Party* proved to be the kind of success the growing enthusiasm for it suggested, I might have many opportunities to realize what had become my dream: the creation of a porcelain room whose imagery extended that of the plates into an environmental installation of monumental proportions.

As a way of earning money, I had continued to deliver lectures about my work around the country and I knew, therefore, that there was an over-riding hunger among women for images that affirmed our experiences. If this audience was greatly moved by *The Dinner Party*, perhaps there would be support for both our ongoing institution and the permanent housing for which I began to plan. So convinced was I of the possibility that this dream might come true that I decided to set up a ceramics studio in Northern California to begin tests on such a room as soon as possible after the exhibition opened, a date that had been postponed several times and was finally set for March 1979.

Sometime in late 1978, I was sitting in one of those charming espresso shops that can be found in so many San Francisco neighborhoods. I was there to supervise the production of a series of woven banners I had designed to grace the entryway to *The Dinner Party*. Looking around at the clear blue sky and lovely pots full of bright flowers that adorned the sweet Victorian houses in the Nob Hill neighborhood, I suddenly thought I'd like to relocate to the Bay Area.

My rather impulsive decision was probably motivated by a number of factors. I had been confined inside my studio space for an awfully long time and found myself craving a natural environment, such as the verdant

atmosphere of Northern California. My relationship with Kenny was over, and I felt that L.A. was filled with too many memories; I wanted a fresh start. I had seen a small town that appealed to me: Benicia, located on the Carquinez Strait, on the outskirts of the Bay Area, north of San Francisco, where a number of artists lived. I found a small studio space there and began to make plans with Judye Keyes, one of the women who had come to assist Leonard with ceramics, then ended up heading the ceramics team of seven or eight people after Leonard left the project. She expressed great interest in working with me on plans for my envisioned porcelain room.

Although I imagined working and even living in Benicia, I intended to help set up Through the Flower in the Santa Monica studio as a self-sufficient entity that could support ongoing projects and also provide fiscal and administrative support for the effort to permanently house *The Dinner Party*. In no way did I perceive my planned move to the Bay Area as an abandonment of either the studio or what was a potentially permanent staff, to be made up of the most dedicated *Dinner Party* workers.

But all these hopes had to be put on hold while we struggled to finish what seemed to be unending last-minute exhibition details. Early in 1979, a number of the studio members went to San Francisco to start installing the piece, as we had absolutely no idea how long it would take. I stayed in Los Angeles in order to complete the hand-coloring of the large photo-murals that explicated the names of the women on the *Heritage Floor*. Everyone on the installation team insisted upon this, probably to keep an extremely nervous artist out of their hair. But by the end of February, I was commuting to the Bay Area and Henry was smoking too much while pacing the floor of the large rotunda of the museum, where the piece was being installed.

None of us had ever seen *The Dinner Party* entirely assembled, and therefore we had no idea if all the systems would work. As March 14, 1979, the date of the opening, drew near, both our anxiety and our excitement mounted. For many of the studio members, this would be their first exposure to the hubbub attendant on a major museum opening. Despite the fact that by then we were no longer lovers, Kenny and I did the lighting together in a mood almost reminiscent of our earlier days, becoming absolutely elated as we discovered that the lights he'd selected provided a wonderful surprise.

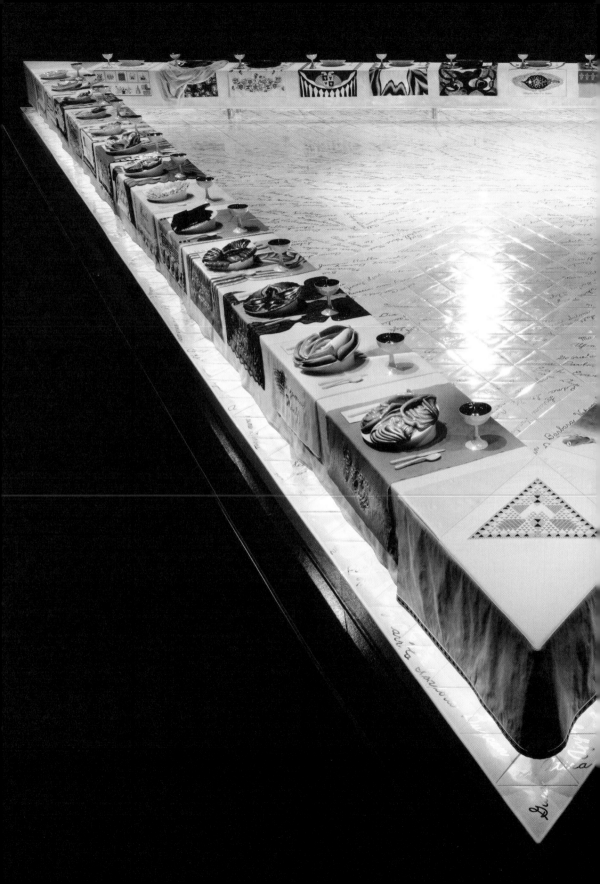

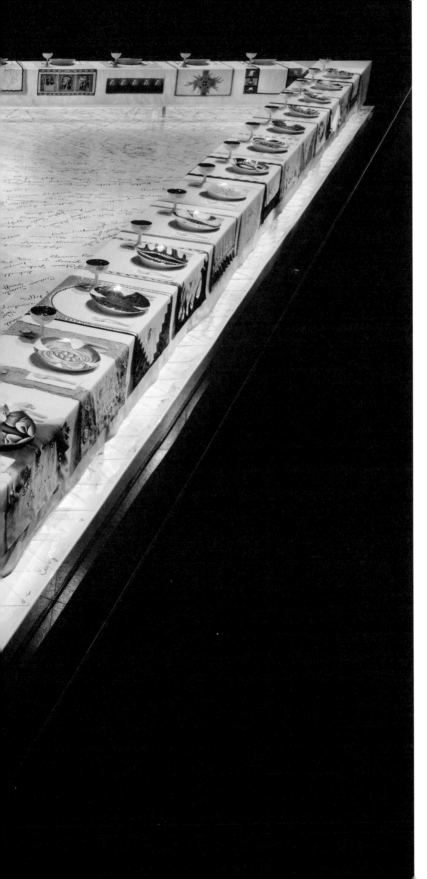

THE DINNER PARTY 1979

Mixed media installation

Collection of Brooklyn Museum,
Gift of the Elizabeth A. Sackler
Foundation

The framing projectors that spotlighted each place setting spilled light onto the porcelain tiles, which bounced it onto the runner backs, dappling them with reflections from the rainbow luster that covered the surface of the floor. The magical effect this created was entirely unanticipated, but it added immeasurably to the spiritual aura of the piece.

It was the physical presence of *The Dinner Party* that was most overwhelming. It seemed to float in the rotunda of the museum, almost entirely filling the huge room, the diameter of which was well over sixty feet. As I stood alone in the space with this work that I had struggled so long to create, I was flooded with emotion and, at the same time, an enormous sense of relief. I had carried its image in my mind for so many years, and to finally see its tangible realization was difficult to take in. By the time the studio members greeted each other on opening night, all decked out in fancy party clothes, the long years of effort had begun to take on an air of almost total unreality.

CONTROVERSY?
WHAT CONTROVERSY?

The Dinner Party premiered at the San Francisco Museum of Modern Art on March 14, 1979. The evening, one of the most glorious in my life, was marred only by Henry Hopkins's absence. He was ill with a virus so severe that he was forced to miss one of his own openings for the first and only time in his long and illustrious career. Cousins Howard and Arleen flew in from Chicago, having rented a plush suite where the three of us had a private, pre-opening party, complete with champagne. Peter Schauseil, my hairdresser, paid his own way from Los Angeles, joining us for a drink and to do my hair. For years, Peter had visited the studio on a regular basis to provide haircuts at a discount. That night, we giggled as he placed flowers in my hair, for we could not help but think about the contrast between this glamorous evening and the many times he'd done shampoos in the grungy fiberglass sink that had been used for ceramics debris.

Five thousand people turned out for the opening, patiently waiting in line to view the piece. All night long, press photographers' cameras flashed, television crews filmed, and I was presented with gifts, covered with flowers, and congratulated on my "stunning accomplishment." There was so much media coverage in the Bay Area that the museum's publicist commented that one would have had to be living in a cave not to have heard of *The Dinner Party*. All the local papers carried feature articles, there was a glowing piece in *Mother Jones*, and *Life* magazine sent a photographer to do a two-page color spread showing *The Dinner Party* from above.

Actually, that led to a really amusing situation. The piece was installed in the rotunda of the old museum, where there was an elevated catwalk in the ceiling that the photographer had to reach in order to take the photograph. Because he was significantly overweight, the museum's press officer

insisted that *Life* magazine indemnify him so that if he fell off the catwalk onto the *Heritage Floor* (which would definitely have sustained significant damage), *Life* would be responsible. In preparation for the photo shoot, the photographer requested that I sit in the center of the porcelain floor. Feisty woman that I was, I refused, saying, "Would you ask Rembrandt to sit on one of his paintings?" Having never told this story before, I must admit to some degree of chagrin at my audacity.

As part of the opening celebrations, performance artist Suzanne Lacy (my former student from Fresno) organized the "International Dinner Party." People all over the world—including my brother, Ben, and his new Japanese wife, Reiko, in Kyoto—held dinner parties in their communities. Everyone sent congratulatory telegrams, which Suzanne posted on a giant map of the world that was mounted in one of the museum corridors.

During the three months it was on view, one hundred thousand people came to see *The Dinner Party*, and the museum bookstore brought in substantial revenues from sales of *Through the Flower* and the first of two books about *The Dinner Party*, along with other related items. In fact, the store made so much money that they were able to purchase a new, computerized cash register that the staff affectionately named "Judy." There were events, classes, tours, and parodies. For the next few weeks, everywhere I went around the city, I was recognized, greeted warmly, told that seeing *The Dinner Party* had changed the person's life, or thanked for having created the work.

Sometime after the opening, I was interviewed by Susan Stamberg for National Public Radio's *All Things Considered*. I excitedly described the opening, the enthusiastic crowds, and the thrill of seeing the overwhelming reactions to *The Dinner Party*. I concluded my remarks by stating that I believed this to be an indication that women could now openly express themselves and their own perspectives. I was shocked when Susan asked, "But Judy, what will you do when the controversy starts?" Without missing a beat, I replied, "Controversy? *What* controversy?" I honestly did not know what she was talking about, probably because I was so caught up in the fervor that surrounded the exhibition.

The opening took place on a weeknight, and there were public events throughout the ensuing weekend. It was like a dream come true: a

mainstream museum playing host to a major work of Feminist Art while also providing a framework for women of all persuasions to come together to demonstrate the larger intellectual and aesthetic context from which this work emerged. The only negative note was sounded during the question-and-answer period after a lecture I gave. I was stunned when a couple of women in the audience made comments implying that the people with whom I had worked on *The Dinner Party* had been exploited.

As there were a number of studio members present, they immediately jumped up to counter these charges, stating that their experiences had been altogether empowering and growth-producing. None of us took this accusation seriously. We assumed that the testimony of those who had actually worked on *The Dinner Party* would carry more weight than the attitudes of people who had not been there. None of us could have imagined how distorted some of the perceptions would be of the studio environment, the art, and me. It became clear that I had absolutely no idea how unusual the studio environment actually was.

One of the unique aspects of the *Dinner Party* studio was that it provided continuous reinforcement for a feminist perspective and feminist values. I defined these as being supportive of honesty and the open expression of one's vulnerability. Outside this environment, not only were these traits often eschewed, but women and women's concerns were almost always marginalized, which is possibly why so many of the studio members used to comment, upon going home at night, that they were returning to their "real" lives. For me, the studio *was* my real life in that it reflected my values and aspirations. Moreover, there was an incredible sense of freedom and hope—a result of experiencing the thrill of having the power to shape our own history and to define both the nature of art and what constitutes aesthetic quality. Within the walls of the studio environment, a feminist point of view was not only possible but seemed entirely natural.

When the accusation about exploitation first came up, I should have confronted it head-on, but I didn't, not then and not later, when it was reiterated both in print and in public forums. I always felt so hurt by this unjust charge that I could not muster a response. I now recognize that those who issued this accusation were ignorant about the egalitarian nature of the

studio. Moreover, most *Dinner Party* participants were enriched by their experience, not only by the artmaking but by my treating them and their ideas with a level of respect that most of them had never enjoyed before.

As Diane Gelon, the studio administrator (who still works with me as the president of the board of Through the Flower), reflected in a recent conversation:

> Judy inspired good people with skills to work "with" her and not "for" her, to be guided by her and to learn from her as an example of what it takes to be an artist. *The Dinner Party* was a project that no single person could have done on their own. We worked not just to support her but for the vision she had; we were making history and we knew it. We all got something out of the experience of working in a team, working on this large-scale artwork that we all hoped would change history and that was empowering for all of us.

Some people, especially those unfamiliar with the art world, might have misinterpreted the fact that, despite my efforts to acknowledge everyone who had worked on the piece—in both credit panels in the exhibition and in the *Dinner Party* books—most of the attention was on me. But this is not unusual in the world of art, where everyone focuses on the so-called star. And even though a few studio members might have felt resentful, I believe that most understood that ultimately *The Dinner Party* was my conception and were glad that my long and arduous years of work were being recognized.

The people who came up with this notion of exploitation must not have had any idea of how unusual it is for an artist to give *any* credit to collaborators, artisans, or assistants. Although a good deal of art is not created solely by an individual artist, it is not customary to acknowledge those who, for example, do the bronze casting for a Picasso or Henry Moore sculpture. Nor does one generally see panels in museums listing the team of printers who produced a suite of Rauschenberg lithographs (which are typically a more collaborative effort).

It is true that these people are usually paid in wages, but in the case of most artists' assistants, the sums tend to be small. Even so, there was no way I could have paid everyone who worked with me. Furthermore,

who is to say that money is the only adequate payment for such work? In a capitalist society, that is what is stressed. But there are rewards other than money. In addition to the thrill of working on a piece that was aimed at changing history, I provided something that women in particular have had little access to: the opportunity to participate in work of both personal and historic meaning, as well as the chance to learn from another woman artist in an environment that was conducive to their growth.

Considering the fact that no *Dinner Party* worker has ever told me that he or she felt exploited, why should anyone feel compelled to come to their defense? In addition to being unfair, this accusation is insulting. By suggesting that the people who worked with me were exploited, the speaker implies that they were so stupid as to be unable to recognize their own ill-treatment. The truth is that some people traveled many miles, gave up paying jobs, and chose to make considerable sacrifices in order to work in the studio, sometimes for years.

As to *The Dinner Party*, there were probably warning signs of what was in store for it, but I paid them no heed. I remember being flabbergasted when Manuel Neri, one of my artist friends, told me about an argument he had had with another male artist, who insisted that *The Dinner Party* was "politics rather than art." We laughingly agreed that, had I wished to "do politics," I would have been better off running for office. Considering the number of years I had spent drawing, painting, sculpting, and designing, I could hardly believe that anyone would attempt to argue that *The Dinner Party* was not art. To me, the long lines and enthusiastic crowds seemed to attest to what I had communicated to Susan Stamberg on NPR: "Women's time had finally come."

Why wouldn't this be my assumption? My many public appearances that spring—book signings, lectures, and interviews—were received enthusiastically. And then there was the crucial fact that my upbringing had taught me to treat people equally, regardless of their supposed position in the world. As a result, I did not take into account any differences between "important" and "unimportant" people. It never crossed my mind that because many of the museum visitors were women or from outside the art community, their opinions might not mean much to the art world.

As I have already mentioned my casual attitude toward art reviews (which, throughout my career, have more often than not been negative), it will come as no surprise that I paid little attention to a nasty article by Suzanne Muchnic, the art critic for the *Los Angeles Times*, which appeared some weeks after the opening. Hers seemed like a small and unimportant voice, especially as it was vociferously protested by numerous irate readers who had seen and loved the work. From my perspective, the atmosphere surrounding *The Dinner Party* seemed so encouraging that I had every reason to believe that my plans for its permanent housing could be realized.

In June, Judye Keyes and Juliet Myers, another *Dinner Party* worker, drove a rental truck from Santa Monica and joined me in Benicia. As I went to help Keyes and Julie unload the van, I noticed a couple standing by the truck holding a bouquet of homegrown flowers. Although I had never met them before, I knew this must be the well-known sculptor Bob Arneson and his artist wife, Sandy Shannonhouse, who lived in Benicia, as did Manuel Neri, which is how I had happened to discover this out-of-the-way place. At that time there were only sixteen thousand residents living there, the foliage was lush, and the town's rolling hills were still bare of development. The cordial welcome of Sandy and Bob seemed to augur well for my change in domicile. I had settled in a small apartment and, for the first time in my life, had a separate studio. It was about a mile from my apartment, in a sprawling industrial complex of funky buildings filled with assorted artists and artisans. Although both my living and work quarters were humble, I viewed them as a first step toward establishing something more substantial.

About this same time, I ran into Paula Harper, who had returned to Stanford after her tenure as art historian for the Feminist Art Program at CalArts. She reported that she had been hearing many negative comments about *The Dinner Party* from her art-world colleagues. But my own experience at this point was so affirming that I found it almost impossible to believe there was such an undercurrent of negativity in the art community. I can still hear her saying sympathetically, "Well, Judy, my dear, the prejudice [against women] in the art world is obviously much deeper than we had ever imagined."

Given the passionate reaction of the general audience, one might ask why I cared so much about the art community. The answer is that it is within this sphere that art is ultimately validated. In order to accomplish *The Dinner Party*, it had been necessary to build an alternative support structure, a mixture of people with an array of skills. Only some of them were trained artists, and they were generally early in their development, which was one reason they wanted to work with me. But I was a professional artist, which meant that I had to earn acceptance and recognition within the art world.

With hindsight, I can see that, once again, I must have been unrealistic in my expectations. I firmly believed that the size and ardor of the audience—along with the financial benefit from admissions and sales—would convince museums to show the piece, thinking that the planned museum tour would soon include more than the two other venues Henry had secured. And yet, even though I believed the overwhelming viewer response to be an indication of the power and allure of the work, I did not assume that its financial success could be considered an indicator of its aesthetic achievement.

I fully understood that the determining factor in the evaluation of art has traditionally been its importance *as art*; one can earn seven figures and not be thought of as a serious artist, or be impoverished but considered significant. Art is, at best, about ideas and values, and art objects both reveal and help to shape our concept of what is important and—more significant—what becomes part of the established art canon. However, this canon historically has enshrined only the ideas and values of the small group of people who hold power in our society. One of the reasons for the ongoing intense battle over expanding entrenched views about artistic worth is that there is immense financial and intellectual capital invested in the maintenance of these values.

Historically, women have either been excluded from the process of creating the definitions of what is considered art or allowed to participate only if we work within existing mainstream designations. If women have no real role *as women* in the process of defining or evaluating art, then we are essentially prevented from helping to shape the cultural symbols. This was

exemplified by the fact that, when I was in college, the primary art-history text included only one female artist.

In part, *The Dinner Party* was intended to test whether a woman artist, working in monumental scale and with a level of ambition usually reserved for men, could count on the art system to accept art with female content. The response of visitors to the studio, the support of Henry Hopkins and the San Francisco Museum of Modern Art, and the unbelievable audience reaction suggested that I had every reason to be hopeful, despite some negative press and what seemed to be only a few disgruntled art historians and art critics. After all, one could hardly hope for unanimous accord.

However, a very pressing reason to have been more concerned about some of the hostile art-world attitudes was that they would greatly affect the exhibition tour. First and inexplicably, the two other institutions scheduled to exhibit the piece canceled. When I spoke to Henry, he said, with distress in his voice, that he just couldn't understand it. If there weren't some museum people eager to show *The Dinner Party*, then his profession wasn't "worth shit." But despite the huge audience, the ongoing press interest, and the profit shown by the museum, no other venues appeared. On June 17, *The Dinner Party* closed, was dismantled, packed in crates, and placed in storage. I was in a state of shock, and the staff in Santa Monica were not much better.

The remaining loyal members of the *Dinner Party* core group slowly began packing up and closing down the once-humming studio. It seemed obvious that without an exhibition tour, our hopeful plans for ongoing art projects were ludicrous. My nonprofit corporation, Through the Flower, was completely broke, as was I. Having poured all my resources into keeping the studio going, I was still digging out from the financial burden of finishing the work. Gelon and I were trying to figure out how to repay the $30,000 bank loan we had taken out. On top of this, there was now a monthly storage bill.

It may surprise some readers to learn that, when an artist has a museum exhibition, he or she is not paid, nor was Through the Flower then able to receive any revenues from the show; all monies went to the museum. Even though we had been able to elicit numerous contributions for the artmaking, it is difficult, if not impossible, to interest most donors in the unglamorous task of paying storage bills. I had hoped to make some money from a

commercial gallery show that was held in Los Angeles during the spring, featuring *Dinner Party* test plates, but nothing was sold. I was only barely scraping by through lectures and monies from book advances and royalties.

And then there were the constant phone calls. Before the Santa Monica studio was shut down, people were calling from all over the country, asking when *The Dinner Party* would be coming to their city, finding it impossible to believe that there was no tour. In Benicia, reporters doing articles were phoning to ask why there were no other bookings, which I found difficult to explain, not only because I was so distraught but because the art world couches its decisions in polite phrases like "too expensive," "too big," "doesn't fit into our schedule," and other such euphemisms. I may have quipped then that *The Dinner Party* seemed to be a work that everybody wanted to see but nobody wanted to show, though I was not in much of a joking mood.

Before the *Dinner Party* people went their separate ways, they seemed to wander around the Santa Monica space in a state of stunned disbelief at its emptiness, which must have been amplified by my increasing absence as I went back and forth between Santa Monica and Benicia. At one point, the photographer Annie Leibovitz came to photograph me for a Canadian magazine. She arrived at the Santa Monica studio, took one look around, and left, stating that my "spirit wasn't there anymore." She was right: my spirit *had* left, not only the Santa Monica studio but also, to some extent, my own body.

It seemed entirely futile to start doing tests for a porcelain room based on the eighteenth-century Capo di Monte room in Italy, which I had seen during an earlier European trip. At the time, it had struck me as providing a perfect concept for the permanent housing of *The Dinner Party*. I envisioned a space in which the longing for liberation expressed through the plates would extend to the environment in which the piece would be housed. In fact, I had worked with a designer to create a conceptual design that we turned into one of the documentation panels that traveled with *The Dinner Party*.

But given that the piece was packed away in crates, my idea seemed to have been reduced to an idle dream. I encouraged Keyes to pursue other work and soon sent my kiln and most of my supplies to my brother.

By then, Ben had apprenticed himself to a famous Japanese potter, having discovered that he had a talent for pottery. Luckily, the studio I had rented was inexpensive, as it was to sit empty for many months while I tried to figure out what I would do next, which involved trying to come to terms with what had happened to *The Dinner Party*, along with figuring out what artmaking path I wanted to pursue.

When Annie Leibovitz tracked me down in Benicia, she was probably shocked to see me holed up in such a humble apartment. To most people, it appeared that I had just enjoyed a major success. Though cleaner, this apartment was very much like the railroad flat I had in New York during the early 1960s. I was sleeping on a mattress on the floor of the bedroom and had set up a drawing studio and an office in two small end rooms. The only other spaces were a tiny kitchen and a bathroom, and for almost a year, that cramped place was my refuge.

About a mile and a half from the apartment was a state park, where every day I would seek out the solace of the running path, the comforting beauty of the hills, and the silence. For months, I woke up every morning with an overwhelming sense of futility. What's the point? I asked myself. Forcing myself out of bed and into my running clothes, I needed two or three hours of exercise to help pull me out of my depression so that I could face the day.

This was the summer I turned forty. I had been a professional artist for almost two decades, and I felt as though I had absolutely nothing to show for it. Had it not been for a horrible experience with Lloyd early in the summer, I might have even begun to regret the breakup of our marriage, as I found myself missing him, perhaps the result of my intense loneliness. We'd continued to see each other on and off after he moved out of the Santa Monica studio, and even discussed the possibility of a reconciliation. But this desire on my part had been definitively ended by our conversation about *The Dinner Party*. He had refused my invitation to the opening and instead had gone to see the piece on his own. We saw each other shortly thereafter on one of my visits to Santa Monica. Walking down the Venice boardwalk together while discussing his reaction to the work remains an unforgettable and exceedingly painful memory.

Lloyd mentioned the floor-level lighting system that Kenny had designed to illuminate the fronts of the runners (which, as it turned out, we hadn't needed, as there was sufficient light from the overhead projectors). This lighting grid doubled as a guardrail, and Kenny had decided to soften its appearance by rounding the edges and covering the outside surfaces with carpet. All Lloyd could say about the piece was that he guessed I had finally achieved what I always desired. "What do you mean?" I asked. "Now everyone can kneel down and genuflect in front of you," he replied.

Since that day, we have run into each other only once or twice. From time to time, I feel sorry that we were never able to discuss what happened between us, never mind what could have made him say something so unkind. Perhaps he felt threatened or jealous; I really don't know. Whatever the explanation, it seems unfortunate that an important relationship (to me) disintegrated into what might be described as just another marriage that did not survive the 1970s women's movement.

After that devastating encounter I returned to Benicia and to one of the most difficult periods of my life. *The Dinner Party* seemed to have no future. I had no marriage; no money; no support system for my work; no shows, sales, or opportunities; and for the first time in my adult life, no male companionship. Although I tried to meet men, I had one unsatisfying encounter after another. It seemed that not only were the male-dominated institutions disdainful and rejecting of my art, but men were altogether uninterested in me personally. Throughout that summer of 1979 I was almost entirely alone, and I felt achingly, desperately isolated. I felt as though what I had learned as a child through my experiences with my father and what I had carried in my heart as a longing and an expectation—that I could be loved for being myself and expressing my feelings honestly—was being entirely contradicted by what I was experiencing in both my career and my intimate life.

Family and friends called constantly to ask how I was and to urge me to "hang in there." I could tell from the concern in their voices that there was some worry that I might commit suicide. Certainly, there is no doubt that their love and constancy helped to pull me through. I was also aided by the countless letters I kept receiving, mainly from women, telling me how much seeing *The Dinner Party* had meant to them. These many writers

probably had no idea what their words meant to me, but they helped me maintain my hold on sanity. The contrast between my own experience of *The Dinner Party* and the art world's rejection of it was so stark that it threatened to undo me, and I am fortunate to have had so much help from both close friends and total strangers.

For some reason, I cannot remember any conversations that summer with Gelon, although I am sure she called. She probably knew me well enough to know that nothing anyone could say could compensate for the absence of an exhibition tour. To this day, all she will tersely admit is: "When you went into shock, I went on the road, as there was no way that I was going to let all those years of work go down the tubes." She was spending all her time traversing the country, meeting with countless interested individuals and community groups in an effort to secure venues for the show.

From my journal entries, it is clear that Gelon and I had had a few discussions about what we would do if museums refused to exhibit *The Dinner Party*. In fact, I can recall overhearing a few phone conversations in the Santa Monica studio in which Gelon was discussing someone's idea of showing the piece in a railroad station or some other unlikely venue. One such call had come in while I was still commuting to Santa Monica—from a woman who was going to become an important person in my life. MaryRoss Taylor had retained the mellow-toned voice of her Arkansas upbringing when she moved to Houston in the 1970s, though, as I was later to discover, she was anything but mellow. Her rapid-fire delivery was somewhat hard to follow, but I finally understood that she was asking how she could bring *The Dinner Party* to Houston. I turned her over to Gelon and promptly forgot about the phone call.

I generally paid no attention to these types of inquiries because I was still convinced that the art system would eventually come through. In retrospect, I realize that Gelon was probably not so surprised by the negative stance of the institutions; she certainly wasn't as devastated. Because she had been visiting museums and consulting with art-world people while I was at work in the studio, she might have already heard some of the comments that were to come as such a blow to me; but as was her wont, she had chosen to protect me. Even now I have no idea what she actually did

during that summer of 1979, nor am I clear on how she managed to put together what would eventually become a worldwide exhibition tour.

It was a good thing I had a contract with Doubleday to do the second book, *Embroidering Our Heritage: "The Dinner Party" Needlework*. Although I had been afraid they might cancel the contract, Loretta assured me that she would get the book into print. The first volume was selling well but, more importantly, she had been radicalized by what had happened at the publishing house: she had been accused of promoting pornography. This utterly flabbergasted her—and me—since the plates seemed anything but pornographic. True, they employed a vulval metaphor, but that was just one way of demonstrating that the oppression experienced by the women represented at the table was a result of their sex.

An interesting aspect of this misperception was that it was not put forward only by men. Some of the women at Doubleday were the most vociferous in attacking Loretta, whereas she was entirely supported by the male head of the publishing house. All I could make of this distortion was that many people, including women, have internalized the idea that women's sexuality is destructive and, even worse, obscene. Moreover, there appeared to be a strange analogue between the accusation that I had exploited the people with whom I had worked and the misrepresentation of the plate images as being pornographic. In both cases, the message seemed to be that there was something wrong with female power, in whatever manner it was expressed, whether visually or through women giving their support to another woman.

In the fall of 1979, I forced myself to do what I had done so many times before in painful circumstances—that is, go back to work. Kate Amend, sometimes with Susan Hill, made numerous trips to Benicia to assist me with *Embroidering Our Heritage*. Katie had come to work on *The Dinner Party* some years earlier, when she gave up her teaching job in San Francisco and moved to L.A. in order to do research for the *Heritage Floor*. She had helped me with the first book and we had become extremely close, particularly during a period toward the end of the project when we were holed up in a loaned house in the funky town of Bolinas, frantically trying to get the manuscript ready for publication.

My plan for this second book was to create a modern-day illuminated manuscript, which would involve illustrating the text with black-and-white line drawings based upon the runner designs. My goal was to demonstrate my realization that the needle and textile arts could be seen as reflecting the same changes in women's circumstances throughout history as were chronicled by *The Dinner Party*, particularly the fact that historical periods that benefited men often had negative consequences for women.

I worked steadily on this project until early in 1980. Except for the periods when Kate and/or Susan were there, I spent most of the time by myself, working long hours in my small apartment studio, running daily in the state park, eating, sleeping, and occasionally visiting Marleen Deane, a local woman who had befriended me. Although this quiet type of life can be conducive to creativity, those months were some of the most cheerless of my life. Perhaps my depressed state helps to explain how vague my memories are of the time between the fall of 1979 and March 1980, when *The Dinner Party* came out of storage, thanks to the efforts of Gelon, MaryRoss Taylor, and a community group in Houston.

MaryRoss Taylor (whom I usually call MR) owned a feminist book-store where she often held cultural events aimed at raising consciousness and promoting the arts. It was from Evelyn Hubbard, her Doubleday sales representative, that she first heard about *The Dinner Party*. Even before the work premiered, Evelyn had walked into her shop carrying a copy of the first book, saying "MaryRoss, we need to get this piece here."

It was extremely fortuitous that I had structured *The Dinner Party* so that the information it embodied was able to enter the culture in several forms—initially, the work of art and the first book. Consequently, when the art was blocked by the art system, the publication brought the concept of the piece to what turned out to be an extremely receptive audience. The level of national media coverage certainly worked in our favor, stimulating people to come together to bypass the museums' negative stance. Later, Johanna Demetrakas's film *Right Out of History* also helped to bring word of the piece and its plight to what turned out to be millions of people.

MR had followed the events surrounding *The Dinner Party*, and soon discovered that the museums in her area were not willing to show it.

Fortunately, she found numerous people both in and out of the art community who were interested in trying to locate a venue to exhibit the piece. A volunteer site committee found a black box theater at the University of Houston at Clear Lake City, where NASA is located. Calvin Cannon, one of the deans, had proposed the space, forged bonds between the university and the community group, and also taken on responsibility for preparing the space by organizing an installation crew which, unfortunately, was not equipped for the immensity of the task.

Although I was extremely relieved that *The Dinner Party* was to come out of its crates, I was not at all enthusiastic about the Houston venue, which was a far cry from the prestigious galleries of the San Francisco Museum of Modern Art. Sometime before the exhibition, I went to see the space and, according to Gelon, "went numb" when she showed me the site. The theater itself was all right, but the unattractive university building that housed it had a bland, institutional appearance. The corridors intended for the banners and documentation panels were illuminated with fluorescent lighting and not suitable for viewing art. All in all, the campus seemed more geared toward training astronauts than exhibiting contemporary art.

When I returned to Benicia, I decided that, despite my ambivalence about the Houston setting and my longing for museum spaces, given the obdurate stance of the art institutions, it was a triumph that *The Dinner Party* was to be exhibited again. In celebration of its reemergence, I decided to initiate something I named the *International Quilting Bee* (later renamed the *International Honor Quilt*). I vividly remember when the idea came to me. I was stretching after a long run in the state park and thinking about yet another criticism of *The Dinner Party*, this one in relation to my choices of women.

Apparently, some viewers did not understand that the piece was intended to be viewed *symbolically* and to convey a larger historical picture of erasure. Perhaps this could be clarified while, at the same time, offering the possibility of greater representation than I had been able to achieve in *The Dinner Party* by inviting people to submit triangular quilts—two feet on a side—honoring women of their own determination. This would also provide an opportunity for broad community participation. If *The Dinner Party*

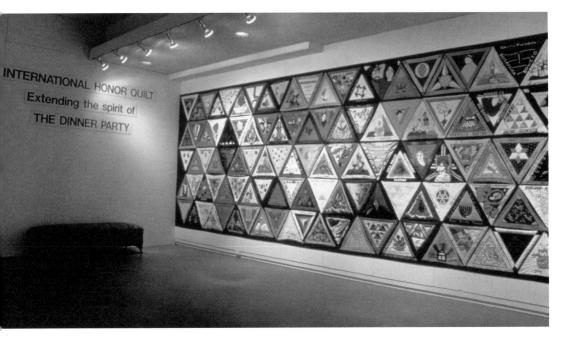

Installation view of the **INTERNATIONAL HONOR QUILT** Melbourne, Australia 1988

continued to travel, more quilts could be added and exhibited in an ever-expanding ancillary show. As it turned out, over six hundred quilts from all over the world would be sent to Through the Flower, which somehow found itself in the position of having to take care of not only *The Dinner Party* but also an increasing number of textiles. Eventually, we would gift these to the Hite Art Institute at the University of Louisville, which seemed a suitable site because of the long tradition of quilting in Kentucky.

Before the Houston show closed, Gelon reported that the piece would probably go directly to Boston, where another community group had organized and was searching for a space. Despite my ambivalence about non-museum venues (which often put the piece at risk), I desperately wanted the work on view. However, installing *The Dinner Party* involved weeks of work and preferably an experienced crew. The prospect of setting up the piece in non-art spaces with volunteers unfamiliar with art installation, exhibition standards, or the handling of textiles was frightening and was one important reason for my misgivings.

It was fortunate for both me and *The Dinner Party* that all the organizational, administrative, and installation logistics were handled by Gelon, along with Susan Hill and Peter Bunzick, for without their dedication there might have been considerable damage to the art. Peter had come to work at the end of the project, taking over Kenny's position as installation supervisor after the San Francisco show. My role was limited to approving the site, installation plans, and graphics, then working on the lighting and participating in opening events, including the press preview and media interviews.

As mentioned, the Houston site needed considerable preparation even before the installation could begin, and the school had either underestimated the scope of the job or lacked the resources to handle it adequately. When I arrived about a week before the scheduled opening, I was confronted with a chaotic scene. Peter, Gelon, and Susan were exhausted, and there was still an overwhelming amount of work to be done. At what seemed like the last minute, MR managed to round up a group of volunteers to help finish the complex installation. I shall always remember the humorous sight of one of her male friends sweeping in, wearing a floor-length fur coat that barely missed being splattered with paint by someone inexperienced at wielding an extension roller.

As in San Francisco, over the opening weekend in Houston in March 1980 there were many accompanying events, including panels and lectures, along with an exhibition of local women artists' work. There were some wonderful moments, most memorably when Eleanor Tufts, an art historian, presented a hilarious spoof on art history featuring only women artists. Her presentation culminated with a manipulated photo of me as "Woman of the Year" on the cover of *Time* magazine. At some point during the weekend, I apparently alienated some of the women by being somewhat critical of their aesthetic and intellectual dialogue, which seemed considerably less developed than what I was accustomed to on the West Coast. Although I thought they might be interested in my feedback, they just took it as criticism.

I should probably have been more sensitive, but tact has never been my middle name. Perhaps my direct manner collided with the gentility of the Southern temperament, but, as is not unusual for me, I was oblivious to the effect my remarks had. I remember being taken aback by someone

saying I was "trampling on people's feelings" when I thought I was only being my usual honest self. I now wish that I had done a better job of communicating with the women in the Houston community, as it was certainly not my intention to make anyone feel bad.

One charge that was leveled against me in Houston was to come up again later on: I was not sufficiently appreciative of all that had been done for *me*. It was as if people there thought that by helping to exhibit *The Dinner Party*, they were somehow doing something for me personally. Other women have also felt this way, it seems, for I was told after the fact that some of the women who helped to bring *The Dinner Party* to Chicago in 1982 were still angry at me for alienating people who were only trying to help me. But it never occurred to me that anyone was helping to exhibit the work because they thought it would benefit me. Had I realized this, I would have made every effort to correct what to my mind was an inappropriate reason for supporting the exhibition of *The Dinner Party*.

I assumed that people were coming together to show the work because they understood its critical symbolic importance in that it represents and celebrates women's rich heritage. It was the task of communicating something of this still largely unknown body of knowledge about women that motivated me and everyone who worked with me to devote so many years to what we viewed as almost a historical imperative. It is for this same reason that I found it so difficult to separate from the work or to destroy it in order to be free of the responsibility it involved. Some of my supporters suggested breaking it up and selling elements so I would make some money, but that was completely unacceptable to me. Destroying it would have been contributing to the erasure of women's history I had worked so hard to overcome.

Another reason I was impervious to the expectation that I should be grateful is that I had almost always exhibited within the framework of the art world. When an art institution shows an artist's work, it does not usually view this as a favor to the artist but, rather, as a benefit to the larger community. Although I was pleased that so many people were organizing to ensure that *The Dinner Party* would be seen, I perceived their efforts as a direct response to the importance of the *art*, not as any personal kindness to me. I wanted the piece on view because that was where it belonged,

particularly given how much interest there was in the work, an attitude I thought everyone shared.

Despite all of the problems I've been describing, the Houston show drew sixty thousand people, another round of media attention (generally positive, though, as usual, I didn't pay that much attention), and was considered a huge success by most people there. I had not actually encountered MR until shortly before the opening for, as she confided to me, she preferred to remain behind the scenes. When we finally met, we hit it off immediately, perhaps sensing in each other some commonality of interests.

After the Houston opening, and using monies from the advance for *Embroidering Our Heritage*, I went on a much-needed vacation to the Yucatan with Katie and Marleen Deane. We drove around visiting ruins and lounged in jungle hideaways for ten glorious days. Perhaps it was the relief of having *The Dinner Party* on display again or the benefits of the long, hot afternoons spent lying in a hammock in Palenque, a tropical paradise in the south of the Yucatan, that allowed me to finally begin turning my attention to some of the ideas I had been considering before *The Dinner Party* was even finished, specifically, the subject of birth.

My interest in this had first been piqued when I designed the runner back for the *Mary Wollstonecraft* place setting. The image depicts the great eighteenth-century feminist writer and theorist's tragic death from "childbed fever" several weeks after giving birth to her daughter, Mary (who, as Mary Shelley, would write *Frankenstein*). My black-and-white runner drawing was so raw and graphic that it unnerved me, but when it was translated into stump work, petit point, needlepoint, and delicate embroidery, it was transfigured. I had decided then that if I was interested in creating images of birth, the needle and textile arts might be a perfect—and softening— medium for this particular subject matter.

After my vacation, I returned to Houston before going back to California, considerably more relaxed and in better spirits. MaryRoss and I spent a long evening discussing the possibility of working together. I had been impressed by the way she'd organized the Houston community, and I asked whether she would consider applying her administrative skills to the project I was formulating. While on vacation, I had thought about

MARY WOLLSTONECRAFT gridded runner drawing from **THE DINNER PARTY** detail
1975–1978. Ink and mixed media on vellum, 56 × 30 in
Collection of Lawrence Benenson

the many letters I'd received from women who had seen or read about *The Dinner Party*. In addition to expressing their appreciation, many of them had stated their desire to volunteer should I decide to do another participatory work.

Among these writers were numerous needleworkers who said that their only requirement was that they wouldn't have to move to Santa Monica—or to Benicia, I presumed. Perhaps I could do another participatory project on the subject of birth, in which people worked on my images in their own homes. Recognizing that I would need organizational help, I hoped that MR would be interested in playing this role. She promised to pay me a visit in order to continue our discussion about joining forces.

Sometime earlier, I had spoken to Audrey Cowan, a weaver who had worked on *The Dinner Party*. Toward the end of the project, Audrey had indicated that she would like to work with me again, an offer that I had not yet had the opportunity to pursue. But the completion of the needlework book and my renewed energy allowed me to think about contacting her, which I did shortly before the Houston opening.

In our phone conversation, Audrey and I discussed the idea of my designing a tapestry cartoon (the drawing or painting from which the

weaver works). In addition to admiring Audrey's weaving skills—she used a modified form of the traditional Aubusson method typical of the great Renaissance tapestries—I very much liked the idea of using this technique for the subject of birth. It seemed both amusing and ironic, as women had not been allowed to work on the huge looms that produced the major tapestries of the Renaissance, often on the pretext that if they were pregnant they might fall and miscarry. I promised Audrey that I would begin working on the cartoon as soon as I returned from Houston.

However, no sooner had I returned to Benicia and the ceramics studio that Peter Bunzick had rebuilt for me while I was away than I spoke to my mother, who told me she had been diagnosed with cancer of the liver. I called my brother, Ben, in Japan, and he made arrangements to meet me in L.A., where I immediately took my mom to my longtime internist. He did some tests and concluded that the diagnosis was wrong. Unbelievably relieved, Ben and I took the opportunity of being in L.A. together to help our mother move into a retirement community.

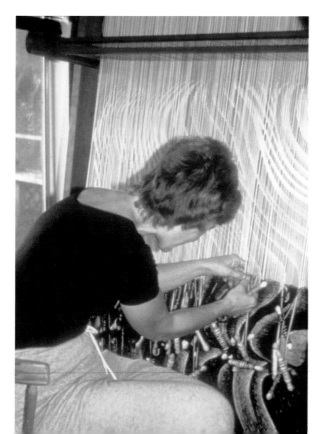

Audrey Cowan working on
THE CREATION tapestry
ca. 1980–1984

171

Within a few days I was at work in my new studio, with its unfamiliar sounds and atmosphere. My quarters were a somewhat cramped space in the back of a large metal building, the remainder of the structure being occupied by two other artists. Although it was not the most comfortable of spaces, before long I was absorbed in creating a birth-and-creation image based on a recasting of the Genesis myth that I had written while working on *The Dinner Party*. My rewriting of this age-old story was intended to challenge the notion of a male god creating a male human being with no reference to a woman's crucial role in the birth process, except as an adjunct figure to Adam, a perfect example of patriarchy turning reality on its head.

During my years of research, I had discovered that there were many creation myths from a variety of cultures demonstrating another historical chronology which I had visually represented in *The Dinner Party*, that is, the changeover from matriarchal to patriarchal societies. This profound change was reflected in the gradual transmutation from female to male deities. Eventually, creation came to be represented as the act of a single male god, notably in Genesis. Interestingly, when I rewrote this myth while working on *The Dinner Party*, I intuitively went back to these earlier concepts of the creation of life as an entirely female act, an idea that not only seemed closer to the truth but also celebrated women.

Once in the studio, I felt like I was all thumbs at first. But then I found my rhythm, and that part of me that had always directed my artistic life seemed to be doing it once again. My first sketches were rough, but the imagery was already all there. I then set out to translate these drawings into a full-scale painted cartoon. I did not know whether to work abstractly or more representationally, as my imagery had changed so much over the years of working on *The Dinner Party*. In 1974, when I began the first plate drawings in Bellingham, I was an abstract artist, still trying to bend my forms to the specific content of women's history. But over the years and particularly while designing the runner backs—which were often narrative in nature—I had gradually begun incorporating more representation. I soon began to fuse abstraction with representation in the tapestry design, and later I would bring this same fusion to other birth-and-creation works.

After several months, I had to interrupt my studio work to go east, stopping in New York before going on to the *Dinner Party* opening in Boston. I stayed in the Big Apple longer than I had planned because the Boston installation was behind schedule due to a leak in the roof of the building where the piece was to be exhibited. I was concerned about the state of the building, the shabby condition of which didn't seem to bode well for the safety of the piece. But Gelon, Peter, and Susan convinced me that all would be well. They urged me to stay in New York and concentrate on the final details for *Embroidering Our Heritage*, which was to be published in the fall.

The publication date was set to coincide with the October opening of *The Dinner Party* at the Brooklyn Museum. Needless to say, I was ecstatic that the piece was to be back in a major museum, particularly one in New York. Michael Botwinick, the museum director, had been approached about showing the work by a group of prominent New Yorkers. They had been working with Gelon and Loretta Barrett, my Doubleday editor, to find a suitable venue for the exhibition, with Gelon operating out of an office provided by Loretta. Even before seeing *The Dinner Party* in Houston, Michael had agreed to its being shown at the museum, and when we met in Texas he was quite encouraging about the response I might anticipate on the East Coast.

The New York art world had never been particularly friendly toward my work, but then I had never had a show there. Michael said I might be surprised by what would happen, especially because it was during that spring that Lucy Lippard's cover story about *The Dinner Party* appeared in *Art in America*, probably the most insightful and substantive writing about the work during that period. I had known Lucy since about 1960, when I was living in New York with my first husband, Jerry. She worked at the library of the Museum of Modern Art, and she used to let him in for free, which is how I first happened to meet her. Like me, she was living in the East Village then. Lucy and I forged a friendship, and we often met during the 1970s to develop strategies by which the Feminist Art movement could be helped to grow. Frequently, when I would lecture in some city, I would answer a question only to be told that several months earlier, Lucy had been there and had said practically the same thing.

I really hoped Michael would be proved right—that as a result of the Brooklyn Museum show and Lucy's article there might be a change in the New York art scene's indifference toward my work. If *The Dinner Party* was successful there, I imagined, I might finally get a significant gallery to represent me, which could mean a stipend, sales, and, most important, the placement of my art in major collections around the world and support for future projects. Perhaps it was because I was focused on this happy prospect that the Boston opening on the weekend of July 4 remains so unclear in my mind. I mostly remember feeling altogether taken aback when I walked in and saw a huge portrait of myself advertising the audio tour of *The Dinner Party* that Michael had convinced me to record.

I realize it might sound odd when I say that I was made unbelievably uncomfortable by this sign, as I was by the sight of my name in large letters on the sides of the buses that were shuttling boisterous crowds to the opening. The months following the closing of the show in San Francisco had been terribly difficult for me, and I had spent much of that time hidden away. Even the success of the Houston show and all the hoopla involved had not made me realize that I was becoming so recognized. Although I had always known that I would be famous, I was finding out that the idea of it and the reality were not necessarily the same. I ended up sitting outside all alone, feeling quite alienated. I had suffered what I believed to be a psychosomatic outbreak of hives all over my face, or maybe it was a reaction to a new hypoallergenic makeup that I had decided to try. Whatever the explanation, I scrubbed my face raw in the bathroom trying to get the makeup off, after which I didn't much feel like the belle of the ball.

Actually, I was getting kind of sick of *The Dinner Party*. Despite its success in Boston—it would attract 40,000 people and a lot of good press—I wanted to get on with my new work. I returned to Benicia ready to focus on the tapestry cartoon, with the idea of further developing my ideas about the subject of birth and creation, soon becoming engrossed in this process. Certainly, I had no notion whatsoever about what was in store for me or *The Dinner Party* in the Big Apple, when, in the fall of 1980, Susan Stamberg's prediction would finally come true.

GIVING BIRTH TO
THE *BIRTH PROJECT*

The Boston opening of *The Dinner Party* marked the end of my first year of living in Benicia. Although this period had been incredibly lonely, and though I continued to spend most of my time alone, I gradually widened my circle of acquaintances in the Bay Area. I began to see more people, including Stephen Hamilton, a San Francisco–based designer whom I first encountered when he was working on a Chevron-sponsored traveling exhibition on creativity in which I was included. I learned something from him that reinforced my practice of carefully documenting my work, something I started doing early in my career.

Although I do not recall who told me, I will be forever grateful that they advised me to make a card recording the size, medium, and date of every artwork I produced and to staple a slide to it. As a result, I started a file that has followed me wherever I've gone, chronicling my long career. The importance of this was underscored when I criticized Stephen and his colleagues about the fact that I was the only living woman represented among the "Sixteen Creatives" in the show. He told me something I never forgot: the criteria for inclusion involved not only having created something significant but also having documented it, something that—he noted—very few women had done.

Through Stephen, I met Brian Klimkowsky, a friend and former lover of Stephen's who sometimes had affairs with women. Before too long we began seeing each other regularly. Brian was young, darling, and not to be taken seriously, but he was great in bed. Around this time, I also became involved with a man named Dusty, whom I came to care about. In contrast to Brian, Dusty was my age and intellectual equal, but he was full of sexual

hang-ups (like many men of my generation, which was one reason I found myself drawn to younger men).

Although it was good to have male companionship again, I was determined to avoid some of the frustrations I had experienced in previous relationships. Over the years (like many other women, I would imagine), I have had sex with men who seemed focused only on their own satisfaction, which left me furious. I vowed to leave each encounter having wrested satisfaction from even the most recalcitrant man, in part by clearly stating my desires. For some men this was pleasurable and even a relief, as they confessed that they had wanted to satisfy their partners but hadn't been told how. But for others it was threatening, although I really didn't care. I had always envied men's seeming ability to achieve orgasm in almost any situation, and I no longer felt jealous or angry once I could ensure this for myself.

My mood was further improved during the summer of 1980 because *The Dinner Party* was back on view and the needlework book was going into production. I was working on the tapestry cartoon for Audrey Cowan and also doing research on the subject of birth. I had assumed that I would easily find a wealth of information, as one would have thought birth to be a significant subject. Strangely, there was almost no material.

There were some photographs, but these were scarce. And when I scrutinized the art-historical record, I was amazed that there were almost no images of birth in Western art, at least not from a female point of view. This iconographic void signified that the birth experience (with the exception of the birth of the male Christ, which focused on him rather than his mother, Mary) was not considered important subject matter. And despite there being a number of major female artists in the twentieth century, none seemed to have addressed this subject—or if they had, their work had not entered the cultural iconography.

At the time, Frida Kahlo's work was still relatively unknown in the United States, and I was not yet familiar with her treatment of this theme. It would be decades before I would discover that another form of erasure has to do with the omission of subject matter not deemed important by men, birth being a crucial example. In 2015, I went to Milan to see the

exhibition *The Great Mother*, which included my work. The show was a revelation, as it demonstrated that the themes of birth and motherhood had been addressed by a number of female artists dating back to the early twentieth century, but most of their work was previously unknown.

Consequently, when I tackled the subject of birth, I was completely unable to draw on this historical image bank. I decided that I would have to turn to direct experience for knowledge about the birth process. While continuing to work in the studio daily, I began seeking out private photographs and descriptions from people who'd either given birth, witnessed and/or participated in the birth process, or studied and documented it. It was an advantage to be in the Bay Area, where there was an active natural-childbirth movement. As a result, many people seemed eager to share their birth stories and pictures with me.

In July, shortly after I returned from the Boston opening, my old friend Janice Johnson came to visit. Since she had had four children, I thought I would ask about her birth experiences, having realized with some chagrin that we had never talked about them. Somewhat sadly, we admitted that it had never occurred to either of us for me to attend the births, even though they had all occurred while I was still living in L.A. Although Janice could recall many details of her birth experiences, she told me they would recede in her memory until the next time when, in the throes of labor, she would angrily ask herself, "How could I have done this to myself again?"

Listening to her made me wonder whether the absence of images depicting the birth experience might actually reinforce such lapses of memory. If women saw numerous images presenting the actuality of birth and were thus reminded of both the pain and the responsibility for another life ushered in by this process, would they still give in so often to what Janice and many others have described as an overpowering urge for a child?

Perhaps if I had felt such a powerful desire, I might have been similarly compelled. But I never did. I have never regretted my decision not to have a child, because I knew that motherhood would interfere with my creative life. I wanted my days to myself so that I could work in my studio. Moreover, while I was in my thirties, when many women reportedly feel their biological clocks ticking, I was steeped in research into women's

history. Discovering that most successful women artists had been childless, I consciously chose to pattern my life upon theirs.

Over the years, I have been questioned repeatedly about whether it was possible for me to deal with this subject authentically, since I have never given birth. But personal experience is not always an adequate criterion for creativity, else we would have no great paintings of, for example, crucifixions. Also, it seemed obvious that having a child did not necessarily qualify one as an expert on the subject, as a woman who had given birth in an anesthetized state could hardly be more knowledgeable than I was to become after my years of study.

Soon after my conversation with Janice, my friend Marleen Deane invited a group of women to her house to talk about their birth experiences. When I arrived, all of them told me how much this meeting meant to them, because they had never had the opportunity to publicly discuss what most of them described as a pivotal moment in their lives. Some of the younger women had benefited from the alternative-birthing movement, characterizing their natural childbirth, at home or in a cozy birthing room, as altogether joyful. The older women (like my own mother) had given birth under anesthesia while their husbands paced outside the delivery rooms. As a result, they remembered little but the excitement of holding their babies in their arms.

This session was to be the first of many in which I would hear stories about the nature of the birth experience. Nothing I learned ever caused me to lament my childless state, particularly after listening to considerable testimony by artist mothers who expressed a seemingly irreconcilable conflict between their lives as artists and the demands of motherhood. And then there were the horror stories: of extended labors, breech births, excruciating pain, and descriptions of some of the terrible and rarely discussed consequences of childbirth, including fistula, incontinence, and, most of all, unremitting exhaustion.

However, the moment of birth seemed momentous—an existential event, when a female is faced with one of life's great challenges: the bringing into being of another human life with all its attendant agony, triumph, and bliss. The actual process of rearing a child was secondary to my focus,

although many women told me that it was the satisfaction of doing so that made all the discomfort associated with birth worthwhile.

The more I learned, the more outraged I became that such a universal topic seemed to be so shrouded in mystery and taboo. Over that summer, it became obvious that, given the lack of iconography about the subject, I would have to start from scratch to invent forms and symbols that could represent this primal human experience. The fact that I had been classically trained in art would prove crucial as I attempted to create an original, woman-centered iconography about the birth experience.

The most overwhelming event of those months was the witnessing of my first birth, an experience that I believe everyone should have. Thanks to my friends Karin Hibma and Michael Cronan, I had the opportunity to see a well-prepared natural childbirth in a hospital birthing room, attended by a doctor and a resident who were not only women but feminists and, hence, sensitive to a birthing mother's needs. I can only imagine my reaction to less empowering birth experiences, like those suffered by too many women in the world.

My journal entry for July 25, 1980, best conveys the vividness of my original impressions:

It was incredible…Lots of vivid visual images that sunk into my mind, the expression on her face, the glazed look that came over her eyes during the height of the contractions, the darkening of the cunt and pelvis as she pushed. Her husband was a real ally in the struggle— but what a lot of pain. At one point, I really understood why some women choose and so many doctors want to administer painkillers. It requires a lot of courage to go through a natural birth, especially one as long as Karin's. She was in labor for almost eighteen hours…I was there for the last three and a half, the most intense part.

She had to have an episiotomy and there was an enormous amount of blood…But once the baby was in her arms, it was as if she totally disconnected from her body. There she was, with her legs spread, the center of her body covered with sheets. She and Michael were holding the baby while the doctor cut and groped and stitched… A halo of satisfied maternity seemed to suffuse her upper body, along

with an almost unearthly glow, while the lower part of her body was cut and bleeding…

Looking at that dripping, engorged cunt with the lifeless umbilical cord hanging out afterward was really something—a view of the cunt I've certainly never seen before nor, I would imagine, have many other people.

I was shaking by the time I left.

I was particularly struck by the strength of the vulva as it expanded and contracted in childbirth; its power was overwhelming, having little to do with sex (although it is always referred to as a sex organ) and everything to do with the life force. I thought then that if everyone was brought up with a familiarity with the birthing vulva, it would be difficult to imagine the female gender as passive. To my mind, the childbirth experience qualified as a heroic struggle, which caused me to wonder again at the absence of images and the mystery surrounding this subject.

Study from one of my **BIRTH PROJECT** sketchbooks 1980–1982
Ink on paper, 8 × 11 in (27.94 × 20.32 cm)

It was striking that no woman I interviewed ever discussed her birth experience from anything but a personal perspective. If a man were to go to war without ever having been exposed to any paintings, plays, or movies valorizing the soldier's life, he would see only the dirt and grime, the bad rations, and the peril. He'd be unable to understand these in the larger context of the national importance of his task, the opportunity to transcend his limits and to achieve heroism through his courage. Why should a woman not have the possibility for this same experience when facing the comparably strenuous, often dangerous, and altogether challenging act of giving birth?

These insights helped shape my determination to make myself into a conduit for the unexpressed realities of the birth process, offering an aesthetic contribution while also helping to reconnect art to the fabric of human life. I also wanted to counter the reality that, while men publicly celebrated almost everything they did, women seemed to deal with some of their most important experiences only in the privacy of the home. "If men had babies," I used to joke at the time, "there would be thousands of images of the crowning."

My workdays again extended into the evenings as I continued my research while trying to complete the tapestry cartoon. As a result of having witnessed the birth of Karin and Michael's child, the imagery underwent some changes, specifically the tearing of the Earth/body in the center of the design. While still immersed in the effort to finish the cartoon, I paid a visit to Sally Babson, a local dressmaker and quilter whose skills had impressed me. She had made me a top for the *Dinner Party* opening in Boston, as well as a small, quilted book I had commissioned as a present for Brian.

I wondered if she might be interested in doing other work with me. At that point, I was thinking about adapting the tapestry cartoon into a more simplified design, one that could be translated into different needle techniques. While engaged in *The Dinner Party*, I had many occasions to visit needlework shops, which is where I first came into contact with the kits that are used by thousands of stitchers. I had always found it maddening that even some of the most sophisticated needlewomen with whom I had worked would use these kits, whose trite sayings and overly cute drawings were, at least to my mind, insulting to their intelligence and demeaning to them as women.

The introduction of needlework kits (or patterns) dates back to the Renaissance, when the idea developed that women were incapable of infusing designs with life, a concept that hearkens back to Aristotle. Because only men were considered capable of such creative acts, needlework designs became the province of male artists, who began to produce pattern books for women, whose lives were becoming more circumscribed. The Reformation continued this process as women were increasingly confined to the domestic sphere.

With women having little or no education and certainly no access to art training, needlework became one of their only creative outlets. But women's dependence on pattern books—combined with their lack of art training—produced a myriad of needleworks in which scale was utterly confused: lions became smaller than humans, fruit became larger than dogs. Although this practice sometimes resulted in charming if slightly askew scenes, it also contributed to a widespread view of domestic needlework as being very far from the domain of real art.

As to the subject matter of kits, it tended toward the inconsequential. I can recall wondering if I could infiltrate this sea of trivia with some images that were better suited to women's real lives as well as their skills. My first idea involved taking the Creation image that I was working on and simplifying it so that it could be adapted to different needlework techniques, and also to a range of sizes—from the small to the monumental.

For those who are unfamiliar with it, the term "needlework" refers to anything done with a needle and thread, and covers a wide range of techniques, including embroidery, appliqué, and quilting, all of which I had designed for during *The Dinner Party*. Frequently, needlework is erroneously called needlepoint, which is a specific technique that is done on a gridded canvas. Over the years, I have been asked numerous dumb questions by reporters, but the stupidest by far was a query about how I got "all those holes in the needlepoint canvas," the question one-upping the ill-founded exploitation charge by implying that I had a cadre of slaves whose dreary work involved punching holes in the fabric. The fact is that needlepoint canvas comes in a range of sizes to allow various forms of stitching, from the tiniest of petit points to the largest of wool textiles.

Sally Babson was enthusiastic about working together, so we arranged to meet at my studio in order for her to see the cartoon for the *Creation* tapestry, which was the first work I'd done on the subject of birth. Once there, we began making plans to buy fabrics together for a quilt that would be based on the same theme as the tapestry but smaller, with a simpler pattern suitable for quilting. As I stated earlier, I was considering making a number of images on the same theme, then looking for stitchers who might like to participate in what I spontaneously dubbed the *Birth Project* when Sally asked me what the title of this new undertaking would be.

By the end of the summer, Sally had fabrics spread all over her living room in preparation for appliquéing, then starting to work on the Creation quilt. Audrey was busily warping the loom in her Los Angeles studio, the first step in weaving a tapestry. I was feverishly trying to finish a series of other images based upon some of the birth testimony I'd heard. I was hoping to initiate at least a few more projects before I left at the end of September for the New York opening of *The Dinner Party*.

In the middle of the month there was to be a publication party for *Embroidering Our Heritage* at the San Francisco Museum of Modern Art, which would also be a sort of farewell party as I would be gone for months. I had arranged to sublet the East Village apartment of Paula Harper, who had taken a teaching job elsewhere for the semester. Her place was only a few blocks from where Jerry and I had lived twenty years earlier, though since that time the East Village had become considerably more fashionable. Maybe, I thought, if things went well in New York, I might relocate there. For even though I liked Benicia, the Bay Area's art scene seemed somewhat limited. As my plan for the *Birth Project* allowed for people working in their own homes, there seemed no reason why I too couldn't live where I chose. I had asked Sally to set up her quilting frame at the publication party as a kind of advertisement for interested stitchers; we also handed out flyers announcing a meeting to be held at the museum a few days later.

Shortly before the party, I was interviewed by a reporter for the *San Francisco Chronicle* who had previously written several sympathetic pieces about my work. This article was supposed to be about the needlework book, but she became so fascinated by the patterns and images she saw in the

studio that she ended up focusing on the fact that I was starting another participatory project. Almost immediately after her article appeared, I began to receive letters from people interested in volunteering for the *Birth Project*, and when the publication party took place it was mobbed.

A few days later, thirty people showed up for the scheduled needle-workers' meeting, all of whom seemed quite enthused about the prospect of working with me. MaryRoss and Kate Amend (who had worked on the first volume and who went on to become an award-winning film editor) came for the publication party and had, fortunately, both agreed to stay long enough to assist with what turned into a rather chaotic afternoon.

We began the session as I like to do, by going around the table, with each person introducing herself, sharing her background and interests, then showing examples of her needlework. I discussed my concept for the *Birth Project* and my plan to apply the same collaborative principles that had produced *The Dinner Party*—that is, people working on my images under my supervision but in their own homes. There was some discussion about my insistence on retaining aesthetic control, until Sally pointed out that

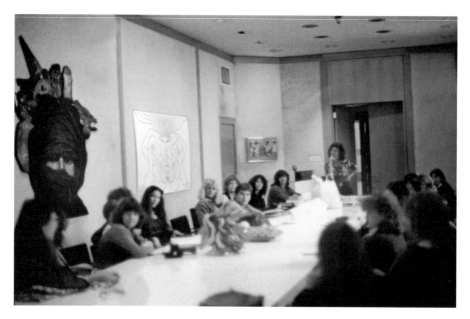

BIRTH PROJECT meeting at the San Francisco Museum of Modern Art, CA 1980

the reason she—and, she assumed, other people—were drawn to work with me was the quality of the art that had resulted from precisely this process.

We talked about my patterns, which Sally and I had put up on the wall. I was gratified by the response of the women present (most of whom had children) who said that my images seemed to express many of the complex feelings they had about their respective birth experiences, which reassured me that I was on the right track. The meeting went fairly smoothly until Sally and I started passing out the pieces, trying to match up each project with a woman's specific interest and set of skills. For some reason, suddenly, there was an uproar, with everyone yelling and grabbing patterns and materials.

Meanwhile, MR and Katie were getting everyone to sign the contracts that I had prepared. These were relatively simple, vesting joint ownership of the finished works in each needleworker and me. (We would later amend these in order to gift the work to Through the Flower, which underwrote the project.) At the same time, they were trying to record everyone's name and address and take individual Polaroid pictures to be put into a notebook with information about each stitcher and the pattern she had chosen.

Then, abruptly, the room emptied. Even though the afternoon had been productive and exciting, it was also somewhat disconcerting to realize that I had just turned over numerous images and more than seven hundred dollars in materials to total strangers, who had been provided with everything they would need to do a piece except the needles and thread. At this point MR turned to Sally and me and said, somewhat wryly, "I guess you-all are going to need some sort of help." For it was obvious that there would have to be some kind of organizational structure to handle these multiple projects. This was precisely the reason why I had asked MR to consider working with me. I had hoped that she would think this project was right up her alley.

MR went back to Houston with the idea that she would return to Benicia in November, when I intended to come back for a few days in order to meet with the needleworkers. When I took her to the airport, she announced that she planned to attend the New York opening. Even though I didn't know her all that well, I was pleased, because I liked the idea of being surrounded by family and friends at this momentous occasion.

Howard and Arleen were coming too, as were Katie and Susan Grode. After chartering Through the Flower, Susan became my pro bono lawyer, adviser, and friend for many years.

Sally agreed to communicate with the needleworkers, answer any technical questions, and oversee their progress while I was away. She also offered to handle letters of inquiry, though she had no idea what she was getting herself into. Over the next few weeks we were to receive over three hundred pieces of mail from eager volunteers. Sally sent polite refusals to those women she deemed unqualified in their needle skills, invited promising stitchers to the November review, and forwarded the most interesting letters to me. Some of these were from people who did needlepoint, a technique with which I had little experience.

At that point I was giving out black-and-white reproductions of my designs, whereas needlepoint is often done on top of hand-painted canvases. In a letter, one woman offered her skilled services in the preparation of a series of such canvases. It was one thing to give out blueprinted multiples of an image, however, and quite another to hand out original paintings to strangers. But the prospect of exploring this technique—usually associated with throw pillows or wall hangings—was irresistible, so I said I would work with her after I had returned from New York.

Because *Embroidering Our Heritage* was being published in conjunction with the *Dinner Party* opening, the Brooklyn Museum was working with Doubleday Anchor to obtain media coverage. Perhaps one reason my work has attracted so much press attention over the years is that the books I have written about my projects have been put out by mainstream publishers. The public-relations resources of such a publisher, combined with those of a major art institution, can produce more media coverage than is normally accorded art exhibitions, which are usually dealt with only in the art press.

In New York, for example, this joint venture resulted in a beautiful television piece on CBS network news, a *People* magazine spread, an appearance on *Bill Moyers Journal*, and, later that fall, a six-minute interview on the *Today* show with then-host Jane Pauley. Although such media attention has helped bring my art to a large audience—which has always been one of my goals—it has also produced some negative consequences in the art

world, where I have sometimes been accused of being a "media phenomenon" rather than a real artist.

The *Dinner Party* opening was spectacular. Loretta arranged for an elegant pre-opening cocktail party at the Fifth Avenue Doubleday suite, and Howard, Arleen, and I greatly enjoyed being chauffeured to Brooklyn in the limousine that Michael Botwinick provided. We were overjoyed by the sight that greeted us, for there were thousands of people at the opening. The only unpleasantness was a fistfight that broke out among visitors who were less than sanguine about having to wait in a long line in order to see the show.

The next few weeks were full of interviews and lectures in New York and elsewhere on the East Coast. Katie and MR took turns with Loretta to accompany me, MR having announced that she was appointing herself my protector and adviser. Everywhere I went, there were enthusiastic crowds, standing ovations, and considerable hoopla. The highlight was a packed lecture at Harvard's Institute for Policy Studies, where I presented a talk on the relationship between art and politics in which I questioned some of the traditional categories and evaluative standards for art.

Like most of the groups I addressed at this time, the Harvard audience only wanted to talk about *The Dinner Party*, despite my desire to expand the discussion. In retrospect, it seems reasonable that this would be the case; after all, the piece had just opened in New York, the center of the art world, and there had been plenty of art and popular writing about it. Plus, I was from California, which was looked down on by the East Coast. Years later, a friend of mine who had attended Yale told me that when he announced to the Art History Department that he wanted to write about Los Angeles art for his PhD thesis, the response was: "What art?" But I became frustrated and also felt a little trapped when people called *The Dinner Party* the "culmination" of my career. I knew that it was just the beginning of my mature work, and I wanted it to be seen as such.

All I can say is that for most of my life I was so wrapped up in my work that I was oblivious to the rest of the world, a tendency that has been good for my studio life but terrible for my interactions with other people. Also, although I always knew I would be famous, I actually found all the attention somewhat frightening. Most of my friends knew that I was nowhere near

as tough as I was assumed to be, which was the reason they felt I needed to be taken care of. I often broke down or developed a variety of physical manifestations of my feelings. For example, I would come down with laryngitis when I couldn't stand talking about *The Dinner Party* anymore. And I could not bear the unreal way in which people were beginning to treat me because of my seeming celebrity status.

When I returned to New York after several weeks of travel, Michael Botwinick, the director, reported that the Brooklyn Museum was consistently mobbed, with people waiting in line as long as five hours to see the show (in fact, *The Dinner Party* turned out to be the museum's most successful exhibition to that point, so much so that they instituted a timed ticket process for the first time). There were positive pieces in *Ms.* and the *Village Voice*, while *New York Magazine* declared: "*The Dinner Party* arrives at the Brooklyn Museum having caused more furor than any other contemporary sculpture." John Perreault wrote a glowing review for the now-defunct *SoHo News* that praised *The Dinner Party* as the most magnificent and moving work of art he had ever seen.

Only someone as utterly ingenuous as I was at the time could have imagined that all this positive press could act as a counterweight to the review that appeared on the front page of the Friday "Weekend" section of the *The New York Times*. Written by Hilton Kramer, then regarded as the most important art critic in America, the review described *The Dinner Party* as "kitsch" and little more than vaginas on plates. Then a few weeks later, in a kind of double whammy, Robert Hughes, the major art writer for *Time* magazine, went after the piece with equal venom. In an article laced with nasty references to pudenda, Hughes singled out the needleworked runners for the only faint hint of praise. But he went on to say that "regrettably," these had been designed by me—that if only the stitchers had been able to fashion their own designs they might have attained great visual heights.

Perhaps I was exhausted from so many uninterrupted weeks of public activity by the time the Hughes piece came out, or maybe it was its particular mixture of ignorance and misogyny, but it really unnerved me. I bought the magazine as I was on my way to meet filmmaker Claudia Weill for dinner in the Village and read it while walking down the street. When

I arrived at the restaurant, Claudia was sitting at the bar. I walked up to her clutching the magazine, sat down on a stool, put my head down on the bar top, and sobbed.

I think it is important to emphasize that I was *personally* hurt and humiliated by the Hughes article, as I thought about how millions of people were going to read his low opinion of my work. Moreover, even though he knew nothing about needlework—as evidenced by his suggestion that the stitchers would have been able to design the images themselves when most of them had no art training—I knew that his readers would believe his words. At the same time, because there had been such extensive national coverage in the general press, most of it positive, I did not comprehend what the Hughes and Kramer pieces would mean for my career. At the time, I assumed that their hostility was nothing more than their particular opinions.

As I noted, the degree to which I did not "get it" amazes even me, but it would be many years before I comprehended the extent to which art-world attitudes are controlled by the assessments of the very few. And once those folks publicly render their verdicts, they are rarely inclined to change their minds. In fact, many years later, Henry Hopkins was on a panel with Hilton Kramer during which Henry asked Kramer about *The Dinner Party*. His response was that it was "not art." Henry challenged this assessment by saying that he had watched 100,000 people view the piece with reverence, asking Kramer if he thought that Henry, a seasoned professional, could not recognize an aesthetic experience when he saw it. The response was silence. Only later did I realize that the art world's rejection of *The Dinner Party* was also an offensive repudiation of Henry's point of view.

Another example of the New York art world's arrogant disregard for other opinions was that—during this same period—a writer for the *New York Review of Books* described going to the Brooklyn Museum three times, only to witness long lines of people waiting to see *The Dinner Party*. Despite this, he was utterly convinced that all those people were wrong in their positive assessment of the work; in his opinion, it was worthless. I chose not to read the rest of the article because I was beginning to feel like a punching bag.

As I said, at the time I had no real understanding of the ramifications of this critical assault by the New York art press, although I was forced to

recognize that I was not going to secure any of the professional opportu-nities for which I had hoped. In sharp contrast to what happens to many male artists, who are usually besieged with offers from major dealers after an important museum show, I received no phone calls of interest or invita-tions to lunch followed by polite inquiries about my future "career plans." And it wasn't just the dealers who were uninterested: no other American museum would exhibit *The Dinner Party* after its New York showing, no matter how much community pressure was brought to bear. Since that time, people sympathetic to my work have told me stories about how, when they mentioned my name to influential art-world figures, they were met with intense hostility.

One more result of the New York critics' negative assessment was that the discourse about *The Dinner Party* seemed to become peculiarly skewed, not only in the art world but also among numerous feminist theorists. After the Brooklyn Museum showing, Kramer's dismissive attitude toward the piece, implying that it amounted to little more than vaginas on plates began to be repeated, mantra-like, even in feminist circles. As I was far away from the universities, where feminist theory was then being hotly debated, I had no idea that a number of academic feminists were apparently accepting this description of the piece and, as a result, describing me as an "essentialist," supposedly degrading women through my use of vulval imagery.

As the feminist theorist Amelia Jones stated in her 1996 accompany-ing catalog to *Sexual Politics: Judy Chicago's "Dinner Party" in Feminist Art History* at the UCLA Armand Hammer Museum: "Feminist commenta-tors have criticized [*The Dinner Party*] as exemplary of 1970s feminism's supposed naïveté, essentialism, universalism, and failure to establish col-laborative alternatives to the unified (and masculinist) authorial structures of modernist art production…Some feminist responses to the piece converge uncomfortably with conventional modernist evaluations," as exemplified by Kramer and Hughes.

As a lot of ink has been spilled on debates around "essentialism" over the years, I shall not devote any more attention to the subject. As I stated in Amelia's catalog: "I think it's a waste of energy to argue about whether gender is biological or cultural…Of course, femininity is a construct as

is masculinity. I certainly think most gender differences are cultural, but there's also some intersection between culture and biology."[11] Also, when I became aware of this debate years later, I could not figure out how seemingly erudite women could completely miss the point—understood by so many less sophisticated viewers—that *The Dinner Party celebrates* women's sexuality, history, and crafts.

Before leaving New York, I stood in the museum gallery one last time. As I watched the hundreds of viewers silently walking around the *Dinner Party* table—seemingly enthralled by the art and the history it conveys—I thought that, ultimately, the evaluation of the work boiled down to the question: Who decides? I recognized that, once again, I would have to make a choice as to whether to stand by my own experience of the piece or to accept other people's opinions. I could say that I just picked myself up and went on with my artmaking life, but that would be untrue, as the New York experience really hurt. It also denied me what I most desired: support for my art.

In due time, I would realize that one does not die from bad reviews or negative criticism, no matter how excruciating they might be to read. I would also come to understand that controversy usually accompanies any attempt to introduce new ideas or achieve even a degree of change. In fact, it might be said that one measure of my accomplishment is the extent to which *The Dinner Party* continues to stimulate dialogue.

Given the virulence of the New York critical assault, I suppose that some artists might have stopped making art altogether or at least retreated from public view. But these were not options for me. I was always encouraged to believe in myself, a trait that has been tested many times. Whenever this happens, I remind myself of something my cousin Howard said: "In the face of life's adversities, one either gives up or gets up, and in our family, *we get up*."

It was probably a blessing that I was still so naïve about the far-reaching powers of the New York art critics. Moreover, I was not alone in choosing to disregard their opinions. No matter what they wrote, it only served to make community groups more determined to get *The Dinner Party* shown. More and more people were forming committees, raising money, and pressuring

institutions—and when they encountered disinterest or resistance, they found alternative spaces and installed and staffed the show with volunteers.

In 2013, some of these efforts would be chronicled by Jane Gerhard in *"The Dinner Party": Judy Chicago and the Power of Popular Feminism*, where she argued that *The Dinner Party* "offers a case study of how feminist ideas radiated out through cultural pathways to nonactivists...Many women and men who did not participate in feminist activism found a way to express their belief in women's equality by...organizing a community showing of *The Dinner Party*...[It] spoke to many viewers and made seeing the controversial work an event worth traveling to and lining up for."[12]

Eventually, *The Dinner Party* would travel to several more sites in America, then Canada, England, Scotland, Germany, and Australia. It would be shown in a total of fourteen venues in six countries and be seen by nearly one million viewers. This tour was the result of what became a worldwide grassroots effort, which, as far as I know, is altogether unprecedented in the art world. Much of the credit for this victory lies with Gelon, who continued to work with the various community groups and act as administrator even after she went to law school in New York and then moved to London, where she practices tax law and continues to be involved with Through the Flower.

Although it was amazing that *The Dinner Party* was able to be exhibited so widely—given the ongoing art-world opposition—I kept wishing that it could be safely exhibited in museums (which it was about half the time outside the United States), so that I would never have to worry about leaky roofs, faulty wiring, or untrained installation crews. The piece was imperiled in several of its venues, kept from irreversible harm only through the devoted attentions of Gelon, Peter, and Susan. This dedicated crew handled most of the logistics of the installation, their modest salaries and expenses covered by exhibition rental fees paid to Through the Flower. The *Dinner Party* tour, which continued until 1988, inevitably shaped the structure of the corporation, which became the touring agency and sometimes the fiscal receiver for the monies raised by the various community groups.

It was extremely fortunate that we had established Through the Flower. Certainly, at the time we did so, none of us could ever have predicted the

degree to which this small, nonprofit arts organization would become essential to my career as an artist. Slowly, the board would expand as various women around the country came forward—many of them, like MR, after seeing the impact of *The Dinner Party* in their community—to gradually assume most of the fiduciary and governing authority for the organization. Without their support, I do not know what would have happened to the piece, as the storage bills were extremely high.

By the time I finally left New York, I was exhausted and run-down and therefore very grateful that MR offered to take me to Santa Fe for the Christmas holidays. She owned an old adobe house on the historic Canyon Road, which she promised would provide a restorative retreat. Upon landing at Albuquerque airport, we were greeted by a ferocious thunderstorm. The rain slowly subsided as we drove north. When we reached La Bajada Hill and began our descent into Santa Fe, the storm suddenly stopped, leaving in its place the perfectly clear, crisp air that has drawn so many artists to New Mexico, along with a spectacular double rainbow arching over the mesas. MR told me this was an especially good omen, one that meant my life circumstances would soon improve.

IS THERE AN ALTERNATIVE TO THE ART WORLD?

In November 1980, as planned, I returned to California for a few days to see whether any progress was being made on the *Birth Project* pieces we had started in September. I was relieved that work seemed to be going forward, though at a slower pace than I had hoped. Looking at the pieces, I noticed that when the needleworkers transferred my patterns to the fabrics in preparation for stitching the images, the line quality of their drawings was far from precise. Moreover, the thread-color choices they had made were not to my liking. As visual rigor is important to me and color one of my strong suits, I decided that I had best transfer the images myself and also establish their tonal ranges.

By then, a number of people were already waiting for projects, and I worked furiously, trying to get more pieces ready. Because several women had complained that the fabrics we had given them were puckering, Sally and I decided that batting, or backing fabric, should be placed behind the cloth so it would stay flat. While transferring more images to newly purchased fabric for the waiting stitchers, I became anxious about whether this whole project was such a good idea. But then Sally backed the designs I had prepared and put them on the wall. The moment I saw them, I felt reassured that I was conceptualizing this work appropriately. The softening that took place, even before any needlework was added, helped transform the raw and somewhat graphic nature of the images, which is precisely what I had hoped would happen.

When I finally got home to Benicia in January, it was to discover that the *Birth Project* was exploding. Information about my new undertaking had apparently been spreading through the media as well as by word of mouth. We were receiving ten letters of inquiry a day. People were calling with

suggestions that would give me the opportunity to design for techniques I had never tried. Others offered help in preparing needlepoint canvases that could be silk-screened as a way of generating multiples, something I had never considered.

It seemed obvious that without some organizational support, there would be no way for me to create enough work to provide for what seemed like an enormous amount of interest. This is where I would come to rely on MR's organizational skills. Over the years, I have been repeatedly asked how I "get" all these volunteers. Actually, it's the opposite; in most cases, they have approached me after discovering that I was working on some project that interested them.

In this manuscript, I have outlined some of the different ways I have found people to help me. Some small number have been paid, but I could never have afforded to pay everyone. As I've mentioned, for most of my career I have lived without any financial security, pouring all the money I was able to earn into my work. Occasionally, someone I have tried to pay has refused—Diane Gelon, for instance—saying, "If you don't pay me, you can't fire me," a reference to my notoriously fluctuating moods.

Clearly, the many folks who have come forward have done so for reasons other than money, which—in our currency-driven world—has been difficult for some observers to grasp, hence the conclusion that I must be exploiting the people who work with me. As will become clear later in this chapter, many of these same accusers did not see their own exploitative behavior, especially when it concerned the women in their lives. They would think nothing of asking a woman to do errands, stop what she was doing to minister to their needs, or give up her own career in order to take care of her partner.

Most of the women who have volunteered to work with me were white and middle-class (or even more affluent), which is why they could do this. In the 1970s and '80s, they had leisure time to pursue their interests and, as Jane Gerhard pointed out, working with me allowed many of them to feel they were helping to achieve greater equality for women. And like the china painters before them, numerous needleworkers didn't understand why the craft they loved was not considered art; they looked to me to change that.

Since that time, middle-class incomes have stagnated, and opportunities have opened up for educated white women. Still, even today, I would wager that if I were to announce another major project, there would be people who would come forward to volunteer—and not only women. As Diane Gelon stated, being around me has helped innumerable people to grow as human beings, partly because I have always been dedicated to trying to make a contribution and have worked in the service of the vision of a better, more just world. Until recently, I did not realize that this was unusual.

My first weeks back from New York were extremely busy, which was probably a good thing, as it gave me little time to think about how devastating that experience had been. Toward the end of January, Sally Babson—who had taken on the responsibility of being the needlework supervisor—and I held another review. MR flew in from Houston, having decided that she would provide the organizational support we so desperately needed.

The review process—when work would be submitted to me for approval—was fundamental to the *Birth Project*. In addition to giving us a chance to see the pieces in progress, reviews were a time for the stitchers to interact with each other, which helped to build a group spirit. At the initial meeting in September, I had requested that everyone do something I called "translation samples" before they started on the actual pieces, and that they bring them to the January review. These samples were intended to give each needleworker an opportunity to think about how best to "translate"

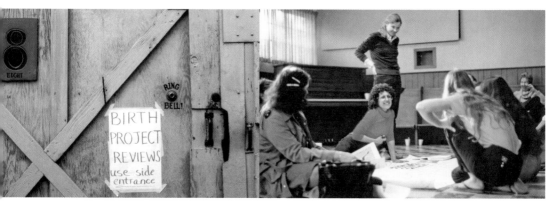

The door to our review meeting place and an early **BIRTH PROJECT** review, Benicia, CA 1980

my design or embellish it with thread and also how to bring her particular technical expertise into the framework of my image.

The first review in November had been limited to dealing with the most immediate technical problems. At this second meeting, Sally and I wanted to work with each needleworker in greater depth, so we had set aside an entire weekend. Because my studio was unheated and Benicia is quite cold and damp at that time of the year, everyone spent a lot of time huddling under blankets and sharing sweaters or jackets. By this point, there were already almost twenty projects underway, with still more qualified stitchers waiting. We invited everyone to attend, scheduling appointments on the half hour to look at works in progress and give out new pieces. By noon of the first day, we were already running behind.

I had anticipated that this January review would consist almost entirely of aesthetic issues. But we ended up listening to an endless list of reasons why nearly every woman had been unable to stitch regularly, which helped to explain the slow pace of the work. It seemed that once the women brought their pieces home, most of them had been faced with numerous obstacles, ranging from a lack of confidence in their abilities to resistance from their mates.

As I am accustomed to working a minimum of ten hours a day, I found it startling that for many of these women, devoting even a few uninterrupted hours a week to stitching was a challenge. For one thing, few had disciplined work habits, which I tried to address by suggesting that they commit themselves to a regular schedule, putting in at least ten hours of uninterrupted work weekly. When they objected, I explained that I could see when they put down their needles, because the stitching appeared disrupted.

In my opinion, the rhythm of the needle establishes an energy that is essential to the quality of the needlework; it is important to sustain this rhythm. That the interruptions in their stitching were evident to me shocked most of the women, as they seemed to think it made no difference if they worked for only moments at a time. And then there were their feelings of guilt: if they stitched, they felt guilty for neglecting their families, particularly their children; if they didn't stitch, they felt as if they were failing me. Add to this the demands of jobs, housework, and sometimes school,

and it was easy to see why so many of the women described themselves as stressed-out and conflicted.

Moreover, many of them confessed to a myriad of unrealized ambitions. Though some had studied art in college and even dreamed that they might become artists, after marriage and giving birth to children, they found themselves mired in domestic life, often taking up needlework in order to find some kind of creative outlet. And—as I suggested before—a number of the women saw themselves as ardent feminists and wanted to feel that they were making a contribution to expanded opportunities for women, particularly their daughters. Still others were devoted needleworkers and angry that needlework was not considered art. What they all had in common was a belief that by working with me they would be able to accomplish something important—something, all admitted, that they could never hope to achieve on their own.

However one wishes to interpret these self-evaluations, I have always believed in accepting people wherever they are in terms of their personal growth. This approach was basic to my teaching methods and to the principles by which the *Dinner Party* studio was organized. I was convinced of the importance of encouraging people to grow from a base of self-acceptance, for in my opinion, real empowerment begins by honestly confronting oneself. Though few would admit it, it is probable that most of the *Birth Project* participants hoped that, by working with me, whatever had blocked them from achievement would magically disappear.

Another significant hindrance seemed to be that most of the needleworkers were encountering the presumptions of their families, friends, and community that they should put their own needs last. We heard about angry husbands who expressed resentment that their wives wanted to stitch rather than spend time with them; about family members who came to town and assumed that the women would drop everything and entertain them; about calls from school-board members and PTA officials insisting that the women help with one or another seemingly pressing crisis.

The women also heard the accusation that they were being exploited because they were working on my images without pay. This was particularly ironic because much of the work that friends, families, and communities

expected them to do was lifelong, for free, and totally unacknowledged as labor. (And many women today are *still* toiling under the weight of the second shift, doing paid work, then coming home to more responsibilities.)

The needleworkers were baffled by the way the issue of exploitation kept coming up, no matter how many times they insisted that they did not feel exploited, that they had chosen to work with me, and that they *would* profit from any sales.

Unfortunately, as the project expanded, I was forced to recognize that my original idea about joint ownership of the finished needleworks was entirely unworkable for several reasons. The first was my decision to paint needlepoint canvases, including some of so large a scale that they could only be completed by groups of stitchers. The previous fall, some volunteers had asked about the possibility of working on group projects, something that, before I decided to take up needlepoint design, I had no plans to offer. But I reconsidered this idea, not only because of the tantalizing prospect of designing for needlepoint but also because I realized that such group efforts would allow more people to participate. However, as MaryRoss pointed out, it would be near impossible to figure out how to deal with multiple ownership of these group pieces if they were ever sold. Given that people move, change names, even die, how would we keep track of everyone, much less their heirs? (This was before the advent of computers.)

Even more of a problem was that the *Birth Project* was taking off so quickly. At that point the pieces were being financed one at a time. I was putting up all the money for patterns and fabrics, which was becoming quite expensive. If the project kept expanding, how would we be able to fund and also coordinate so many works? MR and I started thinking about putting the *Birth Project* under the sponsorship of Through the Flower, which would allow for the establishment of some formal organizational framework and would also open the possibility of accepting donations and applying for grants to underwrite the costs of materials.

Everyone thought this a good idea, even though no profit sharing would be possible in the event that any of the pieces were sold (this would be illegal when operating within a nonprofit structure). After some discussion, with everyone insisting that profit was not their motive in working with

me, we agreed to discard the original contract in favor of turning over all finished works to Through the Flower. In exchange, the corporation would raise money through donations and, hopefully, grants.

In addition to solving some of the practical problems, I hoped that donating all the work to Through the Flower would forever defuse the accusation of exploitation. Like all the needleworkers, I would be working as a volunteer. This meant that throughout the five years of the project, I would not receive any direct financial benefit, not even a salary. I would support myself as I always had: independently. Moreover, any money I earned above what I needed to live on was funneled back into the project, which prompted me to sometimes joke with the needleworkers that at least they didn't have to pay to work.

However, even this did not stop the misperception that the stitchers were being exploited while I was laughing all the way to the bank. As to grants, I must have been my usual naïve self; despite dozens of applications written by MR and a volunteer fundraising team, we would receive just one grant, which was for $6,000. Fortunately, we would be sustained by numerous private donations along with MaryRoss's personal generosity. Despite these various problems, one of the things I had learned about myself in the *Dinner Party* studio was that I am at my best creatively when involved in a large-scale, complex project that is challenging on multiple levels. This was certainly what the *Birth Project* was becoming, particularly once I decided that—because the subject of birth was so vast and (I thought) virtually unexplored—it seemed to lend itself to monumental scale. The *Creation* tapestry, being woven by Audrey Cowan, was 14 feet long, and the group needlepoints were of a comparable size. But as the project progressed, so did the scale.

Over the years, some feminists have argued that aspiring to the monumental is inherently a male trait. Why does this make me livid? Perhaps it is because, for centuries, women were unable to obtain the large studios, teams of assistants, and financial backing that allowed male artists to work in huge scale. After so many centuries of effort, women were finally able to break free from the constraints that had prevented us from reaching toward the highest levels of achievement, a struggle that, in my opinion,

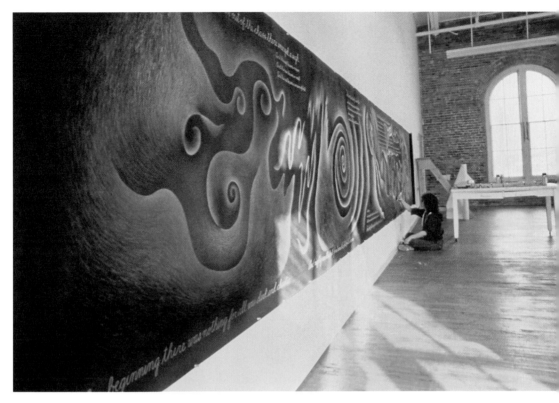

Working on **THE BEGINNING**, Benicia, CA 1984

carries with it a profound sense of satisfaction. Those who argued that the monumental was masculine seemed to be basically setting up yet another obstacle for women.

Traditionally in art, size has equated with importance, an association that I internalized. When visiting the studios of female artists in the early 1970s, I noticed (and commented upon the fact) that their work tended toward the small, as if they didn't consider their art worthy of the time and economic investment to render it in a larger size. It is only recently that I have begun to question this idea, initially when I found myself with limited studio space and financial means in the mid-1990s, and, again, later in my career, when I realized that a modest format could have a powerful impact, largely as a result of writing a book about Frida Kahlo with the British art historian Frances Borzello.[13]

I had first become aware of Kahlo's work in the early 1980s when I went to Mexico City in order to study the murals of Diego Rivera, thinking they might be instructive in terms of the *Birth Project*, primarily because, like him, I wanted to teach through art (in my case, about the realities of the birth experience). However, once I got to Mexico City, I found myself spending more time at the Frida Kahlo house than with the Rivera murals. Two decades later, while working on the Kahlo manuscript, I came to realize that the potency of her art lay in the imagery rather than the size. But when I was involved with the *Birth Project*, I was still under the impression that big denoted significant; thus my impatience with feminist theories about monumentality.

The Dinner Party taught me two important lessons about achievement: first, that many women have aspired to greatness; and, second, that real achievement is impossible without substantive backing, one example being that female artists in Mexico were not allowed to work on murals during the period when Rivera was receiving support for his. More crucially, I am simply unwilling to allow monumentality in every sense of the word to be considered the province of men. Why shouldn't women make monuments of all kinds? I would love to see them everywhere and, in fact, I feel deprived by the presence of so many memorials to and by men and so few devoted to members of my own sex.

Previously, I had been able to find a modicum of support for my work, but only up to a point. Unlike the artist Christo or the environmental sculptor James Turrell, an old friend, I have never been able to garner millions of dollars for my work, although, like them, I have had big ideas. So where did this leave me? On the one hand, I wanted to do another large-scale project. And although it was not my primary motivation, I also wanted to demonstrate that *The Dinner Party* had not been a fluke, that I could accomplish another such undertaking if that was what I chose to do.

But I did not have a large studio, staff, or funds. All I really had—in addition to MR's willingness to help and Sally's skills—was this enormous outpouring of interest from people wishing to work with me. The problem was that these offers came with a caveat: I would have to provide support for these women as they struggled to overcome the obstacles they faced. I

felt caught: I wanted to move ahead as an artist but realized that making this commitment to the needleworkers would mean that, in addition to making art, I would have to provide a level of emotional help that promised to be nothing short of exhausting. On the other hand, I felt as if I had no choice.

My troubled state of mind was reflected in a recurrent nightmare that I began having at this time. I would dream that a man was pursuing me, intent upon destroying me. I kept running and running but couldn't get away, waking up just as he was about to catch me. My anguish also manifested itself in an increasing obsession with my weight. Although I had never been fat, I had tended to be somewhat stocky until I started running long distances. Even though my many hours of exercise had whittled down my body, for the first time I became overly concerned with even minor fluctuations on the scale, castigating myself for eating when I was probably feeling uncomfortable about the high price I was paying for openly expressing my creative powers.

Making the level of commitment to the needleworkers that seemed necessary was frightening to me. I knew I would be confronted with what I had run away from when I left Chicago many years before. I had never wanted to be like my mother or her friends; I rejected an "ordinary" woman's life to fashion my own path. Moreover, given my personal history and my feeling that my mother had failed me when I needed her most, becoming so embroiled with women terrified me. But perhaps my reader is wondering how I could say this after spending so many years in the worlds of the china painter and embroiderer, not to mention the *Dinner Party* studio.

To tell the truth, I was a visitor in the world of women's crafts, intent upon transforming them into fine art. When I started *The Dinner Party*, I was part of the Los Angeles art community, and support came from both the art establishment and the many volunteers. Even though people worked in my studio, I had managed to stay aloof; in fact, doing so had probably been essential in order to get any work done. I still remember one woman becoming furious when I wouldn't let her tell me about her marital problems in the middle of a workday. Thursday nights were the only time I made myself available for such conversation, which was one reason I found our potlucks so tiring.

When I began work on the *Birth Project*, I had planned that people would work in their own homes—not only because this is what they preferred but also because I did not want so many people in my studio again. In order to preserve my psychic privacy during the *Dinner Party* days, I had closed myself off from many of the interactions that went on in the studio, which is probably why I had so often felt as if I were separate from the group even while I was its essential core. In structuring the *Birth Project*, I had not anticipated that because the participants would be taking my images into their houses, whatever was happening in their lives would impact so heavily upon the art.

The January review made it all too clear that I would have to become much more personally involved. But I am not a therapist, nor did I want to be; rather, I wanted to make art. It was a trade-off, and, in my opinion, once I made the commitment, I gave as good as I got. I brought to bear my years of work with women—my time in Fresno, CalArts, the Woman's Building, and the *Dinner Party* studio—along with my intuition, facilitating skills, and, more, my feminism, which shaped my notion that I have an obligation to extend my hand to other women.

However, throughout the *Birth Project*, I would feel torn, except when I was in the studio, when the long hours of creating would make this personal effort worthwhile. But one consequence of going forward with the project was that I had little time for a private life. When I wasn't making images, doing reviews, or counseling troubled needleworkers, all I wanted was to be by myself: to exercise, rest, or find a way to get my energy back. Not only was I emotionally exhausted most of the time, I was living almost entirely within the framework of a women's community. Still, my longing for male companionship would not subside. I kept wondering whether, at that moment in history, it was even possible to live a life such as mine, which was so devoted to women's issues and the expression of women's experiences, while being in a relationship with a man.

Over the course of the next few years, I would be involved in what might best be described as hand-to-hand combat with all the obstacles the women were facing. With Sally Babson as my ally, I pushed, supported, taught, and guided them. Sally occupied a singular place in that she was a lot

like the other needleworkers, facing many of the same external hindrances and internal blocks. But as she was to realize, she was far more capable, and stronger, than she had ever imagined. As she took on more and more responsibility for the *Birth Project*, becoming its official needlework supervisor, she discovered the range of her talents, which were remarkable, to say the least.

In addition to Sally, I was fortunate that MaryRoss brought her many resources to bear on the organization of the *Birth Project*. Without her support, neither the artist nor the project would have stood a chance. First, she helped me rent the apartment next door to mine, which she set up as a *Birth Project* office, instituting procedures that allowed us to find out more about prospective needleworkers than just their needle skills. We began sending out a "tell us more" letter, in which interested applicants were asked a series of questions intended to help Sally and me evaluate which women seemed the most prepared for all that working on a *Birth Project* piece had actually turned out to entail.

Sometime after the January review in Benicia, I presented a slide lecture about the *Birth Project* in Houston, showing some of the initial images and discussing my ideas for extending the participatory nature of the project to people in Houston and other parts of the country. When I asked how many folks would be interested in working with me, a hundred and fifty hands went up. MR offered to set up a space in a building next to her bookstore (whose operation she was slowly turning over to the staff), where the *Birth Project* could have an office and where everyone could meet with me for regular reviews. We thought we might set up other such regional offices as the project grew.

By the time of this talk, I had decided it was important to establish an archive containing information about worldwide historical and contemporary birth practices, a resource I could draw upon for image-making. (This turned out to be more difficult than I had anticipated, as many countries keep no maternal mortality statistics, much less information about the birth experience.) I also began to develop a questionnaire to collect information about women's birth experiences in other parts of the United States. Several women in Houston volunteered to compile such an archive and organize the mailing and collating of information from this survey. Thus began the

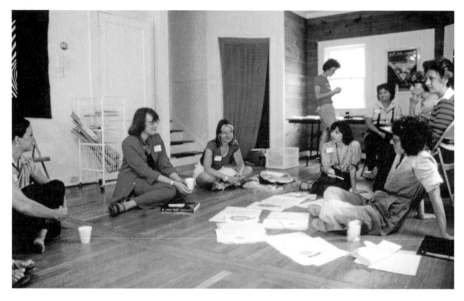

A **BIRTH PROJECT** review meeting at the bookstore of MaryRoss Taylor, Houston, TX 1981

research wing of the *Birth Project*, which was soon being coordinated out of both Houston and Benicia.

Before too long, both offices were beehives of activity, with their own volunteer administrators. MR was flying back and forth between Texas and California, overseeing everything. By late spring, there were almost fifty projects underway and many dozens of people involved. Some were stitching alone, others in groups, many were doing research, and a few were helping in each office. Two needlepoint groups had formed, one in Houston and the other in Benicia. No one had room in her house for the oversized, specially built frames on which the large canvases were to be rolled and worked. Instead, the groups set them up, one to each space, and before we knew it, there was a steady stream of visitors to both offices. It seemed that people just couldn't get enough of watching the stitchers select, strip apart, then insert and blend the brilliantly colored threads into the tiny holes that characterize eighteen-mesh needlepoint canvas.

Imagine just one project. A letter of inquiry arrives and must be answered with a request for more information about the person and her skills. Then, when this query is satisfied, a decision has to be made whether

to accept the stitcher and, if so, which project to assign her. For every application that is accepted, ten have to be turned away with polite letters of rejection or reassuring phone calls. The new needleworker has to schedule a time to pick up the piece and meet with Sally and me, or the work has to be packed and shipped to her along with extensive instructions. Materials have to be ordered and sent regularly, and reviews—either in person or through the mail—scheduled and recorded. Multiply the number of projects by fifty, double or triple the number of people involved, and add to this the continuous questions to be fielded, and one can see how intensely busy MR, Sally, and I became.

I don't know how MaryRoss was able to handle all the administrative work, which for some time she did almost single-handedly. As the project expanded, she was aided by a small staff, a few paid but most volunteers, who brought with them many of the same problems that so many of the stitchers had. Eventually, we established a sort of national creative network whose interactions were facilitated by the U.S. Postal Service, Federal Express, UPS, and AT&T. I shall always be thankful to MR because, like Gelon before her, she made it possible for me to bring all my focus to the array of artmaking problems associated with any major project, along with the particular challenges of the *Birth Project*.

In addition to creating images and supporting the needleworkers, I began to grapple with three issues that were crucial to the organization of the *Birth Project*: audience, context, and distribution (exhibition). Consciously or unconsciously, most artists shape their work for an intended audience, often envisioning (or hoping) that their finished art will hang in pristine galleries or airy white museum spaces. As long ago as the early 1970s, I had begun to think about the problem of audience. First, I tried to figure out how to bridge the gap between the art and feminist communities, both of whom were then seeing my work. My efforts to create art that was intelligible to both audiences had influenced the way I shaped *The Dinner Party*, whose popular success provided new and interesting challenges about how to continue reaching such a heterogeneous audience, which also began to include needleworkers and a more general audience that was introduced to my work by the popular media.

Art-world viewers brought with them a sophisticated aesthetic knowledge, along with a general ignorance about women's issues. Conversely, most feminists were less aware of how to decipher contemporary art but had a far greater understanding of women's circumstances and history. The *Birth Project* only compounded this problem in that it brought viewers from the alternative-birth movement, which included people who knew a lot about the subject but were not necessarily as well-informed aesthetically. At the same time, there was a whole generation of women who had experienced totally anesthetized births, with their male partners pacing outside the delivery room.

After *The Dinner Party*'s reception in New York, I had concluded that the reason I had come up against so much resistance in the art world was that there was no place for art that expressed so openly female a perspective. Since then, there has been a good deal of art exploring the world from a female point of view, but the hostility toward my work continued. As a result, I have come to believe that the more important explanation for the exceedingly vicious response to my oeuvre is that I rejected the coded language forms of contemporary art. In *The Dinner Party*, as in all my subsequent art, I deliberately discarded the visual posture and markings that typify most contemporary art.

To my mind, it was desirable to break out of the limits imposed by the overly abstract, self-referential, conceptual, or theoretical nature of the prevailing art language, because only by doing so could art communicate to a broad audience. Since the end of World War II, art has increasingly become the province of the cognoscenti, those few who are versed in the history of modern art. To people outside this world, a lot of contemporary art is baffling even when the subject matter might be of interest. Because the forms in which it is presented more often than not render the content obscure, the potential communication between artist and viewer is blocked.

When I went to Fresno in the early 1970s, I did so not only to create the Feminist Art program but to see if I could figure out how to reverse the process I had gone through in becoming a professional artist, which basically involved learning how to code my content—or, as I like to say, to talk in tongues. Although I had to do this in order to be taken seriously in

the L.A. art community, I later came to the conclusion that this coded art language is actually the symbol face for a set of values and attitudes that are *encoded into* these forms.

Although the art world might vociferously protest otherwise, it is actually a mirror of the larger society, in that it exists primarily to support the creation and distribution of art by and about men. There are individuals who dissent from this position, but they cannot single-handedly overturn a larger system, which promotes an art language that is in and of itself exclusive. Within this system, those in power are the "experts," adept at decoding this rather incomprehensible art language; and because the system is so undemocratic, their power is almost absolute. At least it was, until the advent of the internet, which has brought multiple voices into the art-critical conversation, though, even now, the *The New York Times* still maintains its dominance.

As to women artists, although many more are becoming visible through a flurry of recent exhibitions, it is crucial to understand that temporary shows do not represent substantive change. It is major solo exhibitions with accompanying monographs, museum acquisitions, and breathtaking auction prices that reveal what is truly valued by the art world. Many young women artists—who had been hoodwinked into thinking that everything had changed—were shocked by the September 2019 ten-year study by *Artnet News*, which demonstrated that "Just 11 percent of all acquisitions and 14 percent of exhibitions at 26 prominent American museums over the past decade were of work by female artists." And only 3 percent of the women artists were African American.

As *Artnet News* concluded, "These findings challenge one of the most compelling narratives to have emerged within the art world in recent years: that of progressive change, with once-marginalized artists being granted more equitable representation within art institutions. Our research shows that…this story is a myth." What this actually means is that the supposed improvements have not been translated into *institutional change*—without which change is transitory. This point was driven home to me by my study of women's history, particularly my realization that there have been numerous periods when women artists became prominent, only to have their work obscured later on.

This has been underscored lately by the ongoing "discoveries" of early women artists by various institutions around the world. The question is: Where have they been all this time? The answer is that they have always been there (as my research demonstrated); their work has just been systematically devalued. Because of my knowledge, I was always suspicious of claims that all was well in the art world. At the same time, my understanding of the critical importance of institutional change led to my insistence that *The Dinner Party* had to be permanently housed, so that it would not repeat the story of erasure that it recounts.

With *The Dinner Party*, one of my goals was to test the art world, to see if a female artist working at the level of ambition generally reserved for men would be equitably supported by the art system. The answer was a resounding NO. Even as thousands of viewers lined up to see my piece, major critics disparaged it. Then the museum system, instead of distributing the work to audiences eager to see it, refused to show it even while its financial benefits were being demonstrated. Even now, the art world—through exhibitions and the critical valuation and sale of art—is basically the only viable system for the distribution of art; hence its ongoing power. However, this system, which has always been small, cannot accommodate all the work being done by male artists, much less add to its already strained resources the art being made by their female peers, not to mention artists of color, of varying sexual orientations, or of a range of economic classes.

Because there are far too many artists for the tiny art system, dealers enjoy a buyer's market in which they seem to feel they can be as rude to artists as they choose, and we rarely protest. A particularly egregious example of the arrogance with which artists are treated is the Art Dealers Association of America's continued opposition to something that artists of all persuasions other than the visual enjoy; that is, royalties. As I am both an artist and a writer, the contrast between the art and literary worlds is quite apparent (and shocking) to me. Writers typically receive royalties on their published books, but when attempts were made to broaden the California Resale Royalty Act—which guaranteed California artists a meager 5 percent of the profit on any work resold for more than $1,000, dealers managed to prevent this from becoming part of the accepted procedure in the art

world. Then they managed to get the California law overturned. So, my reader might ask, what's to be done?

When I wrote *Through the Flower* in the mid-1970s, I thought I had the answer because at that time I was convinced that the egregious injustices I had encountered as a young woman artist in Southern California were all a consequence of my sex. Obviously there was some truth in that. As a result, I decided to help create an alternative female-centered art community, which provided numerous female artists a modicum of support, an appropriate context, and some degree of distribution of their work, notably through the Woman's Building, which Sheila de Bretteville kept going for twenty years. But eventually, like many other alternative institutions, it closed.

Since that time, I have come to understand that even though the art world is definitely tilted toward white men, the art system is unjust to both female and male artists—particularly if they are minorities. I now believe that real change will only occur when like-minded people come together to rethink the purpose of art, the relationship between art and community, and, most important, the audience for art. Are we just making art for the top 1 percent, those who constitute the major players on art-museum boards, the patrons and buyers for the "top" artists, and the participants in the global art whirl in which people fly around in their private planes from art fair to art fair, being feted and entertained at outlandishly expensive events where artists are trotted out to deliver remarks, explain their work, and mingle?

Recently there has been a trend to rid art institutions of "shady" money, but there isn't a lot of money that doesn't have nefarious associations. Rather than protests aimed at getting rid of unsavory patrons, I'd rather see artists use their energies to come together to try to find viable alternatives to the existing art world. This happens from time to time but so far has never managed to topple what has become a money-driven art madhouse where "content" and "meaning" are dirty words.

Long before *The Dinner Party*, I had begun to reject the traditional artist's role, in which an artist quietly works in her studio waiting to be discovered by one of the "experts" who will bring her work to the marketplace (in this case, the art world), and decode it (at least partially) while extolling its merits. In retrospect, it seems clear that I had never felt comfortable with

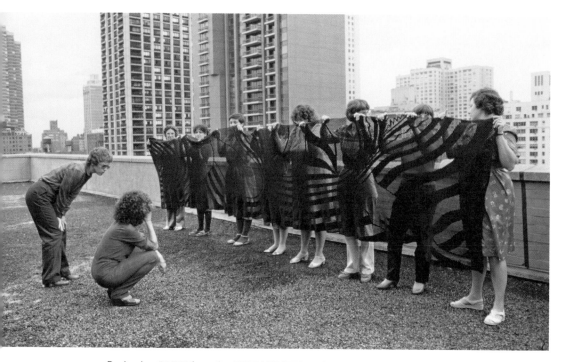

Reviewing **BIRTH** from the **BIRTH PROJECT** 1984
Filet crochet, 94 × 225 in, crocheted by Dolly Kaminsky, on the rooftop of a New York City
apartment ca. 1983–1984

the prescribed role of the artist, nor could I accept the narrow confines of art's place in contemporary society.

After New York and during the *Birth Project* years, I started to rethink everything, asking myself: Who is the audience for my art, and how can I best reach it while remaining true to myself, my ideas, and my aesthetic intentions? How can I exhibit (distribute) my work so that the varied audience I have built will be able to see it? And how can I ensure that my work will be presented so that its larger context will be clear? This last point was extremely important to me because I believed that another explanation for *The Dinner Party*'s impact was that viewers entered an installation that extended a feminist perspective into an environmental space.

That environment allowed women to experience their own bodies, their everyday work, their crafts, and their history in a public arena, sharing this space with others and thereby seeing themselves and their lives validated in

ways that were entirely new. For men, the viewing experience was every bit as unusual, albeit in other ways. For probably the first time in their lives, they were not at the center of the viewing experience. Not unlike the men who encountered *Womanhouse* in 1972, this was, for some, altogether unpleasant; for others, fascinating. However, all viewers experienced something unfamiliar, which was seeing female subject matter in a female context rather than in relation to male art history.

This issue of context is one reason that I understand the crucial importance of the National Museum of Women in the Arts (NMWA) in Washington, D.C., the only such institution in the world. Even though I prefer the idea of fully equalized institutions, it is still crucial to be able to see women's art in relation to women's own aesthetic history. Too often, women's work, if exhibited at all, is presented in a way that is decontextualized, leaving viewers with no understanding of where this work fits into the history of women's struggle for full personhood or women's efforts to arrive at an openly woman-centered perspective.

Place one or two paintings of women by men like Renoir, de Kooning, or David Salle in a room full of images of women by such painters as Artemisia Gentileschi, Berthe Morisot, Mary Cassatt, Suzanne Valadon, Käthe Kollwitz, and Frida Kahlo, and see how they fare. I would suggest that, at least to this viewer, the men's work—in contrast to the full human beings presented by the women artists—would look more like the projection of male fantasies, desires, or fears than the great icons they are touted to be. Again, this raises the issue: Who decides what art is and according to what criteria its quality is to be measured?

When some women argue that museums devoted only to the achievements of women ghettoize us, I wonder why they don't say this about all the museums that feature only, or primarily, work by men. To be kind, I might suggest that they have not counted the paltry number of women artists included in most museum collections or read some of the recent statistics like those I quoted earlier. But for those who have observed the reality of our exclusion and still put forth this argument, all I can say is that they qualify for the "I like their ghetto better than my own" award (though I, of course, long for the end of ghettos of any sort).

The same argument could be raised in terms of artists of color or artists of different sexual orientations and/or cultural, religious, and class experiences. A few museums—for instance, the Tate Modern and the Brooklyn Museum—have been experimenting with creating culturally specific installations or new ways of hanging their collections. But generally, it is still in context-specific institutions like NMWA, the Studio Museum in Harlem, or the Leslie-Lohman Museum of Art in SoHo, New York, that non-dominant perspectives in art become clear.

As I stated previously, one of the reasons for the art world's continued power is that there are so many artists and such a restricted number of outlets for serious art: a limited number of galleries connected to a small number of art magazines and a tight structure of critics, curators, and collectors. At base, the art world is actually a distribution system—the only such system, in fact, for serious art. I wondered: Could I develop an alternative strategy for the creation and exhibition of my work that would allow me to operate independently of this system that had proved itself so resistant—or, worse, hostile—to my art, while still having my work remain visible? For better or worse, it is within this system that art is ultimately validated.

I pondered what to do with the *Birth Project* once it was done: How would I show it? I definitely wanted to avoid another collision with the art world like what happened with *The Dinner Party*. At some point early in the project, I found myself in Hatch, New Mexico, whose claim to fame is its incredible green chili (one of the hallmarks of New Mexico cuisine). I can still remember a piece of raisin pie I had there, but a more vivid memory is of quilts hanging on a clothesline. "Aha," I thought, "that's it; images of birth popping up on clotheslines all over America with no one to stop them."

Although I still love this idea, it soon got "mugged by reality," as my weaver, Audrey Cowan, was fond of stating. What I mean is that as soon as I began to spend countless hours hand-painting needlepoint canvases or carefully transferring and painting my images on assorted fabrics—not to mention the hundreds of hours invested by needleworkers—they became unsuitable for the casual display I had initially envisioned. Over the subsequent years of the project, I became increasingly interested in combining painting and needlework, leaving large areas of the pieces unstitched so

that the fusion of paint and thread remained visible. The resulting works, though ever more visually appealing, became ever more needful of proper display. One could say that I was trying to reconcile two basically opposing impulses: democratizing art vs. creating objects of beauty.

I cannot claim to have solved all the issues I have raised; rather, I have tried to point out some of the challenges of being the type of artist who wants to make art more widely available while also understanding that the very nature of much of the art I have created limits it to a rarefied viewing environment. Nonetheless, I believe that with the *Birth Project*, MaryRoss and I devised a flexible exhibition system that allowed a wide range of both viewers and venues to engage with the work. And who knows, perhaps some of my questions will spur younger artists to explore paths that I was not able to imagine.

EXPANDING MY GAZE

Neither MR nor I remember exactly when we made the decision to rent one of the large buildings in Benicia's old industrial park for the national headquarters of the *Birth Project*; all I know is that the small apartment that housed the West Coast office was overflowing, and we had realized that it would be too expensive to operate multiple regional centers. Instead, we decided to consolidate the organization in California.

Building 57 was a spacious, two-story, 11,000-square-foot structure that had originally been part of an old army installation. The military had vacated the area in the 1950s, and the vast, cavernous structures had gradually been taken over by a variety of light manufacturing industries. Then, slowly, artists began to move in, attracted by the large spaces and cheap rents. Our building's light-filled upper floor would provide me with a huge, gorgeous studio, a tiny living loft, and an attractive drawing studio. The second floor would also afford a large workroom for Sally, with gigantic tables and floor-to-ceiling storage cabinets. Here she would prepare the pieces to be sent to the needleworkers, and here we would hold reviews. On one wall, my thread palettes would be hung in preparation for color-coding the various works.

The downstairs space would house the office, work and meeting areas for group projects, my library of books by and about women, and a large gallery. In addition to a changing exhibition program, MR and I intended to offer lectures, workshops, and public events, hoping to attract many visitors to Benicia and to thereby interest them in supporting Through the Flower. By October 1981, the building was ready, and we held a grand opening. Hanging on the entrance wall was my large painting *Through the Flower*, graced by a handwritten phrase welcoming everyone to the corporation's

Building 57, Benicia, CA. National headquarters for the **BIRTH PROJECT** 1983

official new space. And the first finished *Birth Project* works were displayed in our brand-new gallery.

Hundreds of people streamed into the building to watch a slide show about the project, examine the needleworks, rummage through the materials for sale in the gift shop, and check out books from the library. As I watched the crowd milling around, I thought about the time that had passed since *The Dinner Party* had closed in San Francisco more than two years earlier, what a dismal period that had been, and how much effort it had required to rebuild my support structure. I was lucky to have MR at my side, for throughout the years of the *Birth Project*, she was my partner, my patron, and my best friend.

Shortly before the public premiere of Building 57, I left Benicia for Chicago because *The Dinner Party* was scheduled to open in my hometown. It was being brought there by a grassroots effort spearheaded by the Roslyn Group for Arts and Letters. Gelon had been working with them for many months while they raised money and searched for a site. Though Chicago's Museum of Contemporary Art was supportive of the piece, it didn't have the space to show it. Instead, the exhibition was held at the old Franklin Building in the South Dearborn area, and both the site and the neighborhood were quite run-down.

The piece was presented on the top floor of the building, with the documentation show, banners, and *International Quilting Bee* in a ground-floor space, next door to which a shop was set up to sell arts and crafts items by local women artists. The raw upstairs space had a huge glass ceiling and no floor to speak of. Fortunately, the developer who owned the building was willing to use his own construction crews to renovate the space, which was a formidable task.

Although I found this developer incredibly attractive, going so far as to indulge in a brief fling, I soon got into trouble with him. *The Dinner Party* requires a darkened space, and the guy was less than enthusiastic about blacking out the gigantic skylight, because he hoped to turn the upper floor into a restaurant after the show was over. (Later, when this plan didn't work out, he put the building up for sale with the enticement that people might enjoy living in apartments where a famous work of art had once been exhibited.)

The Roslyn Group was not happy that I insisted on covering the skylight; in fact, I bumped heads with them more than once, particularly with the group's leader. Though the exhibition proved to be a tremendous success, the recollections of the Chicago show that mean the most to me are connected to my family. A few hours before the show premiered, my cousin Howard called. He wanted to hire a limousine to ferry close family members to the opening and wondered if this would seem pretentious. He reminded me how much fun it was being chauffeured to the Brooklyn Museum opening in a stretch limousine, adding that the only time our family rode in limos was on the way to funerals. His one proviso was that the car had to be white, as "black would be too reminiscent of all the deaths our family suffered over the years."

I was touched by his suggestion and thought that my mother, whom I'd flown in for the opening, would get a kick out of this, as she always said she loved "to be treated like a queen." I had hoped Ben would come for the opening, but he had declined on the grounds that he couldn't afford the airfare and was too busy with his pottery. My mother; Howard and Arleen; Howard's mother (my Aunt Enid); cousin Corinne (Howard's sister) and her husband, Gene; and I squeezed into the stretch limo, which

went speeding down the Outer Drive so fast that the driver got stopped by the police. Then the cop took so long writing the ticket that we were late for the opening.

Although my mother had attended the original premiere of *The Dinner Party* in San Francisco, I thought she would probably enjoy the Chicago event far more, because I had invited so many of her friends along with the remaining members of my father's family. Throughout the evening, I could see her beaming as they crowded around her. Afterward, Howard hosted a large banquet at a Chinese restaurant. He and Corinne told me how proud they were of me, saying that I was the "pearl" of the oyster that was our family, in that some of its best traits seemed to have come together in me.

In addition to the joy their words brought me, I was also deeply gratified by another event: touring the show arm in arm with my old art teacher, Manuel Jacobson. By then, he had retired from teaching at the Art Institute's Junior School, where he had trained numerous well-known artists, though he would never admit how many or who. I can still hear him confiding, in his soft and distinctive voice, that he had always known I was destined to do something important.

Shortly before the opening, I appeared on the Irv Kupcinet TV show. He was a well-known figure when I was growing up, beloved like another famous Chicago broadcaster, Studs Terkel. In what still strikes me as an ironic twist of fate, I arrived at the TV station to discover that one of the other guests was Roy Cohn, the lawyer best known for his association with McCarthy during the worst days of Red-baiting and, more recently, for his mentorship of Donald Trump.

An old-time liberal, "Kup" knew nothing of my background and probably thought I was just a hometown artist with an interesting art show. As is wont to happen, the men talked to each other almost as if I weren't there and were taken aback when I interrupted a discussion of the Rosenberg trial. For those unfamiliar with this event, allow me to say that Cohn was the prosecutor in the questionable legal proceedings that resulted in the execution of both Julius and Ethel Rosenberg as Soviet spies. Revelations in 2008 and 2014 indicated that Julius was probably guilty, but Ethel's

involvement remains unclear. In addition to his role in the trial, Cohn was the chief architect of the McCarthyism that swept the country in the 1950s and ensnared many people, including my father.

I don't remember exactly what I said, though I am pretty sure I stated that McCarthyism represented a shameful period in American history. Before long, Cohn and I were shrieking at each other, while Kup's wife was standing in the wings offstage, yelling, "Give it to him, girl, give it to him!" At any rate, I must have done a good job defending liberal causes in general because, for the next few days, people stopped me on the street and thanked me for what I had said. But flattering as their comments were, what meant more to me was the praise of my family, who told me that I had vindicated my father in standing up to this loathsome man.

A few days after the opening, I did something I had long wanted to do. Before going to Chicago, I had asked Howard if he would take me to my father's grave, which neither Ben nor I had ever seen. My relationship with my brother had remained strained, and the fact that he lived so far away didn't help. He came to Los Angeles to see our mother about once a year, and I would always try to meet him there in hopes of establishing some better communication. But he would become defensive whenever I started to discuss our childhood and how we had come to be so alienated. I always ended up feeling frustrated because he seemed unwilling to make any effort to resolve the considerable tension that remained between us. Yet he would routinely ask me to visit him in Japan. I never wanted to go, as it seemed so distant and foreign. In retrospect, I wish I had agreed to witness his Japanese life, since it was important to him and it might have helped our relationship.

My mother was not at all happy about the cemetery visit. When I asked her to come, she reluctantly agreed, saying that she had "no need to do this." When we arrived, I became upset that the grave was overgrown and decided to start paying for in-perpetuity care. My mother walked away while I knelt down in front of the simple marker and spoke to my father, then cried and cried. I told him about all that had happened with *The Dinner Party* and my confrontation with Roy Cohn and how I wished

he were alive to see how I had turned out. But I also told him how angry I was that he had made me believe I could be loved for being who and what I was, which didn't seem to be true.

Even though I knew full well that he couldn't hear me, saying all this out loud at his grave helped me no end, as did being able to finally release my long-held grief. Despite my mother's refusal to fully share this experience with me, I found myself able to forgive her for what she didn't—or couldn't—do for me at the time my father died and during the terrible years afterward.

I returned to Chicago on several occasions, the last time toward the end of the show. It was in the dead of winter, but the exhibit was mobbed. In fact, viewers were packed three deep, many carrying large handbags and wearing bulky backpacks. I complained to the guards that this was potentially dangerous for the art but was told that, when people were asked to check their belongings, they refused on the grounds that "this wasn't a museum." As glad as I was of *The Dinner Party*'s popularity, I was also concerned that such mass viewing—in addition to the possible dangers it posed to the work itself—did not seem to allow the kind of one-on-one relationship with art that, in my opinion, yields the greatest rewards.

With this in mind, I returned to Benicia and to long months of work in the studio, preparing *Birth Project* images to be sent to the needleworkers while pondering the best way to achieve both a broad audience and a more intimate viewing experience. I wanted the art to be seen by a diverse range of viewers because I was intent upon trying to extend the process of democratization exemplified by both the creation and (although I had not planned this) the distribution of *The Dinner Party*. With the *Birth Project*, the images were being executed or embellished through a national network of participants. I wondered whether I could figure out a way for *Birth Project* work to be widely exhibited as well, easily displayed and at the same time structured to allow the type of viewing I deemed most desirable.

I kept thinking about how wonderful it would be to see images of birth and creation cropping up on clotheslines all over America—and how unstoppable this method of exhibition would be. I loved the idea of art (or

craft, as in the case of the quilts I'd seen in Hatch, New Mexico) hanging in the middle of communities where the work could be viewed by just about anyone. As I've explained, the *Birth Project* was originally conceived of as a series of basic patterns to be translated into fairly straightforward needleworks that were intended to be sturdy and, hence, could have been presented rather informally, if not literally on clotheslines. But as the project, and the techniques involved, grew more complex, this means of exhibiting the works became less feasible.

I decided that one way of accomplishing some greater democratization while also meeting my own creative needs would be to offer the *Birth Project* art for exhibition in a variety of venues, depending upon the nature of the work and the particular site. Instead of becoming a single mammoth work, the *Birth Project* might be better organized as a series of individual pieces of varying character that could be viewed one-on-one while also being monumental in overall concept. As I became fond of saying at the time, if a hundred works were shown in a hundred venues, each to a hundred viewers, one million people would see the *Birth Project* art.

To help develop such an exhibition concept, I turned to my friend Stephen Hamilton, who had worked on the Chevron-sponsored *Creativity* show and was an experienced exhibition designer. He agreed to moonlight from his full-time job to work on the *Birth Project*—like most of us, as a volunteer. Stephen brought a different sensibility to exhibitions than that which prevails in the art world. In contrast to the one-time, labor-intensive installations that are seen in most galleries and museums, commercial exhibition designers tend to think in terms of flexible, reusable systems and presentations that can be understood by a wide range of viewers. His approach was perfect for my purpose, which was to make the art accessible, both physically and aesthetically.

Because of Stephen's comment years earlier about women not adequately documenting their work, from the beginning I planned that the *Birth Project* would be thoroughly chronicled, not just the process of creating the art but also the nature of the imagery, the needlework techniques employed, the historical conditions surrounding birth, the birth experience itself, and something about the needleworkers' lives. With that in mind,

we involved photographers from the start of the project. As my exhibition ideas evolved, so did their roles.

When we moved into Building 57, we set up a working darkroom and photo archive, which was run by Michele Maier, who moved to Benicia from Houston because of her interest in ensuring that the *Birth Project* would be properly photographed. This would involve shooting all the finished works after they arrived in Benicia and also recording all the reviews. Later, when Sally and I traveled around the country in an effort to meet all the needleworkers and see them in their homes, Michele went with us to take photographs.

Despite my apprehension, there were definite rewards in getting to know the stitchers, and I appreciated the graciousness with which we were welcomed into their homes. One thing that was striking was how many of the women held what would be called feminist values. In fact, it seemed as though many of them had forged lives that reflected a set of human values not dissimilar to my own. It was just that they had done this in private, whereas I was struggling to bring these ideals into the world outside.

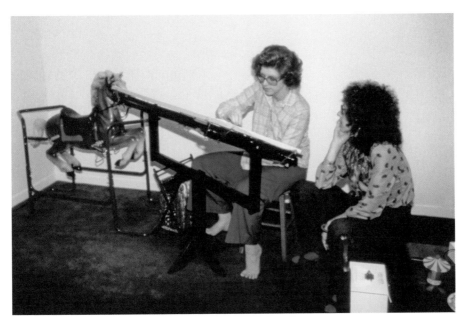

Working with Jane Thompson at her home in Houston, TX ca. 1981–1982

Entering the stitchers' worlds was sometimes unnerving, as when I first saw a *Birth Project* piece in the middle of a room crowded with toys, right next to a child's rocking horse. However, most of the stitchers were insistent upon working in the center of their household environments rather than shutting themselves off in a clean white studio, which of course is what I was used to. As I continued visiting participants' homes, I began to question my assumption that art needed to be something so apart; perhaps it would be better if it were more integrated into the fabric of existence in both the public and private spheres. Eventually, I became convinced that the Romantic notion of the "alienated artist" only served to further ostracize women from the artistic tradition, inasmuch as so many women (including my stitchers) were firmly rooted in domestic life and unwilling to relinquish the many satisfactions it provided them.

Given the thousands of letters of interest we received from potential volunteers over the course of our work on the *Birth Project*, it could have gone on for years. But by mid-1982, when there were over one hundred needleworks in progress, it became clear that it would be impossible for Through the Flower's small staff to handle any more, which meant I would have to stop initiating any new projects beyond those that were already promised to waiting stitchers.

All in all, we started about one hundred and fifty pieces. Some ended because the needleworker had boasted of skills she didn't possess or was unrealistic about what she could actually do. Others blew up through misunderstandings or unresolved conflicts. A few collapsed because they were badly conceived, and not even the most able needleworker could compensate for my mistakes. But the single greatest reason that projects failed was that the stitcher could not resolve the contradiction between her personal aspirations and the expectations placed upon her by partners, children, and society.

As a result of the *Birth Project*, relationships changed or ended; priorities shifted or the piece was returned; the needleworkers learned to stand up for themselves and their beliefs or they failed to complete the work. Out of the projects we started, one hundred were what I consider to be victories. Pieces were executed in homes all over America, where they

were sometimes worked on for as long as three years. According to many of the stitchers, the presence of these needleworks in progress made their houses the focal point of attention for family, friends, neighbors, and even journalists. Many reported being interviewed for local newspapers, and by 1985, when the last *Birth Project* piece was completed, there had been numerous articles in papers all over America, and many of the stitchers had become local celebrities. This strikes me as a further indication of how empowering art of meaning can be.

In terms of the exhibition of the finished pieces, I eventually decided that the needleworks would be best understood if they were contextualized so that viewers could develop some sense of what lay behind each image—experientially, aesthetically, and technically. I thought it crucial to emphasize that each finished work was a triumph of sorts, having been wrested from lives in which stitching had to be fitted into the seams and cracks of what was often an overwhelming array of responsibilities.

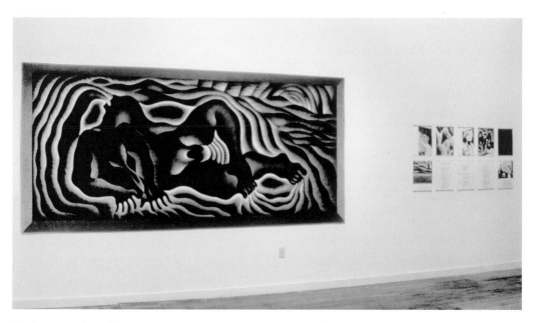

EARTH BIRTH from the **BIRTH PROJECT** 1983. 60.75 × 132.25 in. Quilting by Jacquelyn Alexander

225

The sum total of my ideas for the exhibition of each piece ended up in thick folders full of historical information, correspondence, review notes, sketches, notations, translation samples, information about each stitcher and (if appropriate) her family, and documentation of the work in various stages, both in progress and completed. Whenever a piece was finished (and sometimes even before), Stephen and I would sit on the floor of my studio and spread out these various materials, searching for the particular "story" each project seemed to convey. Then Stephen would start to organize what often seemed like an overwhelming and chaotic amount of "stuff." I always marveled at his ability to do this, and I learned a great deal from him.

At first, Michael Cronan (the father of the baby whose birth I had witnessed and a skilled graphic designer) worked with us to establish a simple visual presentation format incorporating text and photos into laminated panels that could be easily affixed to a wall (I later decided to add stitching samples and some of my drawings). But it was Stephen who, over the course of several years, would turn the extensive documentation of dozens of works of art into a series of self-contained exhibition units that could be installed multiple times. What we eventually came up with was a kind of mix-and-match exhibition program in which we could continually combine the exhibition units in different ways, depending upon the venue.

Even before we opened the Benicia building, we were receiving requests for shows of the *Birth Project*, and we used our own space and some of these early exhibits to try out our installation systems. After a while, we arrived at a process of asking potential exhibitors to submit floor plans of their spaces along with descriptions and photographs of the venue's physical conditions. Based upon these, we would choose the work that seemed most appropriate, and Stephen would do an installation drawing for the show, which we would send out even before we shipped the art. Every needlework was framed, either with fabric borders or, if fragile, in wood. Each of these was placed into a specially designed packing system made of a breathable plastic—ingeniously designed and fabricated by Sally—and then crated. A second, smaller crate held the panels and ancillary materials, including information that contextualized the needlework and credited everyone involved, along with installation instructions, condition report

materials, brads for hanging the panels, and even white gloves for handling the needleworks.

This approach made it possible to put on shows in many different spaces: museums; university and commercial galleries; hospitals; women's, maternity, and birthing centers; even storefront spaces. No venue was considered too humble as long as the show's organizers could meet certain criteria, established in relation to the particular characteristics of the work to be exhibited and the space. For example, a small birthing center with fluorescent lights and no security could be assigned durable quilts or embroidered multiples, while a gallery with track lighting and an alarm system might get the more delicate and valuable art.

Between 1981, when we inaugurated Building 57 with a show of the first finished pieces, and 1987, when we ended the formal tour, Through the Flower organized over one hundred exhibitions. During the height of our exhibition program, between 1985 and 1987, there were sometimes as many as five shows a month. These were all handled by MaryRoss, first alone, then aided by a full-time curator—Patricia Reilly—and a part-time registrar, whose salaries were paid through exhibition rental fees. Early on, we established a sliding scale in order to accommodate the constraints of different communities. These fees helped not only to pay salaries but also to defray some of the costs of organizing this complicated exhibition program.

Although our viewing audience would never attain the goal of one million, it did reach 250,000, and from the start, the audience response was overwhelming. As with *The Dinner Party*, we continuously heard that seeing the *Birth Project* had changed the viewers' lives. Some show organizers reported large crowds in spaces that had never drawn more than a few visitors. There were memorable opening nights, such as the one in Minnesota where, in the middle of a freezing winter, the gallery lost both electricity and heat. Undaunted, the opening-night crowd went back to their cars, returning with blankets and flashlights, determined to see the show. In Alaska, a large exhibition traveled to both Juneau and Anchorage. It proved so popular that the sponsors applied for and received grant funding to send a smaller show to all Alaskan towns with at least 5,000 inhabitants.

In 1985, Through the Flower inaugurated something we called our Permanent Placement Program, aimed at placing *Birth Project* work in institutions around the country. We would eventually present as gifts or on extended loan over forty exhibition units to museums, university galleries, Planned Parenthood offices, women's organizations, hospitals, and birthing centers.

For a long time, we had no idea what impact *Birth Project* pieces had on the institutions that had received them as gifts. When I lectured, I sometimes joked that the one outcome I had not thought about in relation to our Permanent Placement Program was museum basements, having heard innumerable stories about work by women being lost, misplaced, locked inside unopened storage facilities, or even dumped into garbage cans. In 2014, Through the Flower arranged for Dr. Viki Thompson Wylder (a scholar on *The Dinner Party* and the *Birth Project*) to do a follow-up study with some of the institutions.

Her findings were both gratifying and heartwarming; for instance, *Guided by the Goddess*, a 14-foot piece combining sprayed paint, pulled thread work, appliqué, and embroidery, was gifted to the Hartford Seminary in Connecticut. Apparently, they established a permanent installation in a space where Christian, Jewish, and Muslim students gather to discuss the "feminine divine," which—for some young people—is an entirely new concept. Other examples included several universities that, based on widespread interest in their *Birth Project* work, were able to convince reluctant administrations to create museums or installation conditions consistent with the conservation needs of textiles. Over and over again, Viki was told how important the works had been in opening new avenues of dialogue. I must admit that I have never been so happy to have been proven wrong.

Throughout the years of the creation, exhibition, and placement program of the *Birth Project*, *The Dinner Party* continued to travel. I missed its opening in Montreal due to illness, but in the spring of 1982 I went to Toronto, where the piece was being exhibited at the prestigious Art Gallery of Ontario. (This was one place where a powerful art critic, in this case John Bentley Mays, embraced the work.) In conjunction with the opening, a journalist who had written about me and was married to a senator serving

in then–Prime Minister Pierre Trudeau's cabinet, organized a private viewing and supper for a select group of prominent people, including the prime minister as well as the writer Margaret Atwood and her husband.

In the middle of its Canadian tour, *The Dinner Party* returned to the States for its exhibition in Atlanta, which was held in an old Art Deco theater. It was brought there by a now-defunct organization whose director proved to be less than reliable. This was the only venue that was not financially successful, through no fault of the piece. One disaster after another seemed to befall the organizers, including a rainstorm so ferocious that it caused the ceiling of their offices to collapse, thereby ruining their planned 60,000-piece mailing announcing the show. The highlight of the opening for me was that then–Mayor Andrew Young attended and presented me with a citation. Even better, his marvelous wife, Jean, toured me around the city the next day, taking me to a restaurant that served the most memorable sweet potato pie. I shall always remember this place, and not just for the food: It was called the Beautiful Restaurant and was run by the Perfect Church.

In June 1982, between the Toronto and Atlanta exhibitions, we held what was called the Big June Review in Benicia. More than seventy *Birth Project* participants showed up. Folks started arriving on Thursday for what were to be three jam-packed days. In addition to the reviews, which Sally and I did for many hours each day, there were various other activities, both planned and unplanned, including slide shows, lectures, and all-night talk sessions. There was an incredible sense that we were sharing so much, not just the art but ideas, hopes, and dreams. There was also a strong feeling of community (although, once again, I felt both part of and separate from it).

Loretta Barrett flew in to discuss publishing a *Birth Project* book and to meet Stephen, as I had proposed that he be hired to do the design. Even though he had never done a book, he was so gifted that I felt confident he could design just about anything, and his familiarity with the project would be of great benefit. Somehow, in the middle of all the commotion, the three of us were able to carve out some time to make preliminary plans. We soon came up with a concept that might best be described as a pieced quilt, like the *Birth Project* itself, made up of disparate parts, but with some visual relationship between the book's format and that of the exhibition units.

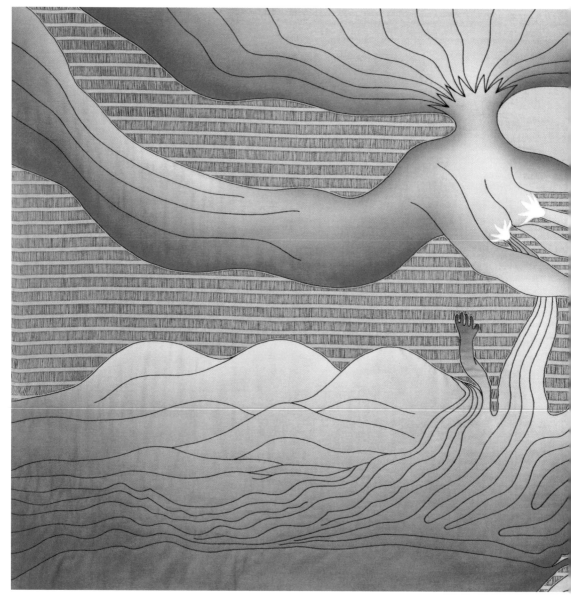

GUIDED BY THE GODDESS 1983
Sprayed fabric paint, embroidery, and pulled thread work, 54 × 107 in (137.16 × 271.78 cm)
Needlework by Marjorie Smith
Collection of Hartford Seminary, Trinity College, CT

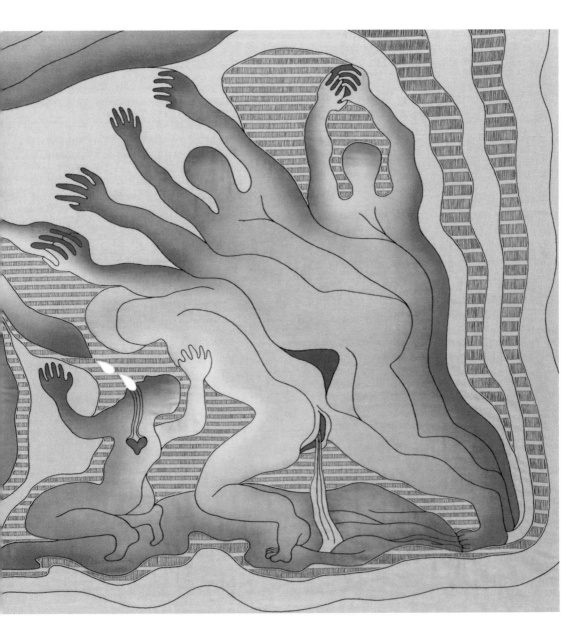

As energizing as the weekend was, its most salient aspect, at least for me, was seeing so much *Birth Project* art at one time. People pinned their pieces up on every available wall; everywhere one looked, there were needleworks in all stages of completion. For the first time it was possible to see a wide array of images and techniques together; even Sally and I had never viewed

so much work at once. Because the weekend was so frenetic, it was only afterward that I was able to think about what I had seen. In my mind the Big June Review was the culmination of the *Birth Project*, in that I realized that the work we had sent out all over America had definitely taken hold.

However, I was disheartened by what appeared to be a lack of visual acuity in some of the pieces. I was also upset by the realization that once I stopped generating new projects, it was the needleworkers who would enjoy the process I liked the best: that is, the long hours of bringing the images to life. But most important, I suddenly recognized that I was becoming restless with being so focused on female subject matter.

I had spent more than fifteen years in a long search for my identity and heritage and felt that I had answered many questions about what it means to be a woman, at least to my own satisfaction. Moreover, I was beginning to feel critical of an aesthetic fixation upon the female. Men painted women, women painted women—it was as if the female were everyone's love (or hate) object. I wanted to move beyond this obsession, "beyond the flower" of femininity, as it were. Problem was, the Benicia building was full of the *Birth Project*, and there was no place for me, either psychically or physically, to take up new work.

I decided to take advantage of the fact that the artmaking phase of the *Birth Project* was coming to a close by establishing a schedule that would allow me to start some new work. I planned to complete the last promised needlework projects; set up a stricter review schedule (I often veered away from it if someone had a piece she wanted seen); do exhibition preparation in short, focused periods; work on the *Birth Project* book at fixed intervals; then go away for a month or six weeks at a time whenever I could. I thought I might rent a house in a place I had visited and especially liked—Galveston, or Port Townsend on the Northwest Coast's Olympic Peninsula—where I could be alone.

By then, I was beginning to think about examining the gender construct of masculinity in much the same way as I had been investigating what it meant to be a woman. Once again I was interested in dealing with ideas I had rarely seen represented in art—specifically, how some women, myself included, perceived men. Over the years, I had listened to women share their

fears, rage, and frustration about how men acted both in private and in the world. Yet I had seen few images that presented this same level of truthfulness. I knew that I didn't want to keep perpetuating the use of the female body as the repository of so many emotions; it seemed as if everything—love, dread, longing, loathing, desire, and terror—was projected onto the female by both male and female artists, albeit from different perspectives. I wondered what ideas I might use the male body to express. Also, I wanted to understand why men acted so violently. As MR has often said, I think through making art.

It seemed fairly obvious that this type of inquiry would not lend itself to a collaborative project, at least not one involving married women, who had always constituted the bulk of my volunteers. If their husbands had become upset about their working with me on the *Birth Project*, I could not imagine them taking kindly to images of men that might involve a critical gaze. Two other issues leading me away from collaboration were my concern about a lack of visual acuity similar to what I'd seen with some of the needleworkers and my regret about giving away any part of the joy of bringing images to life. I guess this was rather a momentous step, after so many years of doing collaborative projects with primarily women's communities. But I did not consciously recognize it as such. In my mind, I was just doing what I had always done, which was to follow my muse wherever it led me—this time, seemingly, back into private artmaking.

In retrospect, it seems somewhat puzzling that, in starting to formulate my next body of work, I apparently paid little attention to the issues I had so carefully addressed when embarking on the *Birth Project*: audience and distribution. I made the assumption that the audience I had built would follow me wherever my new ideas took me, not realizing that not everyone was ready to move "beyond the flower." Moreover, even though I was prepared to show whatever I created in the Benicia gallery, I hoped I would have other exhibition opportunities. I hadn't discarded my long-standing desire to be accepted by the art community; instead, I had designed numerous strategies to compensate for its rejection of my work, all the while believing that, eventually, this would change.

In November 1982, I was brought to England for the publication of *Through the Flower* in the U.K. In addition to lecturing to large crowds and

media interviews, I also met with some folks who were interested in trying to bring *The Dinner Party* to England. We visited several alternative sites because apparently there was no chance of museum sponsorship, which was disappointing but no big surprise. I also learned that Johanna Demetrakas's film *Right Out of History: The Making of Judy Chicago's "Dinner Party,"* had aired on BBC television, which raised my profile in Europe. It was extremely gratifying to realize that my work was becoming so widely known.

Although I'd been to Europe several times, I'd never been to Italy, where I traveled after England. I met up with MR, and together we visited some of its great cities. It was amazing to finally see some of the works I had studied in art-history classes, especially the major Renaissance paintings. Looking at their monumental scale and clarity led me to cast my examination of masculinity in the classical tradition of the heroic nude and to do so in a series of large-scale oil paintings. Though I had used oils in college, I had hated the texture of the paint and, even more, the smell of turpentine. I was determined to overcome my aversion, however, because I was convinced that this was the right medium for such images.

It occurred to me that, along with modern society, the Italian Renaissance had also given birth to the contemporary notion of masculinity, which may be said to date back to the moment when Leonardo configured his version of the Vitruvian Man, putting forward the idea of "man as the measure of all reality." Although this particular image was modest in scale, its implications were vast, for it presented the male as the center of the universe. I wished to both examine and challenge this construct in a visual form similar to the one in which it had been originally formulated—that is, through a heroic mode.

I returned to Benicia, having made the determination that I needed to hone my drawing skills. (Designing for needlework requires a generalizing of form that seemed inappropriate to what I wanted to do.) I began to work one-on-one with a male model, finding it absolutely fascinating. It was remarkably different from drawing from a woman, which was what I had done in most of my figure-drawing classes. Whereas female models were totally exposed, the few times there had been male models, they were required to wear jockstraps, justified by the explanation that, if naked, they

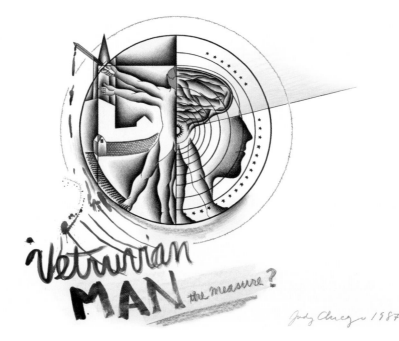

VETRUVIAN MAN, THE MEASURE? from the **HOLOCAUST PROJECT** 1987
Prismacolor, ink, gouache, and micrography on paper, 29.5 × 41.25 in (74.93 × 104.78 cm)

might get erections. At any rate, there was a distinct energy, gesture, and attitude in the male body, and also a strange sense of personal power in that I could render the figure any way I wished. At first this scared me, but then I thought: This is a power men have had for centuries—the power to represent women however they wish. If they could handle this, I saw no reason that I could not learn to do the same.

Before long, I found myself thinking about the difference between men as individuals—the husbands, fathers, or friends who could be so kind and loving—and the patriarchal structure of male dominance, which, to my mind, is a global set of values that benefit all men. Curiously, it seemed that most of the men I knew found it difficult to see themselves as acting not just as individuals but also as members of a gender. It was almost as if the kinds of insights that women had arrived at through feminism were still

entirely foreign to most men, notably that the construct of gender greatly influences and in fact limits one's options. I was interested in exploring how "being a man" shaped a male person and the seeming relationship between the concept of masculinity and male violence.

Of course, most men, along with the rest of society, are trained to see white men's experiences as the default mode, rather than influenced by gender and race, like everyone else's. This limited perception was reflected in the fact that, when I went to the library to research gender, the only books that appeared were those on women—as if women have gender and men do not. Since that time, gender studies, queer theory, and masculinity studies have developed, a welcome and overdue change.

I was convinced that one reason men could act so destructively is that in "becoming men" they are required to disconnect from their feelings of vulnerability, a process that begins in childhood when little boys are taught that it is "unmanly" to cry. I wondered about the emotional consequences of such a process and wanted to examine the connections between this rejection of vulnerability and men's capacity to rape women and molest children (although some women commit sexual abuse, it is predominantly men who are guilty of these crimes). The sheer act of thinking about all this terrified me, because it brought me in touch with my rage at how too many men act. I remembered how fearful I was when I wrote the *Cock and Cunt* play and worried that I would be horribly punished if I honestly expressed what I perceived.

Given my anxieties, I could only imagine approaching these issues in solitude. MaryRoss suggested that I might like to use her Santa Fe house, which was unoccupied. Tucked behind a wall that seemed to shut out the world, the house afforded a marvelous sense of privacy. I accepted her offer and made plans to go there early in December. When I arrived at the Canyon Road house, I set up the small room off the kitchen as a drawing studio and was soon engaged in my new ideas. I was trying to work more directly than was my wont, determined to discard a kind of overcontrol that sometimes happened in my art, in favor of greater spontaneity.

One of the first drawings I did involved a figure shooting a handgun, from which spurted blood and tears. This image grew directly out of my

revulsion at the seemingly endless depictions of men with guns on TV, in movies, and on billboards. I perceived these almost as a form of terrorism, in that they caused women to become frightened of men while giving men a false sense of themselves as overly powerful, an illusion I saw as destructive to both genders. Then I did a drawing that nearly scared me to death. *Crippled by the Need to Control* presents a crippled, blindfolded man riding a woman, using her hair as reins. This image implies that the price men pay for their need to dominate women is that they become blind both to women's suffering and to their own crippled state.

CRIPPLED BY THE NEED TO CONTROL
from **POWERPLAY** 1983
Sprayed acrylic and oil on Belgian linen 108 × 72 in (274.32 × 182.88 cm)
Collection of Graznya Kulczyk

Almost immediately after starting work on these images, I came up against what I would describe as an internalized taboo against depicting men critically, which manifested in a ghastly nightmare. One night I woke up with a start. I was sure that someone was in the house and that I was going to be viciously brutalized or killed. This fear was so intense—and irrational—that I could only explain it as the result of making images about men. Throughout the years I worked on this series, I would have this same nightmare again and again, always awakening in a cold sweat. Each time I would try to reassure myself that surely I would not be so punished; after all, I was only making art.

Over the next five years (during the first several of which I was still engaged in completing the *Birth Project*), I would slowly create a new series of works titled *PowerPlay*: drawings, paintings both small and monumental, a suite of tapestries woven by Audrey, cast-paper reliefs, and bronzes. This last technique was one in which I had never before worked, and it intrigued me, particularly the process of trying to achieve unusual colored patinas. Creating this body of art caused me to take up what turned into longer and longer sojourns in New Mexico.

Before long, I found myself craving the solitude of the Canyon Road compound and the ever-changing light of the Santa Fe sky, particularly the unique pink glow that suffuses the winter landscape. I also enjoyed being able to walk downtown and do most of my shopping in local stores. That was before the old Santa Fe was gone, buried under an avalanche of gentrification that has nearly destroyed the charming qualities that I and so many other people found there, qualities that were to nurture me and my work for the next decade.

IF YOU DON'T HAVE,
YOU CAN'T LOSE

In mid-January of 1983 I returned to Benicia from Santa Fe. As usual, I was quite occupied, juggling *Birth Project* work while continuing regular drawing sessions with my male model. Then I made a short trip to Seattle to attend the opening of the *Creativity* exhibition at the Pacific Science Center, the show through which I'd first met Stephen Hamilton. There I had the opportunity to meet the great dancer Merce Cunningham, one of the other artists represented, and we had a conversation that was extremely significant to me.

We discussed the need for some type of administrative structure to support and facilitate one's creativity—in his case, his dance company; in mine, Through the Flower. Once in place, however, such an organization required at least some degree of attention, which could take time away from creative work. As I explained to him, I had neither the resources to hire professional staff nor the kinds of support offered by the art world. Therefore, I had to depend primarily upon volunteers, who had varying levels of expertise. Although his situation was not the same, in that he had more traditional forms of support and more qualified personnel, it seemed that he felt just as conflicted about balancing practical and creative concerns as I did.

Until this exchange, I had not realized that this was a common predicament for creative people. When I asked him how to resolve the dilemma, Merce said that there was no resolution; one simply had to handle the frustrations and go on working. I returned to Benicia with the determination to try to put his advice into practice.

Before long I was busy again with exhibition preparation and writing. Then I started to experiment with oil paints as preparation for translating

some of the drawings I had done in Santa Fe into large-scale paintings. At some point MaryRoss suggested adding a real studio to the Canyon Road house, which she generously offered to finance in exchange for a *Fresno Fan*. She had decided to do some other renovations there and arranged for the construction, which she asked me to oversee. In the early spring, I made a short trip to New Mexico to see how the remodeling was coming along.

While there, I met with some fellows who prepared canvas for artists, as I had decided that I would paint on Belgian linen, the traditional artist's canvas. But rather than having the linen primed with a white gesso, as is customary, I asked if the guys could figure out a transparent coating that would allow the color and grain of the linen to come through while also providing a sealed surface, which is essential for oil paints. I hoped that by using a thin and transparent primer, I might be able to achieve the fusion of color, surface, and form that I prefer.

When I returned to Santa Fe in mid-June, the canvas makers had found a way of preparing the Belgian linen so that its warm and inviting beige surface could show through the primer coat. But they had not yet managed to achieve an even prime coat on the large canvases, so, while waiting, I set to work on a series of small paintings. Using a technique modeled upon Renaissance methods, I first underpainted the images—though in sprayed acrylic rather than the traditional gesso and thinned-down oils—then applied the oil paints. That summer I began a group of works entitled *Maleheads*, which dealt with the way in which some men seem to become disfigured by power. Many of the faces were grotesque, others sad; all in all, they reflected my impressions of the ways in which men's humanity can become stunted as a result of carrying the burden of power.

Because there was so little scholarship on the construct of masculinity (there was not even widespread acceptance of the idea that it was a social construction), I had to depend upon my own sense of truth, working from observation, experience, and, of course, my rage at how destructively so many men seem to act toward women and the world at large. As I grew more deeply involved in thinking about this, I slowly came to believe that the power that is assumed to belong to all men is, for most, actually a

facade. In fact, many men may actually feel quite powerless, particularly to change a world that they—sometimes even more than women—recognize as both unjust and cruel.

As soon as the 9-foot-high canvases were ready and lined up in my painting racks, I started on the first of what would be six monumental works, beginning with *Crippled by the Need to Control*, the study for which I had done the previous year. The moment I began tracing the outline of the image onto the canvas, I knew I had been right: these pictures definitely required the grandeur of this scale. Once the forms were drawn, I began mixing colors in preparation for the spray-painting.

When I airbrush, I work on sections at a time, leaving large portions of the surface taped and covered so that the paint will not bleed. This meant

DISFIGURED BY POWER 4/
POWERHEADACHE
from **POWERPLAY** 1984
Sprayed acrylic and oil
on Belgian linen, 14 × 10 in
Collection of Kevin Marvel and Robert Gardner

that the overall image was not visible until all of the spraying was done, at which point the male figure not only came to life but practically leaped off the canvas. Again, I became fearful of what I'd created, especially after I started applying the oils, which made the forms appear even more powerful. The oil painting took a long time, the process made even lengthier by the fact that I would paint and cover the same area repeatedly. If I let my brush freely express what I felt, I became scared of what I had painted, thinking it ugly and obscuring it, only to paint exactly the same thing all over again.

PowerPlay was to be a rather formidable challenge, primarily because of some of the psychological obstacles I had to overcome. Surprisingly, it would turn out that my fear of depicting men critically had historical antecedents, as outlined in the catalog essay that Paula Harper wrote for my 1986 exhibition of this series:

> Images of men as destructive or power mad are not new in the history of art. The grand tradition of figure painting since the Renaissance is populated with powerful and aggressive heroes…But women artists have rarely painted men in an unflattering light…The tradition seems to demonstrate that women are more willing to portray themselves as victims than men as perpetrators.

During the summer of 1983, I spent many weeks by myself, immersed in this struggle. Then my friends Stanley and Elyse Grinstein came to Santa Fe. I showed them what I was working on, afraid that Stanley, in particular, might feel uncomfortable with my depictions of men. But if these images disturbed him, he did not make it evident in any way. Rather, he and Elyse were as usual entirely supportive, not only of my new ideas but also of my decision to take up individual artmaking again.

With the exception of them (and MR), the only people I saw that summer were the artist Larry Bell and his longtime companion, the designer Janet Webb, along with the actor Dean Stockwell and his new wife, Joy. I had known both Larry and Dean in the 1960s in L.A., and it was fun to reconnect with them. MR and I asked Jan about assisting Stephen Hamilton with some of the *Birth Project* exhibition work, which was becoming too much for him to do alone. Then Doubleday hired her to do the production

on the *Birth Project* book, which meant that I would have many occasions to see both her and Larry over the next few years. Dean had abandoned Hollywood in disgust to take up real estate in Santa Fe, only to have his acting career suddenly spring to life again as soon as he'd moved.

Through Dean, I met the dealer Marilyn Butler, who then ran galleries in both Santa Fe and Scottsdale. By the time I left New Mexico in the early fall, she had asked me to join her gallery and also to have solo shows in both spaces the following year. About this same time, I was finally approached by a New York dealer. Through Stephen, I had been introduced to someone who had once worked at ACA Galleries. Indignant that I had no East Coast representation, he contacted the gallery owners, who indicated that they would be extremely interested in handling my work.

In October, I went on the road to do reviews and lectures in several cities. When I got to New York, I met with Jeffrey Bergen; Jon, his identical-twin brother; and their father, Sidney, a short, portly man who had taken over ACA from an uncle whose left-wing political persuasions had shaped its once-radical character. In existence for more than half a century, the gallery had retained a decidedly liberal flavor, even though it was then in an elegant brownstone on the Upper East Side, off Madison Avenue. From the start, Sidney made me feel almost like a member of the family, insisting that I stay with him whenever I was in New York. As he had a fabulous apartment overlooking Central Park, I was delighted to accept his invitation and even more pleased when he announced his intention to be my escort to the next opening of *The Dinner Party*, which he had never seen. Sidney was unfazed when I told him that would probably be in London, as Gelon had informed me it was tentatively scheduled to be shown there in early 1985.

Before I left New York, we agreed that my first ACA show would be a small retrospective in the spring of 1984, covering the years 1973–83, with a catalog to be written by a critic of my choice and published by the gallery. The twins then announced that they wished to see some of my early work, which was stored at Cooke's, a huge facility in L.A. where I had two bins crammed with assorted artworks, as well as numerous other pieces that were scattered among the rambling buildings. I met Jeff, Jon, and Marilyn

(who had decided to join us) there for several days of rooting around, looking at all my stored art. Even though I felt somewhat skeptical of the opinion of these two—they seemed rather boyish and giddily enthusiastic about everything—after so many years of rejection or indifference by the art community, I could hardly believe my ears when the brothers proclaimed this or that work a "masterpiece."

Marilyn chose some representative pieces for her gallery, then left. After selecting work for my retrospective, the twins and I went to see the *Creation* tapestry at Audrey's. Although it was the first work I started for the *Birth Project*, it was still not done. She became so excited about the prospect of the New York exhibition that she swore the weaving would be finished, even though it had been progressing at a painfully slow pace. Before they left, I told the Bergen twins that I felt somewhat gun-shy after my last New York experience (an understatement), but they told me not to worry, as this time it would be different.

No sooner had they gotten on the airplane home than I experienced the most terrible pains in my side. My suffering soon became so intense that I flew to L.A. to see my longtime internist, who immediately referred me to a urologist. Apparently I had kidney stones that required immediate surgical removal. As soon as I was able to leave the hospital, MR arrived, bundling me into her Blazer and driving me to Santa Fe. I spent some time recuperating and then began working in the studio again.

I stayed in New Mexico for three months, focusing on another large canvas, *In the Shadow of the Handgun,* a 9′ × 12′ painting based upon my *Hand! Gun* drawings of the previous year in which blood and tears were shown spurting from a gun. Again, I had to struggle to overcome my fright of what was an extremely forceful image, putting in long hours of concentrated work that left me exhausted at the end of every day. Almost as soon as I started this picture, I began having nightmares again. Then, almost as if my bad dreams were summoning terrible events into being, I began to be harassed by a man in the alley that ran along the side of the house, where he would stand at my window and masturbate.

Calling the police turned out to be an exercise in futility, as they either failed to respond or did so only hours later. By then I had hired a

IN THE SHADOW OF THE HANDGUN from **POWERPLAY** 1983
Sprayed acrylic and oil on Belgian linen, 108 × 144 in
Collection of Elizabeth Sackler

wonderful housekeeper, Mabel Griego, whose family would become very dear to me. Her ex-husband, Manuel, suggested that if the guy showed up again I should call him, and he would come right over and "shoot his cock off." As appreciative as I was of his protective gesture, I was surprised that he had a gun, as I knew no one who kept weapons in their house (or so I thought at the time). The Griegos insisted that I should get a pistol for protection, and Manuel offered to teach me how to use it. I could never imagine doing this, even though I was scared. When MaryRoss came for

the holidays, she decided to have bars put on the windows, which helped me feel somewhat more secure.

Although I was pretty much finished with my exploration of female subject matter, I still felt engaged in the work of preparing the *Birth Project* documentation panels and the book. Doubleday was planning to send me out on a six-week promotional tour when the book was published the following spring; given my propensity to break down on the road, I was already fretting about how I'd handle such a long period of uninterrupted public exposure. There was no question, though, that I was going on the tour. I knew that all the people who had worked on the *Birth Project* were counting on me to bring it into the world.

Toward the middle of January, I returned to Benicia to do still more exhibition preparation. While I was there, MR and I sent out a letter to the remaining *Birth Project* stitchers, asking that they all finish their pieces by the end of the year so that everything could be made ready for exhibition by the spring of 1985. In conjunction with the publication of the book and the promotion tour, MR and I intended to officially "launch" our formal traveling-exhibition program with simultaneous shows around the country. Both she and I were distressed to realize that some of the needleworkers were upset that the *Birth Project* was ending, as apparently they had thought it would go on indefinitely.

By early March I was back in Santa Fe, where Janet Webb was working steadily on the exhibition units and the book. Stephen, who loved New Mexico almost as much as I did, was happy to have an excuse for making regular trips to consult with one or both of us. In between his trips, I concentrated on drawings for my next major painting, a huge triptych entitled *Rainbow Man*, which I planned to work on over the summer. In it, I wanted to express my own experience with too many men over the years—in particular, their seeming fear of intimacy. In the first image, a male figure holds out a rainbow as if to entice a woman with its beauty and thereby draw her close. The second painting presents this same man drawing away, as though fearful of the very closeness he had offered initially. In the last picture, the figure becomes violent, threatening to do harm if he is pushed for greater emotional contact.

At the end of March I flew to L.A. because, true to her word, Audrey had finished the tapestry just in time to have it prepared for hanging at my ACA retrospective, scheduled for six weeks hence. Because the weaving had been rolled on the loom during its four years of execution, neither Audrey nor I had had the chance to see the overall image, except in the form of the cartoons I had prepared so long before. Audrey and her husband, Bob, had decided to hold an "unveiling," setting up a makeshift exhibition space in their living room. It was quite a thrill to finally see the completed weaving, in which my painted image had been transformed and softened through the richness of the wool thread, not to mention Audrey's incredible skill.

I then went up to Benicia for another week of *Birth Project* exhibition work, but not before stopping off to pick up the most incredible beaded top, made especially for my upcoming opening by the designer Holly Harp, who had become one of my supporters (and, sadly, died in her fifties from ovarian cancer in 1995). In early April I returned to Santa Fe, primarily to concentrate on the book, which was soon to go into production. Needless to say, I would have much preferred to spend all my time in the studio, but I had to content myself with continuing the drawings for *Rainbow Man* in between frantic bouts of writing, as I was already behind on the manuscript. I also managed to expand my tiny circle of New Mexico friends by one: on this trip I had dinner with the potter Rick Dillingham, whom I believe I met through Larry Bell.

I can still remember Rick—an exuberant and remarkable man who died of AIDS at the age of only forty-one—telling me that he had heard and read so much about me but had never actually seen my work. Therefore, he announced with a flourish, he thought he might fly to New York for the ACA opening, which is just what he did. Another New Mexico out-of-town artist made a special trip to see the show: the painter Fritz Scholder, who then had a home in New Mexico and who also exhibited at ACA. According to the Bergen twins, he came because he wanted to welcome me to the gallery. Sometime during the crowded opening, he invited me to visit him at the house he owned with his then-wife, Romona, in the village of Galisteo, some miles outside Santa Fe.

I could hardly believe how my life was changing; it seemed as though my many years of struggle were finally beginning to bear fruit. As to my retrospective, I thought it looked fantastic, and I guess that many people agreed. For the first time in my career, I would actually sell a significant amount of art, thanks primarily to Amy Wolf, a young woman who worked in the gallery and who spent a considerable amount of effort cultivating some major clients.

Heaven Is for White Men Only, which I had done in the mid-1970s and which had never been shown before, sold almost immediately, as did a companion piece, *Let It All Hang Out*. Both paintings were 80″ × 80″, sprayed acrylic on canvas, like the *Great Ladies*. *Let It All Hang Out* had scared me to death when I finished it, because of the power of its imagery, which dealt with female sexuality. *Heaven Is for White Men Only* focused on the intersection of race and gender, symbolized by a series of diverse flesh-colored forms that barred the way to an inviting open space.

Over the course of the next few months, the gallery would sell hundreds of thousands of dollars' worth of work (although about half of this was resale—that is, sold by collectors who had bought it from me for a fraction of its 1984 resale price). However, the *Art in America* review was extremely negative, with the writer going so far as to say that I could not draw, an accusation that would be repeated for several decades. It took a long time for me to realize that when critics were faced with content that apparently made them uncomfortable, rather than being honest about their discomfort, they attacked my draftsmanship.

But it really upset me, as I prided myself on my drawing skills, which had been perfected by over four decades of practice. At the time, I talked to Sidney Bergen about it, and he insisted that this was a ridiculous criticism since, judging from the work in the show, he thought I could draw just about anything. As for the twins, they were awfully sweet. Jeffrey said he planned to pop himself a huge bowl of popcorn that very night, to which he intended to add plenty of butter and salt, after which he would sit down, put his feet up, eat popcorn, read the article, and laugh while smearing butter on the pages of the magazine.

After the show, I returned to Benicia and to the last formal *Birth Project* review; after this final gathering of stitchers, the few remaining pieces would be reviewed through the mail. The impending end of the project had sort of snuck up on me, and even though I was ready for it, it was still somewhat sad. Because I was spending more and more time in Santa Fe, MaryRoss suggested that perhaps it was time for me to give up the upstairs studio in Building 57, an idea that stunned me at first, though I realized there was really no reason to keep paying rent on a space that was so little used. Even though I was in California less and less, I had not accepted that I had basically moved to New Mexico, though I kept thinking that I'd move back to L.A.

MR thought it best to retain the ground floor of the Benicia building. It would be useful for art storage, and she needed office space to administer both Through the Flower and the *Birth Project* exhibition program, which she planned to run with a small staff. She soon enrolled in a museum-studies program in the Bay Area, with the idea of turning her years at Through the Flower into the basis of a career in arts administration. By then she had her own circle of friends in California, most of whom I did not know, though we continued to feel extremely connected through our shared work and values.

By the end of May, I was itching to get back to the Southwest so that I could plunge back into the only life that has ever fully satisfied me: being deep inside myself and creating art. By then, ACA had offered to finance a suite of prints. Although I was preoccupied with *PowerPlay*, there was still something about the *Birth Project* that felt aesthetically unresolved. I planned to take some of the *Birth Project* images I liked best and rework them in order to achieve the level of visual acuity I desired, intending to find a printshop in New Mexico where I could accomplish this.

I returned to Santa Fe on June 1, and before too long I was hard at work on the *Rainbow Man* triptych. Soon after I had settled in, Gelon called to tell me about European interest in *The Dinner Party*. In addition to a London showing in early 1985, the organizer of that exhibition had arranged to have it first presented in Scotland—in fact, during that very

summer, in association with the annual Edinburgh Art Festival. Of course, Gelon wanted me to come to the opening in July, but I declined, as I did not want to give up one moment of my planned four months of painting.

I was slowly becoming more adept with oils, which had been difficult for me at first. The imagery was also gradually becoming somewhat easier for me to handle. As to my fears of being punished for my depictions of men, these weren't helped by my ongoing troubles with the guy in the alley. He had somehow managed to get into the house while I was away, leaving telltale marks of having slept in my bed, which freaked me out. MR and I beefed up the security even more, installing an alarm system.

In early July, I spent some time at Unified Arts, a silk-screen shop in Albuquerque that I'd learned about through Larry Bell. Coincidentally, Judy Booth—who had gone to work with, then become the partner and companion of, Jim Kraft, the owner of the shop—had been a curator at Tamarind when I was there making the *Through the Flower* lithographs in 1972. I had only done one serigraph and that was many years before, but when I visited their shop, I knew that I wanted to do the *Birth Project* suite there, not only because of the wonderful quality of their environment, but also because Jim was a technical whiz.

I made several trips to the shop to do tests in preparation for creating a suite of five prints. These were to be completed for my next ACA show, which was to feature *Birth Project* work and be timed so as to be part of the 1985 official launch. I planned to start the innumerable drawings necessary for the prints toward the end of the year in my Santa Fe studio, then, soon after New Year's, move into the apartment that Jim and Judy kept for artists. I would finish the drawings while doing the proofing (the process of color-testing the prints) in Albuquerque; I intended to remain there until the London opening of *The Dinner Party*, which was scheduled for early March.

Sometime in July, I received a call from a curator at the Museum of Art in Santa Fe who had pried my unlisted number out of Marilyn Butler. It seemed she had a group of young male artists in her office who had asked her to contact me because they were organizing an exhibition of New Mexico artists for a Dallas museum and, as the curator said, it had come to their attention that they had failed to include any women. She wondered

if I would meet them for a drink to discuss this problem, which I agreed to do later that week. A few days later I met the "puppies," as I called them, a group of good-looking and frisky artists, all in their mid-thirties, who totally charmed me. They also convinced me to be in this show, despite the fact that—as I kept telling them—my short time in Santa Fe hardly qualified me as a local, which was ostensibly one of the criteria for inclusion.

Summer is the height of Santa Fe's social season, and soon I found myself being invited to art openings and parties by these guys and their male artist friends. Suddenly I was popular and I loved it, discovering that there was something I actually liked doing more than working and exercising. What a surprise! I began dating again and hung out with the puppies, who were great company. I can remember thinking that perhaps I might even find a serious relationship.

Every year in mid-August, there is a prestigious show in Santa Fe called Indian Market, where Native American craftspeople from various tribes present their work. Usually there are conjoint exhibitions all over town, along with parties, openings, and festivities of all sorts. Fritz Scholder, as an artist of Native American heritage, was holding a show that was to premiere that weekend. I was invited to the opening and the party afterward at his house in Galisteo. At that time I had not yet met his wife, Romona, nor had I visited the old adobe home they then shared. I went to the party with one of the puppies.

Like many New Mexico dwellings, the house had a wonderful court-yard, which had been set with numerous tables where many boisterous people sat, drinking and laughing within the glowing circle of light that had been created by the careful placement of fixtures and candles. Although I had not been introduced to Romona until that evening, I had certainly heard about her incredible charm and how it was she who had engineered Fritz's successful art career through parties such as this one. When I finally encountered her that evening, I was struck by how handsome she was, and how warm. We exchanged a few words, at which time I learned that she was a therapist, a fact I tucked away and forgot for a while.

The rest of that summer was spent finishing the *Rainbow Man* triptych and working on the small *Malehead* paintings that I had started the previous

year. Audrey wanted to start weaving again, and I suggested that she do a series based upon those images, though in a slightly larger format. I figured out a way to use photographs of the paintings as cartoons from which she could weave and went to L.A. to work with her in early September. While there, I saw my mother, who was not doing too well. The retirement place where she was living was rapidly going downhill, and we agreed that perhaps it was time for her to move. She surprised me by saying that she had been toying with the idea of applying to the Jewish Home for the Aging in the San Fernando Valley. This place was far from where she had lived during most of her time in Los Angeles and thus not near her California friends.

Moreover, given her long-standing lack of interest in anything smacking of Judaism, it seemed somewhat strange that she was thinking about making this move. But the home offered high-quality care along with a wide range of activities, which she seemed interested in and I thought sounded good. She was sleeping too much, which I attributed to boredom but was actually a result of her being overmedicated. But this would only become evident when she got into the Jewish home after a considerable time on their waiting list.

I returned to New Mexico and another bout of focused work (along with some socializing). At the beginning of October, shortly before my Santa Fe sojourn was to end, the "guy in the window," as I called him, began to show up again. His escapades suddenly became more frequent and intense, involving not only masturbating but putting panties on the bars of the windows, knocking on the panes, and making lewd remarks. One day several of the puppies appeared at my door. I had more than once expressed my fear of this guy—along with my frustration with the police—and they had decided that the time had come for me to know how to protect myself by learning how to shoot a gun. Refusing to take no for an answer, they herded me into their four-wheel-drive vehicle and headed out of town. Before long we were in the foothills of Santa Fe, where there was not another soul around.

The guys had brought a variety of weapons, along with so much ammunition that I told them they could pretty much wipe out everyone in Santa Fe. I could not figure out why I had to learn to shoot with real

bullets, nor could I understand what had possessed them to bring—much less to own—an Uzi. "What if I were to blow my foot off?" I asked one of the guys, who assured me that I had nothing to fear. "Easy for you to say," I replied, "but I am a middle-class Jewish woman, and in our family, a gun was *unheard-of*." He countered by stating that I was now in the Wild West, where many people had weapons—which, at first, I did not believe. Later, when I asked around, I discovered that he was correct.

Although I was scared to death the entire afternoon, my male friends seemed to enjoy themselves immensely, taking turns shooting at various inanimate targets and showing me how to load, unload, and fire a .22. I found the guns and the sound of the bullets revolting, while the guys clearly loved the whole enterprise, joking about the phallic shape of the bullets and reveling in the sense of power and the noise, particularly that of the Uzi, which they shot again and again. Even though these fellows were all artists and, hence, we had a lot in common, in some ways it seemed as if we were members of different species. Or, as I would later laughingly say: that day, the basis of male dominance was revealed to me. It seemed to boil down to a simple equation between guns and masculinity, or, to put it more baldly, "Shut up or I'll shoot you."

Although I was not comfortable having a gun in my home, the guys insisted that I keep the .22, which I would repeatedly load and unload, not knowing whether it was worse to have a loaded pistol or an empty weapon and bullets rolling around in the drawer. Nonetheless, some months later, when my cousins Howard and Arleen came to visit, I would be happy that it was there. I gave them my bedroom in the back for the days they were in town.

The "guy" had not been around for some time, nor had he ever shown up when other people were in the house. I was in the front room and Howard was taking a shower, when suddenly I heard Arleen scream. I ran into the bedroom to discover the jerk masturbating in the alley and Arleen shaking with fear. Reaching into the drawer, I pulled out the gun and did just what Manuel Griego had suggested some months before. I pointed the pistol at the guy and shrieked at the top of my lungs that I would blow his cock off if he didn't leave.

With Howard and Arleen Rosen at my childhood apartment, Chicago, IL 1988

Howard came tearing out of the bathroom dripping wet, wrapped in a towel and yelling frantically. He could not believe his "baby cousin Judy" (his pet name for me) was standing there with a loaded pistol in her hands, for when it came to weapons, Howard was definitely more like me than like my male artist friends. He kept pleading with me to call the police, though I explained to him that I had done so at least eight times to no avail, and that I had been given this weapon for just such situations. Howard was so freaked out that he stayed up all night guarding the house. But the guy never came back. Perhaps he got arrested for harassing someone else, or maybe he just disappeared.

This event proved to be a crucial juncture, in that having that gun in my hand seemed to empower me, which taught me something about human beings' potential for violence. Subsequently, and rather surprisingly, my fear in relation to painting men seemed to subside. Moreover, the *PowerPlay* images began to evolve, becoming less angry and more sympathetic toward men. When I handed the pistol back to the puppies sometime later, I thanked them for having so opened my eyes.

The same fall in which I had my lesson in guns, I received a phone call from a former *Dinner Party* worker, Juliet Myers. She surprised me with the announcement that we were now both residents of New Mexico, although I pointed out that I still didn't really think of myself as having actually *moved* from California. One reason she had relocated was that she knew I was there. She came to work for me one day a week, bringing with her an extensive knowledge of my art, a familiarity with my network of supporters and friends, and some measure of the quality of assistance and connection I had enjoyed in the *Dinner Party* and *Birth Project* environments, something I had missed.

As I watched her settle down to work each week, I marveled at how far she had come from the young woman in the *Dinner Party* studio who had dropped whatever she was doing to socialize with anyone who walked by. As this had prevented her from accomplishing much work, I had finally made a big sign to be posted where she sat: "I am working, and if I stop, Chicago will kill me." A photo of Julie and this sign would appear in the *Dinner Party* book, apparently causing some people to conclude that I was extremely dictatorial. When I spontaneously made the sign and later decided to include it in the book, it never crossed my mind that it might be so utterly misinterpreted. This lack of self-consciousness is a trait that has been with me all my life, one that I would soon realize was having serious repercussions in terms of other people's perceptions (or, more accurately, misperceptions) of me.

In mid-October 1984, I (reluctantly) left Santa Fe for Ottawa, Canada, where I did numerous media interviews in relation to the opening of a drawing show there. But instead of experiencing this press interest as flattering—which I sometimes had in the past—I found myself becoming extremely uncomfortable. I was also scheduled to present a luncheon lecture, which, I was told, was to be attended by over a thousand people. According to the sponsors, they could have sold twice as many tickets had they only thought to hire a larger hall. Almost immediately upon hearing this, I suffered an asthma attack, seemingly brought on by the prospect of facing so many people. It was becoming ever more disconcerting to leave the absolute quiet of the studio for the frenzied atmosphere that seemed

to surround me whenever I appeared publicly, which I did at intervals of about three months. As a result, I was becoming increasingly prone to such somatized panic attacks.

Moreover, there seemed to be a growing gap between how I saw myself and how others perceived me. Whereas I knew myself to be vulnerable and sensitive, many people viewed me differently, apparently assuming that I was strong and fearless. Either they became aggressive toward me or they approached me with trembling hands. I was also being treated as though I were an extremely successful artist, which is not at all how I saw myself. For one thing, I kept getting terrible reviews—and, of course, my financial situation continued to be precarious.

The one positive thing about this frame of mind was that it kept me from getting a swelled head. As Stephen used to say, I was one of the few well-known people he'd encountered who weren't jerks. I had made a conscious decision not to become like some of the famous folks I had known (and by then, I had met many) who seemed full of themselves. Instead, I was determined to stay true to something my father used to say: "On the toilet, everyone looks pretty much the same."

Shortly after Thanksgiving, I went back to Santa Fe. As soon as I was reestablished in my New Mexico life, I called Romona Scholder, whom I'd seen socially a few times since our meeting the previous summer. I told her about my escalating problems in relation to public appearances, saying that I was becoming increasingly concerned about being able to handle the upcoming *Birth Project* promotion tour, which at that point was about four months away. Having decided that it might be a good idea to get some therapy, I asked Romona if she thought that, given our social relationship, it would be inadvisable for me to see her. She thought it would be all right, and it might actually be helpful that she was familiar with the art world.

At my first session, I told her about my propensity to break down on the road and how determined I was that this not occur during the *Birth Project* tour, particularly because all the needleworkers were counting on me. Over the next few months, I was able to recognize that one way I had coped with so much loss as a child was to develop a protective strategy that might be characterized as "If you don't have, you can't lose." It turned out

that this attitude had profoundly shaped my life. I had always marveled at my friends' expectation that their lives would move along in an uninterrupted rhythm and their presumption that they would survive to a ripe old age, something I had never counted on for myself. The death of my father when I was young, combined with so many successive sorrows, had taught me that tragedy could strike at any time.

More than twenty years earlier, at the time of Jerry's premature death, I had vowed that I would build my life around my own identity and needs. Although this resolution allowed me to forge the life I wanted—one based upon artmaking—I slowly came to understand that it had also insulated me. My fear of loss caused me to be mistrustful of others and wary of intimacy. The other side of this was a childlike innocence that left me overly vulnerable, a trait that, Romona pointed out, resulted in my bringing a rather childish desire to be loved into my adult and very public life. She suggested that I needed to learn to better protect myself emotionally, something I had never even thought about. It was as if Romona had to teach me skills that I should have acquired at a much younger age but hadn't, perhaps because my childhood was so shattered by my father's death.

Romona asked me to imagine myself as a spectator sitting in the audience for one of my lectures or attending the opening of one of my exhibitions. "Think how much everyone has heard about you," she said. "They know you've had innumerable shows. They might have read one or more of your books, seen your name in art-history texts or magazines, or watched you in a film or being interviewed on TV. They consider you a star, and they are nervous about approaching you, which they evidence through, for example, fawning, animosity, or fear."

To tell the truth, I had never tried to look at myself from this perspective. Starting to do so was a revelation. I began to see what Romona meant, that others viewed me far differently from the way I saw myself. As I explained to her, I approached my life and especially my days in the studio as if I had never achieved anything. This allowed me to start from scratch again and again, something I have always liked doing as it has prevented me from repeating myself. Given the ongoing lack of art-world recognition, it was also necessary. For example, after *The Dinner Party*, I

lost everything. And because the *Birth Project* belonged to Through the Flower, I made no money for five years of work. In both cases, when the projects were finished, I had to start all over again.

In a related vein, one that might serve as an example of this pattern, I had never wanted to own any property, insisting that I didn't want to be tied down. Of course, this decision freed me from the obligation of mortgage payments, but more significantly, it protected me from the possibility of losing something that I had. That this is somewhat screwy logic, I certainly would not disagree. But it was where I was at that moment in time and was one of the primary reasons for my breakdowns. In public situations, I would experience a dramatic collision between my own sense of self and other people's perceptions of me. My own accomplishments were so invisible to me. This, combined with the ongoing art-critical hostility toward my work, meant my public acclaim was lost on me. Therefore, its effect on others was entirely outside of my consciousness. Consequently, I could not understand why they treated me the way they did.

Thanks to my ongoing sessions with Romona, I would be able to successfully negotiate the *Birth Project* tour, primarily because she taught me to see myself more realistically and, more to the point, not to bring my private longing for love into my public life. However, what I was suffering cannot be explained merely as a personal dilemma. There was also the issue of the negative manner in which strong and talented women are often viewed by society. I had of course studied many women who had been depicted in history books in ways that had little to do with who they really were or what they had achieved. And over the years, I had heard about numerous well-known and accomplished women, such as the artists June Wayne and Louise Nevelson, who had been characterized as "bitches." But when I met them, I found them to be wonderful and complex human beings.

At the end of 1984, while still seeing Romona regularly, I attended a Christmas party at Rick Dillingham's, where I met a poet named Harvey Mudd. He had just finished a long poem dealing with the Holocaust, a topic, he said, that had always interested him. With some consternation, I realized that this was a subject about which I knew almost nothing; in fact, it had never even been discussed when I was growing up. I can recall thinking

how odd it was that I was so ignorant about an event that had taken place during my childhood, especially in light of our Eastern European Jewish heritage and my father's avid interest in politics and history.

As we were talking, I experienced something akin to the "click" so many women have described in terms of the awakening of their feminist consciousness. Perhaps I sensed some connection between the Holocaust and my inquiry into male power, suddenly remembering something that Virginia Woolf had written about the rise of fascism and Hitler's march across Europe in terms related to "patriarchy gone mad." Whatever the reason, I found myself rather inexplicably asking to read Harvey's (then unpublished) manuscript, even suggesting that I might like to illustrate it. I certainly had no notion that I was on the brink of a journey of discovery that would occupy me for more than eight years.

Soon after the first of the year, 1985, my cats and I headed for Albuquerque, where we tucked ourselves into the apartment at Unified Arts that would be our home for the next few months. I worked hard on the *Birth Project* prints, trying to finish them before the London opening of *The Dinner Party*. At the beginning of March I flew to England, and, true to his word, Sidney Bergen arrived soon afterward to escort me to the show. Although the installation was in a ratty space in a run-down part of London, the evening was rendered unforgettable by a rousing opening address by the writer Germaine Greer.

I returned to New Mexico and some more weeks at the printshop, finishing up and signing the serigraphs so they could be shipped to ACA. Before I knew it, the long-anticipated (and feared) *Birth Project* tour was at hand. To tell the truth, I ended up having a pretty good time, thanks to my months of therapy and also some advice I received from Dean Stockwell shortly before my departure. Regarding his years of public life, he told me that he looked at each encounter as a fleeting occurrence, thinking at the end of an interview or appearance: "Next!" This approach helped me, largely because it allowed me to stop taking everything that happened on the road quite so seriously.

I went back to Santa Fe with a new and unfamiliar feeling of satisfaction. This sense of accomplishment, as I told Romona, was a pleasurable

sensation, and one I owed primarily to her. "Now, if I could only find a real boyfriend," I said. "There must be some men out there who are nonsexist, interesting, and able to deal with me." Even though I had been dating, many of the guys seemed intimidated by me. Again, I found this difficult to understand, because, as my reader surely realizes by now, in my own eyes I was a pussycat.

Not too long afterward, Romona called to say that she had a psychiatrist friend, about my age, whom she wanted me to meet. We had been discussing the fact that I had a seemingly irresistible attraction to younger men, and she had suggested that perhaps I should look for someone more mature. Such a man might not feel so threatened by me and might be responsive to my desire for a serious relationship. This psychiatrist, David, and I dated throughout the summer, during which time I worked on *Driving the World to Destruction*, another monumental picture. In this image, a man clutches a steering wheel with which he is "driving" the world to its doom. Propelled into madness by the overwhelming burden of power, he seems incapable of releasing his grip, even though his action foredooms the planet to destruction. Although this is an angry painting, it is also a compassionate one, because it suggests that no person, regardless of gender, could remain sane while wielding such unlimited power.

While reading my journals from this summer of 1985, I was amused to note that despite dating David the psychiatrist, not to mention my promise to Romona, I was still indulging in quick flings with younger guys. No matter how I tried, I couldn't seem to contain my lust for them, particularly tall, slender fellows in their thirties. I mention this because around the time of my birthday, in late July, David took me to a rodeo (which I found appalling: imagine, grown men tying up baby calves), where I met Donald Woodman. I was extremely drawn to him, and he to me. He was just my type: in his late thirties, tall, rugged, and charming. But he turned me off by asking if I would like to "see the bulls" with him (he was photographing them), a comment that seemed just too much like the old cliché about "seeing my etchings."

After the rodeo, I forgot all about Donald until the fall, when David organized a picnic supper at something called the Burning of Zozobra. Each

September, shortly after Labor Day, there is a weeklong fiesta in Santa Fe that could not possibly be less politically correct, in that it celebrates the "reconquest" of New Mexico, when the rebellions of the Native American peoples were finally subdued. It culminates in the burning of a 50-foot-high papier-mâché figure called Zozobra, or "Old Man Gloom."

I had often admired the colorful fiesta dresses that are traditionally worn to this event and decided to buy one for myself, a flashy pink number that my housekeeper, Mabel, hemmed for me so that it was well above my knees. I put my hair up with a series of bright barrettes whose vibrant colors matched the embroidered flowers on my outfit. I arrived at the park and found David and several other friends sprawled out on a blanket right in the front, drinking frosty margaritas and eating chips. I joined them, enjoying the hot, dry air and the rapidly expanding audience, which must have numbered about twenty thousand people.

There was the brilliance of the setting sun, the noise of the excited crowd, and soon the colorful fire dancers appeared on the stage at Zozobra's feet, near where we were encamped. Just as the music began and the dancers started their frenzied movements, Romona arrived, bringing along her former companion, the artist Patrick Mehaffy, and Donald. As soon as Donald and I saw each other, sparks began to fly, which caused a considerable amount of friction between Donald and David. Before long, the two were vying for my attention, almost as if we were kids in high school. Of course, this had never happened to me when I was a teenager, which made it all the more enjoyable.

About this time, Zozobra began to move around in puppetlike motions, emitting strange sounds. Smoke and fire filled the stage; the dancing became more frenetic; the music grew louder; and we all got drunker. When the sun went down and Old Man Gloom was consumed in flames, the huge, noisy crowd began to surge toward the downtown plaza for more celebration. The next thing I knew, Donald had lifted me onto his shoulders and was carrying me the mile and a half to the plaza. Once there, he put me down, then bought twelve purple balloons (which I had admired at the fairgrounds), tied them around my wrist, and said he had to be going, at which point David breathed an audible sigh of relief. A few days later,

Donald called, and we made plans to see each other the following week. Almost immediately thereafter, I wrote a "Dear John" letter to David, which was my generation's version of ending relationships via text.

In mid-September, Donald and I had our first formal date, dinner at the Santacafé, an elegant restaurant that, it turned out, was a favorite place for both of us. As we sat across from each other in the courtyard, I found myself thinking that I could marry this man, an idea so outlandish I could hardly believe it had crossed my mind. Yet, as I wrote in my journal at the time, if I were to make a list of the qualities that were important to me in a man, Donald possessed most of them. Born in Massachusetts, he was raised in a family somewhat like my own, though less intellectual. And even though there had never been any pressure put upon me to "marry Jewish," I had always felt most comfortable with Jewish men, and in fact all of my husbands were of this tradition.

Me with purple balloons in Santa Fe, NM 1985 and Donald, Galisteo, NM 1978

From childhood, Donald had never fit in. His father had objected to his youthful aspirations to become a ballet dancer because of the misguided fear that his son might thereby become homosexual. In college, during the days of the Vietnam War, he was a draft resister. Although he had started out in architecture at the University of Cincinnati, he switched to photography. He later became an assistant to Minor White, an important photographer teaching at MIT, which brought him back to Boston. Donald ended up in the center of Harvard Square during the height of the antiwar protests and in close proximity to the burgeoning Boston women's movement, which exposed him to feminist ideas.

Strangely, he was in Houston as a returning graduate student when *The Dinner Party* was there. He had been approached to work on the installation (among his other talents, Donald is a mechanical genius with a wide knowledge of construction techniques). In the end, he had been excluded from participating on the basis that he was a man. (Later, I would joke that Donald had to marry me to install the piece.) He had moved to New Mexico in 1972, taking a job at a solar observatory doing photography, then acted as an assistant to the painter Agnes Martin, during which time he lived in a tepee. All in all, he was just my kind of guy: a rebel, a loner, handsome, and incredibly sexy. As avid for physical intimacy as I was, after our first night together Donald confided his belief that for each person in the world there is only one other, and we were such a pair.

We were inseparable for almost a week, but then I freaked out. Donald had organized a big fortieth-birthday bash for himself, to be held that Sunday at Romona's house, and he wanted me to attend. On Saturday morning, however, as Donald puts it, I "threw him out." I just couldn't accept that I had met someone and fallen head over heels in love like a teenager. As I said to my friends: "Things like this don't happen in real life—at least not to me." Donald was heartbroken, but I was convinced I had done the right thing. By Monday I was regretting my decision; by Tuesday I was beside myself; on Thursday I called Romona to say that I had made a big mistake. She told me she was sure Donald would jump at the chance to try again.

On Friday I broke my usually rigorous work schedule to have lunch with him on my patio, at which time we acknowledged that we simply

couldn't live without each other. Soon afterward, Donald suggested that we get married. Though I felt anxious about making such a seemingly precipitate decision, I agreed. As we shared a desire to have a wedding ceremony that reflected our joint dedication to full equality between women and men, we thought we had best turn to a female rabbi, and we found Lynn Gottlieb in Albuquerque. Although Donald and I shared the kind of ethical Judaism in which I was raised, we were almost equally ignorant of Jewish history and culture. Donald asked Rabbi Lynn not only to prepare us for our wedding, which was to be held on New Year's Eve, but also to help us discover something of our tradition as Jews.

By this time, I had read and decided that I could not illustrate Harvey Mudd's poem, thinking I would have to make my own voyage into this subject. I had been planning to educate myself about the Holocaust while finishing *PowerPlay*, the first step of which would be traveling to New York to see *Shoah*, the nine-hour documentary by Claude Lanzmann that was about to premiere there. At one point I told Donald about my growing interest in the Holocaust and my plan to see this film. He said he would like to go with me, which is precisely what he did, in October 1985.

As we sat together, holding hands, we found ourselves overwhelmed: by the film, by our mutual ignorance about the enormity of this tragedy, and by the sudden realization of the preciousness of our shared Jewish heritage and the fact that it had been nearly wiped out. After two days of sitting riveted in that dark theater, we began to discuss working together on a project. Neither of us had any idea what we were getting ourselves into, or how painful a voyage we were about to take. What an odd set of sensations: the heaviness of what I had learned from the documentary juxtaposed with the realization that, for the first time in my adult life, I felt bonded to another person, not by gender but by culture. It seemed as if a chapter in my life might be ending; as I turned the page, I sensed that my future might be filled with a companionship I had longed for but despaired of ever finding.

WHY THE HOLOCAUST?

In approaching the next period of my life, I am faced with a dilemma, the same one that deterred me from illustrating Harvey Mudd's poem and that plagued me during the many years of working on what would become the *Holocaust Project*. Harvey's poem joined together the subject of the Holocaust with his issues with women. I found this an untenable association in that everyone's private difficulties seem to pale in comparison to the enormity of the tragedy that was the Holocaust. Consequently, I decided that I would have to find my own path into this subject.

Moreover, throughout the eight years of the *Holocaust Project*, I was confronted by the same problem that appears before me now: how to write about my pained response to viewing *Shoah*, then segue into my—by comparison, trivial—conflict about following my heart and marrying a man I hardly knew. Even then, I recognized that the many victims of the Holocaust would have been only too happy to have struggled with such mundane issues as wedding jitters. If I felt discomfited by trying to traverse the enormous distance from historical tragedy to subjective reality even in the privacy of my own journal, how much more difficult to do so in the manuscript I eventually published.

Yet, during the next eight years, Donald and I struggled to understand and (if ever one can) come to grips with this appalling chapter of history. As hard as we tried to keep these issues separate, we were not always sure when our marital troubles were the result of interpersonal problems or a consequence of the unending turmoil this subject matter caused us. Nevertheless, it would be inexcusable to meld together personal and historical conflicts of such vastly different scales when discussing these next years.

In addition, it would be impossible to summarize in a few pages what took so long to create: a 3,000-square-foot exhibition augmented by an audio tour; a video presenting insights into the process by which the *Holocaust Project: From Darkness into Light* was created; an ancillary show of documentation panels that provides background information; and a book about the project. Even if I were to attempt an adequate written description of this complex and layered undertaking (an impossible task, else why choose the vehicle of visual art?), it would crowd out all of the remaining pages of this publication.

In structuring both the exhibition and the book about the *Holocaust Project*, Donald and I consciously decided to include some aspects of our subjective experience. These were carefully selected with the intention of providing a bridge for viewers or readers by which they might approach a subject that we ourselves had found incredibly daunting. Even so, we were to be criticized for having introduced anything at all about our individual struggles. How, then, shall I approach these years in which our personal dilemmas interfaced daily with our efforts to forge images from a tragedy so terrible it is often said to be entirely unrepresentable? Unlike a scholar of this subject, whose approach demands objectivity, creating the images that constitute the *Holocaust Project* required that I continually access my feelings. If my hands stopped translating the myriad emotions this material elicited, the images became flat and inexpressive. Consequently, I could not allow myself the kind of protective distance that seems to afford intellectuals a way of handling long years of study in a topic as heartrending as this. As I write, I become queasy at the very prospect of going over this agonizing terrain once again, because these years were some of the hardest of my life, at least until my most recent project, *The End: A Meditation on Death and Extinction*, during which I grappled with the terrible damage we are inflicting on other creatures, which caused me endless grief.

For now, it seems best to step back in order to give something of an overview of the *Holocaust Project* and also to discuss how Donald and I came to be so engrossed in it. When I resume my personal saga, the reader will have to remember that what I recount about my life between 1985 and 1993 took place against the backdrop of Donald and I slowly entering the

subject matter of the Holocaust, then becoming entirely occupied with the challenge of translating what we were discovering into a series of images, whose apparent simplicity belies their complexity.

When Donald and I saw *Shoah*, it was as if my entire life had led up to the moment at which we spontaneously agreed to work together on this subject matter. But why would we spend so many years on it? In the first section of the *Holocaust Project* book, titled "Awakening," I tried to explain some of what motivated me. Having spent decades exploring my identity as a woman while neglecting a comparable investigation of my Jewish roots, I became determined to rectify that void. Also, there seemed to be an iconographic absence in the contemporary art world on the subject of the Holocaust, while in the Jewish community there was a plethora of both art and discourse. Even now, in most contemporary art museums, it is rare to see art on this subject, which in other contexts is often presented as a central philosophical dilemma of our time. Just this rather stunning contrast alone might have provided sufficient reason for my interest, as I have so often been drawn to subjects that are absent from the mainstream aesthetic dialogue.

But these interpretations cannot explain a project that, once initiated, could not be stopped—at least not until we had come to the point at which we saw how the Holocaust related to larger historical forces. When we took up this study, most Holocaust scholars were adamant that the Shoah was entirely unique. By the end of our journey, we had concluded that the Holocaust grew out of a worldwide structure of injustice and oppression that, sadly, still exists today. In terms of my own decision to take up an inquiry into the Holocaust, it was probably inevitable because issues of power and powerlessness have been central to my work for decades. And the Holocaust certainly represents a grotesque misuse of power.

When I turned my attention to this topic, it was, in part, an effort to understand the connections (if any) between the small, everyday abuses of power and the larger horrors of the Holocaust. I was also motivated by the realization that most scholars have paid virtually no attention to the fact that the architects of the Third Reich were all men. It is true that there were women who participated and who, according to some accounts, exceeded

men in cruelty. But there were no women who actually engineered the Third Reich and the Final Solution. Was there some relationship between the Nazi doctrine of masculinity and such wanton abuse of power? Was Virginia Woolf correct in her assessment of Hitler's march across Europe as "patriarchy gone mad"?

I still do not really know what motivated Donald to get involved in this project. Certainly, he was interested in collaborating with me because he loved me and would probably have done almost anything I asked him to, largely because that is the kind of person he is. To my surprise, he and I have complementary abilities, in that he is adept at all things mechanical and technical (areas in which I am seriously wanting), whereas I bring a kind of conceptual strength and emotional directness that are somewhat foreign to him. This intersection of abilities provided us with an unusual basis for the collaboration that would produce the *Holocaust Project*.

Another aspect of Donald's personality is that, like me, he is a risk-taker. Both of us were willing to risk everything in order to accomplish this project, including our financial security (we ended up deeply in debt), our future prospects for earning money (who would buy art about such a subject?), and our mental health (which, in my case, was threatened more than once).

Donald was certainly intrigued by my idea that a fusion of painting and photography would be the most appropriate method of dealing with the subject of the Holocaust. He had long been dissatisfied with some of the expressive limits of photography and was attracted to the possibility of expanding its parameters. I had come intuitively to the notion of uniting these techniques, and seeing the Lanzmann film *Shoah* reinforced this idea, as did examining drawings by prisoners, survivors, and sympathetic observers. Most of these were not sophisticated images but, rather, sketches and notations done to "bear witness" to the horrific events. I found these drawings quite compelling, so much so that they validated my feeling that painting could play a potentially useful role in dealing with the subject of the Holocaust.

In the early part of 1986, while completing *PowerPlay*, I undertook to educate myself about the Holocaust, trying at the same time to become somewhat more familiar with Jewish history and culture. While I compiled

and examined an exhaustive library of books and studied the art that had been made on the subject, Donald pored over photo archives. We also saw many exhibitions, soon discovering that the Holocaust was represented largely through documentary photographs or film footage; of course, what had been photographed was primarily the aftermath of the event.

I realized that what I was even more interested in was the people— their actual experiences, feelings, and fears. I became determined to try to understand the Holocaust in terms of how such horror could have been inflicted *on* people *by* people. Moreover, even though many students of the Holocaust argue that there is no more suitable way of conveying the scope of this tragedy than through this type of photo-documentation, I found it difficult to relate to pictures of piles of bones or to the somewhat abstract and always overwhelming statistics that characterize so many presentations about the Holocaust, at least in the United States.

I soon became immersed in my self-guided study program. At first I had to force myself not to fall asleep or just numb out. Before too long, I discovered a way to make a more real connection with the material. For example, to translate what was sometimes rather dryly imparted informa-tion about the "liquidation" of a ghetto, I began thinking that, had Donald and I lived in such a community, we would surely have been caught in the Nazi net. By inserting myself and people I knew into the picture, I found that it suddenly became quite vivid to me. This was precisely the role I felt painting could play; that is, it could introduce the *human* story. But it seemed crucial that the images stay rooted in the historic events as a way of emphasizing that this tragedy was something that had indeed happened; this was the major reason for my decision to combine the two media.

During our years of work and study, we frequently encountered the argument that the Holocaust is so unique and mysterious as to be beyond understanding; more, that it is not only incomprehensible but totally unrep-resentable. I was disconcerted by the notion that *any* human event, even one as hideous as the Holocaust, was beyond comprehension. I found it impossible to accept that there was even one aspect of the human experi-ence that could not be dealt with through art. As for its uniqueness, what has always seemed to make art so important and distinctive is its capacity

to identify the universal in the unique. Art seemed to offer *precisely* what was needed in terms of helping audiences understand what they had to learn from the Holocaust—which, from the beginning, was what I was after.

Initially, our intention was to create a body of art from the same perspective we saw represented in American documentary exhibitions about the Holocaust; that is, with a focus on the Jewish experience. Then, after a couple years of intensive research, Donald and I traveled for two and a half months through the landscape of the Holocaust, visiting concentration camps and massacre sites and experiencing the almost deafening absence of Jewish life in Germany, Austria, Czechoslovakia, Poland, and what was then the Soviet Union. Despite our long immersion in the historical record, we were still unprepared for this trip.

As we drove from site to site, following Hitler's footsteps as he set out to vanquish Europe like some brutal conqueror of ancient times, we were shocked to discover how differently the Holocaust was represented in these various countries. Not only was the Jewish experience not the primary focus, as it was in the United States, but in some areas one would have been hard-pressed to understand how many Jewish victims of the Holocaust there had actually been.

Probably the most significant thing that happened to us was the sense of coming face-to-face with evil (a concept I had never really understood), especially when entering a crematorium for the first time and seeing its oven with a residue of ashes, or in the dank slave-labor tunnels in Ebensee, Austria. Until we arrived there, we had known little about the Nazis' enslavement of millions of people, or of their plans for a permanent slave-labor system. As we pushed our way into an incompletely boarded-up entrance to one of these tunnels—built by prisoners who were worked to death in less than three months—we shook with terror and disgust. How could such unmitigated evil exist in the modern era? Moreover, this evil had affected millions of people in addition to the Jews—and had been allowed to spread through the complicity or indifference of millions more.

After we got home, I expanded my investigation beyond the Jewish experience of the Holocaust, while remaining determined to have the art rooted in the enormous tragedy that it represented for the Jewish people.

My extensive studies included reading personal testimonies by survivors of other genocidal actions of the twentieth century (described by some historians as the "age of genocide"). I noticed certain similarities between these writings and Holocaust-survivor literature and, then, other narratives, like those by former slaves or victims of other historic tragedies. What linked them, of course, was their perspective, which was from the point of view of the victim/survivor.

If *The Dinner Party* grew out of my realizations about women's obscured history, the *Holocaust Project* was the result of my dawning recognition that, until recently, history has excluded the experiences not only of women but of most of the human race. What we have viewed as the historical record is primarily a chronicle of those few people in power. And these few control the destinies of most of those who inhabit the earth (and here I refer to both human and animal life). Gradually I came to see the Holocaust in the larger context of a global structure of power and powerlessness. The Nazis exemplified perhaps the grossest abuse of power ever manifested, demonstrating all too clearly what can happen when such an extreme level of abuse occurs. Given the massive technology of destruction in the hands of those in power on the planet today, if they were to exercise a similar lack of restraint, the rest of us would be as powerless as the Jews were to prevent our own victimization and the annihilation of life as we know it.

There is a notion in the Jewish community that the Jews' position in the world is like that of a canary in a mine, the death of the bird signifying dangerous conditions within the underground shaft. Using this analogy, one might say that the Holocaust of the Jews could be construed not only as a warning but as an omen, one that human beings may choose to confront or, at our peril, to ignore. But what, exactly, is this sign telling us? The answers that Donald and I came to are best expressed through the art we created. We tried to share what we had discovered and concluded in the exhibition and the book. But perhaps to learn the crucial lessons of the Holocaust, people will have to be willing to take their own journeys, to *choose*, as Donald and I did, to enter the darkness of the Holocaust—although I am not suggesting our journey as the only route. We simply offered our experiences as a possible path.

I must now come back to the argument posited by so many scholars about the uniqueness of the Holocaust. Maybe this is true, but if so, why should anyone but the Jews (and survivors or descendants of other groups deemed "racially inferior," whom the Nazis similarly targeted) care about it? This seems an especially crucial question as the Holocaust-survivor generation dies off and, with it, the insistence that we remember or should even be concerned. As Donald and I became more deeply involved in the subject of the Holocaust, its lessons seemed increasingly urgent to contemporary society, which is why we dedicated so many years to this unsettling undertaking.

At one point during the project, while on a Japanese lecture tour, we went to Hiroshima. As we live in New Mexico, the birthplace of the atomic bomb, it was especially distressing to confront—through the photos and film footage we saw there—the ghastly human consequences of the American decision to use the atomic bomb. We had to face the fact that we ourselves were engaged in a form of denial not unlike that for which we vehemently denounced the Germans. After all, Donald and I live in a place in which all around us there are weapons and materials whose potential—either intended or accidental—involves global destruction, which we try not to think about. Nor do we spend our lives working toward the disbanding of this arsenal, even though we understand the huge threat it represents.

Certainly, there is an important distinction between the Holocaust, which actually occurred, and that which only threatens. But as Robert Jay Lifton points out in the book *The Genocidal Mentality*, the process of what he calls "doubling" and the forms of denial practiced by Nazi doctors and nuclear-weapons designers are nearly identical. Which leads me to yet another query: What is the point of studying the dangerous patterns of, for example, the Nazi doctors if we are not going to apply what we learn to change our own behavior?

My last—and probably most controversial—point concerns the notion that the Holocaust is somehow too mysterious to comprehend. By the time Donald and I were finished with our inquiry, we had concluded that, rather than being inexplicable, the Holocaust is all too understandable. We came to believe that, to put it bluntly, the Holocaust was a manifestation of a world

in which power rather than justice prevails. Here it seems important to stress that I am not speaking about my own concept of power as *empowerment* but, rather, of *power over others*, which seems to be the prevailing paradigm around the globe. Moreover, the Holocaust demonstrates something that is also evident today: those who have the least to say about human events suffer the gravest of consequences, and this is particularly evident in the destruction or extinction of billions of creatures as one of the tragic consequences of human-induced climate change.

But, Judy—I hear my reader protesting—it can't be that simple. My answer is that I believe it is; the problem seems to be a general unwillingness to peer through the window provided by the Holocaust, which offers a clear picture of the dreadful darkness that now shrouds our planet, as well as our own lack of consciousness. Another seeming deterrent to looking through this pane of glass is that many questions are raised for which there may not be any adequate answers, at least not at this moment in history.

The goal of the *Holocaust Project* exhibition was to raise these questions, no matter how troubling or unresolvable they may be, which was one reason it took so long to complete. Each of the images, particularly those that combine painting and photography, had to be carefully engineered—philosophically, technically, and visually. Each painting/photo synthesized an enormous amount of information into a presentation that was elegant and simple—in fact, deceptively so; the purpose was to engage viewers rather than have them close off emotionally or quickly walk by. One task I set for myself was to make the art intelligible to Holocaust survivors. I wanted it to be not only authentic to their experience—after all, it was their courage in bearing witness that brought this tragedy to light—but also intelligible to them, not so visually coded (as so much of contemporary art is) that they'd have no notion it was based on what they had gone through.

I also hoped that the show might begin to lessen the vast distance between the frequent description of the Holocaust as one of the major philosophical dilemmas of the twentieth century and the near-total silence about this subject in the art world. The *Holocaust Project* was intended to bring some understanding of the extensive scholarship on this subject to a broad and diverse audience, who might be united primarily by the fact

that few would be able or willing to spend the many years that Donald and I did on this topic.

The exhibition was structured as a journey into the darkness of the Holocaust and out into the light of hope, paralleling the type of journey—intellectual, physical, emotional, and aesthetic—that Donald and I made. It included not only a series of painting/photo combines but also a monumental tapestry, *The Fall*—a visual narrative placing the Holocaust in the "fabric" of Western civilization—and two stained-glass windows.

The last piece in the show was entitled *Rainbow Shabbat*. It is a large stained-glass work, a triptych whose center panel extends the Friday-night Jewish Sabbath meal into an image of sharing across race, gender, class, and species. This particular work unites my feminism, my Judaism, and my personal background. The image is specifically based on the Jewish practice of Shabbat, with all heads turning toward the woman, as if to suggest that the structure of male dominance that now oppresses the planet must make room for a profound change, one in which women's voices can truly be heard, along with those of everyone who shares this tiny globe. Also implied, the words "Never Forget"—so often stated in relation to the Holocaust—will never become more than an empty slogan unless many of the world's people (men and women acting together) take up a commitment to *tikkun olam*, the healing and repairing of the world that my father had taught me to strive for.

Audrey Cowan wove the 18-foot entryway tapestry, *The Fall*, from my full-scale painted cartoon. A number of other artisans worked with us. No one was paid and nobody seemed to care. All of us felt engaged in work of a higher purpose, and money seemed almost beside the point, except in terms of getting enough to accomplish the art. The subject matter of the Holocaust was too difficult for Donald and me to expect that anyone else (except maybe for Audrey) would be prepared to spend so much time on it. (In fact, Joyce Gilbert, one of the *Birth Project* needleworkers, who worked on *Double Jeopardy*, an image examining the specificity of women's experiences during the Holocaust, later confessed that because of the feelings it engendered, she could only work short hours on the piece she embroidered.)

Consequently, it was essentially Donald and I who together created the *Holocaust Project*, united in our effort to first understand and then communicate our discoveries and conclusions. Personally, the two of us came out of it stronger, wiser, and closer, though deeply in debt. The price we paid (on every level) was worth it, if only for the profound responses to the art—both to the traveling exhibition and later, whenever the work is shown—by people who have thanked us, saying that the art inspired, moved, and enlightened them, which is all one can hope one's work can do.

I would now like to pick up my more personal chronicle. By the time we flew to New York to see *Shoah* in October of 1985, we were engaged, which caused a degree of concern among some of my friends, as they were worried about how short a time Donald and I had known each other before taking this momentous step. I must confess that I would not recommend such a whirlwind romance to others, as I am sure that, more often than not, these types of relationships do not last. I would say two factors worked in our favor. First, we were relatively grown up and clear about what each of us wanted in a mate. Second, both of us had learned to live on our own and were extremely self-reliant, something we both believe is critical in forging a marriage, as it prevents overdependency.

One thing about Donald that astounded me from the start was how steadfast he was in his commitment to our relationship. In all my previous relationships, I had vacillated—sometimes on a daily, if not an hourly, basis—about whether I really wanted to be involved with the person. But instead of reinforcing my ever-changing feelings with a comparable ambivalence or withdrawing or becoming angry, as others had done, Donald always maintained that what he wanted most was to make a life with me. This single characteristic of his is what has made our marriage turn out well, and I am grateful that he has had this strength of purpose.

It could not have been easy for him, particularly at the beginning. At the same time that I was madly in love with him, I was scared and anxious about whether agreeing to marry him would prove to be the biggest mistake of my life. My apprehensions were not lessened when I met his family, which occurred shortly after we saw *Shoah*, as they live on the East Coast. Donald had been alienated from his parents for many years; in fact, they did not

even have his phone number until I came on the scene. Nonetheless, he wanted me to meet his entire family.

My first inkling of why Donald had become so disengaged from his family came when we had dinner in New York with his Aunt Lillian. The older of his mother's two sisters, she was a crotchety and rather spiteful woman who greeted us at the restaurant by grabbing my hand and asking if her "dumb nephew" had even had the courtesy to give me a proper engagement ring, ignoring the beautiful silver-and-turquoise ring on my finger and pushing an enormous, ugly opal into my hand.

Before we left New York for Newburyport, a city north of Boston where Donald's parents lived, I met with the people at ACA. They had agreed to provide me with a monthly stipend until 1986, when I was scheduled to have my next show with them, which would be the exhibit of *PowerPlay*. Given all that seemed to be happening in my career, I felt hopeful that I would sell some art, so I was rather blasé about the fact that, as a creative photographer, Donald didn't exactly earn a steady income, something his Aunt Lillian had pointed out during dinner in a rather disagreeable manner, as would his brother and sister-in-law.

Having had my own family torn apart when I was young, I was hoping for a warm relationship with Donald's family. Instead, when we met his immediate family, I was treated to a list of Donald's character flaws by his brother, Jon, and sister-in-law, Betsey. They harped on his financial instability, though never in my adult life had I been supported by a man, nor did I ever expect to be. I quite liked Louis, Donald's father, a charming though rather mute man. Less educated than his wife, Bertha, he had spent most of his life doing blue-collar work, sometimes holding down two full-time jobs at once. There was something about his manner that reminded me of Donald's, and I could see where my soon-to-be husband had gotten some of his sweetness. As to Bertha, over the years I would come to appreciate her and the active life that she was able to make for herself in the middle of what struck me as a difficult family situation. I also developed a close relationship with Donald's Aunt Rosa, his mother's other sister, who lived in New York.

After our Newburyport trip, we stopped in Boston to have dinner with some friends. By then it had turned cold, and an unexpected early

snowstorm had left the streets icy. After an enjoyable meal, I slipped on the frozen sidewalk and landed on my right wrist. Although it hurt like crazy, I wrapped a bandage around my hand and the next morning went about my usual exercise stint. That day we flew home, and I ended up in the emergency room a few hours after we arrived in Santa Fe.

I had broken my right hand, which meant that I was out of commission for six weeks in terms of any studio work. As I still had the use of my fingers, I contented myself with doing a humorous series of *Cast* drawings, in which I recorded everything that had happened to make me suffer this accident and its consequences, including how smelly the cast became. I also began my Holocaust research and spent time with Donald, working on the many details of our wedding, and studying with Rabbi Lynn. At the end of November we flew to L.A. so that Donald could meet my mother and friends. Everybody adored him, as did my Chicago relatives when we went there in December for my Aunt Enid's eightieth-birthday celebration, although Howard was a little standoffish, as he has always been extremely protective of me. But this would not have kept him away from the wedding, and eventually he came around.

On New Year's Eve, 1985, Donald and I were married at Romona's house in Galisteo. Our bonding began with a contemporary version of the ritual cleansing known as the *mikvah*. This is usually performed separately by men and women, but we did it together in a hot tub. After our bath, we went through a rather odd ritual, which involved our facing each other and holding hands while someone circled around us carrying a moonstone. This actually seemed to send energy back and forth between us, until we felt almost as if the wedding knot had been tied right then. (If this sounds rather New Agey, my reader must remember that we lived in Santa Fe, the center of this kind of celestial magic, and also that we were crazed with love.)

Immediately afterward, we separated to prepare for the more formal ceremony, each of us aided by our two "best people." My cousin Arleen, another friend, and I crowded into one of the bathrooms at Romona's house, primping and giggling like teenagers (a belated activity on my part, as I had never had experiences like this in my teens). My dress was ecru, kind of netlike, covered with pale sequins and beading. In a sweet gesture,

Donald's mother had made me a blue garter and also sewn me a lace-edged ecru chiffon veil. This was designed to completely cover my face during the early part of the ceremony, then be flipped back after the *bedekken* ritual to show both my face and a beautiful crown of flowers that matched the one on Donald's head.

I should explain why, as a feminist, I would agree to incorporate such a rite, which in many traditional societies is associated with some extremely oppressive practices regarding women. By the time of our wedding I had begun my study program for the *Holocaust Project*, and one of the books I had read concerned Hasidic customs, many of which, according to the author, had been seriously misunderstood. As an example, the *bedekken* ceremony was originally intended to enhance the erotic connection between husband and wife. Whatever its origins, the way in which we enacted this ritual was nothing if not intensely erotic.

I was seated in a small room with our family, closest friends, and Rabbi Lynn while the rest of the guests were gathered in the living room. After some moments of expectant waiting, Donald entered this antechamber, and when he walked up to me I was trembling. I can still remember the tingling sensation on my neck as he approached to lift my veil, at which point we beheld each other, transformed from the people we had been only hours before into *bride* and *groom*. Carrying in one hand our *ketubah*, the marriage certificate we had spent many days working on together, Donald reached out with his other hand to grasp mine, and we walked over to Rabbi Lynn. After reading aloud the vows we had composed outlining our commitment to each other, our *ketubah* was signed by the two of us, our rabbi, and our witnesses.

Then Donald dropped the veil back over my face and we sat down on chairs. Suddenly we were hoisted into the air and carried into the front room, which was filled with more than fifty of our friends noisily clapping to the raucous strains of a klezmer band. The room was hot from the fire blazing in the huge fireplace, in front of which was the gigantic *huppah* (marriage canopy) that Donald had built out of logs and pine branches. It was so heavy that our four best people had trouble holding it up during the ceremony, and only Cousin Howard's exertions prevented it from capsizing

and covering bride, groom, rabbi, and attendants with the bower of pine needles that constituted the top of this oversized canopy.

As we faced Rabbi Lynn and she began to chant the traditional Hebrew prayers, both Donald and I felt moved in some deep, unfathomable way. Even though both of us had been married before, neither of us had been married by a rabbi, and somehow we had never felt truly bonded to another person until that evening, at which time Donald told me that this was the happiest day of his life. After the ceremony, there was eating, drinking, and ecstatic dancing. At midnight, Rabbi Lynn gathered us together for New Year's blessings and blew the *shofar* (ram's horn), a sacrament performed each year on Rosh Hashanah to commemorate the Jewish New Year. Many of the guests commented that ours was one of the most wonderful weddings they had ever attended, a sentiment definitely shared by the bride and groom.

Me and Donald at our wedding on New Year's Eve 1985, Galisteo, NM

They are very happy

We soon settled into married life, Donald taking a part-time job with an architect friend while I returned to my studio and my studies. Before I broke my wrist, I had begun a series of cast-paper reliefs as part of *PowerPlay*. They synthesized the sad and angry male faces of earlier work into a single image, expressing a kind of divided self. Over the next few weeks I worked on drawings for this series, along with some sketches of Donald. While he was modeling for me, he commented that one thing that had always struck him about some of my work was that I had provided alternative images of women, in which they were presented as strong and powerful rather than passive or victimized. He suggested that I try to do something similar with men, perhaps offering a picture of men as women might wish them to be. I began to ask myself a version of the old Freudian question: What do women really want? My answer was put forth in *Woe/Man*, for which Donald posed. In this large relief, the head is lifted, the throat exposed in a strong gesture that also suggests vulnerability.

One Sunday in January 1986, three weeks after our wedding, as was my weekend habit, I went running on my favorite trail: up the twisting hills of the neighborhood and down Upper Canyon Road, then looping back toward the house, where I knew that Donald would probably have a steaming cup of cappuccino waiting for me. We had taken to sitting on the sun porch with our kitties curled up next to us and reading the Sunday papers. I was looking forward to a quiet day. The morning was cold and crisp with the clear, delicious blue sky of a New Mexico winter. As I rounded a turn and started my long downhill sprint, I saw a large, beat-up truck coming up the road. The next thing I knew, I was sprawled out on the ground with an excruciating pain scalding my right side.

Several cars stopped, which caused the truck driver to pause, then back up. Although I didn't know it at the time, he was a myopic eighty-one-year-old who should have stopped driving years before but had been allowed to keep his license thanks to the lax laws of New Mexico. An ambulance was summoned, and I was taken to the hospital. I can remember wondering if I was going to die. Meanwhile, a man who'd been at the scene somehow found his way to my house and notified my husband.

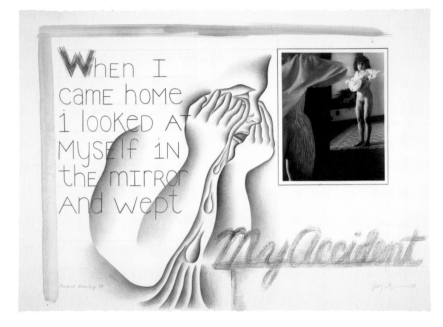

When I came home I looked at myself in the mirror and wept

My Accident

ACCIDENT DRAWING 18 from **MY ACCIDENT** 1986
Mixed media on paper, 22 × 30 in (55.88 × 76.2 cm)

Poor Donald! He rushed to the hospital and must have been shocked to see his wife of less than a month lying in a bed in the emergency room. Actually, I was extremely fortunate, because although my pelvis was broken, I did not need surgery or a cast, though I was badly bruised. After three frightening days in intensive care, I spent about a week in the hospital, during which time I had to be transfused because I had lost so much blood from internal bleeding.

I didn't fully realize that I'd had an extremely close call and that my body had suffered such trauma that it would take six months to fully recover. Donald was wonderful, although for some weeks he walked around in a state of shock. Finally, we decided to try and deal with our feelings about this upsetting incident by collaborating on a series of images that combined my drawing with his photographs, re-creating the accident and documenting the damage to my body. It was difficult for me to have my new husband staring at my disfigured body through his camera lens, though I was glad

for the opportunity to work together in an attempt to transform the raw emotions of the experience and painful photographs of my battered flesh into something resembling art.

It took some time before I was able to resume my schedule of regular hours in the studio, study, and exercise, combined with lectures, openings, *Holocaust Project* research, and other related activities. Whenever we could manage it, Donald traveled with me, which was great; in fact, we would have some of our best times on the road. Gradually, our life was taking on a pleasant rhythm. A few months after the accident, we began to make plans to go to Germany. After the London exhibition of *The Dinner Party*, a group of German women had begun organizing to get the piece shown there, eventually convincing the director of the Schirn Kunsthalle in Frankfurt—a "real" museum, thankfully—to mount the exhibition.

This German effort was spearheaded by two women, Dagmar von Garnier and Anne-Marie Gesse, but it eventually expanded to include a vast network of (primarily) women from Germany, Austria, and Switzerland. To build support for and interest in *The Dinner Party*, the organizers were planning something called the "Festival of One Thousand Women," to be held at the restored Frankfurt Opera House in June 1986, one year before the scheduled show. Hundreds of people from all over Europe were preparing to assemble there, each costumed as one of the women on the *Dinner Party* table or the *Heritage Floor*. The organizers invited me to come for this gala and to see the museum space, which I agreed to on condition they also bring Donald over to discuss the planned exhibition installation, as he had taken over as installation supervisor.

Shortly before leaving for Germany—where I had been only once before, for a brief visit—I traveled around the United States for several weeks, going first to L.A. with Donald to view survivor testimony in the UCLA archives and also to celebrate my mother's seventy-fifth birthday, an occasion for which my brother also came to town. At this time, Ben and I had another difficult conversation, during which he told me that he viewed all my efforts to discuss the problems of our childhood as being "negative," insisting that he only remembered "good times." I was stunned to realize that we had such different memories, although I was tempted to

suggest that he was practicing a high level of denial about the reality of his childhood. From there I went to Benicia by myself for a two-day Through the Flower board meeting, which by then had become an annual event. I did a few lectures around the country, then went to New York, where Donald met up with me.

While we were there, we attended the opening of a *Birth Project* show at a small museum on Staten Island. In another attempt at family solidarity, I invited all of Donald's relatives to the opening, after which my new sister-in-law Betsey, who had an art-history degree, took it upon herself to write a critique of the exhibit, which she circulated to all her friends. As I told her in my customary less-than-tactful way, I had enough trouble with the art critics without such comments from one of my new relatives. As to Donald, he became so furious that it intensified his already tense relationship with his family.

We went on to Washington, D.C., where Donald did some photo research in the National Archives. We also met Isaiah Kuperstein, who was then working at the Holocaust Memorial Council and would become something of a mentor to me. Because he was a Holocaust scholar and educator, we wanted to discuss our initial ideas for the *Holocaust Project*, along with our anxiety about the upcoming trip to Germany. Isaiah, who had been born in the German town of Essen, suggested that we might like to visit the old synagogue there, which had been turned into the only museum in Germany then dedicated to the Holocaust. He also advised us to try to keep an open mind about Germany. This was to be the first of many such conversations in which Isaiah gently steered us away from a somewhat emotional reaction and toward a more measured point of view.

Not too long afterward, Donald and I flew to Germany. Gelon, who was living in London, met us in Frankfurt. A day or two later, we arrived at the Opera House for the scheduled festival and found the front of the building draped with a gigantic blood-red velvet curtain with a small, vagina-like entrance. With some dismay, we squeezed through the folds of the fabric. Inside, hundreds of decoratively adorned women mingled, introducing themselves as this or that historical woman, then reciting her biography. After a rousing performance of a piece by Fanny Mendelssohn

Festival of One Thousand Women in Melbourne, Australia 1988 and at the Frankfurt Opera House, Germany 1986

that had never before been performed (presented by an all-female orchestra conducted by a woman dressed up as the composer), it was time for a performance in which the thirty-nine women dressed as the figures on the table were to assemble in a sort of living triangle in the center of the hall.

The person representing Petronilla de Meath, the first woman burned as a witch, was missing, and I spontaneously took her place, encouraging the other women to join hands while we waited for another bout of music to begin. For some reason, never explained, this planned musical interlude did not occur; instead, there was an eerie silence, then a crooning sound seemed to arise as if from nowhere. It was a cross between a moan and a wail, and soon all the women in the room added their voices to this tone. The rhythmic pitch built to a loud crescendo, then abruptly subsided. At the moment when the sound reached its height, all thirty-nine women raised their arms in unison; it felt as though the very spirit of *The Dinner Party* entered the room. I would be told again and again that this moment was the highlight of the festival.

Later, while I was being interviewed by some major media, the hundreds of costumed women descended from the upstairs hall to the foyer,

dancing and passing around a large clay amphora. To some, this large jug apparently represented the ancient Goddess, whose various names were repeatedly invoked. Then, all at once, the women began to chant my name louder and louder, until someone came to fetch me. I was immediately hoisted up on many shoulders, whereupon the huge crowd of women surged outside to the plaza, which was thronged with bystanders.

During this and our subsequent trip in 1987 for the *Dinner Party* opening, I felt that both the work and I were well received. And yet, according to Anette Kubitza, a young art historian who has written extensively on the German reaction, my own perspective was once again quite different from that of the art and feminist press. This contrast can probably be explained in several ways. First, I was buoyed as usual by the huge popular outpouring of positivity, both during the festival and at the exhibition the following year. Second, *The Dinner Party* was the most successful show ever held at the museum up to that time, and I again naïvely believed this would count for *something*. Third, I don't read or understand German, and no one ever mentioned that the reviews, according to Anette, were so hostile as to be poisonous. Finally, by the time of the exhibition I was completely absorbed in the *Holocaust Project*.

As Jews in Germany, both Donald and I were glad we had taken Isaiah's advice to keep an open mind and also go to Essen. The trip there was quite moving, in that the Holocaust exhibition at the former synagogue chronicled events that had happened in the very streets we could see out of the building's windows. However, the German woman who accompanied us as our translator and guide refused to come into the museum, saying that she could not deal with the Holocaust, as her father had been a police officer during the years of the Reich. Although she and everyone else we met in Germany were very nice to us, her comment gave us a sense of the enormous shadow that lay over the German past.

When we returned from our initial trip to Germany for the Festival of One Thousand Women, we decided we would use the months when *The Dinner Party* was to be in Frankfurt the following year to travel through the landscape of the Holocaust. By then I was negotiating with Doubleday for a book about the project and intended to use part of the advance to

pay for this next journey. I spent the summer working in the studio and doing research.

Early in September I received a call from Brian, my former lover, telling me that Stephen Hamilton had been diagnosed with AIDS and that Stephen was so shattered by the news that he had been unable to tell me himself. Over the next few years I spoke to Stephen weekly, and he visited us frequently. But at the end, when he was close to death, I would not be able to bring myself to see him, something I still feel distressed about. By then, several other people close to me were terminally ill, and my emotional stamina was terribly strained, especially given the ongoing demands of the *Holocaust Project*. I grieved for Stephen for a long time.

Later that month, Donald and I flew to Chicago for a *Birth Project* show at the Richard Love Gallery, then to New York for the opening of my *PowerPlay* exhibition at ACA. Right after this we went to the Caribbean for our first real vacation, arriving back in New Mexico in mid-October. I left soon afterward for a Through the Flower board meeting in L.A. While there, I made another attempt to talk to my mother about what she and my father had known about the Holocaust during my childhood. My first effort had not gotten me very far, as she had bristled when I brought up the subject. This time she was somewhat more receptive, and we were even able to talk about why we had celebrated Christmas every year until just after the war. She explained that she hadn't wanted Ben and me to feel alienated from the other kids in the neighborhood, but then she and my father became uncomfortable about commemorating that holiday once all the facts about the Final Solution were known.

I then went up to Benicia to spend a few days with MR, primarily to follow up on some of the discussions that had taken place at the board meeting. The board had talked about the relationship between Through the Flower and the *Holocaust Project*, agreeing to my proposal that the corporation act as sponsor so that Donald and I could apply for grants and accept donations. MR and I agreed that the administration of the *Holocaust Project* should be based in Santa Fe, where Juliet Myers, who was already working for me, could provide us some degree of support. MR had her hands full with the *Birth Project* tour, which was then going strong, and she had also

begun to take on some *Dinner Party* duties, as Gelon was increasingly occupied with her London law practice. MR indicated that at some point she would like to return to Houston but, given all that was happening, it would be best to keep the Benicia building open somewhat longer.

I went home in late October to discover that there had been almost no *PowerPlay* sales at the gallery and, curiously, a near-total silence in terms of articles and reviews, the first time such a thing had ever happened to me. I still don't know what to make of this, but I do know that at the time I was worried about the gallery's response. The Bergens were unfazed, however, and told me to just keep working. The problem was that, given the lack of sales, my gallery stipend would soon come to an end, which meant that our finances would get extremely tight.

Shortly after the first of the year, MR arranged to buy a small house at the back of the Santa Fe property, which she agreed to rent to me for use as a studio at an extremely modest cost and in exchange for art. I received my advance from Doubleday (when Doubleday was later sold, they let the book contract go, which is how I ended up at Viking Penguin), which would pay for our upcoming European trip as well as renovations on the new Santa Fe building. Once these were finished, Donald would take over my former studio quarters in the house so we could each have our own space.

Throughout the early part of the year we were busy with research, renovations, and preparations for the trip. These were interrupted when my mother was diagnosed with breast cancer and we went to L.A. for the operation, which involved a radical mastectomy. The tests showed that the cancer had spread to her lymph nodes, but we were told to take some comfort in the fact that cancer metastasizes slowly in elderly people. Then, within weeks of my mother's operation, Donald's father was found to have colon cancer, and we flew East. Louis's malignancy was localized, fortunately, and his prognosis was good after it had been removed.

In response to these trials, Donald and I set to work on a suite of drawings we called *Coast to Coast Cancer*, in which we dealt with our feelings in images that combined my drawings with his photographs. While thus engaged, we went back to L.A. to check in on my mother. When I saw her, I thought about the arrogance with which the Nazis deemed some people

unworthy of life, because I realized that, given her age and infirmity, she would not have been allowed to survive. My contemplation of the Nazi "euthanasia" program triggered an enormous wave of compassion for her.

In mid-April of 1987, we left for Germany. As soon as we arrived in Frankfurt we went to the museum, where the installation of the *Dinner Party* exhibition was already underway. Unlike on our previous trip, we were going to be in Germany for several weeks, and soon began experiencing a dual level of reality. For example, whenever I went running in the lush park that bordered our hotel, I would pass elderly gentlemen taking a stroll. They would nod politely and I would smile back, all the while wondering what they had been doing during the war. Then there was the near-constant noise of trains rumbling in the background, as the hotel was close to a train route. This sound, summoning thoughts of the transports to the concentration camps, would haunt me throughout the days we were there, many of which I spent curled up in the hotel suite studying writings by Elie Wiesel.

Audrey Cowan and Susan Hill both came to work on the *Dinner Party* textiles, which needed some repair. Gelon came in for the opening, as did Juliet Myers. It was quite an event, introduced, as in London, by an opening speech, this time by an art historian whose words seemed to indicate an understanding of *The Dinner Party* that was contradicted by everything reported by Anette Kubitza (no wonder I get confused). Audrey wanted to accompany Donald and me on some portion of our trip, so shortly after the opening, the three of us set off for France. Our first stop was at the Natzweiler-Struthof concentration camp in Alsace-Lorraine, cold and snowy even in May. No amount of study could have prepared us for the dank, chilly, humid air; the seven-kilometer road built by the prisoners; then the crematorium building with its oven and dissecting table; and the nearby hotel and bar, across from which there was an old bathhouse that had been converted into a gas chamber for this camp.

From there we drove back to Nuremberg, site of early Nazi rallies and then the war-crimes trials after the war. We went on to Dachau, a camp that has been thoroughly sanitized for the tourist trade, at which point Audrey left us and we continued east into Austria. I wrote Isaiah a letter about our experiences in the slave-labor tunnels of Ebensee that caused him to

worry about my sanity. His fears were justified, because only two weeks into the journey I was coming undone, as was Donald. There were many nights when we would collapse at our hotel; Donald would withdraw into silence while I sobbed for hours.

We continued on to Theresienstadt in Czechoslovakia, site of a former ghetto, and then to Prague, where I had another epiphany, this time at the old cemetery filled with innumerable Jewish graves and gravestones. Walking among them created a sense of both pride and despair, as if I finally understood the long and rich tradition of Eastern European Jewry and, at the same time, what it meant that so many parts of Europe were now *judenrein*—"Jew-free." From there we went to Poland and the very center of hell: Auschwitz-Birkenau, the scale of which astounded both of us.

Everywhere we went I sketched and wrote in my journal and Donald took photographs, trying to establish an image base that we could draw upon even before we knew exactly what we were going to do. Whenever we visited a camp or site, it seemed to rain; I called the downpours "tears of sorrow." Nowhere was our despondency greater than at Treblinka, which Harvey Mudd had described in his poem as one of the saddest places in the world. Seventeen thousand stones commemorated the murders of hundreds of thousands of people who'd been herded onto trains and brought here tired, hungry, thirsty, and terrified; all were put to death within hours of their arrival.

From Poland, we were scheduled to go to Russia. By then it was June, and after a big hassle with the Polish authorities about our visas, we made our way to Leningrad (as it was still called) at the time of the White Nights. The long, oddly lit days were spent visiting dissident Jews, who educated us about the ongoing anti-Semitism there. Our one break was a visit to the famous Hermitage museum.

At one point, we had a screaming fight on the Nevsky Prospekt, watched by Russians who seemed alternately surprised, fascinated, and amused by the sight of two Americans shrieking at each other in the middle of a crowded downtown street. I stomped off, announcing that I was going home—an impossibility, given Russian travel arrangements, and laughable when I think about it, particularly in light of my terrible sense of direction;

I probably couldn't have found my way back to the hotel, much less all the way to America. Fortunately, Donald followed me to make sure I got to our quarters safely, by which time I had cooled off. We soon made up and then went on to Latvia and Lithuania. In Vilna—by either miracle or fate, I could not decide which—we found the tomb of my illustrious ancestor, the Vilna Gaon. As I stood inside his mausoleum, I marveled at the personal and aesthetic journey that had brought me here (along with Donald's insistence). I could not help but wonder what my father would have thought about my determination to reconnect with the family's Jewish roots.

By the time we arrived home in July, we found ourselves transformed by all that we had shared, suffered, and learned. Although we didn't realize it at the time, we had also been more firmly bonded as a couple by what we had been through together. As we would sometimes say later on, if we could get through a trip as grueling as this, there was not too much that could rend us apart. Our trip dramatically broadened our understanding of the Holocaust—its scale, scope, and meaning. After almost two years of preparation, I had many ideas, beginning with *The Fall*, the large tapestry

Drawing at the tomb of the Vilna Gaon, Lithuania 1987

that placed the Holocaust in the context of Western civilization and examined the historical relationship between anti-Semitism and antifeminism. I worked on studies and then on the painted cartoon until the end of the year. At the same time, as it has often been my practice to work on multiple projects simultaneously, I was finishing a series of cast-paper and bronze *PowerPlay* reliefs at Shidoni foundry in Santa Fe.

By the fall of 1987, plans had been finalized for *The Dinner Party* to go to Australia as part of its bicentennial celebration, scheduled for early 1988. Through the Flower decided to hire the young man who had overseen the installation in Germany, to work with the people in Melbourne to set up the space at the Royal Exhibition Building, which needed considerable renovation. (Because of the demands of the *Holocaust Project*, Donald didn't have the time this would take. Instead, he would handle the actual installation, then I would come for the opening.) In addition to the exhibition

Working on a **DOUBLEHEAD** bronze at the Shidoni Foundry, Santa Fe, NM 1986

in Australia, I was also making plans for two gallery shows, one in Los Angeles and another at the Andrew Smith Gallery in Santa Fe with Annie Leibovitz, whom I'd seen from time to time since she photographed me in Benicia in 1979.

She and I joked that this exhibit should probably be called "The Queen of Content Meets the Queen of Form," as her highly polished portraits were in stark contrast to what I intended to display: a series of pieces I dubbed "Accidents, Injuries, and Other Calamities." My plan was to exhibit the various works I'd done over the years—some in collaboration with Donald—on the mishaps sustained by other family members and me. Most of these pieces were quite direct, even raw, and I hoped that by showing them I might put an end to the many hospital trips I had been forced to make during the previous years.

Donald had been seeing a psychiatrist named Donald Fineberg, and toward the end of the year I joined my husband in therapy. Early in our sessions, Dr. Don, who'd treated a number of Holocaust survivors, told me that I seemed to have many personality traits similar to theirs. Dr. Don was to help us immensely over the next few years as we became increasingly immersed in an artmaking project that caused us both such endless sorrow. Even though we had become much closer after our months of travel, our marriage still might not have survived the stress the work would cause, primarily because we reacted so differently. Donald's tendency was to shut down emotionally, whereas I became hypersensitive. Dr. Don helped us to build communication skills so that we could better deal with the many hurdles, both personal and artistic, that might otherwise have torn us apart.

Shortly after Donald and I celebrated our second wedding anniversary on New Year's Eve, 1987, he left for Australia. I followed him a few weeks later. *The Dinner Party* was ushered in by a "Dinner for One Thousand Women" (attended by many more) that mimicked an all-male event held one hundred years earlier in conjunction with the Australian centennial. Once again, the exhibition generated some degree of controversy, but the criticism seemed nowhere near as mean-spirited as that in Germany and New York. The show proved to be such a popular success that a museum in Western Australia asked to mount the exhibition at the end of its Melbourne

stay. I refused because by then *The Dinner Party* had been exhibited fourteen times, more than I had originally planned. It was showing considerable wear and tear, particularly the runners, some of which had sustained damage when the roof of the London venue had leaked.

Moreover, I thought—and Through the Flower's board agreed—that it was time to bring the piece back to America. We were under the impression that *The Dinner Party* had triumphed over the resistance that the art world had initially evinced, as indicated by the fact that the piece was being featured in so many art-history books and taught in both art and women's studies classes all over the world. We firmly believed that the work might finally find a permanent home, thinking that, after its demonstrated audience appeal, any number of institutions would be interested in housing it. This assumption was reinforced by what we knew of art history, which demonstrates a trajectory from creation to exhibition to preservation of works of art, at least those viewed as historically important. Judging from its international impact, it seemed that *The Dinner Party* might certainly be so evaluated.

Before leaving Australia, Donald and I traveled around while I did some lectures. We climbed Ayers Rock, a sacred Aboriginal site. Germaine Greer, whom I ran into at our hotel in Melbourne, had described the Aborigines as "driven mad with grief" by what she characterized as the Australian genocide. Somewhere in Queensland—in my opinion, one of the most exquisite and (at that time) ecologically untouched spots in the world—I contemplated her remarks and thought about the connection between the cultural genocide of the Aboriginal people and the Holocaust.

When we returned to New Mexico, Donald and I set to work on the first series of painting/photo combines. The months soon settled into the pattern I like best: long, focused periods in the studio, then breaks for travel—to lecture, do research, and make presentations on the *Holocaust Project*, which helped us raise funds.

In the early spring of 1988, my mother was finally accepted into the Jewish Home for the Aging. After her initial surge of interest in living there, she had decided instead to move into another retirement home in her neighborhood. This place proved as inadequate as the previous one, rapidly going downhill in terms of services and offering no intellectual stimulation

whatsoever, which left her with not much to do but sleep. Ben and I were both concerned that if she didn't make the move soon, it would be too late, as the Jewish Home requires that people be in good health when they enter. Despite the cancer, my mother was still in relatively decent shape physically.

Over the previous few years, things had eased up some between my brother and me, particularly after I followed his lead and stopped trying to rehash our childhood. Instead, I focused on the present and sharing stories about our work and respective lives. Ben was becoming established as a potter in Japan, and he and Reiko had two sons, Elijah and Simon. At one point he offered to come over and help my mother move, a task in which he was aided by Kate Amend. She had worked on *The Dinner Party* as well as the book *Embroidering Our Heritage*, and had always been particularly fond of my mom. In addition, I believe that Kate wanted to ferret out and save some of my letters and early drawings that my mother had squirreled away (I tend to throw out such materials).

About this same time, I had my Los Angeles show. Even though my art-world friends and I thought it looked spectacular, the review in the *L.A. Times*—by the same critic who had so hated *The Dinner Party*—was scathing, reiterating the opinion that I cannot draw. Far worse, there were no sales from this exhibit, which ended up costing me money (in framing and shipping) that I could ill afford. On Memorial Day weekend, my two-woman show with Annie Leibovitz at the Andrew Smith Gallery in Santa Fe opened with a line down the block. On the day of the opening, one of the largest of my works fell off the wall. Everyone commented on the irony of an exhibit about misfortunes beginning with an accident. No one was injured, fortunately, though the piece was ruined.

Over this summer of 1988, I worked steadily on the *Holocaust Project*. The work was hard, made even more difficult by the fact that by then we were living month to month and not sure how we'd pay the next month's bills. I can still recall the Monday afternoon when we were faced with running out of money by Friday. On Tuesday, I had to force myself into the studio, reminding myself that it was still early in the week. By then, we had started sending out a newsletter, which, with our presentations around the country, brought in some donations, but only enough for supplies. In

August, Elizabeth Sackler came to see the *Holocaust Project*. The daughter of famous art collector Arthur M. Sackler, she visited us as an evaluator for the Threshold Foundation, which was an organization through which those who, like Elizabeth Sackler, had inherited wealth sought to put it to good use. The Bergen twins from ACA had put us up for a grant.

Meeting Liz was extremely propitious, and we soon became good friends with her and her then husband, the filmmaker Fred Berner. More important in terms of the *Holocaust Project* and our strapped finances, she aided us in securing the Threshold grant. She also became a major patron, helping to sustain us through her art purchases and her contributions to both the project and Through the Flower, whose board she joined for a few years. And she played an indispensable role in fulfilling my lifelong goal of permanent housing for *The Dinner Party*.

Liz would become an important feminist philanthropist and went on to establish the Elizabeth A. Sackler Center for Feminist Art at the Brooklyn Museum. For decades, women artists, including myself, have benefitted from her support. She has been sidelined by the scandal that engulfed the Sackler family in the 2000s, even though she has publicly disavowed the unethical behavior of other members of the Sackler family.

In November, Donald and I went to Israel, as our research would not have been complete without such a trip. Neither of us had ever been there, and many people had told us we could not imagine what it would be like to visit a Jewish country. They were right: here it was the Jews who were the norm, while others were the outsiders. Our reactions to Israel were complex, as it is a place of stunning contradictions. On the one hand, I loved the energy of the Jewish people, demonstrated by the way they had literally made the desert bloom. At the same time, I deplored the sexism that seemed to pervade the country and hated the omnipresent military (while recognizing its necessity). We drove all over, visiting museums, kibbutzim, and Holocaust memorials. We took a dip in the Dead Sea, floating around like corks in the slimy water. One of my favorite spots was the Galilee, so beautiful as to be breathtaking, almost like a picture postcard.

We were home in time to prepare Thanksgiving dinner, to which Howard and Arleen came, along with nearly twenty friends. Unfortunately,

Donald became ill with pneumonia and ended up in the hospital. By early December he had recovered and we were both back in the studio. The first half of 1989 was spent working on the *Holocaust Project*. A short interruption came in April when Donald and I went to L.A. for a tenth-year reunion for *The Dinner Party*, attended by more than forty people (including Gelon, who flew in from London). Before we left for California, Donald and Juliet organized a private celebration at the Santacafé. Julie decorated the table with *Dinner Party* motifs and the chef concocted a series of courses based upon the place settings, my favorite being the "Georgia O'Keeffe" chicken wings. The pièce de résistance was an "Emily Dickinson" cake with layers of shaved white chocolate formed like the lace-draped image on the plate.

In May, we made a short trip to Chicago to meet with the Spertus Museum, a Jewish institution whose curator, Olga Weiss, had written to us after receiving one of our newsletters. It seemed that they were interested in premiering the *Holocaust Project*, an idea that appealed to Donald and me because, even though we were determined to exhibit the show in both Jewish and secular art institutions, we thought it important to start the exhibition tour in a Jewish museum. We believed this would demonstrate that, although the exhibition broadened the dialogue about the Holocaust beyond the Jewish experience, nonetheless, the art was authentically embedded in a Jewish perspective. Both Donald and I very much liked the (then) museum director, Morrie Fred, with whom we would work on plans for the exhibition over the course of several years.

On July 20, 1989, I turned fifty, and two days later there was a huge birthday party at our house, attended by more than fifty of our friends, all costumed in 1950s outfits, who danced all night to the strains of a band playing 1950s tunes. Our friend and housekeeper, Mabel Griego, prepared a wonderful feast of spicy New Mexican cuisine. Bob Cowan read a poem he had composed about me, culled from interviews with countless friends, that was so funny I fell on the ground laughing. I received gifts and flowers, including a wonderful letter jacket (as they call it in the South) from MR that was emblazoned with my initials and my age. Whenever I wear it I am reminded of this fantastic night, which remains one of the best memories of my life.

The next morning, Ben called from Japan to tell me that he had been diagnosed with amyotrophic lateral sclerosis (ALS, also known as Lou Gehrig's disease), the same disease that had stricken my uncle Harry when I was a child. Ben had been given less than three years to live, during which time he would become progressively more paralyzed. Whatever difficulties we had had over the years dissolved in that one moment when my baby brother reached out to me, his only sibling, in terror and misery. I could not believe my ears. It seemed so cruel. Ben was just getting established professionally; he and Reiko had small boys, they were planning to buy the house they were renting and were looking forward to a long and happy life together after years of considerable financial struggle.

It was as if time collapsed; my brother was just about the same age my father had been when he died, also leaving two children. The circumstances seemed too similar to be only coincidence. It felt as though our childhood had come full circle, paralyzing my brother physically as a metaphor for what it had done to both of us emotionally. At that moment of shared torment, we agreed not to tell our mother, since her cancer, though spreading slowly, was terminal. We decided that we would protect her from this sad knowledge for as long as we could. Donald and I insisted upon paying for Ben to come to America immediately for further tests; perhaps the diagnosis was incorrect. We held on to this hope like drowning people, while in our hearts we knew there was only a slim chance that the prognosis was wrong.

I was fortunate that so many of my friends were in town. All day they sat with me while I cried, offering sympathy, loans of money—anything at all. I was desolate, not only for Ben but for my small family, who had suffered so much loss. Suddenly Dr. Don's words about my resemblance to a Holocaust survivor came back to me. I realized that by the time the *Holocaust Project* opened, I would be the only surviving member of my family because, in all likelihood, both my brother and my mother would be dead.

THE DINNER PARTY GOES TO CONGRESS

The next few days were awful, full of alternate bouts of anxiety, grief, and hysteria. As I am an extremely physical person, the idea of my brother's body slowly deteriorating until he was unable to move at all was almost more distressing to me than the ultimate outcome of such a diagnosis—that is, his death. Memories of our father's eldest brother, Harry, kept roiling around in my mind. I could still see him lying on his bed, wearing only underpants, crippled by the lateral sclerosis that would shortly kill him. How would Ben be able to face such a terrible fate? Was it just coincidence that two family members could be stricken with the same neurological illness?

A friend of ours brought over information about ALS, as her father had also suffered from it. It turned out that there was some familial predisposition, though the genetic link had not yet been located. What of Ben's sons? Could they get it? I spent hours on the phone with my longtime internist in Los Angeles, asking questions and arranging for medical tests. I intended to meet Ben there, to be with him while he went through the examinations my doctor was setting up.

I had been scheduled to lecture at an international arts conference in Norway. Because neither Donald nor I had ever been in Scandinavia, we thought we would enjoy a holiday while there, as we were told that the landscape was spectacular. But I couldn't imagine cavorting around the fjords while my brother was struggling to come to grips with this frightful news. Moreover, I wanted to be accessible to him at any time, day or night. At first I was going to cancel the trip altogether. But when I called the conference organizers, they said people were coming from all over to hear my speech.

Donald suggested that we go but that we cut the trip short; also, we would stop in Chicago on the way back so that I could see Howard, which

he knew would do me good. It was definitely helpful to get away for a brief time and also to talk to my cousin Howard, who of all people most understood me and my family history. We got back to Santa Fe in early August 1989, and the next few weeks were full of such intense sorrow that it required all my strength and discipline to get up each morning, exercise, paint, eat, sleep, then do it again the next day.

In mid-August, I went to Los Angeles to spend several days with Ben, who had flown in for tests. On the first day, we talked and wept together for hours. The following morning, we went to see the neurologist. He did not even bother doing all the tests that had been scheduled but coldly confirmed the diagnosis and said that Ben would probably not survive for more than a year and a half. I called Donald that evening and begged him to fly in, as I was desolate. The next day, the three of us visited an ALS center, where we were educated in the techniques that had been developed

With my brother, Ben Cohen 1989

to manage neurological diseases; the methods were far more advanced than in my uncle's lifetime, at least in the United States. Along with this information, the people at the center gave us a degree of hope, saying that in some cases patients are able to survive far longer than predicted by the doctor we had seen the previous day.

At dinner on our last evening together, we discussed some of Ben's fears for his wife and children. Reiko didn't drive and at the moment had no way of making a living. Although she was anxious about doing so, she had enrolled in driving school, and Ben said he was thinking of training her in ceramics so she could take over his pottery, whose business aspects she was already handling. (Reiko did indeed become a successful potter, eventually earning enough money to put both boys through college.) Ben also disclosed his desire for his sons to have the opportunity for some sort of American life, because he was afraid that in Japan their mixed blood would cause them difficulty. He requested that Donald and I provide for them, should either Elijah or Simon wish to live or go to school in the States, which, of course, we promised to do.

Donald and I went back to New Mexico with the intention of returning to L.A. before Ben left at the end of August. My brother had many friends in America, both in California and around the country. I had encouraged him to share the news about his illness with them, and they responded with great sympathy, many flying in to be with him over the next few weeks, which was a source of great comfort to Ben. During this time he did not contact our mother, although we repeatedly discussed whether we should tell her. My brother felt unprepared to see her and unable to confess that he was sick; when the time came that it was unavoidable, he said, he wanted this job to be done by me. In late August, Donald and I went back to the West Coast to be with Ben and to put him on the plane back to Japan. By then, my brother was beginning to lose some degree of muscle control. As a result his gait was slightly unsteady, and when we walked him to the gate and said goodbye, he was so scared it broke my heart.

Words cannot express how dreadful I felt. All I knew to do was what I had always done before in the face of life's tragedies: go back to work. I suppose it was sadly fortuitous that the subject matter of the Holocaust

was such an unhappy one, as it provided an apt vehicle for my personal misery, which I struggled to incorporate and transform into visual images of a larger and more historic suffering. Over the next months, while Ben became progressively more paralyzed, I plunged ever deeper into the grim terrain of the Holocaust, immersed both privately and artistically in unremitting sorrow and grief.

At first I found it difficult to stay in the studio and was tempted to leave for any number of excuses, like making a phone call or having a cup of coffee—anything to get away from the distressing feelings, if only for a moment. Gradually I became accustomed to the dull ache of sadness and the awful reality that my brother was going to die in the near future. I was distraught that he was so far away and wanted him to return to America, where he would have access to the type of care described to us at the ALS center. In Japan, at least at that time, people with catastrophic illnesses were put into the hospital, where they stayed until they died. Ben was adamantly opposed to spending what time remained to him in an institution, but there was no precedent for home care in Kadanji, the small town where he and his family lived. He insisted, however, that he wanted to stay there, feeling that it was his home and that Reiko and the boys were under enough strain without being uprooted.

Ben asked if Donald and I could come to Japan soon and, though we had no idea how we'd pay for such a trip, we agreed. Money was scarce as it was, and we had already borrowed the funds to cover Ben's airfare to America as well as the medical tests. I wanted to arrange some Japanese lectures so that our plane fare and expenses might be covered, so I contacted a woman named Kazuko Koike, who lived in Tokyo. She was the daughter-in-law of my old friend Dextra Frankel, who had been the director of the gallery where I had long before held my name-change exhibition. Some years earlier, Kazuko had arranged for the publication of *Through the Flower* in Japan and had translated the text herself. She had also organized a traveling show of my work in conjunction with the book's publication. Though I had not been invited to Japan at the time, I hoped there might now be some degree of interest in my doing a speaking tour, and, fortunately, there was. Kazuko set to work organizing a series of lectures for the following spring.

Throughout this period and for as long as he was physically able, I spoke to Ben weekly and sometimes more frequently. I continued to speak to my mother on a regular basis and amazed myself by my ability to dissemble with her, something I had never felt comfortable doing with anyone. But because Ben and I had decided to protect her from any knowledge of his illness as long as possible, I felt I had no choice. In fact, we hoped that, given her cancer, she might die before he did, as we both thought this preferable to her having to experience such woe.

At this point in the *Holocaust Project*, I was working on several images in a series entitled *Banality of Evil*, a reference to the phrase coined by the philosopher and political theorist Hannah Arendt in relation to the trial of Adolf Eichmann, one of the organizers of the Final Solution. The paintings were all done in tones of gray, which seemed an apt hue for my downcast state. Painting became my only solace other than Donald, who was endlessly supportive.

The next months went by as they do when I paint every day, taking on a rhythm that seemed to flow in a steady stream. I spent long hours carefully blending the oil paints in what felt like an almost timeless state, punctuated by exercise and the obligations of everyday life, along with long phone conversations with Ben every Saturday night. Each week before calling him, I became besieged by such fear and anxiety that I began to see Don Fineberg by myself, as I wanted to be there for my brother and needed help in fighting off the depression that threatened to choke me. I can remember Dr. Don trying to comfort me by saying that I was not clinically depressed but, rather, merely responding as anyone would in the face of so much stress.

While I struggled to maintain some semblance of normalcy in my life, Ben began to find ways to deal with what would never again be an ordinary existence. He started building a network of people willing to help him find a way to remain at home as his ALS progressed, eventually organizing an ALS chapter in his region. Under his direction, Japanese and American friends were preparing to mount an around-the-clock regime as he became more paralyzed, so that he would be able to stay in Kadanji with his family. Before he lost the use of his hands, he did some simplified pottery designs

based upon his style of ceramics, which he was teaching Reiko to duplicate. He was also making a series of audiotapes for his sons, so that they could retain a sense of their father after he died. Having experienced the loss of his own father at a young age, my brother was acutely aware of how hard it was going to be for them. During this time I began to develop an incredible respect for Ben, who seemed to be mustering spiritual resources that I had never suspected he had.

In October 1989, MR informed me that she was going to leave Through the Flower by the end of the year. Of course, her timing couldn't have been worse, what with our being in the middle of the *Holocaust Project* (which was taking longer than we had anticipated) and with Ben's physical condition deteriorating rapidly. But she had run the corporation for almost ten years and certainly had the right to go on with her life, though I couldn't help but wish she could have hung in there a little longer. She wanted to put everything in storage—the art and the office equipment, slide files, et cetera. I was happy to accept her offer to place the *Birth Project* and *The Dinner Party* in art storage and to pay the costs for a while. But Through the Flower provided a certain level of administrative support that I really couldn't live without.

In fact, one reason I had been so free to concentrate on *PowerPlay* and the *Holocaust Project* was that the constant barrage of requests for information, reproductions, and other materials connected to my career and work (traditionally managed by a gallery) had been fielded by the corporation. The Benicia office also dealt with the various fiscal and organizational responsibilities associated with Through the Flower's nonprofit structure. In Santa Fe, Juliet operated more like a personal assistant, handling only those duties pertaining to me or the *Holocaust Project*, which was still in the artmaking stage and therefore required little in the way of administration.

Even though the *Birth Project* exhibition tour was over, Through the Flower continued to receive occasional requests for shows; we were still involved in the gifting of exhibition units through our Permanent Placement program; there was the future of *The Dinner Party* to be concerned about; and there was also the *International Honor Quilt* that I had initiated in 1980 in conjunction with the Houston showing. Somehow that project had

grown to include hundreds of small quilts for which Through the Flower was responsible. There were also thousands of slides and photographs of my work; drawings and studies scattered all over the building; files; archival materials; in fact, the sum total of a career spanning almost three decades. How could we just stuff all of this into storage lockers?

As I look back on this period, I find myself wishing I could have done what MR had suggested, although I am not sure that even now I would be capable of such an act. By then, the substantive body of my art was tied up with Through the Flower, and closing it down and putting everything in storage would have meant walking away from all that I had generated and turning my back on its fate. On the one hand, this would certainly have allowed me to just go on making art, but at the same time doing such a thing would have basically involved repudiating my whole life's work. Because I had had little to do with the administration of the corporation over the years, I really had no idea what I was in for when Donald and I decided to move Through the Flower to New Mexico and set up its offices in the front rooms of our house.

Julie and I discussed the possibility of her taking over as the corporation's executive director. But she was not really prepared to work full-time, nor could we afford to pay her enough. We decided we would try to figure out some way for her to at least assume greater administrative responsibility, and she agreed to go to Benicia with Donald and me to help pack up the building. In the middle of December, she and I flew to Benicia, and Katie Amend came up from L.A. to meet us. Donald drove from New Mexico at hair-raising speed, joining us soon after we arrived. About a week later, our friends, the printers Jim Kraft and Judy Booth, arrived to help. We had made plans for Julie to fly home and for Donald and me to drive back to New Mexico with Jim and Judy, alternating stints in our car and the huge U-Haul truck that would be required to transport the office equipment, photo and paper files, and archives, along with the remaining art, personal possessions, and furniture I had left in Benicia when I took up residence in Santa Fe.

While in Benicia, I ran daily in the state park, as I had done so many times when I lived there. The park ends on a rocky point abutting the

Carquinez Strait, and on my final run I took a last look out toward the water. As I sat on a rock in the morning fog that characterizes Benicia in January, feeling the damp, chill wind on my face, I ruminated about the fact that closing down the Benicia building at the end of 1989 seemed to mark the end of an era, one that began with the opening of *The Dinner Party* in 1979. There had been so many changes and challenges during these last years; it seemed astonishing that they could all have taken place within a decade. Suddenly and quite uncharacteristically, I found myself praying, asking God that the next ten years of my life might be somewhat easier.

There are many people in the Jewish community who are critical of Jews like Donald and me, those who come back to Judaism through the Holocaust. Maybe we made the reconnection when we recognized how precious our heritage was, and how close it had come to being lost. Whatever the reason, after this surprising invocation, I felt much lighter. As I ran back the length of the park, I found myself thinking that it might be appropriate to end the *Holocaust Project* with a prayer.

It was at this point that I began to plan *Rainbow Shabbat*, the stained-glass installation that ends the show. "Light is life," I thought as I completed my last sprint, "and the project should culminate in an image that affirms life—along with an invocation." Eventually I would decide to flank the center Shabbat panel with two side windows bearing yellow Jewish stars, again in a transformational impulse, for these were the humiliating badges forced on Jews by Hitler. Sandblasted into their centers—in Yiddish and its English equivalent—is a prayer based upon a survivor's poem, asking for a better and more just world.

Donald and I got back to Santa Fe on New Year's Eve, in time to celebrate our fourth wedding anniversary. Within two weeks, I did something for which I have never forgiven myself: I fired Julie. She was so shocked and hurt that she stomped out without even finishing the letter she was typing. My action was provoked by frustration, precipitated in part by the fact that after many days, all the boxes we had moved from Benicia remained unpacked. Although Julie had been coming into the office regularly, it seemed as though she was making no attempt to institute the kind of major reorganization we had agreed was needed. I have no idea why I

Working on the shaded pattern for **RAINBOW SHABBAT**, Santa Fe, NM 1991

didn't simply sit down and discuss this with her; the only explanation I can come up with is that I was under so much stress. But I shall always regret what I did, which was a function of impatience and stupidity.

With Julie's departure, I lost the last staff person who was familiar with my history as an artist, knowledgeable about and comfortable with my temperament, and experienced in handling the many details of my career. Since then, I have gone through one employee after another, not until recently finding the quality of loyalty and devotion to which I had become accustomed, or the attention to detail that is so essential in an art organization. Fortunately, we now have a fine staff, but this took many years.

After Julie left, I needed to quickly find some administrative help to handle the corporation's ongoing duties and provide me with at least a degree of support. In order to accomplish this, there had to be greater financial resources, which I set out to acquire, in part through expanded board membership (which carried with it an annual pledge). In the fall of 1990, Through the Flower began to show films and videos from our archives and to organize panels of women in the various arts at different art venues around the state. These programs made Through the Flower somewhat visible in New Mexico, one positive consequence being increased memberships and donations. But my primary reason for instituting such a program was that there began to be a number of art and art-history students who expressed interest in interning at our organization. Along with some modicum of skill, they brought with them a near-total ignorance about women's history and the Feminist Art movement, which shocked me.

In fact, one reason they began arriving on my doorstep was that they wished to learn more about my work and that of other women artists. The programs offered by Through the Flower were extremely well received, suggesting that the hunger for such information had in no way abated since the 1970s and early 1980s. The only problem was that, given the corporation's more pressing mission—involving the support, exhibition, and care of my large collaborative projects—we could ill afford the resources or staff time required for such programming, and within two years we had to cancel it.

Throughout the early part of 1990, while trying to move Through the Flower (TTF) along, I also worked hard in the studio, impelled by the need to complete the *Holocaust Project* and driven to find some relief from my personal anguish about my brother through artmaking. I remained in continuous contact with Ben, whose paralysis was becoming progressively worse.

In March, there was a TTF board meeting in Santa Fe, during which we discussed a proposal for the permanent housing of *The Dinner Party*. This had been presented to us by a woman named Pat Mathis—a Washington businesswoman and former assistant secretary of the Treasury under President Jimmy Carter—who was a longtime supporter of my work. She was also a trustee at the primarily African American University of the District of Columbia (UDC), one of the country's historically Black colleges and

universities (HBCUs). The university board was apparently interested in establishing a groundbreaking multicultural museum and archive whose purpose would be to house the art and papers of a coalition of artists of color, feminists, and others whose life and work were devoted to the struggle for freedom and dignity.

It was the university's intention to turn the Carnegie Library, which they owned, into this type of institution. There had already been an appropriation of funds by the D.C. city council for the library's restoration, which UDC intended to supplement with private donations. Donald flew to Washington to see the space and reported back that the Carnegie Library was a handsome and historic but deteriorating building located on UDC's Mount Vernon Square campus in the city's downtown arts district. He was sure that with proper renovations the building could become an appropriate setting for *The Dinner Party*. Also appealing was the fact that the library was not far from the newly opened National Museum of Women in the Arts.

The plan Pat presented to me and the board of Through the Flower involved my donating the piece (then valued at $2 million), which, in combination with the university's existing collection, would form the core of the proposed museum. The board was excited about this proposal, thinking that it suited the vision of *The Dinner Party*. My longtime friend, patron, and board member Elyse Grinstein had become an architect; she was so enthused by the idea that she offered to create a conceptual design and also ask some Black artist friends for help in enlisting donations of African American art in hopes of turning the school's existing collection into a landmark assemblage. Some of the art they hoped to attract was that of such luminaries as Elizabeth Catlett, Jacob Lawrence, Romare Bearden, and Alma Thomas, all of whom have recently been featured in major exhibitions and prominent publications. The addition of their work would have added significantly to UDC's prestige as well as to the value of their collection.

Soon after the board meeting, Susan Grode, who originally chartered TTF and was also on the board, began working with the university on an agreement. As UDC intended to charge an admission fee at the planned museum—and, based upon the financial history of *The Dinner Party*

exhibitions, the university anticipated significant revenues at the gate—Susan wanted the contract structured so that the corporation and I could derive some small percentage of whatever profit the university might enjoy.

Since I was gifting a multimillion-dollar work (instead of its being purchased, as is customary), this plan seemed reasonable; it was a way for the university to obtain a major work of art without buying it and a method of providing me with some modest financial reward for all the years of unpaid labor that had gone into the creation of *The Dinner Party*. And it would seem obvious that Through the Flower, as the caretaking organization of the work, deserved to recoup some of the monies expended over the years.

Never thinking that such an arrangement might appear suspect to people unfamiliar with the conditions under which I have worked—that is, without traditional support, with little financial reward, and forced to create alternative strategies for the creation and distribution of my art—all of us were onboard. To prepare the renovation plans, the university engaged an architect who was to work with Donald and Elyse. I stayed pretty much out of all these interactions, focusing on everything else I had to do, though it was understood that I would have final approval of the installation design.

In April 1990, while all this was going on, Ben called to say that his illness, progressing more quickly than anticipated, had already begun to attack the muscles of his throat and chest. He needed a tracheostomy and would be placed on a respirator in order to prolong his life; he would also have to use a voice machine to talk. Up until this time he had been speaking regularly by phone with our mother, but the machine would dramatically change his voice, which meant that the time had come for her to be told about his illness. Donald and I had been expecting that we would go to Los Angeles to inform her, but Ben had decided this was something he needed to do himself.

As Ben and I had arranged, immediately after he had spoken to her I called her and asked if she wanted Donald and me to fly in to be with her. But my mom said she just needed some time alone to adjust to the news. For the next few weeks, I talked to her almost every day. Each time she would ask for a little more information. Several friends had been critical of our decision not to tell our mother for such a lengthy time, insisting

that she had a right to know. But as she came to understand how long my brother had been ill, my mom expressed gratitude that she'd been spared the painful knowledge until then.

In fact, when we went to see her in May on our way to Japan, she made it clear how much she appreciated my having carried the burden of this information on my own shoulders, understanding that I had done so in an effort to protect her from the grief she was now experiencing. By the time we got to Japan, Ben had undergone surgery and was being kept in the hospital. Now totally paralyzed, he was locked inside his body and not yet able to use the voice machine. He later told us that this was the most isolating and horrifying period of his illness, prompting him to say that if he should be rendered permanently unable to communicate, he wanted to be helped to die.

When we spoke before the operation, Ben insisted that we not come to Kadanji until he was out of the hospital and had recuperated sufficiently to be able to master the voice machine, which he said would take some time. In deference to his wishes, I scheduled our visit at the end of the Japanese lecture tour. Although I found it difficult to do public speaking while my brother lay mute and motionless in a hospital bed, I managed to present four talks: in Hiroshima, Tokyo, Yokohama, and Kyoto. While in Hiroshima, Donald and I visited the Peace Memorial Museum, which is where we saw the horrifying photos and films that attested to the tragic human cost of the dropping of the atomic bomb. Our time there made our work on the subject of the Holocaust considerably more complicated, primarily because what we learned caused us to question the widely held presumption that the evil unleashed during the Second World War had only a Nazi face.

All of my lectures in Japan were well attended, the response was gratifying, particularly in Kyoto, where numerous women stood up after my slide lecture and, seemingly empowered by the images I had shown, began testifying about their experiences of sexual harassment and rape. This so shocked my translator that all of a sudden my earphones went dead; apparently such public honesty was unheard-of there.

Ben had arranged for Donald and me to stay in a lovely inn in Kadanji, where he and his family lived. He put us up at the Pottery Park, so called

because it was at the center of what was a thriving ceramics community, where exhibitions were regularly held. Some of my brother's pots were on display, which gave us the opportunity to see how skilled a craftsman he had become. The inn was only a few miles from Ben and Reiko's house, which was situated in a stunningly beautiful area, amid rice paddies and immense stands of bamboo. I could see why my brother so loved it there, though its lush beauty made our first exposure to his situation even more excruciating.

Because Ben was totally paralyzed by then, he was entirely dependent upon the constant attentions of Reiko and his network of friends for all bodily functions. Despite the enormous effort it took for him to speak—accomplished in rhythm to the pumping of the respirator—he was insistent upon spending many hours each day in the studio. There he patiently instructed Reiko in the pottery techniques that would allow her to support herself and her children after his death. At every mealtime he wanted to be put into his wheelchair and brought to the table, so that he could participate as best he could.

His courage was inspiring, but the whole experience was so painful and terrifying for me. Except for the brief time I had spent with my Uncle Harry when he was at a late stage of his neurological disease, I had never been around anyone who was so ill. I wish I could say that I rose to the occasion, but mostly I tried to offer what help and comfort I could, spending as much time with my brother as his strength would allow, then returning to our quarters and weeping. Thankfully, Donald was somewhat better able to cope than I.

I also spent a good amount of time with Reiko, something Ben had asked me to do. Every afternoon we went off together, our conversation facilitated by an American friend who spoke fluent Japanese. At one point I pushed her to share her feelings about my brother's illness and its emotional impact upon her. Becoming quite frustrated, Reiko said sharply, in a tone I understood even before her words were translated, "You Americans, and especially you Jewish people, you always want to know how I feel, but *I don't know how I feel*." I suddenly realized that the kind of insight I was seeking was entirely foreign to her.

I was sure that her remark was simply the expression of the bafflement she felt about what I—and, as I was to learn, Ben—expected from her. During our talks, my brother confessed that what was hardest about his illness was the absence of a level of emotional connection he longed for, which was precluded by what seemed to be a cultural abyss. Even though Reiko was extremely devoted to him, I realized that, romantic ideals aside, building a life with someone of such a different cultural background must have been difficult. As our translator pointed out to me—and as my lecture experiences reinforced—not every society values such interpersonal intimacy.

Fortunately, over the years, Donald and I have been able to communicate with Elijah, who has visited us many times and is bilingual. But Simon, the younger son, remains rather unknown to us even now, as he speaks little English and we no Japanese. (Unlike Ben, who was gifted in languages and taught himself many, I am singularly untalented in this area.) As I write these words, Elijah is living in a town outside Detroit. He was sent there for three years by his employer, Kobe Steel, where he works as an environmental engineer. Both boys are married with children, and Simon works as an occupational therapist in a town near Kadanji.

Reiko's career as a potter really took off, and she even had a show in Santa Fe while Donald and I were still living there. I remember Elijah

My nephews, Elijah (LEFT) and Simon (RIGHT) Kakiuchi. Kadanji, Echizen-cho, Fukui Japan 2009

calling and telling us the news, adding that his mother did not plan to come to the opening. We convinced him that she should, so he came with her to translate and also, because he is comfortable in America, to act as her guide. It was quite a thrill to welcome them to New Mexico, especially as her show sold out. She continued to exhibit at that gallery for a number of years, though our relationship has been limited by the language barrier.

Almost as soon as we got off the plane back from Japan, I began to suffer pelvic pain at night that kept me awake and sent me to the emergency room. After a series of hideous and futile medical procedures aimed at finding out if I had cancer or was only suffering from stress, it turned out to be a lack of estrogen, but I wouldn't know that for some months. On top of this, we learned that while we were in Japan, Donald's father had suffered a seizure during a routine hip-replacement surgery, and it had put him into intensive care. Bertha, his wife, was flat on her back with an undiagnosed problem, and one of Donald's cousins had died of AIDS.

Stephen Hamilton, meanwhile, had been placed in a hospice, as he was going into the final stages of his illness. I fervently hoped he would still be alive in November, when we were scheduled to go to the Bay Area, as I desperately wanted the opportunity to say goodbye. But there was no way I could fly out there at this time; I could afford neither the airfare nor the emotional energy. And Donald, who had suffered uncomplaining through so many grievous incidents, finally broke down, and for a few days he had trouble getting out of bed.

When he got himself back into the darkroom, he started working on the photo panels for *Double Jeopardy*, the 22-foot installation that explores women's experiences during the Holocaust. While waiting for him to finish the photo prints, I began doing research for the next image, this one dealing with children during the Holocaust and more recent times, to be called *Im/ Balance of Power*. At the end of June, Bob Gomez, the stained-glass artisan who had volunteered to fabricate *Rainbow Shabbat*, came to Santa Fe for a few days to work with me on the plans.

We still had very little money, and living month to month was producing a high level of anxiety in me, particularly because in order to keep

313

going we were getting further into debt. (Donald would call our financial situation the "Spike Lee Plan," which involved using our credit cards, as Lee was wont to do, in order to finish a project.) The Through the Flower office was occupying the front of our house, which meant that I could never entirely get away from its demands, although I did my best by going into my studio in the back of the house, where I had no phone, and staying there all day (with my cat Sebastian for company). The corporation was also quite tight for funds, and I was trying to make do with one full-time person and an intern.

The only glimmer of light was that *The Dinner Party* was finally going to be permanently housed—which from my point of view made any amount of struggle worthwhile. I assumed that its housing would make my circumstances somewhat easier, if only because with Through the Flower's anticipated percentage of the gate, it might be able to acquire independent quarters and more (and more qualified) staff. The gifting ceremony was scheduled for July 20, my birthday. Many friends, supporters, and Through the Flower board members were planning to fly to Washington for this momentous occasion.

The large crowd at the gifting ceremony would also include Wilhelmina Holladay, founder of the National Museum of Women in the Arts. She had been quite enthusiastic when I told her about UDC's plan, even offering to establish joint programming with the new museum. She and several others—including Henry Hopkins—sent congratulatory letters that we put together in a small booklet to be given out in Washington. As to what was an increasingly hostile atmosphere surrounding the visual arts in our nation's capital, I am afraid that my friends and supporters and I were guilty of incredible naïveté. We honestly believed that the controversy about *The Dinner Party* was old hat, and that the piece was by now almost an accepted part of art history, which its permanent installation would reinforce.

A few days before the gifting ceremony, Donald and I flew to Washington. On the morning of July 18, I went to a local health club to work out. While walking back to where we were staying, I happened to glance at a kiosk displaying the *Washington Times*. There on the front page, in full color, were photographs of both me and *The Dinner Party*, along

with the ghastly headline: "UDC's $1.6 million 'Dinner.' Feminist artwork causes some indigestion." As I had no change with me, I could not even buy the paper and find out what this was all about. When I finally read the piece, I was stunned by the outright lies about both the art and the terms of the gift.

The article incorrectly claimed that *The Dinner Party* had been "banned in several art galleries around the country because it depicts women's genitalia on plates" and that public funds were being spent to buy (and house) the work. It also erroneously implied that monies intended for UDC's operating budget were involved. This false report was my first indication that there were any problems regarding the UDC plan. Throughout the month of June, apparently, rumors had circulated on the campus about an underground sabotage campaign being mounted by some conservative members of the faculty senate who were supposedly unhappy about the trustees' decision to turn the Carnegie Library into a multicultural museum. There was some speculation that these were the people who had leaked the misinformation to the *Times*, where it seemed to dominate the news for the next few days.

I was not at all happy about this negative and distorted coverage, particularly the falsehood that the renovation money for the library was being taken from the university's budget. Nor was the school "buying" *The Dinner Party*; instead, it was about to receive a substantial gift from me, which was to be supplemented by private monies, pledged contingent upon *The Dinner Party*'s permanent housing. University officials dismissed the paper as a "loony, Moony rag" and advised me to put its "right-wing drivel" out of my mind. They promised to hold a press conference the day after the gifting ceremony to set the record straight.

On the morning of my birthday, numerous people gathered with members of the press in the spacious upstairs gallery of the Carnegie Library. On behalf of Through the Flower, Susan approved the terms of the gift; then it was my turn to sign the document that would formally transfer ownership of *The Dinner Party* to UDC. Afterward, a group of us went to a restaurant for a lovely lunch, where, as planned, we celebrated this momentous occasion as well as my birthday.

The next day, the university held a press briefing, at which I presented a slide talk about *The Dinner Party*. Several trustees explained the vision of the museum, the terms of the gift, the financial arrangements, and the many expected benefits to UDC, and then we answered questions. This event, which was well attended, resulted in accurate articles in both the *Washington Post* and *The New York Times*. As both of these papers are considerably more influential than the *Washington Times*, everyone associated with the university was convinced that these pieces would stem the tide of misinformation being disseminated by that right-wing paper. Donald and I went home feeling reassured, without a clue about what was to come.

On July 26, while recuperating in Santa Fe from yet another wasted surgical procedure, I received a phone call from Cheryl Swannack, a former student of mine at the Feminist Studio Workshop. She had gone to work as a lobbyist for the Gay & Lesbian Alliance Against Defamation, a job that put her on the floor of Congress during the dispute about Representative Barney Frank (concerning an alleged homosexual encounter). She discovered that *The Dinner Party* was about to be discussed by the House of Representatives and called to alert us. For the next hour and twenty-seven minutes, Donald and I sat stupefied in front of the televised proceedings on C-SPAN, while a war of words took place as part of a much longer debate on UDC's budget, which Congress controls.

We still have no idea how *The Dinner Party* ended up in the hallowed halls of the House of Representatives. I was flabbergasted by the way in which *The Dinner Party* was denounced, excoriated, and eviscerated by men (no women participated even though there were 29 women in the House at the time—16 Democrats and 13 Republicans). No one who spoke had ever seen the work except perhaps Ron Dellums, who came from the Bay Area; he was extremely eloquent. But the rest of them did not know what they were talking about. As I commented to Donald, "If they understand as little about the other issues they debate and legislate, this country is in big trouble." We watched while distortions, misrepresentations, and even total fictions were read into the *Congressional Record*, thereby convincing even intelligent observers that some sort of hanky-panky was going on, or at the very least an irresponsible financial scheme.

Before long, the dialogue—if it could be described as such—moved beyond fiscal issues. "We now have this pornographic art," railed California's Robert Dornan, "I mean, three-dimensional ceramic art of thirty-nine women's vaginal areas, their genitalia served up on plates." Holding up the *Washington Times* cover story of July 18, he continued: "Look at this garbage… [which was] banned in art galleries around the country…and character-ized as obscene." The theme was picked up by one of his colleagues, Dana Rohrabacher, another demagogue from Southern California, who carried on for many minutes about how *The Dinner Party* was "weird sexual art."

Both Pat Williams of Montana and Ron Dellums tried to introduce some reason and perspective into this ridiculous discourse, but to no avail. The House was convinced to support a measure that deleted $1.6 million from the university's budget as a way of punishing the school for initiating the museum plan. This was precisely the amount of money that had been previously allocated for the renovation of the Carnegie Library, to be supplied through city bond funds. No federal funds were involved, though one would have been hard-pressed to know this from the specious arguments.

After the punitive bill passed the House, it went to the Senate, where it was taken up by the Appropriations Committee. They would be con-vinced to restore the money, the result of an intense lobbying campaign put into action by Susan Grode. With the help of the Hollywood Women's Political Committee—at that time, the largest fundraising group for liberal candidates in America, which Susan helped to create—she put together educational packets about *The Dinner Party* (emphasizing its position in many art-historical texts) that were sent to every senator.

Sometime later, MR began a lobbying effort in Texas that effectively dissuaded Phil Gramm from taking the debate about *The Dinner Party* to the Senate floor; this had been urged by Jesse Helms as a way of trying to overturn the decision by the Appropriations Committee. Other grassroots groups organized around the country, bombarding senators with letters and phone calls. Throughout all this turmoil, the university trustees stood firm in their decision to go forward with the museum, predicting that the conference committee (which adjudicates disputes between the House and

Senate) would support the decision of the Appropriations Committee and reinstate the funds.

Unfortunately, when the right-wingers realized that they were probably going to be defeated in Congress, they turned their attention to the university campus, where the Black religious right got into the act. Charges of pornography and inappropriate federal funding were leveled, and then blasphemy. I was called "the Antichrist," and it was rumored that *The Dinner Party* had been in boxes for twenty years because it contained the Devil. Ultimately, events in Congress, coupled with intense right-wing agitation at the university, created a breakdown of confidence in the trustees' judgment among some members of the faculty and the student body, resulting in a disruptive student strike. At the beginning, *The Dinner Party* was not the primary issue, but it soon became a symbol for other dissatisfactions felt by the students. By the end of September, the protest had escalated, with calls for the cancellation of the planned museum and the trustees' resignation.

The student strike was extremely problematic for me and the board of Through the Flower. It highlighted problems at the university of which we were completely unaware (for example, an ongoing level of unrest on the campus and distrust of the leadership) and which made us question the stability of the institution. More important, I did not wish to be in a position of foisting something upon the students to which they were opposed, although I was disconcerted by how easily they had been manipulated into seeing me and my work as "the enemy," when, in fact, the new museum would have brought increased attention and resources to them and their needs. Unfortunately, it seemed as if *The Dinner Party* was becoming a lightning rod for some of the students' previously unarticulated grievances.

Throughout the summer and early fall, Donald and I had managed to stay out of the fray, continuing to work on the *Holocaust Project* as best we could. Of course, we could not help but notice the irony of being engaged in a project about a moment in history in which the state had turned upon its own citizens while the struggle in Congress was going on. I had found the congressional debate and the unceasing distortion in many of the media reports quite unnerving, partly because of the work I was doing, but even more because I am someone who is devoted to the truth and cannot bear to

see it so utterly disregarded. (Moreover, the angry faces of the congressmen who had so bitterly attacked *The Dinner Party* bore an uncanny resemblance to the disfigured images of my *Malehead* series.)

As the student strike intensified, so did press attention and misrepresentations. Our small office was besieged with inquiries, phone calls, and faxes, bewildering the staff. Finally, Donald and I had no alternative but to spend many hours in the office, answering questions and doing phone interviews, Donald sending out piles of information materials by Federal Express and fax. Reluctantly, the board of Through the Flower and I determined that I had best withdraw the gift of *The Dinner Party*, which I did in a letter to the trustees at UDC and in a press release, stating that the virulent misinformation campaign had "managed to create a division of values where there was none—i.e., between the concept of *The Dinner Party* and the issues that are important to the students." I went on to say that "as my life's work has been dedicated to the [right] of self-determination of all people," I felt I had no choice but to rescind the gift.

Later, in the only thorough investigative article on these events, published in 1991 in *Art in America*, Lucy Lippard speculated: "Had the student strike not happened, *The Dinner Party/UDC* partnership probably would have survived…[However,] the prospect of an alliance [between feminist and multicultural] forces may have set off subliminal alarm systems among those for whom multiculturalism…is threatening." Lucy went on to regret the demise of the "proposed center [because it] could have inspired not only exhibitions and art-world attention but also a much-needed historical analysis of the connections between feminism and the civil rights movement."

Some people have dismissed what happened to *The Dinner Party* in Washington as just another assault on the arts, in particular the National Endowment for the Arts (mention was made in Congress of some paltry amount of money provided by this agency for the creation of the work almost two decades earlier), but I do not agree with this analysis. Rather, I believe that what occurred there might be more closely related to other tactics that had been used against the piece since it was first exhibited in 1979—specifically, the effort to prevent it from being seen.

Members of Congress repeated art critics' flagrant misrepresentation of *The Dinner Party*, which involved focusing almost exclusively on the plates. These were decontextualized from the larger intent and scope of the work—that is, teaching women's history through art and honoring our aesthetic, intellectual, and cultural achievements. In Washington, once again, the plates were the ostensible issue and misinformation the method. Only this time the stakes were higher, because they involved not a temporary exhibition but a permanent installation in our nation's capital, home to innumerable monuments to men and their history, a history that the presence of *The Dinner Party* might have called into question.

Since these events in Washington, the Carnegie Library remained unused and in disrepair for years until recently, when the building was restored and part of it was converted into an Apple store. As for *The Dinner Party*, thanks to Henry Hopkins—the loyal "daddy" of the exhibition, who had become the director of UCLA's Hammer Museum—a commemorative exhibition occurred in 1996. Curated by art historian Dr. Amelia Jones and entitled *Sexual Politics: Judy Chicago's "Dinner Party" in Feminist Art History*, this show placed *The Dinner Party* in the context of twenty years of Feminist Art theory and practice, its impact examined by a new generation of critics and historians, most of whom had not had the opportunity to see the piece.

In conjunction with this exhibit, I wrote a new book about *The Dinner Party* that featured an extensive color section demonstrating that the plates are but one element in this multilayered symbolic history of women in Western civilization. In addition, I discussed why, at that point, *The Dinner Party* remained without a permanent home. After the UDC debacle, and for a number of years thereafter, there would be no other offers for permanent housing.

After Washington, the board of Through the Flower and I concluded that, given the virulent resistance demonstrated by the art institutions and then the United States Congress, *The Dinner Party* would surely be lost if we did not undertake its permanent housing ourselves. But we were a small group of dedicated women, none of whom had the resources to accomplish this goal. I was often asked if I myself was going to house *The Dinner Party*—as if this were something I could accomplish alone or with

my paintbrush. Although I was somewhat unrealistic in my ambitions when young (or how could I have had such large dreams?), as I matured I became humbler, recognizing that I could not single-handedly alter a world that continued to devalue women's accomplishments.

With hindsight, I have come to believe that *The Dinner Party* represented a substantial challenge not only to the art world but also to the larger society, in that it directly contravenes the lack of self-worth experienced by too many women, in part through an esteeming of our bodies, as conveyed through the imagery of the plates. It is no wonder that male art critics (and those women who have internalized their loathing of all things female) and congressmen alike focused on the plates and their vulval forms. Rippling out from their tiny centers is the insistence that female sexuality is to be celebrated and embraced, not hidden away, purchased, excised, or despised.

In life, as in art, from the base of self-acceptance all else issues. In the case of *The Dinner Party*, this meant replacing the *absence* of icons celebrating female agency with a new *presence*, that of self-love and the honoring of the feminine. *The Dinner Party* was intended to help break the cycle of history that condemns each generation of women to grow up ignorant of their heritage and, as the historian Gerda Lerner stated, ignorant of what women before them thought and taught (and, I would add, created), a situation that persists even today. But I will return to the (ultimately) triumphant story of *The Dinner Party* later in these pages.

By the fall of 1990, while the UDC events were still unfolding, my brother was going through a terrible depression, brought on by his decision to go on a respirator (his alternative would have been to die right then). This meant that for the rest of his days he would be attached to this machine, and he was obsessing about whether he had made the right choice. At the time, I wrote him a long letter to report on all that had transpired, explaining why I had been somewhat remiss in my attentions to him. Ben immediately called to reassure me that he understood and to offer his sympathy and his support, a gesture that, given his own condition, was so generous that I burst into tears.

Fortunately, my brother's spirits were improving. He told me that he had some goals he wished to accomplish, including completing his tutelage

DOUBLE JEOPARDY and **WALL OF INDIFFERENCE** from the **HOLOCAUST PROJECT**
Installed at the Orlando Museum of Art, FL 2002

of Reiko, finishing the tapes for the boys, and purchasing the house in which they lived, which he believed could be done through sales of his pottery. Before becoming completely paralyzed, he had worked furiously in the studio—aided by several assistants—to create a large body of work. He was now unable to attend his shows, so Reiko was going in his stead. Happily, his last pots were some of his best, and they were eagerly snapped up. Ben said that once all these plans were concluded, he would be ready to die, an eventuality he was coming to be at peace with. I fervently hoped that our mom would be able to handle it as well.

Throughout that period, I kept working on *Double Jeopardy*, a huge painting/photo combine dealing with the intersection of anti-Semitism and sexism that shaped women's experiences during the Holocaust. Including the research, drawings, half-scale model, and final painting, it involved

several years of effort. While engaged in that project and in the midst of the UDC debacle, I enrolled in a weekend stained-glass painting seminar in Albuquerque because Bob Gomez, the glass fabricator, had told me that the only way to achieve the face details in *Rainbow Shabbat* was through hand-painting. My glass-painting teacher was a woman named Dorothy Maddy, an experienced painter, whom I asked to be my adviser, as I had never done any painting on glass.

Some months later, in early 1991, Dorothy was diagnosed with lung cancer and told that she had only a short time to live. Although she had painted glass for many years, she had never had the opportunity to work on anything in the scale of *Rainbow Shabbat*. In a testament to the power of the human spirit and in keeping with the nature of the *Holocaust Project* itself, Dorothy decided to use her remaining time and energy in a final burst of creativity. Working from my full-scale shaded drawing, she painted the innumerable pieces that make up the 10-foot-long center section virtually

single-handedly. Sadly, she would never get to see the piece put together, let alone installed.

That fall I went to L.A., where I was given a Vesta Award by the Woman's Building. At the last minute I decided to present my mother with the award, which I did at the crowded ceremony, to which I had taken her in hopes of giving her some pleasure. As we stood side by side on the stage in our matching Holly Harp dresses (made especially for the occasion to show off our similarly shapely legs), I handed the medal to my mom with thanks for her having sent me to art school and also having bequeathed me her great legs, which produced a big round of applause. Sometime later, Howard and Arleen came to Santa Fe for a quiet, private Thanksgiving,

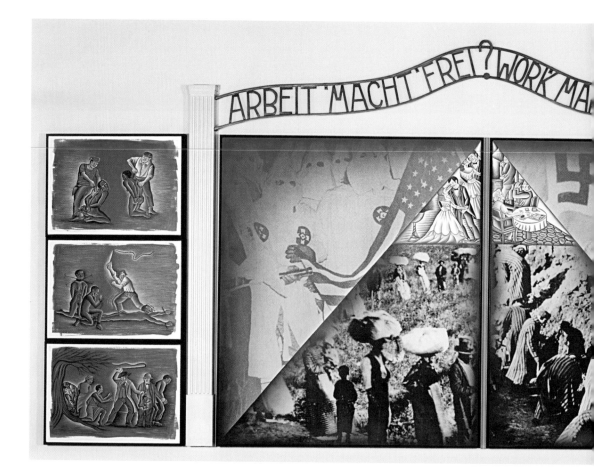

which was wonderful. The rest of the year was spent tucked away in the Canyon Road compound, working in the studio, exercising, and hanging out with Donald and the cats, which was about all I felt capable of doing.

On New Year's Eve, Donald and I celebrated our wedding anniversary in our customary way: at home and at the Santacafé. The early part of the year was busy with painting, working on the stained glass with Bob and Dorothy in Santa Fe (this was shortly before her diagnosis), and trying to move the *Holocaust Project* along. At the beginning of April, Donald and I went to L.A., where I held an eightieth-birthday party for my mom at Audrey and Bob Cowan's home. Upon our return, I set to work on *Im/Balance of Power*, which occupied me until July, when I began the research on slavery

ARBEIT MACHT FREI/
WORK MAKES WHO FREE? 1992
Sprayed acrylic, oil paint, metal, wood, and photography on photolinen and canvas
67 × 143 in (170.18 × 363.22 cm)

that would result in *Arbeit Macht Frei/Work Makes Who Free?* This large, multipanel installation explores the slave-labor aspect of the Holocaust in relation to American slavery, which, I feel ashamed to admit, I knew less about than I should have. One interesting aspect of this inquiry was that once again I stumbled upon what was then a disgraceful iconographic void: that is, a relative lack of images about the American slave experience in both photography and the other visual arts.

That summer, Donald and I indulged in the purchase of a tandem mountain bike, an extravagance but one that provided us with a welcome escape from the troubling work of the *Holocaust Project* and our family's woes. By this time, the two of us were finding it difficult—and exhausting—to socialize. Moreover, we weren't the most desirable dinner guests; we referred to ourselves as "Ms. Doom and Mr. Gloom; invite us to dinner and get depressed." It was almost impossible to put aside the work when visiting with people, and it was uncomfortable—for them as well as us—to have to discuss it. Instead, we took up mountain biking, going for long rides and looping downhill at breakneck speeds. I sat in the back and pedaled steadily with my eyes closed, shrieking with fear and delight as Donald steered us around mountain precipices. Actually, biking together became another measure of the growth of our marriage in that, like the making of the *Holocaust Project*, it required that we cooperate in order to get anywhere.

We were anticipating that we'd finish the art early in 1993, then take another six months to produce all the ancillary exhibition materials. The opening was set for October of that year at the Spertus Museum in Chicago. I liked the idea that the premiere was to be held in the town of my birth, as it seemed fitting to return there with a project through which I had become reconnected with my Jewish heritage. Other institutions were expressing interest in the show, and we were working on putting together a tour that would span Jewish museums and art museums around the United States, hoping that at the end of its American travels, the exhibition would be shown in other countries.

Throughout the course of the project, Donald and I held private viewings of the finished pieces in our respective studios. At the end of 1991, when *Rainbow Shabbat* was completed, Donald set it up in his space.

With Donald on a tandem bicycle, West Mesa, Belen, NM 2011

Among the invited guests was David Turner, at that time director of the Santa Fe Museum of Fine Arts, who peered admiringly at the illuminated windows, then turned to me and said, "It's really wonderful, but what's Shabbat?" Evidently, crossing over from the Jewish to the art communities was going to be more of a challenge than I had anticipated. Once again, I began to think hard about how to span audiences. Whenever we held these types of viewings, people would ask many questions about the imagery and its historical underpinnings. After receiving the desired information, they seemed to want to be quiet and just look.

Observing this same pattern at every one of the showings led us to the decision to incorporate an audio tour, which could provide such knowledge while also assuring a relatively silent and contemplative viewing atmosphere, given that viewers would be listening to the tape. Working with our mentor, Isaiah Kuperstein, and a Santa Fe company called Thwaite Productions (which produced such tours), Donald and I spent months developing an

audio component that could provide a bridge for multiple audiences into a project whose subject matter could overwhelm the most sympathetic viewer, particularly if that person knew as little about the Holocaust as, for example, Donald or I had when we began.

It never occurred to us that someone would be offended by the notion that they might need some education in order to fully understand and appreciate the art. In yet another example of my naïveté (maturity may have mellowed me but it has obviously not changed my fundamental nature), I assumed that people would be glad for whatever help they could get in dealing with a subject matter that—in my opinion, anyway—was humbling, to say the least. However, I would discover with some shock that art critics in particular found it insulting to have to don headphones, presumably feeling that this reflected badly upon their supposed expertise in all art concerns.

In retrospect and despite their displeasure, I would still have decided to make the audio tour an integral part of the exhibition, because the *Holocaust Project* grows out of an amalgamation of experience, knowledge, and scholarship that is largely unknown to most people outside the Jewish and academic communities. Moreover, we would hear again and again from those to whom the show is addressed—that is, a broad audience who are not so arrogant as to think that they require no guidance on this topic—how valuable the audio was for them.

By the early part of 1992, Donald and I were beginning to talk about where we would live after the *Holocaust Project* was done. MR had generously agreed to extend the lease on the Canyon Road house until we were finished, but then, it was understood, we would leave. We had been looking around at various places in the area, although I was not sure that I wanted to stay in New Mexico. But Donald feels rooted here, and I therefore agreed to consider remaining in the Southwest, though not in Santa Fe. The city was becoming too expensive for us, particularly because Donald expressed his ongoing—and abiding—desire to own a place. Moreover, the town had changed so much over the years, I just couldn't feature spending the rest of my life in a place overrun with tourists. Sightseeing buses often passed by

our front door, and sometimes when I took out the garbage I would find people peering over the adobe wall.

Sometime earlier, we had found and—thanks to Donald's ingenuity—actually bought a building, a dilapidated but imposing Victorian hotel, built in 1907, in Belen, a small and unpretentious town thirty miles south of Albuquerque. The structure's strong, masonry-ringed, 7,000 square feet of space appealed to both of us. We thought it would allow us large studios, ample living quarters, and the delicious quiet of a small New Mexico town, the kind of peace I had found in Santa Fe when I first started going there. Donald had swung a deal by which, with a combination of art and an unexpected and modest lump-sum inheritance (via his Aunt Lillian, who had passed away), we could make the down payment. My mechanically inclined husband believed he could slowly work on renovating the hotel while we completed the *Holocaust Project*, even thinking that by the time the show opened we might be moved in.

Unfortunately, things didn't work out quite as we had planned, and we soon ended up giving the hotel back to the owners because of some serious problems that would have been too expensive to rectify. Although they returned the art that had provided part of the down payment, they had used up all the money. They offered to repay these funds over the course of some months, with a balloon payment due at the end. As it turned out, the owners would disappear, leaving us with another chance at buying the building, though at a greatly reduced cost.

In mid-February we received the news we'd been dreading for so long: Ben had died. Donald and I flew to L.A. to tell my mother, which we did in the office of a sympathetic social worker at the Jewish Home. I can still see my mother—who by then was quite weakened by the cancer that had already metastasized to her bones—sitting on the couch. When we told her, she took the news like a body blow, crumbling with a pained grimace on her face, then pulling herself erect as if to brace for the waves of grief. That Sunday we held a memorial service in the lovely garden of Audrey and Bob's house, to which Howard and Arleen came. Although I was deeply pained by Ben's death, I was also relieved that his ordeal was

finally at an end. But before too long, it would become evident that even though his suffering was over, my mother's was to intensify.

When we returned to Santa Fe, I began work on a large triptych entitled *Legacy of the Holocaust*, which explores the survivor experience and which would be positioned just before *Rainbow Shabbat* in the exhibition. The juxtaposition of these two works leads viewers back to the Jewish experience of the Holocaust: what the survivor experience might have to teach the larger human community, and then how the Jewish Shabbat ceremony might be regarded as a metaphor for global healing and sharing. Working on *Legacy*, I struggled to achieve a level of integration of everything I'd learned and been through that, in some small way, might be likened to what was required of Holocaust survivors.

This image was to present significant problems when it came to bridging the gap between audiences, as the Jewish community possesses an understanding of the Holocaust-survivor experience that is utterly lacking in, for example, the art world. Here, my commitment to creating art that was authentic to this experience would be put to the ultimate test. Could I come up with a painting that suggested how much could be learned from survivors and that would be intelligible to viewers who knew little about the Holocaust or the diverse ways in which survivors had dealt with their experiences?

This was problematic for a number of reasons. First, let us go back to the museum director who didn't understand the word "Shabbat." The Jewish Friday-night practice is not exactly arcane, and at least a minimal understanding of it would seem to be desirable in order to relate to *Rainbow Shabbat*. However, there is little precedent in the art world for art with openly Jewish content (Chagall's work being the outstanding exception). Thus the question: By what standards should such art be measured? In terms of art dealing with the survivor experience in particular, are the images to be evaluated according to their authenticity? By their formal properties? By how they fit into the canon of modern art? How problematic this would be did not become apparent until after the opening of the exhibition.

While working on *Legacy*, my personal and aesthetic lives would merge; my grief about the worst that people could do to each other—manifested

in such catastrophes as the Holocaust—came together with my private sorrows. Creating this image caused me to traverse a path I might best describe as trying to achieve spiritual survival, along with some level of integration, after my long descent into the darkness of the Holocaust, during which time I seemed to have been accompanied by an inordinate number of personal tragedies. As I painted the center panel—which presents two survivors, an emaciated female figure leading an equally gaunt man out of the hell that was the bombed-out crematoria of Birkenau—I thought about Terrence Des Pres's book *The Survivor*.[14] In this amazing (and extremely slim) volume, he argued that it was in the camps that the need to bear witness was born, that "if nothing else is left, one must scream." Each day as I struggled to bring the figures alive, I thought this mandate might actually describe my own life.

LOST IN ALBUQUERQUE!
FOUND IN BELEN?

I worked on *Legacy* until the end of the summer of 1992, alternating intense periods of painting with finishing the *Holocaust Project* book. In the months since my brother's death, the Belen saga had inched along.

I was ambivalent about this enterprise, but Donald was intent upon going ahead with it if at all possible. Given the way he had supported me through the years of our marriage, it seemed fair that he should have the opportunity to pursue something as important to him as achieving a place of his own.

I had never been involved in a building project and had no idea what we were getting into. First, there was the problem of financing. Donald had tied our buying the hotel to obtaining renovation monies, an effort I got tired of after being turned down by a few banks. Not Donald; he patiently applied to one lending institution after another until he had pretty much exhausted all the options in New Mexico. (In the process, we learned why so much local development is done by outsiders: the state's banks are not exactly supportive of regional enterprises.)

At one point, Donald thought he'd found an interested lender and was trying to convince them of the importance of saving the hotel, which had been put on the National Register of Historic Places by a former owner. He asked if I would phone the head of the State Historic Preservation Office for a letter of support because I had met the man before; he and his wife had stopped to help me when I was hit by the pickup truck in 1986. When I called, I inquired as to whether he remembered me, to which he replied, "Of course. My kid still asks, 'Whatever happened to that woman we found lying in the road?'"

Eventually, with his help, we received renovation funds from both the state office and the National Trust for Historic Preservation, a

private organization that tries to save valued buildings from destruction. Unfortunately, it turned out that these funds were insufficient for the remodeling of a building that needed everything: new mechanical, electrical, and plumbing systems; a new roof; restored windows and brickwork; and what continues to be a seemingly endless stream of additions, subtractions, alterations, and adjustments. It would have been a lot smarter to get through the *Holocaust Project*, get ourselves out of debt, and then try to buy or build a place. But I suppose that everybody could acquire a PhD in hindsight.

While these negotiations dragged on, we decided that we would move to Albuquerque, which was cheaper than Santa Fe, as soon as the artmaking was done. This way, Donald could be closer to Belen, where he would be doing most of the renovations (with a small crew). We were fortunate to find a rental property that, though inexpensive, was situated on an acre of land, which provided our bevy of cats room to roam. The building itself was of modest size, but I figured that I wouldn't need a large studio to do the exhibition work—which would occupy me between the time of our

With Donald in front of the Belen Hotel, NM 1996

moving and the opening of the *Holocaust Project* show—or to write, which was what I planned to do, at least for a little while. Moreover, I thought ("dreamed" would be a better verb) it would not be long before we could move into the hotel, where we'd have ample space.

Having no experience with such a large-scale building project, I accepted Donald's assessment that it would take a year and cost less than $200,000, which the funds from preservation organizations would ostensibly cover. As I have often complained, three years and $385,000 later it was finally done.

Along the way, we kept running out of money, and I doubted that it would ever be finished, but, as usual, Donald's steadfast persistence paid off. When he first started work on the building, we held a reception for local folks, many of whom had fond memories of when it was a functioning hotel—or rather, a boardinghouse for railroad workers, as Belen is a railroad town. Dozens of freight trains switch cars there every day, and the sounds of the trains can be heard in our building, which is close to the railroad yard.

During this same period, my mother was failing and had to be moved into another wing of the home, where she could have more care. This was very upsetting to her, as it meant she would have to give up her private room. She had prized these quarters, which were filled with my art, Ben's pots, and her favorite records and books. Donald and I went to L.A. to pack up her things and move what little she was allowed to take into her new quarters.

When we returned home, we soon became absorbed in working out *Four Questions*, the last and most complex piece in the *Holocaust Project*. Its title is based on the traditional ritual of asking the same four questions every year at the Passover seder, queries that were once quite significant but have now become somewhat blunted by both repetition and the passage of time. Not so the issues invoked in this image, which represents some of the most perplexing ethical problems raised by the Holocaust. Four slatted panels entirely blur the distinction between painting and photography, as a visual metaphor for how "blurry" and unresolvable these dilemmas appear to be.

In November, Donald's father, Louis, had a massive heart attack. Donald flew east with the idea that, if it looked as if he would not recover, I would immediately follow. Although Louis pulled through, he never fully

With Donald working on **FOUR QUESTIONS** from the **HOLOCAUST PROJECT** ca. 1992

regained his strength, which was to prove difficult for him, as he had always lived a very physical life. This affected my husband more than I would have anticipated. Given all we had been through during the previous years, I was surprised that Donald had never before really confronted his own or his parents' mortality, as I have lived with this type of awareness for many years.

While Donald was in Massachusetts, I sprayed *Four Questions* with acrylic to establish the basic tonal ranges of the four panels, whose facing sides are done in color opposites so as to reinforce the contrast between past and present realities, which are presented on the opposing sides (Holocaust events on the left, contemporary situations on the right). When he returned, we began hand-coloring the panels, a tedious process and one with which I was unfamiliar, as photo oils—the medium we were using—are more a photographer's than a painter's method of applying color. We had chosen to

employ these because of the fineness of the pigments and the transparency of the colors, which seemed to suit the nature of these particular images.

Our seventh anniversary brought with it a sense of approaching transition, in that the conclusion of the *Holocaust Project* was in sight. Finishing the project would usher in a new period for Donald and me, one we both felt somewhat anxious about. There had never been a time in our marriage when we were not working on the project. Consequently, we could not help but worry whether there would be life after this intense collaboration and, if so, what it would be like. It seemed altogether appropriate—and also reassuring—that we would finish the *Holocaust Project* as we had started it years earlier, when we had sat in the movie theater watching *Shoah*: that is, side by side.

Until February 1993, Donald and I spent long hours together in my studio, carefully manipulating the photo oils with cotton balls and Q-tips, after which I would apply the final coats of oil with tiny brushes. Even as we suffered together over the disquieting nature of these pictures, we took considerable pleasure in the ease with which we worked in concert (something we had not always been able to do). This gave us confidence that our marriage would not only survive the end of the project but might even thrive once we were no longer dealing with the anguish the subject matter caused us.

Once the painting of this image was completed, we had one more hurdle before we could celebrate, with kisses and champagne, the culmination of our long struggle: the silk-screening onto the slatted panels of the letters that would communicate the questions to be raised. The only people to whom we would have entrusted such a task were Jim and Judy of Unified Arts, because there was absolutely no room for error. Eight passes of the squeegee blade would either make the words or irreparably ruin the finished work. I had to turn away each time Jim drew the squeegee across the screen because I was so nervous; but, of course, they accomplished the job with no mistakes.

Once the artmaking phase of the project was completed, I became occupied with all the logistics involved in preparing the exhibition. In addition to consulting on the framing and crating, I worked intensively with our designer on the documentation panels. While I was writing the text for the

panels and working with her on their visual format, Donald was printing the many photographs that would help to create a short chronicle of our long physical, intellectual, and artistic journey for viewers of the show; he also began dealing with some of the mechanical details of the installation.

I spent many weeks working on the audio tour, including some time with Michael Botwinick, who, as director, had brought *The Dinner Party* to the Brooklyn Museum in 1980. Since then, he had moved on, but we had remained friends. He graciously provided the art-historical narration. The video that introduced—or, in some venues, ended—the show was put together by Kate Amend, who, after *The Dinner Party*, had gone on to become a successful film editor. Like everyone else, she volunteered to bring her considerable professional skills to bear on the making of this thirty-minute video. It was a joy to work with her as she supplemented and edited footage that had been shot by a local filmmaker, who had been documenting the project for a TV program about art.

The music for both the audio and video was done by the composer Lanny Meyers, with whom I'd gone to college, during which time we had considered each other "soulmates" (which, in the 1950s, meant being close but never having sex). We had stayed in touch over the years, and, as it turned out, just at the time I asked him for help, he had begun exploring his own Jewish roots. Doing the music for the *Holocaust Project* provided him the opportunity to explore some traditional vocal and musical compositions, and he produced a hauntingly beautiful score. Then, thanks to another one of my cousins, Allen Schwartz, who is a TV producer, Katie was provided with excellent postproduction facilities.

Everyone who came forward during this period demonstrated yet again how indispensable support is in accomplishing an ambitious project such as this one. And even though I have spent much time in this manuscript lamenting my ongoing problems with inadequate levels of backing, I must acknowledge and rejoice in the generosity of those numerous people whose magnanimity ensured the completion of the *Holocaust Project* (and, in some cases, sustained me for many years). However, in terms of the preservation of the art I have created, such individual support is insufficient unless, of course, it is offered by patrons of vast wealth or power.

Most of my network has been made up of people of more modest means and position—a structure that has been demonstrably adequate for the creation and even the exhibition of my work, but not always able to guarantee its future. Even now, the upper echelons of the art world remain beyond my reach. As a result, despite my worldwide fame, the long-term preservation of my art is not assured. Donald and I have been trying to figure out ways that we can accomplish this, as ultimately it will fall to us. There are times when this task feels onerous and I have to remind myself that if it was worthwhile to spend my life making art, it is also important to make sure it is not lost—or erased, which remains a problem for women artists, primarily because we do not have enough institutions of our own.

This was the problem that the board of Through the Flower had been discussing, specifically in regard to *The Dinner Party*, since the congressional debate and the consequent blocking of its permanent housing. In March 1993, we held a board meeting in New York, during which much time was devoted to this topic. The women on the board have come together over the years largely out of their desire to support me in my artmaking. I doubt that any of them predicted that they would end up responsible for *The Dinner Party*, the *International Quilting Bee*, the *Birth Project*, and, now that it was done, the *Holocaust Project*. (The last was toured under the auspices of the corporation, though most of the responsibility was handled by Donald and me. For a while it had seemed that the tour would be coordinated by the Spertus Museum, but this fell through.)

At this time, Donald and I had no thought of keeping the exhibition intact, although we had come up with an installation plan in which the individual pieces would fit into a larger whole. We had hoped to sell each of the works to museums, so we were quite surprised after the show opened to hear numerous viewers say that the various parts belonged together permanently. But if we pursued this idea, it would only exacerbate the problem that Through the Flower's board was already addressing, which was what to do with *The Dinner Party*.

At the March meeting, the board continued to discuss *The Dinner Party*'s permanent housing, a conversation that centered on the notion of

trying to build a museum in Santa Fe, an idea which, in retrospect, was completely unrealistic, given that no one had the resources to fund such an effort or the time to undertake a capital campaign. All I can say is that I guess hope springs eternal. Then, after Henry Hopkins announced his plan to exhibit *The Dinner Party* at the Hammer Museum in 1996, the board's focus shifted to California and a more modest goal, one that involved trying to forge a partnership with an existing institution, either on the West Coast or in another part of the country. Given that I still had a large audience in L.A., this seemed more practical.

Even this goal required the strengthening of Through the Flower's infrastructure, which was minimal, to say the least. Since we were living in Albuquerque and the president of the board lived in Santa Fe, the board decided to set up two offices, one in each town, an idea that sounded all right at the time but proved to be completely unworkable. There was a small building on the property where we were living in Albuquerque that we turned into the art office, while the Santa Fe operation revolved around the president and the board's efforts to house *The Dinner Party*, which was really their primary focus.

This left me in a quandary: Through the Flower was the only framework for my collaborative projects, which were educational in nature and thus met the criteria for support by a nonprofit organization. Given that the effort to find permanent housing for *The Dinner Party* would now be Through the Flower's priority, I could not look to its structure for support of any future projects. In fact, I was beginning to question the point of making any more art if the work I had already created was in such jeopardy.

After this rather significant board meeting in the East, Donald met me, and we went to Newburyport to visit his parents. We especially wanted to see Louis, who was in a terrible way, his physical strength diminished and his emotional state one of pure rage. Hardly speaking to us, he openly took his anger out on Bertha, though she was certainly not to blame for his debilitated condition, which had been brought on by illness and age. After this disheartening visit, we returned to Santa Fe and the task of packing up and preparing to move, store, sell, or throw away the accumulation of ten

years of living and working in the large, sprawling Canyon Road compound. We moved on Memorial Day weekend, leaving a hauntingly empty series of rooms where once there had been a bustling domicile.

There was one amusing moment in what was otherwise a rather dismal weekend, concerning our black-and-white cat Sebastian, who had arrived at my doorstep before I met Donald. At the time, I was watching *Brideshead Revisited*, the television miniseries based on the Evelyn Waugh novel that starred the divine Jeremy Irons as Charles Ryder and Anthony Andrews as Sebastian Flyte. Perhaps it was because I named my cat after this character that he developed such a compelling personality. Whatever the explanation, I was besotted with him. And I guess the feeling was mutual, because he was always with me, following me to my back studio every morning and patiently waiting at the door until I arrived. When he was six, he developed diabetes, which meant I had to give him insulin morning and night and also control his diet. Over the weekend we moved, innumerable neighbors came to say goodbye to Sebastian. When I asked how they knew him, they informed me that, unbeknownst to me, he supplemented his diet by visiting—and eating at—all the houses in the neighborhood.

Once we were settled in Albuquerque, Donald began going to Belen every day, leaving me alone in the small house with our cats, who numbered six by then. My solitude was interrupted only when my assistant at the time, a young artist named Jessica Buege, came to work part-time in the small building on the property that housed Through the Flower's art office. It was barely adequate for the cabinets full of slides that were suddenly the only reminder of my lifetime of work. Most of the *Holocaust Project* was off being framed and crated, and what was not to be in the show (preparatory drawings, studies, and photographs) was stuck away in flat files or yet more storage bins.

As I looked around at our new quarters in the semirural and funky South Valley of Albuquerque, there seemed no evidence that we had ever even undertaken such a large and significant project, as if the previous eight years had been a dream. I felt lost, as if my accomplishments—not just the *Holocaust Project* but my total career—were dissolving before my eyes. At this time, I began to be plagued by the memory of Anaïs Nin's

nightmare; her fright about the insubstantiality of her achievements was becoming my own. Looking back, I can see that my despair was the result of many factors, one of which was the shock of having traded in our spacious quarters in Santa Fe for this humble house. And even though I could not bear what had happened to the so-called City Different—which had gone from being a charming and livable small city to an Aspenized retreat for rich people—I missed the landscape, the sense of community, and the continuity of my life there.

Moreover, even though I had told my board (and other people) that I saw no sense in continued artmaking, still, creating art had defined my life for decades. The prospect of not doing so deprived me of a sense of purpose—and of joy. I desperately missed the long, uninterrupted days in the studio, and my impulse to create would not subside. For no reason except my intense need, I began a series of small drawings, the *Autobiography of a Year*, on which I would work whenever the urge to put marks on a page became overpowering.

I would not draw for long hours—as had been my habit—but, rather, in short bursts, sometimes doing the same image again and again until I located the desired aesthetic impulse, then expressed it as directly as I could. Over the next year, I would do 140 drawings, which would not be shown for a long time. A few years ago, they started being exhibited and have had an amazing impact, with people reading every word of the text. Until then, they sat in two archival boxes in my study/studio, evidence of that painful year in which I was convinced that I was reenacting Anaïs's nightmare in my own life.

It seems somewhat odd that I should have felt this way just prior to the opening of a major exhibition. Not only was the *Holocaust Project* going to premiere the following October, but Donald and I had managed to put together a respectable museum tour. This should have given me some sense that I was making progress, especially because, unlike the exhibition of my earlier projects, this tour involved no alternative spaces—seemingly, some small indication of greater acceptance of my work. Maybe I was suffering something that had never happened to me—that is, postpartum blues. Previously, I had always been immersed in another ambitious undertaking

by the time a major project was completed. But I had promised my board that this would not happen, and without Through the Flower's support, there was no way I could take on any more large-scale work.

When I think back upon this period, I realize that I was considerably more worn out from the *Holocaust Project* than I knew at the time. But even my exhaustion does not explain my mood over that summer of 1993, which was so dark as to have made suicide seem an attractive way out. In fact, I found many journal entries from these months concerning ways of "offing myself" while Donald was in Belen. One thing that stopped me was that I could not bring myself to inflict upon him the level of grief this would certainly have caused.

Ultimately, once again, Anaïs's advice saved me. I remembered her saying that if you could not "live through" confusion, you could "write your way through it," which prompted me to do a second volume of my autobiography. It was writing *Beyond the Flower* that helped me understand the primary reason for my depression, which basically came down to my fear for my body of art.

In July of that year, Louis died, and Donald and I flew east for the funeral, after which my husband went through a really bad period. Then, in August, my mother died; as I had anticipated, I was the last survivor of my immediate family at the opening of the *Holocaust Project*. Donald and I went to L.A. for a memorial service at the Jewish Home, to which Howard came, as did my cousin Alan and his older brother, Julian. After distributing her ashes in a rose garden as she'd requested, I came home and opened a bag I had retrieved when we'd moved her to the nursing section of the Jewish Home. I had thought that these were her limericks, funny poems she had written over the years; but instead, they were letters to several friends who had apparently saved them and sent them back to her.

These letters spanned the period from when she first moved to California until she retired, fifteen years during which her exhaustion and her loneliness were apparently far greater than she had ever let on. I was angry that she had not shared this part of herself, while at the same time I admired her determination to keep her problems from intruding on her children's lives. It was this fierce pride, however, that had prevented us

from ever achieving the closeness I had so desperately needed when I was young. While reading these letters, I realized with a start that she had passed this same tendency on to me. For I, too, have hidden behind a facade of strength when my heart was breaking, a facade that writing again helped me break down, in part because it allowed me to publicly reveal my real feelings, something that has always been difficult for me to do.

My intention was to begin work on *Beyond the Flower* in Chicago, where we planned to go in the early fall of 1993. As the *Holocaust Project* had never been assembled, Donald and I had no idea how long it would take to install, so we wanted to leave ample time for any unanticipated problems. We arranged to rent an apartment where I could write (and draw) when I wasn't needed at the Spertus, while Donald would supervise the installation. The place where we would be staying, overlooking Lake Michigan and up the street from Howard and Arleen's, was not far from where I had grown up. The Spertus Museum is located on Michigan Avenue some blocks south of the Art Institute, where I had spent so many happy days during my childhood.

Shortly before we left for Chicago, I had received word that Viking Penguin, the publisher of the *Holocaust Project* book, would be working with the publicists hired by the museum and that *The Village Voice* was sending a reporter to cover the opening. I was particularly happy with the paper's choice. Though I had never met her, I knew that she was an experienced art writer and also a friend of a number of my close friends, including Lucy Lippard. I knew her to be sympathetic to feminism and, I thought, to my work. Moreover, she had been assigned by an editor who happened to be the longtime companion of the guy who had written such a positive piece about *The Dinner Party* in New York and had later organized the Staten Island *Birth Project* show.

Finally, I thought, people with attitudes similar to my own were in positions of influence in the New York art media, and thus I had no reason to fear this reporter. Given that there was (in my opinion) so little art of merit in the museums on the subject of the Holocaust, at the very least I expected to have the project accepted for the integrity with which we had approached this subject matter, not to mention the length of time we had

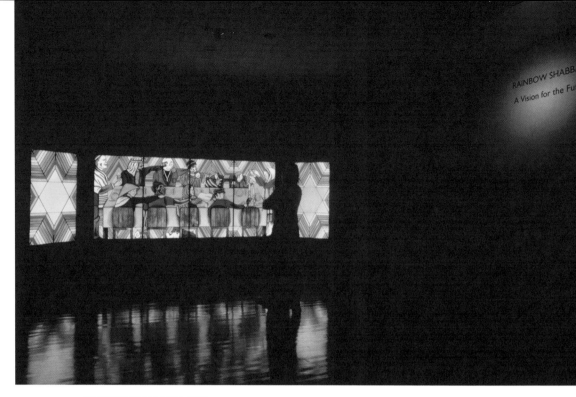

RAINBOW SHABBAT 1992
Installed at the Rose Art Museum, Brandeis University, Waltham, MA
Stained glass, 54 × 204 in (137.16 × 518.16 cm)

devoted to it. And both Donald and I presumed that the uniqueness of the ways in which we had combined painting and photography would earn us some respect. Actually, I was far more worried about the Jewish press than the art press, because—even though the *Holocaust Project* was rooted in the Jewish experience—we had departed from the way the Holocaust is traditionally presented in Jewish institutions.

The opening was to take place, oddly enough, almost eight years to the day after that momentous viewing of *Shoah*. Numerous events were scheduled over that October weekend, beginning with the opening of our joint exhibition of drawings, studies, and photographs on Saturday afternoon at the Joy Horwich Gallery. That evening, Through the Flower hosted a gala banquet to celebrate the completion of the *Holocaust Project*, which people attended from all over the country. The next morning there was a private viewing, inaugurated by a specially composed prayer and a ribbon cutting. The Spertus had scheduled its opening activities for Sunday afternoon, which included time for its trustees and constituency to see

the exhibition and attend its huge annual fundraising dinner, where I was presented with an award.

Prior to the weekend, I had several busy days of interviews, book signings, and a press conference. I guess I should have become suspicious when the *Voice* reporter arrived at the end of this press event wearing an army flak jacket, which she never took off all weekend, even at the festive dinner on Saturday night. When I met her she appeared friendly, expressing appreciation that we had consented to her being present at all the events surrounding the opening (including the Saturday-night dinner, which was a private affair). After seeing the show, she interviewed me at my apartment, an interchange that was quite unsatisfactory in that I felt we were unable to make any real connection, something I always try to achieve with reporters in order to break through the impersonality of interviews. On top of this, I felt somewhat let down because I had looked forward to a stimulating exchange.

Her first question baffled me, for she began by asking me about my "agenda." In retrospect, I realized that she was actually telling me something about herself, which I didn't pick up on at the time. She had probably already made her assessment of both me and the show, and neither my answers nor her witnessing the incredible audience response to the exhibition would have any effect on the ax she'd apparently come to Chicago to grind. On Saturday night, more than 125 people assembled at a hotel for our celebration banquet, another one of the memorable evenings of my life. Isaiah Kuperstein acted as the master of ceremonies for a joyful, exuberant event that sometimes seemed more like a bar mitzvah than the prelude to a serious art opening. There were toasts and tears throughout the night, along with dancing to the music of a klezmer band; at one point, Lanny Meyers joined in for a special musical moment dedicated to Donald and me.

In attendance that evening were some of my oldest and dearest allies; in fact, there were faces in that room that I had seen at the party after the San Francisco Museum of Modern Art opening of *The Dinner Party* in 1979. No matter how much love they might have felt for me, they had come to Chicago for the same reason they had gone to San Francisco and stood by me for so many years: their commitment to my work. Given the varied

credentials of the people in that room, they had every right to expect that both they and their opinions would be respected. Unbeknownst to any of us, we were all about to be openly ridiculed.

On Sunday morning, Donald and I waited anxiously during the hour or more it took them to see the show, because it was this group of people whose opinions we most valued. My first patron and staunch friend, Stanley Grinstein, emerged from the exhibition with tears in his eyes, folded me into his arms, and said, "I'm so proud of you!" In all the decades I had known him, I don't think I had ever seen Stanley cry—and certainly not at an art opening. One after another, individuals or small groups emerged to embrace and extol us; one museum director was so overwhelmed he could hardly speak.

"Go into the show," everyone urged, "people are crying in the exhibition"—which was somewhat hard to accept. Although I have repeatedly expressed my belief in the power of art, it was difficult to imagine such unrestrained emotion in a gallery setting. But it was true: everywhere Donald and I looked, people were weeping—a response so gratifying it was, as I said to Donald, beyond my wildest dreams. Throughout the morning, the *Voice* woman stood around watching these reactions, which are hardly usual at art shows. Although she didn't say anything to me or to Donald, I was sure she would at least comment upon this remarkable, effusive response. Instead, she wrote a piece so hateful it was hard to believe we were at the same opening.

By the time it was published, Donald and I were home, trying to get settled back into the routine of our lives after an absence of more than a month. We felt good about the initial reception of the work. And even though the exhibition would not draw the huge crowds that some of my previous shows had, it would still prove to be one of the more successful exhibitions at the Spertus (and subsequent institutions), reportedly stimulating an unusual amount of dialogue, along with ongoing expressions of gratitude from many viewers. Although I certainly did not expect unanimous critical acceptance, I must admit that I was taken aback when the Viking Penguin publicity people called to say that the *Voice* piece was "horrible," and they were faxing it to us so we could read it. At first glance, it seemed to be just

another example of the New York art world's negative stance toward me; it was the "same old same old," as I described it to my publishers. But I was nevertheless surprised that, after so many years, this position seemed not to have changed one whit.

To tell the truth, I did not read the article all that carefully at the time, having surmised from its title and tone that it might be best not to take it too seriously, though I was somewhat concerned because I knew the art press often picks up on earlier writing (as had happened with *The Dinner Party*), especially articles emanating from the East Coast. But this particular piece of writing was to have a far more detrimental effect on me both personally and professionally than any before or after it. And this despite the fact that the reporter confessed that she had always felt "squeamish" in Jewish institutions, an announcement that would suggest to any intelligent person that this writer was incapable of rendering an objective opinion about the show.

The article, which featured what appeared to be a deliberately unattractive photograph of Donald and me, was entitled "Planet Holocaust: From Feminism to Judaism," as if to imply that I am someone who jumps on bandwagons. Much of the piece was devoted to disparaging our private party; the distinguished people gathered there were dismissed as nothing but a bunch of "fans." She critiqued my outfit, the color of my hair, the way I interacted with Donald, my lack of a sense of humor, even the sauce on the hotel chicken dinner. Only in the last third of the review did she even take up the subject of the art, describing it as an "aesthetic travesty," an odd phrase and one that reminded me of Hilton Kramer's labeling of *The Dinner Party* as "failed art." The rest of the review fell into the old New York cant about how I make bad art. But in an especially malicious gesture, she played Donald and me off each other by suggesting that my inadequate painting skills had "ruined" his wonderful photographs.

I tried to blow off the article, as I had done so many bad reviews. But it was not easy to maintain my usual cavalier attitude, given that the phone started ringing with people voicing their outrage, particularly over having their sincere outpouring of feelings publicly denounced as nothing but the gushings of a fan club. Then I received a phone call from my old

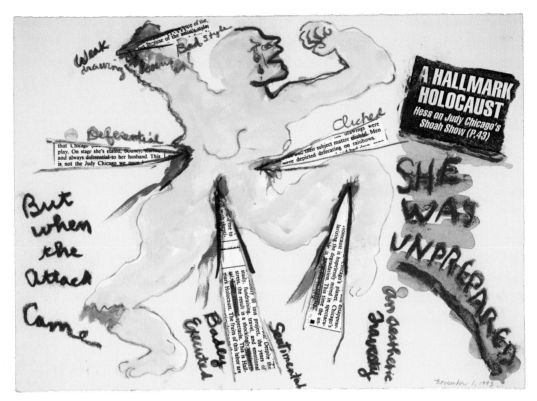

Within the drawing, the following handwritten and collaged text appears:

Weak drawing

Bad Style

A HALLMARK HOLOCAUST
Hess on Judy Chicago's
Shoah Show (P. 43)

Deferential

that Chicago
play. On stage she's elated, bouncy, warm,
and always deferential to her husband. This
is not the Judy Chicago we once

Cliched

...drawings were
... one their subject matter dished. Men
were depicted defecating on rainbows.

SHE
WAS
UNPREPARED

But
when
the
Attack
Came

An aesthetic travesty

Badly Executed

Sentimental

November 1, 1993

DRAWING NUMBER 54 from **AUTOBIOGRAPHY OF A YEAR** 1994.
11 × 15 in (27.94 × 38.1 cm)

friend, the art critic Arlene Raven, who also wrote for the *Voice*. Shortly after the opening weekend, she had been in Chicago and had gone to see the show, which she had greatly admired. When she returned to New York, she read the review and asked the editor (the same one whom I had mistaken for a friend) for the opportunity to present an opposing, more positive perspective, a request that was denied. Arlene asked Donald and me to write letters in response to the article, something I had never done. But Arlene insisted, saying that everyone who had been calling to express their indignation should do the same.

I think she hoped that such an effort might convince the editor to let her write another piece, a strategy that proved unsuccessful. In fact, sometime later, Arlene was fired from the *Voice*, but not before the newspaper

received dozens of letters of protest, including one in which the writer sent a Fleet enema to the reporter, along with the humorous advice that she might consider using this offering to cleanse herself of the vile temperament evidenced by her review. In preparation for writing my letter (one of the very few of this group to be published), I had to read the piece again, far more closely; I almost wish I hadn't, largely because its seemingly gratuitous viciousness caused me to suffer for a long time. I guess I was in no shape to handle such hostility then.

I am in no way suggesting that my work could not do with some good criticism or that the *Voice* reviewer was not entitled to her opinion of the art. It is just that—as in this instance—what has been put forth in regard to my work has too often been vitriol rather than a thoughtful critique. As a result, I have frequently felt forced into a position of having to throw out the baby with the bathwater, unable to accept any possible critical insights because they have usually been couched in such rancor.

As I look back upon this whole experience, I believe that I see revealed one of my most fundamental problems. In my mind I see a different world, one far less cruel than the one in which we live. By spending so much time in my studio, I had been able to believe that the world I could so clearly envision and tried to express through my art existed outside my imagination and the personal, educational, and artmaking environments I have created. Whenever I left these environments, I would be stunned. Then I would return to the alternative reality that I had constructed in order to forge yet another body of art in the belief that eventually my work and values would be apprehended and appropriately recognized.

When I read the *Voice* article carefully, I realized that basically nothing had changed despite decades of work; it seemed that I was as misunderstood as I had ever been, maybe even more so. Also, I could not reconcile what appeared to be a vast abyss between my own perception of the *Holocaust Project* as my finest achievement to date and the evaluation that the work was utterly devoid of any quality at all. This was particularly distressing because one reason I thought the project especially good was that I had brought together the various aspects of my identity—that is, artist, writer, woman and feminist, Jew, and student of history. Now, for the first time,

I began to doubt my abilities as an artist as well as my own perspective. If I had been in low spirits before the opening, I found myself shattered afterward, even more lost than when we first moved to Albuquerque.

After the Spertus opening I felt as if I was living in a state of suspended animation, waiting to see if the life I had previously led would resume. That existence would be best described as a large one, defined by big projects and lofty aspirations. To go on with such a life, I would again need a large studio like the one Donald and I hoped to have in Belen. But it would also require some greater level of support than I had then. If the art world remained so dead set against me, and Through the Flower had become unable to provide the framework out of which I had worked over the last two decades, in what terms was I to be an artist? As I mentioned, for a while I contemplated giving up artmaking entirely. But I discovered that I was absolutely unable to do so, nor was I able—or willing—to relinquish my vision of a different world.

In early 1994, I turned to those few needleworkers who had worked with me previously and had expressed an interest in continuing to do so. I had an idea for a series of needleworked and painted images based upon traditional proverbs reinterpreted in a contemporary context. During my research, I discovered that one of the few scholars who had studied proverbs had concluded that when younger generations no longer remember them, the forgetting mirrors the breakdown of social values. This insight seemed particularly pertinent in the early 1990s when right-wing pundits like William Bennett (former secretary of education) were penning publications like his *Book of Virtues*, which ostensibly addressed this situation.

As I kept saying at the time, the conservative right were not the only people who saw the many social problems afflicting our culture. However, their solutions always seemed to involve rolling back women's rights, not to mention the rights of other members of society who aren't white or straight, and his ideas were no exception. I thought it would be interesting to come up with a more progressive set of answers. To get started, I asked my needleworkers to do their own research into proverbs and to bring them to a meeting at my Albuquerque house. We sat around and discussed various adages, soon discovering that not all of them allowed the possibility

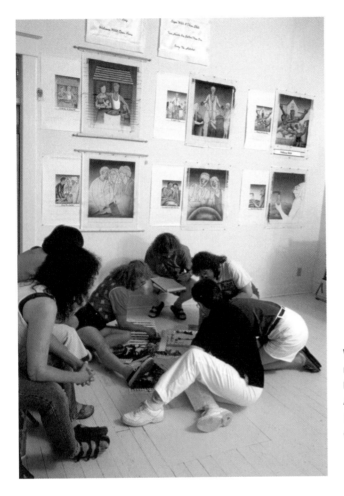

Working with
needleworkers on
**RESOLUTIONS:
A STITCH IN TIME**,
Belen Studio, NM
ca. 1997

of viable images (for instance, "Don't Cut Off Your Nose to Spite Your Face" conjured up a rather obnoxious picture).

Titled *Resolutions: A Stitch in Time*, this series presents images of a world transformed into a global and diverse community of caring people. Though quite modest in scale and somewhat humorous in format, *Resolutions*—which took six years of work and pushed needlework to a new level of skill—ended up being exhibited at and toured to eight venues by the Museum of Arts and Design in New York (formerly the American Craft Museum). It was also the first traveling exhibition that I did not curate myself. Instead, that task fell to the incredible David McFadden, one of the most gifted curators I have ever known.

Despite another extremely hostile review in *The New York Times*, this project had an amazing impact. At the time of the 2001 attack on the World Trade Center, the show was scheduled to open at the Fort Wayne Museum of Art. I assumed that the opening would be postponed, but it was not; instead, the director of the museum took her entire staff into the installation to view and discuss the worldview put forth by my art. Once again, I saw the power of art to educate, comfort, and inspire.

In early 1994, about the time I started *Resolutions*, Donald and I returned to Chicago for the installation of the tapestry *The Fall*, which had not been finished in time for the premiere (I had shown the full-scale cartoon in its stead). While there, we were asked to take the head curator of the Museum of Contemporary Art Chicago through the *Holocaust Project*. He was a pleasant chap who, amazingly, had attended the opening of *The Dinner Party* in London; in fact, he informed me, he had gone to school with Germaine Greer, who had delivered the opening-night speech. After touring the exhibition, we discussed why so many people in the art community seemed to hold such a negative opinion of my art. He said that most people had no context for my work and that it raised numerous issues that made them uncomfortable. When they dismissed the art as "bad," they avoided having to deal with it seriously in any way.

No sooner had we had this conversation than another review appeared in an alternative but influential Chicago newspaper. Headlined "The Banality of Bad Art," the piece demonstrated precisely what we had discussed; the writer described the work in such a negative way as to let himself off the hook in terms of providing any real, thoughtful analysis. As I thought about our discussion, I realized that there has always been a context for my work. But what our conversation made eminently clear was that in the case of both my earlier work and the *Holocaust Project*, their respective contexts were unknown to the art community at the time the art first appeared. For instance, *The Dinner Party* and the *Birth Project* arose from the context of women's history and experiences, their creation and distribution fueled by the activism of the women's movement. And the *Holocaust Project* grew out of Jewish history and values, the survivor experience, and Holocaust studies. More recently, the scholarship has broadened its focus to reinforce some

of our insights; for instance, the fact that Hitler and his cronies studied assembly-line techniques in devising the Final Solution.[15]

Much to my surprise and relief, a number of young art historians and critics—notably Amelia Jones, the curator of the 1996 *Dinner Party* exhibition at UCLA—were beginning to examine 1970s art, especially Feminist Art, with which Amelia was extremely familiar. In the spring of 1994, she came to New Mexico to go through my slide files and archives in preparation for the exhibition at UCLA's Hammer Museum. Here was someone well versed in art history looking at and appreciating what I had created—not just *The Dinner Party* and the *Birth Project* but also works of art from those years that had, in some instances, never been shown.

After spending many days peering at slides and rooting through piles of articles and archival material, Amelia said that in her opinion, most of what had been written about me and my work was not true, and that she intended to *pierce* the misrepresentation that has surrounded me. As I recall this moment, I cannot help but laugh. Amelia was almost nine months pregnant then, and this statement was accompanied by a determined thrust of her very large belly.

In addition to lifting my spirits, her words gave me hope that eventually my whole body of work might come to be understood. I had anticipated that as soon as the Belen Hotel was finished and we were moved in, I would try to get my work out of storage and bring it all there so it could be organized and cataloged. But in the summer of 1994, Donald and I ran out of funds, which threatened to shut down the building project altogether. We were fortunate that Donald's mother, Bertha, gave him a substantial gift, which she dubbed an "early inheritance." But even this generous amount would not be enough, though we did not realize it at the time.

In September, shortly before the opening of the *Holocaust Project* at its second venue, the Austin Museum of Art in Texas, I went to Colorado to begin to rework the manuscript of *Beyond the Flower*. Audrey and Bob Cowan owned a vacation home in Beaver Creek outside Vail, and they made it available to me. Each day I spent many hours writing, then went outside to breathe in the delicious fall air and to push my body in long runs in this mountainous retreat. The leaves of the aspen trees that dot the hills

were beginning to turn brilliant hues of gold, and I inhaled their color and watched the soft pink light of the late afternoon bathe the mountainsides. Some days I wept while I wrote, recognizing that although I had appreciated how hard my life had been, I had also distanced myself from this realization by working all the time, taking all my emotions—the rejections, the disappointments, and the many sorrows—and transforming them into painted images. But the day of reckoning had come. As I forced myself to honestly describe my feelings to my readers, I also came in touch with all of this myself.

After I finished that book, it took another year before the Belen Hotel project was completed. During that time, though he missed doing photography, Donald worked as a foreman at a small construction company in order to meet the mortgage payments and the associated costs of the

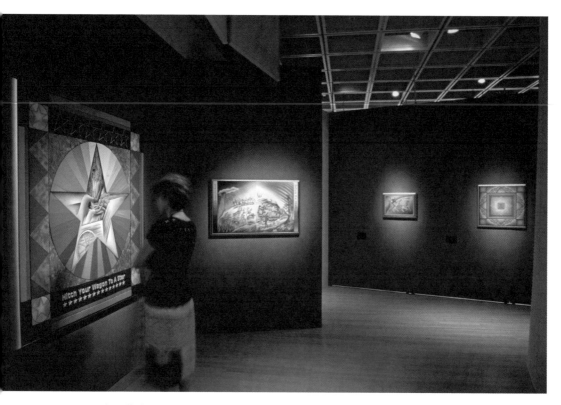

Installation of **RESOLUTIONS: A STITCH IN TIME** American Craft Museum, NY 2000

building. Meanwhile, I continued to support us while trying to slowly cut away at the debt we had accumulated while doing the *Holocaust Project* so that we could qualify for the bank financing that would eventually be needed to maintain the hotel.

As to my artmaking life, Emily Dickinson's admonition, outlined in one of her poems, stayed with me during the three years we lived in Albuquerque. From 1993 to 1996, when the Belen Hotel was finally finished, I made art but not in the uninterrupted ways to which I was accustomed. At the end of that time, I decided that, like Dickinson, I would once again "take my power in my hands and go out against the world," vowing that never again would I be persuaded to put aside my art; it has made my life worth living.

I ended *Beyond the Flower* by expressing my gratitude to those readers who hung in there with me as I made this excruciating journey through the second half of my life and out of the temporary immobilization that I suffered. Whatever the benefit of my tale to others, for whatever time remains to me, I plan to subscribe to the old adage: "It's not over till it's over." And even though I continue to be acutely aware of my mortality—and hence the fact that this condition could change at any time—I have already lived far longer than I ever anticipated. If maturity has brought me anything, it is surely the wisdom that one never knows what the future might bring.

AFTERWORD

Saturday, April 1, 1995

> I made art out of my heart and it speaks to thousands of people...[but] they are not the people who do the buying or the museum-building and those that do hate me and everything I stand for.

As is suggested by this journal entry, 1995 was a really tough year. Donald and I were fighting because the work on the Belen Hotel was dragging on. We were living in a small house in Albuquerque; I had no real studio; I had left ACA by then and had no gallery representation and no opportunities. I was writing and lecturing to make money; my work was in storage in Los Angeles, which meant costs that we couldn't afford; and the *Holocaust Project* was traveling but under a critical cloud after the vitriolic *Village Voice* article. *The Dinner Party* was still unhoused, and the art world was acting as if it had had no impact despite its international tour, a huge viewing audience, and the fact that it was being taught all over the world. Whenever I lectured, there would be hundreds of people in the audience, and I would often receive a standing ovation. It was very confusing. The one bright note was that *The Dinner Party* was going to be exhibited at what was then the UCLA Armand Hammer Museum in the city where it had been created.

In addition to working on *Beyond the Flower*, I was also doing a new *Dinner Party* book for the Hammer Museum show, both of which were to be published by Viking Penguin. This resulted in two new relationships. One is with my editor, Mindy Werner, whom I used to describe as "the woman who made Judy Chicago cry." Often I was convinced I could not do what she was asking, but it turned out that she was always right, and it made my writing far better than I could have imagined.

The first book she worked on was *Holocaust Project: From Darkness into Light*, which also brought me a young publicist named Ron Longe. He knew little about my history and innocently called Robert Hughes of *Time* magazine in an effort to get him to review that project and the accompanying book. To this day, Ron laughs about the half-hour diatribe Hughes unleashed upon him when he mentioned my name (the reader might remember that Hughes was one of those who savaged *The Dinner Party* when it was in New York).

Despite my tenuous situation, I still had such a strong urge to make art that—in addition to working on *Resolutions: A Stitch in Time* with my longtime needleworkers—I began a series titled *Thinking About Trees*, in which I did exactly that: I *thought* about the beauty of trees; marveled at the way they purify the air of carbon dioxide, making it easier for us to breathe;

**A COTTONWOOD
TRYING TO LIVE** from
THINKING ABOUT TREES 1996
Mixed media on bark paper
30 × 22 in (76.2 × 55.88 cm)

mourned over their cut-down stumps; and bemoaned the fact that people rather mindlessly tack signs to their trunks. I began in a small sketchbook and then moved on to larger, more detailed drawings, having set up a small drawing studio in one of the bedrooms of the house where we were living.

I also used that space to design *Resolutions* images. It was difficult to spray-paint there, but I managed, although when I overpainted with oils it was pretty smelly, as there was no ventilation. For this project, the needleworkers and I had a contract for joint ownership of the finished works. Sometimes multiple stitchers worked on one piece, so they devised a complicated ownership system that became extremely cumbersome to enforce. Still, as Jackie Moore Alexander (who has worked with me for many years) commented, "*Resolutions* involved the highest form of collaboration any of us had experienced"—including me—resulting in works of high quality that, I'm now told, appear extremely prophetic.

In the fall of 1995, the *Holocaust Project* opened at the Rose Art Museum at Brandeis University, which was then under the direction of Carl Belz. I can still remember him standing in front of the *Fall* tapestry and telling me that he had been pondering the hostility toward my work, this time expressed in a *Boston Globe* article by a woman who continued the vitriol initiated by the *Village Voice*. Carl recounted having heard a lecture by the artist Frank Stella, who positioned his own work in a historical chain reaching back to Greek times, which no one challenged. In contrast, the tone of her review seemed to be: "How dare she think she can take on a subject as vast as the Holocaust?" Then he looked at me and said, "Ah, I figured it out—you're a girl."

This is yet another example of a supportive man and a hostile woman, which contradicts the simple gender analysis that is often put forward in relation to my work. Unfortunately, in championing my art, Carl lost his job, which has always distressed me because I hate it when people are punished or ridiculed for advocating on my behalf, something that happened frequently to the Grinsteins, my longtime patrons and friends. Nonetheless, they never wavered in their belief in me, for which I shall be forever grateful. I just wish they had lived long enough to see the turnaround in attitudes toward my work.

In preparation for the Boston exhibition in 1995, Donald and I made a trip there earlier in the year. One day, I was riding down the elevator of the building where we were staying; a woman got in, looked at the *Holocaust Project* book under my arm (I was en route to an interview), and said, "You're Judy Chicago, right?" Once she'd established my identity, she said nothing until the elevator reached the ground floor. At that point she exclaimed, "Emily Dickinson wasn't lacy," a comment about the lace-draped plate in *The Dinner Party* honoring this great poet. I replied that it was intended to be ironic but that I was amazed she had remembered her reaction for the fifteen years since the piece had been in Boston.

This story illustrates why this period of my life was so bewildering. On the one hand, I was becoming increasingly well-known, but at the same time, one would never know this within the art community. The same duality appeared in relation to responses to Amelia Jones's 1996 exhibition, *Sexual Politics: Judy Chicago's "Dinner Party" in Feminist Art History*. The opening was fabulous, as I still had many friends in L.A. who were overjoyed that the piece was finally being shown there.

Before the opening, the Women's Studies Department at UCLA announced that they were planning to boycott the show because in their view it degraded women and I was an "essentialist." As a young scholar schooled in feminist theory, Amelia had addressed the issue of "essentialism" in the catalog. In addition, during a tour of the show, she used that term frequently, along with such academic references as "poststructuralism" and "postmodernism." When she asked for questions, a hand shot up. "What's essentialism?" a woman asked naïvely, which caused me to say, "Ah, the academy meets the real world."

Although the exhibition was a popular success, attracting more than 60,000 viewers, again it met with art-critical animus. Writing in the *Los Angeles Times*, Christopher Knight (who recently won a Pulitzer Prize) dubbed *The Dinner Party* a "failed work of art" and dismissed the importance of the show. Although Amelia was personally devastated by Knight's assessment, the exhibit and catalog began a slow turnaround in art-historical circles that helped improve the discourse around the piece, which was the goal of Henry Hopkins, the director of the museum at that time. I was pretty

blasé about the review, having endured the congressional debate about the piece, which had simply amplified the same old distortions.

Still, I tried to process the ongoing schism in the responses to my work, as reflected in this journal entry of May 7, 1996, a few weeks after the exhibition opened:

> When I did "The Dinner Party," I was one with my epoch, a period when women in America made an enormous push forward and in so doing, provided a context and an audience for my work. The resulting controversy took up all my energy, particularly since I was determined to keep working as an artist…I guess I was so busy and caught up in my work that I failed to notice the changes taking place around me—the pushing back of feminism and its near-repudiation by younger women; the effort to erase the impact of the Feminist Art movement and my position in it by both anti-feminists and the art world plus other women artists jockeying for position in what is a tiny, elitist world, the rise of "academic feminism" and its retreat from the (activist) principles of 1970s feminism; and the "re-elitizing" or further elitizing of art language…probably the result of the growth of university art programs which promote the "talking in tongues"…I bemoaned earlier.

As a result, I became out of step with both the academic and the art communities—which were promoting the idea that we lived in a postfeminist time—while continuing to expand my general audience. I ended up feeling like I led two lives; in the art world I was demonized, while in the larger culture I was adored. This might help to answer the oft-repeated question about why there has recently been such a profound change in attitude about me and my art: perhaps many of the people who loved my work gradually moved into positions of power and influence.

We moved into the Belen Hotel over the Fourth of July weekend of 1996. At last, Donald's dream of having a place of our own came true thanks to his hard work, grit, talent, and persistence. To commemorate his incredible achievement (which I thought would never happen), I had a plaque made stating that the Belen Hotel, built in 1907 and already on

the National Register of Historic Places, was "lovingly restored" by my husband. As I often joke, he is probably the only person who could have designed, built, and photographed his own home.

The layout of the building reflects Donald's and my relationship and our values, in that it is egalitarian in nature. The two-story structure affords us his and hers sides; each of us enjoys our own spacious studio on the ground floor, along with an office above. My office is in the original space of Bertha Rutz, who built the hotel. She was the nanny to the town banker's family, and when the children were grown she persuaded the banker to finance the hotel, which is light-filled with high ceilings. It did not take me long to realize why Donald had been so adamant about having our own place, because I discovered that I LOVED IT. Loretta Barrett, my literary agent at the time, had a specially bound guest register made whose pages have been filled over the years with the names of all the people from around the world who have visited us. The Belen Hotel has provided us with a home in which to build a really solid marriage of (at this writing) almost thirty-five years. In addition, we have continued to collaborate professionally, in part because we both love to work and we have differing skills. I often say that together we would make one perfect person. The only drawback to having a home of our own was that I would soon have to confront something I had managed to avoid for most of my career: a mortgage. It became obvious that neither of us had given any thought as to how we would manage the overhead of the building, which was considerable. By the late fall, when the weather began to turn cold, we got a gas bill for $700. I sat down on our stairway and, in a mixture of tears and laughter, said, "If I live long enough to collect Social Security, it will just about pay our utilities." But it wasn't funny, as the challenge this presented would require figuring out how to make a lot more money.

Still, when we first moved in we weren't thinking much about this, as we were completely occupied with getting settled. Even though there was a lot of space, there was not enough room for two of my libraries, the first begun during my early historical research, then expanded during *The Dinner Party* and supplemented because of the *Birth Project*. The Through the Flower Library By and About Women (which has grown to more than twenty-one hundred volumes) was gifted by me and Through the Flower

to the library at the University of New Mexico, Valencia, campus, which is not far from where we live. During the inauguration, a young female student commented, "Art and women—that's a combination I have never seen before," which reinforced our decision to place the books there, where they are available statewide via interlibrary loan. Donald and I gifted the library we had assembled while we were engaged in the *Holocaust Project* to the Holocaust Center of Pittsburgh in honor of our mentor, Isaiah Kuperstein, who had run that institution for a number of years.

In conjunction with the 1996 L.A. exhibition, the board of Through the Flower had organized a focused effort to raise money for permanent housing, which ultimately was not successful. However, enough funds were produced to build a temperature-controlled, humidified art-storage facility behind the Belen Hotel. As a result, we were able to bring all my artwork to Belen, and *The Dinner Party* could be safely stored, which was a major step in protecting it as well as reducing storage fees. The warehouse also allowed space for a group of conservators to descend on us in order to implement the Getty conservation study grant that Through the Flower received, thanks to an old friend, Deborah Marrow, who ran the Getty Foundation for many years. This study laid the groundwork for the eventual permanent housing of *The Dinner Party*.

In the meantime, I learned more about conservation than I ever wanted to know, including what a complex process it can be. I just thought it "magically" happened. Of course, that is often the case, particularly for white male artists, as they have a robust support system. Not so for many women artists or, I would imagine, artists of color. As I mentioned earlier, we do not have enough institutions devoted to the preservation of our cultural production; hence my dilemma, and, I would hazard, that of many other artists. While I really just want to be able to go into my studio, the more art I make, the more responsibility for its care accrues to me.

Later that year, I lectured at Harvard, which turned out to have a significant effect on one of my lifelong goals: ensuring that my work would not be erased. Afterward, there was a dinner where I was seated next to Mary Maples Dunn, who, at the time, was the director of the Schlesinger Library on the History of Women in America. At one point, Mary asked

about my archives, which were then languishing in unheated/uncooled storage, something Amelia had to contend with when she was doing some of the research for her show during the hot New Mexico summer.

After my conversation with Mary Maples Dunn, I made a visit to the Schlesinger Library, which was originally part of Radcliffe College and is now associated with Harvard. I can still remember going into the building—then a much smaller facility than exists today—and seeing photos of many of the historical women I had discovered and tried to depict in *The Dinner Party*. While there, I had an experience that I believe to be akin to what many people say about their first encounter with *The Dinner Party*: I was overwhelmed by being in an institution devoted to women's history, surrounded by dozens of people working to preserve our heritage. Becoming acutely aware of the *absence* of such spaces, I burst into tears and realized that my archives belonged there.

Why such an emotional outburst? One way I was able to survive in the face of so many decades of art-critical assault was by keeping the stories of these women in my mind. For example, there was Elizabeth Blackwell, the first woman to graduate from medical school and become a licensed physician. She was admitted more as a joke than anything else; during the two years she was at the Geneva Medical College in upstate New York, she was treated very badly. Members of the local community ostracized her, sometimes going so far as to spit at her when they passed her on the street. Nonetheless, she graduated with honors, whereupon the college immediately shut its doors to any other women, insisting that Blackwell's "unnatural example" was not one other women should follow. Her courage—like that of all the 1,038 women represented in *The Dinner Party*—inspired me. I would think, "If they could do it, so can I."

In 1997, my archives began to be collected by the Schlesinger Library, and we continue to send material to them every year. Today, mine is one of the largest archives they hold, and I am told that it is often used by scholars. In 2019, *T Magazine* did an article about artists' archives. In addition to citing mine, the writer included the story about the rejection of my archives by the Smithsonian's Archives of American Art. When MaryRoss was running Through the Flower and administering the *Birth Project*, she had written to

see if this organization might be interested in acquiring my extensive *Dinner Party* archives, which were still in Benicia. She even made an effort to visit them in D.C., but was told that the Archives would have "no interest." When the story was published, they protested its veracity, but MaryRoss wrote a detailed account of her treatment in the 1980s, and the Schlesinger Library produced a copy of the actual rejection letter, which put an end to their claim.

Sometime in 1996, Edward Lucie-Smith, the British art historian, came to visit. Although I knew his work (he has written over a hundred art books and is a published poet), we had never met. En route back to the airport, he shocked me by asking what I thought about the idea of his writing what would be my first major monograph. He went on to say that he had been accused of being a male chauvinist by a group of British feminist art historians, to which he'd responded by thinking to himself, "I'll write the first monograph on Judy Chicago," as he has a wicked sense of humor. It took four years before *Judy Chicago: An American Vision* came to pass. Ted (as he is known to his friends) became the first person to address my overall career, aided in this somewhat overwhelming task by his vast art-historical knowledge.

In the interim, he and I collaborated on a book, *Women and Art: Contested Territory*, in which we looked at a number of themes in women's art, comparing their treatment to that of male artists who were their contemporaries. Ted stayed in our guest suite many times during these years, and I watched him ingest huge quantities of feminist art history and theory, which he considered the only important new critical theory at that time. I also learned something from him about how women and artists of color can be their own worst enemies. He warned me that for earlier books, he had had a lot of trouble obtaining reproductions from some of these artists, but I scoffed, saying, "That's because you're a guy, Ted." Then I found myself in the same awkward position.

For our project, I invited artists I knew or whose work I admired to submit reproductions. One Feminist artist insisted that the only way she would give us an image of her work about female deities was if we'd also include a more recent work, even though it did not fit any of the book's themes. Similarly, I wanted to use a self-portrait by Lois Mailou Jones

(1905–1998), whose use of African American motifs paralleled a self-portrait by the Native American artist Helen Hardin (1943–1984), who—at about the same time but unbeknownst to one another—incorporated her own cultural tradition into her self-portrait.

Even though my plan involved full-page color reproductions on facing pages (which would have been beneficial to Hardin's career), the executor of her estate was altogether unrealistic about a reproduction fee, seeing me as somehow representative of the white oppressor when all I was trying to do was be more inclusive. As a result, she ended up not being represented in our book. This was a good example of how marginalized artists often just "don't get the deal." What I mean is that the hugely successful team of Gilbert & George *give* 8″ × 10″ color transparencies of their work for free to interested publishers. Clearly, as white male artists, they can afford to eschew reproduction fees, whereas if I—a white woman—were to do the same thing, it would only devalue my work, and the same would probably be true for artists of color. As a result of their privileged position, the work of Gilbert & George is prominently featured in numerous publications because the authors often have limited funds, so providing free reproductions gives those artists a decided advantage.

Another important lesson I learned as a result of working with Ted is that art historians usually depend heavily on art-reproduction archives, which are generally tilted toward male artists. Not only are women artists not equitably represented, but most of the available images of women reflect a male gaze, which results in too many art books featuring images of supine or passive women. Because most art writers depend on the same major picture archives, it requires conscious effort to reject what's easily obtained in order to present a more representative art-historical approach.

Once we were settled in the Belen Hotel, I decided that I wanted to learn how to use watercolors, a technique I had never tried. I enrolled in a class at UNM–Valencia, the same campus to which we had gifted one of our libraries, registering under the name of my then-assistant in an effort to avoid any undue attention because of my fame (which didn't work, as my teacher kept calling my assumed name while looking at me suspiciously). I found it useful to learn about the various tools and basic techniques, but

LOOKING AT LOS LUNAS HILL FROM THE WEST LATE IN THE AFTERNOON 1996
Watercolor on Arches paper, 22.5 × 30 in (57.15 × 76.2 cm)
Collection of Ellen Poss

after a few weeks the instructor announced that he was planning to do a session on color, which, given how much time I had spent in color study, wasn't of much value to me. I quit the class in favor of applying what I had learned about the basic techniques to a series on the nearby Los Lunas Hill, which presented multiple faces depending on where one stood. I really enjoyed this project, even more so when I showed the watercolors in Santa Fe, resulting in the only sold-out show I'd ever had.

Then I received an unexpected invitation to do a suite of prints at Graphicstudio on the campus of the University of South Florida, the best printshop I had worked at until Landfall Press, where—over a decade later—I would spend five years producing *A Retrospective in a Box*, seven prints surveying my career, which brought my print production to over one hundred creations. I accepted the offer from Graphicstudio on the condition that I would not have to go to Tampa during the summer, which, of

course, is what ended up happening. Over the next several years, I would travel there for intense two-week sessions during which my life involved walking between the hotel, the nearby gym, and the printshop, as it was too hot to do much else.

I chose to work on a series of prints incorporating a new translation of the Song of Songs by the poet Marcia Falk, which presented this intensely erotic text in a unique way—in both a male and female voice, hence the title of my prints: *Voices from the Song of Songs*. My interest in creating erotic images dated back to the 1960s, when I participated in a show of artists' designs for cookies. My contribution was of sex from two sides; turn the cookie one way and the woman was on top, while the reverse featured the man in that position. I had also done a number of erotic images during the 1970s and would later learn that there was a paucity of erotica by women, another absence that I sought to rectify. The *Song of Songs* prints would involve six diptychs, each with a visual image on one page and the corresponding text on another in English and its Hebrew equivalent. Working with master printer Tom Pruitt, I developed a fusion of lithography and helio-relief—a unique woodcut process—that allowed me to use different wood grains expressively.

Working with Graphicstudio on
VOICES FROM THE SONG OF SONGS,
University of South Florida, Tampa
ca. 1998

For some time, I had been wondering if there was a way to combine my talents for the visual and the verbal, and these prints were my first foray. A few years later, I would undertake a project entitled *Fragments from the Delta of Venus*, a series of watercolors, intaglio prints, and a book based on Anaïs Nin's erotic writing. When she and Henry Miller were young and living in Paris, they wrote erotica for one dollar a page. Years later, Anaïs's texts were published, and she worried that they might reflect a male-centered point of view, given that most erotic writing has been penned by men.

Although I had read most of her work, I had never read her erotica and found the stories somewhat silly. However, embedded within them—in my opinion—are some of the earliest female-centered erotic texts. I selected a number of these for my project and tried to fashion corresponding images. One of my favorites involved depicting the head of the penis as a strawberry. When I was working on the small prints, the owner of the shop confessed that the picture made him intensely uncomfortable, to which I replied that turnabout is fair play. After all, how many images are there in museums of the female body as various forms of fruit? Of course, his response is indicative of yet another absence, that is, multiple female views of sex and erotica.

Sometime during this period, I lectured at a women's music festival where I met Vicki Leon, a glass artisan from San Diego. She suggested translating some of my images into a glass technique that she had developed, which involved laminating, etching, and painting flat glass. Until that point, my only experience with glass was designing the two stained-glass pieces for the *Holocaust Project*. But when I was living in Los Angeles, two artists—Peter Voulkos and John Mason—had revolutionized ceramics by using it in a fine-arts context. I wondered if the same thing could be accomplished with glass, which the art world definitely associated with the decorative.

I decided to take Vicki up on her offer, which started me down a long path of working in glass. In addition to producing several series based on earlier works, Vicki and I collaborated on a four-part piece about female bodybuilding for *Picturing the Modern Amazon*, a show in 2000 at the New Museum in New York. In preparation, the museum had offered to send bodybuilders to work with the invited artists. As a result, Donald and I

NINE FRAGMENTS FROM THE DELTA OF VENUS with book, **FRAGMENTS FROM THE DELTA OF VENUS** 2004. Etching and aquatint on paper. Set of nine prints, each 10.25 × 7.5 in (26.04 × 19.05 cm)

spent several days with one of these women, from whom we learned about the dark side of the sport.

I vividly recalled seeing female bodybuilders on television at the end of the 1970s and being fascinated by their musculature, which seemed to challenge prevailing ideas about the female body. Thus, when I was invited to participate in the show, I was ecstatic. But what we discovered complicated my feelings. At first, these women were financially supported by the bodybuilding world, but when it seemed that they were demonstrating that the female body could—from the back—be almost indistinguishable from that of the male, that support dissolved.

Left to fend for themselves, a number of athletes turned to various forms of what might be described as perversions: "muscle worship," in which men pay to touch the women's muscles; "lift and carry," which involves women hoisting (usually) smaller men around; and finally, a kind of prostitution, which might mean allowing men to masturbate during one-on-one sessions. Representing these somewhat nefarious activities became

the focus of the piece Vicki and I created, which unfortunately was irreparably damaged some years later due to careless handling at an exhibition.

In the fall of 1997, I had a show at Hanart Gallery, Taipei. Established by the charismatic Johnson Chang, Hanart at that time had galleries in both Taiwan and Hong Kong, and this would be my second exhibition in Asia. Johnson visited us in preparation for the show, and then we heard nothing. Suddenly, the date was almost upon us and his staff jumped into action. The next thing we knew, Donald and I were in Taipei being wined and dined at various functions, both public and private. All the public events were mobbed with hundreds of people. At one point, we were at dinner with one of the women who worked at the gallery and I commented about being surprised by the large turnouts. I will never forget her reaction. She turned to me with an astonished expression and said: "Judy, you're famous," to which I replied something about not realizing I was so well-known outside the U.S. She looked at me as though I were mad, and commented, "You should get out more."

This dual reality continued to haunt me. But I didn't have time to think much about it then, because from Taiwan we went directly to visit my sister-in-law Reiko and her sons. That visit was difficult for me as it brought back memories of my brother and his premature death. When we got home, I began to think again about the fact that other people seemed to perceive me so differently from how I saw myself. The story told in my journal reveals my inner struggles:

Monday, August 17, 1998

From my mother, I got support for my artmaking and a model of courage in the face of adversity. But it was from my father that I got my sense of history, my values, and my drive to succeed. The problem was that [he] provided a contradictory role model because this positive lesson was contradicted by his slump into failure…When he died when I was 13, a hole in the center of my soul was created, a hole that I have built a life around but a hole nonetheless…The contradictory messages of my father's life…made it difficult for me to embrace my success…Maybe it's unfair to say that my father was a failure and more accurate to say that he was less than a success…As long as I saw myself in the same state…I remained one with my father.

Even though I was happy to finally have a home of my own, I continued to be tormented by the need to earn more money to pay the bills. As talented as Donald is, he has never been good at making money, so that responsibility has fallen primarily on my shoulders, which, despite my love for him, produced ongoing resentment on my part. Although I had sloughed off most social conditioning concerning gender roles, I found myself intensely uncomfortable in the position of wage earner, something I would struggle with for many years.

I began to look around for jobs at one or another university, thinking that I might be able to garner a series of short-term stints along with a decent salary. At the end of 1998, we had a visit from Peg Brand and her husband, Myles. Peg is a feminist philosopher who taught at Indiana University in Bloomington and had written about my art. Even though we had never met, I was familiar with her work. We had invited them to dinner, and Donald (who is the primary cook in the family) was convinced that our many-weeks-old sour cream would still be good if he froze it. Unfortunately, when my husband opened the package, it was a ghastly green inside, so he rushed off to a nearby market. Of course, in his absence, they arrived. While Myles was signing our guest book, I noticed that he put Indiana University as his home address.

"Oh," I asked innocently, "do you teach there too?" to which he replied wryly, "Sometimes, I'm the president," and, it turned out, not just of the Bloomington campus but of the entire IU system. Trying not to appear as embarrassed as I felt, I was greatly relieved when Donald reappeared, sour cream in hand. Despite my opening gaffe, we had a great evening. During dinner, I mentioned my interest in returning to teaching. Soon afterward, I received a formal offer to teach a one-semester class at IU-Bloomington. Over the subsequent months, Peg and I made plans for my residency.

I was particularly interested in addressing the gap between art school and art practice. Many students find this transition difficult, something I had discovered from numerous young artists who had visited us. One encounter stands out in my mind, a young man who, when we showed him our warehouse full of crated art, said, "Oh, I'm going to sell all my work." I responded, "When Andy Warhol died, he left thousands of unsold

works—and you think that you'll manage to sell everything?" This type of unrealistic notion about the art world is fostered by studio-art programs that promote the idea that every student is destined to become a "star," something very few achieve.

Out of the thousands of young people who are pumped out of graduate school programs, after five years most are not even making art, having discovered that art school doesn't prepare you for the reality of life as a professional artist. A recently released survey from *artnet News* demonstrates that three-quarters of artists in the U.S. made less than $10,000 a year from their art. And this doesn't factor in the student debt that most young people accrue. I thought I might be able to provide some guidance about how to traverse the myriad challenges students face after they leave school.

Consequently, I proposed a project class that would allow people to experience the different stages of art practice—from identifying personal subject matter and formulating images to mounting an exhibition. Because my residency was sponsored by the president, the students would have a designated studio and an exhibition space at the I. M. Pei–designed campus museum so that I would be able to lead my students "from theory to practice," as the class was described. Some months before the semester began, I paid a visit to the campus. Peg held a gala dinner at the president's stately house. Although she joked about her position—calling herself the "first spouse" or "spouse girl"—I realized the awkward situation she was in due to the conflicting demands of her own career and Myles's prominent position.

As the evening unfolded, it became obvious that there were many more women of power and influence on campus than when I was a student. Everyone made me feel very welcome. But that feeling ended the next morning when Peg and I had a meeting with the chair of the Art Department, who happened to be a photographer. Almost as soon as we arrived, he started yelling at me, insisting there was gender equity in his department, which contradicted what some of the female faculty had told me. I tried to tell the guy that I would be happy to discover that discrimination against women was something of the past. But nothing I could say interfered with the overt hostility he displayed toward me and my residency. As a result of this encounter, I decided that I would keep to myself while I was there and

concentrate on my class along with my studio work, a practice I maintained in the ensuing years.

Peg had arranged a great house for me on the edge of the campus. In late August 1999, Donald and I drove across the country with our six cats in tow (though they were clearly distressed in the car). I had decided to move forward with my idea of combining my visual and verbal skills and planned to start work on a project that would occupy me for five years: *Kitty City*, a series of watercolors to be collected in a book based on a medieval book of hours. Instead of being devoted to God, however, my project was focused on an exploration of a day in the life of our household, which involves a considerable amount of interaction with our kitties.

Although Donald was not thrilled that I would be gone, especially because the cats would be with me, he helped me get settled and quickly set up a studio in the basement space where I would spend many hours studying and photographing our feline family. Cats are extremely difficult to draw except when they are sleeping, which required me to get up at all hours of the night to see what they were doing and to photograph them. I then composed detailed drawings of their habits over the course of twenty-four hours, using these as the basis for the watercolors. Interspersed between the images were a series of facts about cats that I had garnered from my research.

An underlying theme of this project was interspecies relationships, which are more complex and important than is widely recognized. Many people (including me) feel intense love for their companion animals, along with deep grief when they die. My work on *Kitty City: A Feline Book of Hours* made me even more sympathetic to the harm that human beings can do to other creatures. When the art was exhibited in conjunction with the publication of the accompanying book, I organized cat adoptions around the country. But I am getting ahead of my story.

Although my initial reason for returning to the academy involved money, I am not capable of being motivated purely by financial gain; I had to feel I was making a contribution. One thing that really interested me was whether the pedagogical methods I had developed early in my career were still relevant and if they could be applied to male as well as female

students and students of color. But I would not have a chance to find out at IU because the only people to register for my class were white women. This changed the following year, when I taught a class at Duke and a graduate seminar at UNC–Chapel Hill, where both groups included men. I was pleased to discover that the male students responded as well to my approach to teaching as the women; in fact, in some cases maybe better, because for many of them my content-based approach to artmaking was entirely new.

Between 1999 and 2005, I did six residencies, the first three by myself, and the others with Donald. His presence was valuable for the male students, as they were exposed to a feminist man—again, a new experience for some. In all my (and our) classes, we followed a trajectory that involved self-presentations, content search, artmaking, and, in most instances, an exhibition. The IU show, *SINsation* (whose title referenced the controversial 1999 *Sensation* exhibition held at the Brooklyn Museum), was a huge success, as was the exhibit at Duke, where I taught in 2000. In that class, my students addressed three of the subjects I had taken up: women's history, birth, and the Holocaust. The Duke administration kept the show open past its original dates because they felt it exemplified the type of interdisciplinary approach the school promoted.

Three years after my residency, I was given an honorary doctorate by Nan Keohane, who was then the president of Duke. She told me she had stood in line in San Francisco to see *The Dinner Party*. This award was a singular honor in that it is rare for the university to give it to anyone who hasn't either attended the school or taught there for many years. On the day before the graduation ceremonies, Rick Powell, a well-known scholar of African American art, and his wife, C. T. Woods-Powell, held a wonderful garden party in my honor. Aside from the art historian Kristine Stiles, they were the only people with whom I socialized during my time in North Carolina, where I also conducted a graduate seminar at UNC–Chapel Hill.

In 2001, thirty years after *Womanhouse*, Donald and I did another semester-long project at Western Kentucky University in Bowling Green. *At Home in Kentucky* revisited attitudes toward domesticity and involved both male and female students. Again, most of the Art Department was hostile to our presence, but it didn't matter as we kept our distance. The

university gave us a house in which to create a series of installations, the most provocative of which were by the men, probably because—like *Womanhouse*—their work involved entirely new subject matter. For example, in the *Rape Garage*, one student raised the subject of male rape by women, which had rarely been addressed. Also courageous was the work of one guy who took over the entire basement to deal with the scarcely mentioned (at that time) subject of slavery and racism in Kentucky.

Unfortunately, what happened afterward was reminiscent of *Womanhouse* at CalArts: the university closed the show early and tried to erase any memory of its existence. However, it was documented by the one friendly art faculty member, John Oakes, who participated in the class and memorialized the house in a scale model; it is also included in Vivien Green Fryd's 2019 book, *Against Our Will: Sexual Trauma in American Art Since 1970*. Her study of the project demonstrated the effect art can have when it deals with subjects university administrations often want to sweep under the carpet. Over the years of our teaching, the only real problems we would encounter (other than unwelcoming faculty) were with university administrators who could be obdurate, stubborn, and resistant.

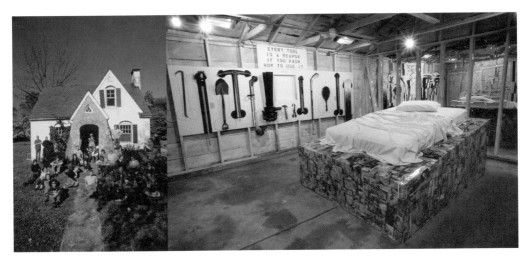

Installation of **RAPE GARAGE** from **AT HOME: A KENTUCKY PROJECT** with Judy Chicago and Donald Woodman 2001 by Stefanie Bruser, Josh Edwards, Katie Grone, and Linsey Lee, and the house where the work was installed.

But that was not always the case. Peg and Myles Brand, Rick Powell, Kristine Stiles, and John Oakes all stand out in my memory because of their singular generosity, as does an artist named Cheryl Bookout, the project manager in Pomona, where, in 2003, we became involved in a public/private partnership between Cal Poly Pomona and the Pomona Arts Colony, a collection of galleries, nonprofit arts organizations, and artists in and around downtown Pomona, which lies about forty miles east of Los Angeles in an area dubbed the "Inland Empire." That undertaking, "Envisioning the Future," would include many more participants than I had ever dealt with before in an educational context. Donald and I should probably have spent more time thinking about what we were getting ourselves into, but, as is our wont, we ran headlong into a project involving almost one hundred people.

We ended up working with eight groups, each of which was composed of eight to ten people along with a facilitator, plus a performance group that functioned somewhat independently. This was the first time either of us had the opportunity to work with a truly diverse group in terms of race, class, gender, and ethnicity; it was great. What had become a joint pedagogical approach worked wonderfully with most of the participants. Of course, there were some problems, but overall the project—like my earlier teaching endeavors—was a huge success. The *Envisioning the Future* exhibition grew out of the community's stated desire to find alternatives to the gentrification that was happening there.

In early 2004, we made a trip to Vanderbilt University in Nashville, Tennessee, which was hosting a traveling exhibition about the *At Home* project that had been put together by John Oakes. I had been asked to present a lecture after the opening, and we had been invited to stay at the chancellor's residence, where we met the (then) chancellor, Gordon Gee, and his (then) wife, Constance. The next morning, I went to their exercise room to work out, where I was joined by Constance. After a few moments she said, "You and Donald should do a project at Vanderbilt."

Donald and I are frequently asked how we managed to be invited to campuses around the country. Such offers sometimes stem from the most unexpected situations, like working out next to a university chancellor's wife. Certainly, without her support, the project would never have happened.

Gordon was particularly interested in the Pomona project because he liked that we had involved artists outside the university community, as one of his goals was to build better relations between Vanderbilt and the surrounding town.

With that mandate in mind, in the fall of 2005 we set about putting together an ambitious plan. The Studio Art Department was moving into a brand-new building, leaving vacant their former quarters, a wonderful 13,000-square-foot neoclassical structure on the Peabody College campus (originally the site of a women's school that had been absorbed into the university). That space would provide studio quarters for the participants (except for those local artists who preferred to work in their own studios) as well as exhibition space for a show that the group titled *EVOKE/INVOKE/PROVOKE*. This was to be our last teaching project, and, to my mind, it was the best on every level. Not only was the classroom process superior (facilitated by the support of the administration), but the art faculty was extremely warm to us, especially an artist named Marilyn Murphy, who welcomed us to campus with flowers in hand.

Again, the exhibition was wildly successful, with a range of work that reflected the diversity of the group, which made me very happy as it showed the potential of my art pedagogy, one that encourages students to openly express who they are and what they care about, a far cry from my experience in college. The entire Vanderbilt experience was fantastic, made even better by the fact that this time we actually had some social life with Constance and Gordon as well as Marilyn and her husband, Wayne Brown. For more information on our teaching experiences and my thoughts about university art programs, I refer my readers to my 2014 book, *Institutional Time: A Critique of Studio Art Education*.

While we still were at Vanderbilt, I received a copy of an article to be published in a K–12 art-education journal that was presumably a tribute to me and *The Dinner Party*. Although I understood that the teacher had good intentions, her project unnerved me. She had encouraged her students to create autobiographical plates, which was a fine assignment but had nothing to do with my goals for *The Dinner Party*, which is intended to teach women's history through art and to build awareness of the many

women worthy of study and honor. In fact, one might say that the teacher's project was antithetical to mine in that *The Dinner Party* is intended to help girls—who are sometimes prone to being overly self-preoccupied as a result of social conditioning combined with gender expectations—to move *beyond* the personal.

Over the years, there have been dozens of school "Dinner Parties," some charming, others egregious because they copied the form but not the meaning of my piece. Like many university-trained artists, I had always looked down on art-education departments, but my conversations with Constance, who holds a doctorate in art education, changed my perspective. With her as my guide, and partly as a response to some of the poor emulations of my work that have appeared over the decades, I spent the next few years working with a group of curriculum writers headed by the redoubtable Marilyn Stewart to produce an online curriculum that aims to introduce generations of young people to *The Dinner Party* and the (still unknown) heritage that it represents.

Before I returned to teaching in the fall of 1999, something happened that would create a big change in our lives. It all started shortly before my sixtieth birthday, which we celebrated in New Zealand, where I did a lecture tour.

Saturday, July 5, 1999

We had dinner with Liz [Sackler]…She was sort of strange and then out of the blue…she said there was something she wanted to talk about. After stammering and stuttering for a few minutes…she said that she wanted to buy *The Dinner Party* with the intention of making it the cornerstone of the Sackler Museum of Feminist Art…Needless to say, I was completely blown away. The rest of the evening was spent discussing this, with me alternating between shock, joy, gratitude, and not knowing what to say.

I imagine my readers are wondering why I continued with my plan to teach, given that the sale of *The Dinner Party* would provide something Donald and I never had: some degree of financial stability. But, at the time, this didn't occur to me. It would be several nerve-racking years before the

sale actually went through. And I hadn't returned to teaching solely for the financial support it provided. Nonetheless, the possibility of the sale hovered over the ensuing period, during which my life seemed to be taking a turn toward the better.

In early 1999, *Trials and Tributes*, a traveling works-on-paper retrospective, opened at the FSU Museum of Fine Arts in Tallahassee, organized by Viki Thompson Wylder, whose scholarship has focused on *The Dinner Party* and the *Birth Project*. In fact, her show was on display at the Indiana University museum during my tenure there, thanks to Peg and Myles. For many years, Viki had used her annual vacation to come to Belen with her husband, Tom, in order to help catalog the work in my flat files. Perhaps seeing all those drawings was the impetus for her show. Then, in 2000, Ted's monograph, *Judy Chicago: An American Vision*, was published, and *Resolutions: A Stitch in Time* opened at the American Craft Museum.

Although *Resolutions* traveled to eight venues and had a significant impact, like the *Holocaust Project* it never emerged from behind the dark cloud that greeted its premiere in New York. Ken Johnson wrote a brutal review in *The New York Times* that opened with the phrase "Judy Chicago's *Resolutions: A Stitch in Time*, an installation at the American Craft Museum, is an excellent candidate for worst New York museum show of the year." He continued in this same vein: "The 19 easel-size compositions look like posters produced by a group of unimaginative but eager-to-please high school students for a small-town community center…And then there is the feminism…Some people may still like this 1970s-style feminism, while others will find it old-fashioned and naive…But her messianic ambitions have taken her far beyond the limits of her real artistic competence."

Despite my earlier claim that I had learned to disregard reviews, I quote this one to emphasize how vitriolic the art writing was. Even now, it is painful to read. Moreover, *The New York Times* still sets the tone in the art world. I mentioned that one of the ways I managed to keep working in the face of such hostile reviews involved drawing upon my knowledge of women's history, specifically the fortitude of so many of my foremothers that sustained me. At the same time, our continued lack of financial security was an unfortunate consequence of the negative art-world stance toward

my work. The absence of tangible rewards—sales, influential art writing, and other opportunities—limited my career options for a very long time. As a result, I retreated ever further into my studio and made working my primary reward.

As long as I could create art, I was able to sustain myself emotionally, which helps explain why having to make money was such a conflict for me. Although I was able to get teaching jobs and lectures, they required time away from artmaking, which was torture. This also clarifies my lack of understanding about my fame; it meant nothing if it didn't make it easier for me to make art. Though the years from 1999 to 2005 were taxing, I did what I always do: just kept working. This was an intensely busy period, between my studio work, teaching, and traveling to lectures and exhibitions, which continued despite the horrible reviews.

Among the exhibitions was a big survey show in 2001 at the New Orleans Museum of Art, courtesy of the director, John Bullard, an old friend who expanded Viki Wylder's exhibition. That same year, thanks to Nancy Berman, who was the director of the Skirball Cultural Center Museum in Los Angeles, there was an exhibition of *Resolutions* at the Skirball, a near-perfect institutional setting in that the museum's mission was *tikkun olam*, the Jewish mandate to heal and repair the world, which was the underlying vision of the show. (Not surprisingly, the *Los Angeles Times* published another nasty review.) I also had several European shows because of Edward Lucie-Smith, who remained a staunch supporter. But even though people repeatedly said that seeing my work moved them to tears or changed their lives, that didn't translate into sales or financial support, even as the negotiations for the sale of *The Dinner Party* dragged on.

In 2002, Elizabeth Sackler sponsored a survey show and catalog at the National Museum of Women in the Arts which, again, yielded a wildly successful visitor response. Liz told me that one reason she did this was to demonstrate to the Brooklyn Museum that there was a broad audience for my work. Apparently, she had been working on a plan with Arnold Lehman, the director of the Brooklyn Museum, for a wing devoted to Feminist Art with *The Dinner Party* as its centerpiece. Supposedly, Elizabeth (who by this time was on the museum's board) walked into Arnold's office carrying a

copy of one of the *Dinner Party* books and asked, "Arnold, how would you like to have this?" to which he responded, "I'd love it. Thanks. Someone stole my copy." "No, Arnold," Liz said, "not the book, the piece." If this is true, it demonstrates that the preservation of art often comes down to individuals like Elizabeth who, with the cooperation of a museum director like Arnold, can single-handedly shape art history.

Tuesday, April 22, 2002

IT'S HAPPENED! Last Wednesday, at 7:30 a.m. [our lawyer] met us at the airport (en route to New York) to sign the agreement between Liz and me…On Friday, Donald and I went out to the Brooklyn Museum so that we could see the rotunda where "The Dinner Party" will be shown this Fall and the 4th floor where it will eventually be permanently housed (thrilling)…Friday night, Elizabeth had a celebration dinner where everyone prepared toasts.

As part of my tribute, I brought Liz a drawing for the *Christine de Pisan* illuminated capital letter that was stitched on the front of the runner for her *Dinner Party* place setting. The image depicts the author on bended knee

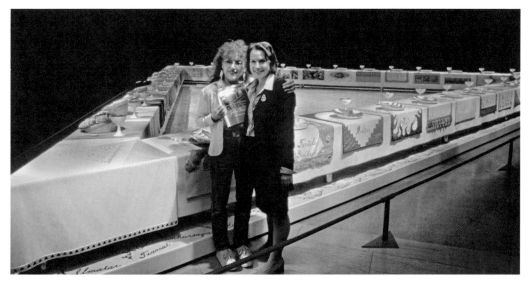

With Elizabeth Sackler at **THE DINNER PARTY** permanent installation at the Brooklyn Museum, NY 2002

presenting one of her books to her patron. I mimicked the gesture when I gave Elizabeth my thank-you gift, though it seemed a modest acknowledgment of what she had done, not only for me and for *The Dinner Party* but for future generations of women who would be able to learn about their rich heritage. In the fall of that year, there was a temporary exhibition that was intended to give the museum a chance to begin planning the permanent housing, which would take five years.

Perhaps my reader is thinking, "*At last*, financial security," but this did not turn out to be the case. Donald and I barely had any savings, nor did we have any experience with financial planning. After various false starts, we were able to find dependable money management, but with a much-diminished portfolio, one that provides a bare minimum of security. Consequently, we have had to continue to figure out ways to make money, especially after we turned our attention to the problem of preserving our bodies of work. Donald started exploring how best to accomplish this overwhelming, expensive, and time-consuming task, which involved estate planning. Again, I had no real understanding of what is involved in protecting an artist's legacy, something that has gone amiss more often than it's been properly done.

Obviously, given my history with the New York critics in particular, I was extremely nervous when the temporary exhibition of *The Dinner Party* opened in 2002. It was with joy that I read Roberta Smith's review in *The New York Times*:

> Is "The Dinner Party" good art or bad art? So far, it's more than good enough, and getting better all the time…So how does Ms. Chicago's "Dinner Party" look now? Moving, illuminating, irritating, flawed, powerful. It is, as the artist intended, a highly informative, entertaining teaching device, designed to raise consciousness in a single bound by providing an unforgettable glimpse of the tremendous contribution of women through history. No one is knowledgeable enough not to learn from it, and most viewers will enjoy the process.

And thanks to the power of the New York press, my profile began to change. The day after the review came out (which included information about the plan for permanent housing), I called Henry Hopkins. "Henry,"

I asked, "am I a different person? Is *The Dinner Party* a different piece?" You'd think so from the reactions to the *New York Times* review, which seemed to validate Roberta Smith's contention that it was "getting better all the time." In 2002, the respected art historian Gail Levin announced that she wanted to write my biography, to be published in conjunction with the permanent housing of my best-known artwork. This started the lengthy process of establishing a larger view of my career. For *Becoming Judy Chicago*, Gail did almost 250 interviews with people who knew me. Occasionally, she would call and report on a story someone told her or something she found in my archive at the Schlesinger Library. In most instances, I had absolutely no recollection of what she recounted, but I could tell her what art I was working on. Ever since I was a child studying at the Chicago Art Institute, my art life has been more "real" to me than my real life, and that continues to be true.

In 2003, I became an artist-in-residence at Pilchuck, the glass school outside of Seattle founded by Dale Chihuly. By then, I had begun working with the glass etchers in Santa Fe, Ruth and Norm Dobbins (who died unexpectedly in the middle of our collaboration). We did two exhibitions together at LewAllen Galleries in Santa Fe, the first of which focused on hands. I had become interested in the way a simple hand gesture could have multiple meanings. For instance, an outstretched hand could be an offering while that same gesture with the hand upright could mean stop. I explored this multiplicity of associations in etched, cast, and painted glass, having worked with Ruth for a year and a half to figure out how to fire glass paint onto castings.

My first series of hands was cast in Prague, which required multiple overseas trips. Given our ongoing financial challenges, perhaps the reader is wondering how I funded my glass work, considering that it required creating a glass-painting studio, buying kilns, and paying for casting and travel. Again, I was fortunate in that the Dobbinses were willing to work for nothing in exchange for sharing in the profits from sales. Luckily our two shows did pretty well. But one reason for Donald's and my ongoing financial worries was that—as always—any money I made went back into my work. Donald is the same way; in this, we are a perfect pair.

Installation of **HEADS UP**, David Richard Gallery, Santa Fe, NM 2014

After the hand series, I turned my attention to the head and its capacity for extremely expressive and revealing facial expressions. I started by doing life casts, working with the incredible artist-artisan Bill Weaver, who is especially skilled in bronze. I cast seven different heads, then became completely wrapped up in one of them for a series titled *Toby Heads*, in which I added bronze and porcelain to my repertoire of techniques, something I continued to do in the third cycle, called *Heads Up*, which included paintings on clear glass as well as a variety of sculptures. By then, I was casting in Taiwan because even though Prague is a glass center, their casting techniques leave something to be desired in terms of fine detail, which was essential in this series of heads.

Finally, in my most recent project, *The End: A Meditation on Death and Extinction*, which occupied me from 2012 until its premiere at NMWA in 2019, I again incorporated all three media. I was first motivated to start this body of work by a potentially serious health scare. As always, I began with research, in this case into the ways in which death has been dealt with by earlier societies, discovering that not all have practiced the denial and silence about the death experience that is common in ours. Elisabeth Kübler-Ross's book *On Death and Dying* provided the impetus for the initial section of the exhibit, which comprises a series of china-painted porcelain plaques depicting the five stages of dying that she identified.

The second part of the exhibition, *Mortality*, includes a bronze relief that introduces fifteen small paintings on black glass. They start with philosophical musings and then move into a series of personal questions about how I might die. As always, I selected the material that would best convey the subject matter. I chose glass because it is both fragile and strong, an appropriate metaphor for the human condition, which I have long sought to convey through the female experience. Black seemed the proper background color for content that is so dark.

The last component of the exhibition is *Extinction*, which includes another, larger, bronze relief along with fifteen paintings that are again on black glass, but of a bigger size. This change is meant to convey my belief that our personal deaths (as frightening as they might seem) pale in comparison to the horror we are inflicting on other creatures—and even

MORTALITY relief from
**THE END: A MEDITATION ON
DEATH AND EXTINCTION** 2018
Patinated bronze
36 × 20 × 7.5 in
(91.44 × 50.8 × 19.05 cm)

Working with Bill Weaver on the **EXTINCTION** relief from **THE END: A MEDITATION ON DEATH AND EXTINCTION** Santa Fe, NM 2017

worse, the scale. For instance, one image deals with the finning of sharks, which is done while they are alive. As a result, they sink to the bottom of the ocean, where they can neither swim nor hunt, and they suffocate to death. An even more harrowing aspect of this carnage is that it is done to over one million sharks a year. The grief I felt while creating this work is still with me, in part because I have no idea if the human race can alter our behavior before we destroy the ecosystem.

Surprisingly, this series met with considerable approbation. Still, much of the glass work that preceded it is little known, in part because it turned out that there is strong resistance in the art world. As one New York dealer put it, "I don't do glass." This has been quite disappointing to me. In the same way that I brought china painting and needlework into a fine-arts context, I had hoped to do the same with glass. How ironic, then, that *The Dinner Party* is permanently housed in a specially built, glass-clad triangular room at the Brooklyn Museum.

The same year *The Dinner Party* debuted in its permanent home (2007), there were a whole range of Feminist Art exhibitions, notably *WACK! Art and the Feminist Revolution*, curated by Connie Butler (the first major show about the Feminist Art movement); *Global Feminisms*, curated by Linda Nochlin and Maura Reilly; and *Judy Chicago: Jewish Identity* at Hebrew Union College

(HUC), New York, curated by Gail Levin and Laura Kruger, who, with her husband, Lewis, has been a friend and supporter for decades. Despite my disclaimer about reviews, I vividly remember being in the elevator the night of the HUC opening with the *New York Times* book review of *Becoming Judy Chicago* in my hands, avidly reading the text with Laura and Gail. When the elevator opened, we all cheered because the review was definitely positive.

Speaking of Jewish identity, throughout the years, Donald and I continued to acknowledge our Jewish roots through a now thirty-year seder practice at the Santa Fe home of photographers and gallerists David Scheinbaum and Janet Russek, who have become dear friends. We started out by piecing together an egalitarian Haggadah from existing sources, then created our own—which I illustrated—based on our form of observance as it evolved. The Exodus story represents what Judaism means to us: that we were once slaves in Egypt and became free. Therefore, it is our mandate to work for the freedom of all creatures on the planet, both human and nonhuman. At one point, I tried to get our Haggadah published, only to discover that the recent acceptance of *The Dinner Party* had not translated into interest in my other work. However, that did not stop me from creating other Judaica in needlework, porcelain, and glass.

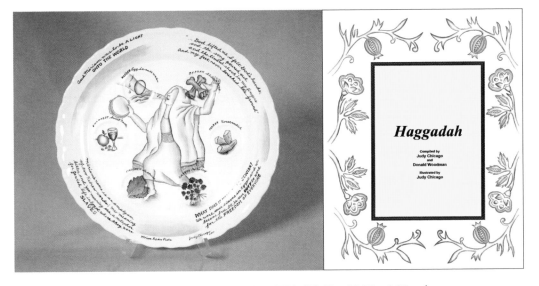

MIRIAM GLASS 2012. Glass paint on glass, 12 × 9 × .375 in (30.48 × 22.86 × 0.95 cm)

Still, having *The Dinner Party* permanently installed in New York definitely contributed to a gradual change in perception of me and my work, as did the publication of Gail's book. By 2010, there began to be a lot of interest in Southern California art of the 1960s and '70s, in part because of the New York gallerist Tim Nye, who worked out of Nyehaus, run by Allison Raddock (with whom I continued to work even after Tim's galleries closed). At that time, I was really irked by the fact that it seemed I was being written out of West Coast art history of the 1960s and '70s even though I had been living and working in Los Angeles then. As macho as the art scene was, still, I was the only female artist taken seriously, and more important, I spent my formative years there, which definitely impacted my work.

In 2011–12, the Getty undertook a major initiative titled Pacific Standard Time, an unprecedented collaboration of more than sixty cultural institutions coming together to document and celebrate Southern California art from 1945 to 1980. In a curious case of "what goes around comes around," by the time of this undertaking, it was unthinkable for curators to mount exhibitions without women artists. As a result, I was in eight museum shows, plus Tim and I had connected by then and he had opened Nye + Brown in L.A., where I had a big show of my early work. After a long absence, I had gone back to showing at ACA, but my association with Tim and Nyehaus (his New York gallery) created a professional conflict so I left again.

Pacific Standard Time was organized by three curators, Andrew Perchuk (with whom we became close friends), Rani Singh, and Glenn Phillips. Glenn organized a performance festival in 2012 and invited me to do two pieces, one in dry ice and the other in fireworks. I had done several collaborative dry-ice installations at Century City during its construction phase in the late 1960s but had not continued working in that mode. I hadn't done a fireworks piece since *A Butterfly for Oakland* in 1974. A number of other invited artists of my generation were planning to reprise earlier pieces, but I didn't want to do that; instead, I was determined to pick up where I had left off with ephemeral performance pieces in order to develop some of my earlier ideas. The dry-ice piece was to be at the Barker Hangar at the Santa Monica Airport, and I would be working with an alternative

With Los Angeles artists, Getty curators, and staff of the Martin-Gropius-Bau, Berlin, at the opening of *Pacific Standard Time: Art in L.A., 1945–1980* 2012

architectural firm called Materials & Applications, run by a lovely woman named Jenna Didier.

The Pomona College Museum of Art was planning an exhibition about the history of its art gallery, which—despite the fact that its female director had shown no women in the 1970s—had done many radical shows. They had also sponsored one of my *Atmospheres* in Mount Baldy, the highest peak in the San Gabriel Mountains east of Los Angeles, something that would be impossible today because of all the governmental regulations. The museum was planning to include some fireworks photos in the show, and Rebecca McGrew, the senior curator, had found a copy of a lecture I had delivered there. When I read it, I was mortified. Young firebrand that I was, I had started out by saying: "You know, I am going to talk about *cunt*." Having been invited to present another talk, I decided to play the part of my younger self in dialogue with my more mature person, changing chairs to signify the repeated alteration in my age as I reviewed the contents of my original talk.

The other momentous occurrence of that time happened as a result of looking for a pyrotechnics company that could assist me in staging *A Butterfly for Pomona*, which was to be presented in early 2012 on the campus football field, a seemingly perfect setting for my decidedly feminine fireworks piece. One day, Donald and I drove out to Rialto, California, to visit Pyro Spectaculars, a sixth-generation fireworks company. As I often say, that was the luckiest day of my life. We met Chris Souza, a member of

the family, to whom I told the story of why I had stopped working in fire-works and about my aborted effort to become a pyrotechnician. In one of the sweetest gestures I have ever encountered, Chris brought an-all female crew to stage the Pomona piece, headed by his mother, who was the first woman to become a licensed pyrotechnician in California.

The only problem was that colored smokes were no longer available. This meant that I had to learn a whole new vocabulary involving aerial fireworks, which are more complex and more expensive than smokes. Since we began working together, Chris and I have presented numerous works; fortunately, smokes began to be produced again and we have been able to slowly expand the ideas I began exploring in the late 1960s. True to form, Donald has gotten involved, bringing his architectural and technical skills to bear; as a result, the three of us have become a great team.

Pacific Standard Time suddenly catapulted my early work into promi-nence, which led to *Chicago in L.A.*, an exhibition at the Brooklyn Museum in 2014, curated by Catherine Morris as part of the 2014 "national ret-rospective" celebrating my seventy-fifth birthday. The highlight of that year was the monumental *A Butterfly for Brooklyn* held in Prospect Park, sponsored by the museum and supported by our friends Barbara and Eric Dobkin. My longtime dream of creating a huge fireworks piece came true as twenty-three pyrotechnicians under the direction of Chris Souza ignited a giant butterfly form that was viewed by over 12,000 people. Afterward, the entire audience sang "Happy Birthday" to me, which reduced me to tears.

That same year, a corresponding show covering my years in New Mexico was held at the New Mexico Museum of Art in Santa Fe, curated by Merry Scully. Additionally, there were shows around the country, including *Inside the "Dinner Party" Studio* at NMWA, an archive exhibition at the Schlesinger Library's small gallery, and two shows at Penn State University, which by then had become the recipient of my art-education archives, thanks to an art-education professor, Karen Keifer-Boyd, who had become interested in my pedagogy some years earlier.

After Through the Flower launched the K–12 *Dinner Party* curricu-lum, the organization became overwhelmed with requests to send people to train art educators in the program, something the small staff couldn't

A BUTTERFLY FOR BROOKLYN 2014
Performed at Prospect Park, Long Meadow, Brooklyn, NY and in collaboration
with Pyro Spectaculars, Rialto, CA. Fireworks, LEDs, and flares

accommodate. Karen suggested that Penn State take it over as part of my
archive there, promising to keep it free, online, and downloadable. In con-
junction with this, Through the Flower established an art-education award
to be presented annually to an art educator who uses any of my archives
and/or the curriculum in an innovative way. At first, the award was funded
in honor of Minx Auerbach, a dynamic woman from Louisville who—until
she died—was on the board of TTF. More recently, it has been renamed the
Judy Chicago Art Education Award and generously funded by MaryRoss.

The attention to my formative work that began with Pacific Standard
Time culminated in 2019 in a significant exhibition at Jeffrey Deitch's new
12,000-square-foot Los Angeles gallery, designed by Frank Gehry. This
show marked a "coming home" in that Frank was my first landlord; his

sister was (briefly) married to Rolf Nelson, my first gallerist; and some of the early sculptures that I had been forced to destroy because of a complete lack of interest were reconstructed for the show. The opening was mobbed; according to Jeffrey, it was the largest art opening in L.A. history.

By then my situation had changed dramatically, in part because of my association with Jeanne Greenberg Rohatyn, founder of the prestigious Salon 94 gallery in New York, with whom I had begun showing. In 2016, Jeanne had come to hear me speak at Crystal Bridges Museum in Bentonville, Arkansas, and was astounded by the audience of 750 people, many of whom had driven all day to attend my lecture. As I said at the time, my art life had finally met my public life. Apparently, Jeanne went back to New York and told everyone that I was a "rock star." Soon my work was also picked up by the young, energetic Jessica Silverman, who runs an important gallery in San Francisco. Together, these two powerful women have managed to highlight many unknown aspects of my career (for example, a much-commented-upon exhibition of *PowerPlay* in 2018 at Jeanne's gallery). Suddenly, my work began to be written about as "prescient," and numerous accolades started tumbling down on me.

Even before then, the tide seemed to start turning, notably with exhibitions in London, my first inclusion in several important art fairs, and then, in 2017, the *Roots of "The Dinner Party"* show, curated by Carmen Hermo at the Brooklyn Museum. This was the first time my creative process had been examined, and, thanks to Jeanne, a significant catalog documented this exhibit, which remains an important source for information about how *The Dinner Party* was actually made. A few years earlier, historian Jane Gerhard had made another important contribution to the history of the piece in her book *"The Dinner Party" and the Power of Popular Feminism*, which documented the unprecedented worldwide grassroots movement that toured the piece around the world.

In 2018, a three-decade survey show opened at ICA Miami, which was greeted by near-constant comments that it was a "revelation." This exhibition was held in conjunction with Art Basel, one of the most important art fairs in the world. Our time there was a whirlwind of activities: multiple interviews, public conversations, and dinners along with a stream of kudos

and a show at the Nina Johnson gallery of my fireworks (which had begun to attract considerable attention and led to the acquisition of my fireworks archive by the Nevada Museum of Art in 2020).

It seemed as though our fortunes had changed for good. By then, Jerah Cordova, the mayor of Belen, and Ronnie Torres, one of the city councillors (and our longtime hairdresser), had asked Donald and me if we would consider reopening the small building Through the Flower owned as an art space, which could anchor the city's efforts to develop an arts district in the historic area where we live. Many years earlier, Donald had taken over the role of executive director of TTF, which I had not been happy about because it meant that work consumed all our waking hours (its offices were then in our building). During his tenure, though, he stabilized the organization and helped raise a modest endowment to buy and renovate a space where, for a while, we offered exhibitions and public programs. Then my career began to take off. Without sufficient funds to hire adequate staff, even more work fell on us, and we had to close it down.

But then our situation improved. Even though the city's original plan to partner with us in the Through the Flower Art Space didn't come to fruition because of a misinformation campaign by a small, outspoken group of religious conservatives, a full-page article in *The New York Times* about what I referred to as the "Belen brouhaha" ended up putting our small town "on the map." Over the weekend of July 20 (my eightieth birthday), we held a spectacular birthday bash that inaugurated the Art Space with various activities. Friends and colleagues from various parts of my life flew in to join dozens of members of our local community who had come forward to raise money for the space. We did a special fireworks piece, *A Birthday Bouquet for Belen*, and Chris Souza and his mother were there to help us ignite a spectrum of color on our street, which seemed to epitomize the marvelous things that were happening.

Although Donald and I originally thought that the Art Space would hold exhibitions of area artists, the local committee was adamant that there should be a small permanent gallery devoted to Donald's and my (over) twenty-year history in the town along with plenty of my work to attract tourists, which was a boon to Belen as it had never really recovered from

A BIRTHDAY BOUQUET FOR BELEN 2019. Fireworks and colored smoke. Belen, NM

the 2008 recession. For the first eight months, everything went well—far beyond our expectations, in fact. We had visitors from all over the world. The Through the Flower shop, part of the Art Space, was humming along, with plenty of traffic both on-site and online thanks to a wonderful collection of "Judy Chicago" products that had been developed by a company called Prospect, owned by the charming Laura Currie. Across the street from the Art Space is the Jaramillo Vineyards and Wine Tasting Room, started by a local vintner couple who developed two award-winning "Judy Chicago" wines for which I designed the label. (Part of the profits go to Through The Flower.) As much as Donald and I wanted to support the economic recovery of Belen (which was the reason the city had approached us), we were also worried that it would end our privacy. But that hasn't happened because, happily, the locals protect us from unwanted intrusions.

In the fall of 2019, the Judy Chicago Portal was launched, the result of a unique collaboration between the Schlesinger Library, Penn State University, and NMWA, which will be joined by the Nevada Museum

of Art as soon as they get my fireworks archive digitized. The purpose of the Portal is to make all my archives available to students and scholars worldwide. As part of the Art Space, we set up a resource center with an extensive art library, a film library, and computer terminals that provide access to the Portal along with various other art websites. Our hope was that it could provide a window into the larger world for young people who often never leave the Belen area or avail themselves of the cultural riches that are accessible via the internet.

In October 2019, I was honored by L.A.'s Hammer Museum at their annual gala, where I was introduced by Gloria Steinem. Because I have a long history with both UCLA and the museum, I was delighted by the recognition, and, of course, Gloria's remarks. The event also gave me a platform to publicly acknowledge those who, over the decades, have ignored the critics and promoted me and my work, which must have taken considerable tenacity. As I repeated many times that evening as I listed their names, "My honor is their honor," because no artist can succeed without some level of support. The three daughters of the Grinsteins bought a table, and we all cried thinking about how vindicated their parents would have felt.

With Elyse and Stanley Grinstein, Brentwood, CA 1997

Throughout that fall, Donald and I were incredibly busy with an unexpected project that proved to be the greatest creative opportunity of my life. I was invited to collaborate with Maria Grazia Chiuri, the first female creative director of Dior. Donald and I worked closely with her and Olivier Bialobos, the chief communication officer, who had been introduced to us as the "man who makes dreams come true." As promised, the Dior enterprise proved to be what their publicists deemed a "triumph." It brought to life an unrealized concept from the 1970s, a monumental goddess figure, 225 feet in length, positioned in the garden behind the Rodin Museum in Paris for the January couture show, which was held inside the body of this immense deity.

The interior of the space was suffused in a golden glow, and a 600-plus-foot-long, specially woven millefleurs carpet (based on my drawing for the *Eleanor of Aquitaine* runner top from *The Dinner Party*) served as the

Overhead view of the goddess structure created for **THE FEMALE DIVINE** Paris 2020

Needleworkers from the Chanakya School of Craft in Mumbai, India, working on the large banner from **THE FEMALE DIVINE** 2019. Photo by Sahiba Chawdhary

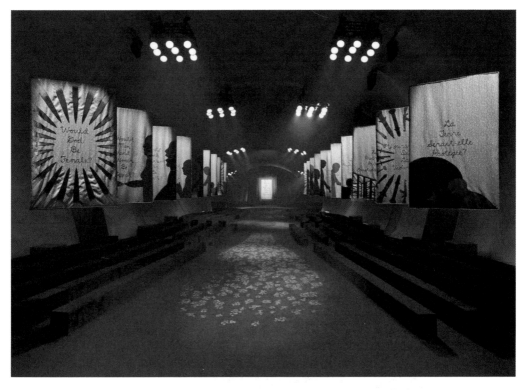

Installation of the banners inside the goddess structure for **THE FEMALE DIVINE** Paris 2020

catwalk. At the back of the installation hung a 17-foot-high appliquéd and embroidered banner asking: "What If Women Ruled the World?" Suspended on either side of the catwalk and extending this initial query were twenty 10-foot-high banners, half English/half French, posing a series of questions that seem relevant to today's world, including "Would the Earth Be Protected?" Unfortunately, the answer to this query was to become all too clear when the coronavirus came upon us—the likely result of the animal markets and their hideous treatment of sensate creatures, combined with the loss of habitat, poaching, economic interests, and our decades-long disregard for climate change—to wreak havoc on the world.

The long-term implications of COVID-19 slowly became evident. At first, everything came to what seemed to be a temporary halt as governments attempted to interrupt its spread. The abrupt slowdown turned into an economic disaster as businesses closed, millions of people lost their jobs, and the international art world (like every other business) tried to figure out what to do. Donald and I were lucky; before this happened, I had finally begun selling significant amounts of art, so we were able to keep paying our staff and manage. But in order to keep doing this, we had to

With Maria Grazia Chiuri at the Spring–Summer 2020 Christian Dior couture show, Paris
Photo by Sarah Blais

use money we'd saved to fund a private foundation that, after our deaths, could preserve our work and legacy, a plan we had developed over many years. It was clear that if the economy did not turn around, we would end up depleting our reserves, and many of our hopes would be dashed in the face of a worldwide crisis beyond anything we had experienced in our lifetimes.

I started work on this book in early 2020, right after we returned from Paris, when it seemed as if it would end on an upbeat note. This year was supposed to be the culmination of my career, with my first retrospective—at the de Young Museum in San Francisco—and an accompanying catalog cementing my legacy. In addition, there were to be a number of "Smoke Sculptures;" one in conjunction with my retrospective, another in relation to the Nevada Museum of Art's acquisition of my fireworks archive for their Center for Art + Environment and a third in Berlin. All have been postponed.

Then, just as I was finishing this manuscript, an unexpected and happy event occurred: my print archive was acquired by the Jordan Schnitzer Family Foundation, carrying with it the promise of a catalogue raisonné of my more than 100 prints, along with traveling exhibitions. These would be handled by a gallery, Turner Carroll in Santa Fe, where I hadn't exhibited for many years. Still, when the pandemic first hit, I felt guilty because other people were suffering so terribly. At first, I was happy for the slowdown as it allowed me months of quiet time to concentrate on the book. But as the scope of the devastation wrought by the coronavirus became clear, I began to understand that life—and art—would probably never be the same. I tried to remain positive, helping to launch Create Art For Earth, a worldwide initiative intended to stimulate art that might illuminate some new paths. I also started thinking about innovative ways of introducing art into the culture that combined on-site and online exhibitions, since it will be a long time before any of us will be willing to attend a crowded art event. Whether any of these efforts will make a difference, I have no way of knowing.

What I do know is that our future—both Donald's and mine and that of the human race—is uncertain. This period does seem to have a precedent, the Great Depression of 1929–33, which ushered in an incredible period of growth in the United States and many other parts of the world. It also produced the WPA, which brought millions of jobs, a renovated

infrastructure (which this country badly needs again), and a flowering of public art. But we had political leadership then; now we have the worst president in American history, a dysfunctional Congress, and a polarized populace. Hopefully, by the time this book is published, there will have been a change in governance, one that produces the substantive, systemic changes that are so badly needed.

Instead of being able to offer a conclusion to my story that trumpets "triumph over adversity," all I can say is that when I am done writing, I will do what I have always done: go back into my studio and try to wrest some meaning from life and the many challenges it presents, including the current one, which seems the most daunting in that it is so far beyond the control of individuals like Donald and me. Fortunately, we have each other, the Belen Hotel, and our cats. I also have the deep satisfaction of decades of artmaking and the sense that I have done what I set out to do: trying to make a contribution to a better, more equitable world, which is what my father taught me was my obligation.

Donald and I have had an incredible life.

ENDNOTES

1. Valerie Solanas, *SCUM Manifesto* (New York: Olympia Press, 1967).

2. Judy Chicago and Miriam Schapiro, "Female Imagery," *Womanspace* 1, no. 3 (Summer 1973): 11–14.

3. "Woman's Art: The Development of a Theoretical Perspective," *Womanspace* 1, no. 1 (February/March 1973): 14–20.

4. Chicago and Schapiro, "Female Imagery," 11–13.

5. bell hooks, *Feminism Is for Everybody: Passionate Politics* (Cambridge, MA: South End Press, 2000).

6. Johanna Johnston, *Runaway to Heaven: The Story of Harriet Beecher Stowe* (New York: Doubleday, 1963), 357.

7. Kate Chopin, *The Awakening* (New York: Avon Books, 1972), p. 189.

8. Nancy Reeves, *Womankind: Beyond the Stereotypes* (Chicago: Aldine-Atherton, 1971), 29.

9. Elissa Auther, *String, Felt, Thread: The Hierarchy of Art and Craft in American Art* (University of Minnesota Press, 2009).

10. Anaïs Nin, *A Spy in the House of Love*, mass market paperback ed. (New York: Bantam Books, 1968), 6–7.

11. Amelia Jones, *Sexual Politics: Judy Chicago's "Dinner Party" in Feminist Art History* (Berkeley: Hammer Museum in association with University of California Press, 1996).

12. Jane F. Gerhard, *"The Dinner Party": Judy Chicago and the Power of Popular Feminism, 1970–2007* (Athens: University of Georgia Press, 2013).

13. Judy Chicago and Frances Borzello, *Frida Kahlo: Face to Face* (Munich: Prestel, 2010).

14. Terrence Des Pres, *The Survivor* (New York: Oxford University Press, 1976), p. 33.

15. Charles Patterson, *Eternal Treblinka: Our Treatment of Animals and the Holocaust* (New York: Lantern Books, 2002).

INDEX

Page numbers in *italics* refer to illustrations.

ACA Galleries, 243, 249, 250, 259, 295, 356, 388
 JC retrospective, 243, 247
 PowerPlay, 276, 286
airbrush. *See* sprayed paintings
Alexander, Jackie Moore, *225*, 358
Amend, Kate, 163, 184, 294, 304, 337
Andrews, Oliver, 23–25, 56
Andrew Smith Gallery, 292, 294
Art Institute of Chicago, 7–8, 17, 18, 219, 343, 383
Atmospheres, 45–47, *46*, 49, 50, 389
Autobiography of a Year, 341, *348*
auto-body school, 30, 31, 38–39, 40

Babson, Sally. See *Birth Project*
Barrett, Loretta, 140, 163, 173, 187, 229, 361
Belen Hotel, 1, *333*, 360–61, 362, 365, 400
 purchase/renovation of, 329, 332–34, 353–55, 356
Bell, Larry, 50, 242–43, 247, 250
Belz, Carl, 358
Bengston, Billy Al, 30, 117
Bergen, Jeffrey, Jon, and Sidney, 243–44, 248, 259, 287
Berman, Nancy, 380
Beyond the Flower, 1, 4, 342, 343, 353–55, 356
Bialobos, Olivier, 396
Bigamy, 27
Bigamy Hood, *28*
Birth, 27
Birth Project, 175–86, 194–215, 216–38
 audiences for, 207–8
 Beginning, The, *201*
 book/promotion tour, 229, 232, 243, 246, 256–58, 259

Building 57, 216–17, *217*, 223, 227, 249
Creation, *171*, 172, 182, 183, 200, 244
Earth Birth, *225*
exhibition program, 214–15, 222, 225–28, 246, 249, 283, 286, 303, 343
Guided by the Goddess, 228, *230–31*
Permanent Placement Program, 228, 303
prints, 249–250, 259
research for, 176–81, 205–6
reviews, *196*, 196–97, *206*, *212*, 216, 223, 232, 243, 249
 Big June Review, 229–32
 January, 196, 197, 204, 205
 November, 185–86, 197
bodybuilding, 368–70
Booth, Judy, 250, 304, 336
Borzello, Frances, 81–82, 201
Botwinick, Michael, 173–74, 187, 188, 337
Bouquet for Belen, A, 393, *394*
Brach, Paul, 68, 71
Bretteville, Sheila de, *101*, 113, 116, 211
Brooklyn Museum, 214, 295, 374, 390, 392
 See also *Dinner Party, The*
Bullard, John, 380
Bunzick, Peter, 167, 171, 173, 192
Butler, Marilyn, 243–44, 250
Butterfly for Brooklyn, 390, *391*
Butterfly for Oakland, 388
Butterfly for Pomona, 389–90

California Institute of the Arts (CalArts), 68, 96, 111, 112, 204
 See also Feminist Art Program; *Womanhouse*
Car Hood, 31
Cast, 277
Chicago, Judy (JC)
 archives, 363–64, 390–91, 393, 395, 399

college and graduate school, 18–21, 23–24, 110, 115
early years and family, 6, 7–18, *15*
name change, *49*, 50–51, *53*, 57, 301
china painting, 117–20, 123, 136, 195, 384, 386
 See also *Dinner Party, The*
Chiuri, Maria Grazia, 396, *398*
Christian Dior, 396, *398*
Coast to Coast Cancer, 287
Cohen, Arthur (JC's father), *8*, 9–10, 259
 Communism/Red Scare and, 12–13, 16–17, 220
 death of, 14–17, 20, 22, 25, 27, 220–21, 257, 297, 303
 family, 10–11, 13, 15, 17, 219, 298
 impact on JC, 9–10, 60, 161, 256, 274, 370, 400
 Jewish identity, 10–12, 274, 286, 290
Cohen, Ben (JC's brother), *299*
 birth of, 12
 death of, 329–30, 332, 370
 illness, 297, 298–303, 307, 310–11, 321
 pottery, 159–60, 302–3, 311, 322
 relationship with JC, 13–15, 220, 282–83, 294
 wife and sons, 152, 297, 300, 301, 303, 311–13, *312*, 321–22, 370
Cohen, May (JC's mother), 7, *8*, 9–14, 16
 illness and death of, 287, 294, 297, 329, 334, 342
 Jewish identity, 9, 11, 286
 relationship with JC, 7, 9, 14–15, 17–20, 138, 203, 218–21, 324, 370
color systems, 35, 41, 43, 74, 83
Cowan, Audrey, 170, 214, 238, *241*, 252, 274, 288
 See also *Birth Project: Creation*
Cowan, Audrey and Bob, 325, 329, 353
Create Art for Earth, 2, 399
Cronan, Michael, 179, 181, 226
Cunningham, Merce, 239

Deane, Marleen, 164, 169, 178
Deitch, Jeffrey, 391–92
Demetrakas, Johanna, 109, 141, 142, 144, 164, 234
de Young Museum, 2, 399
Dillingham, Rick, 247, 258
Dinner Party, The, 117–50, *148–49*, 151–74

books, 154, 163, 164, 169, 173, 183, 186, 255, 294, 356
documentary, 141, 142, 144, 164, 234
exhibition venues, 191–92
 Atlanta, 229
 Australia, 192, *284*, 291–93
 Boston, 166, 173–75, 181
 Brooklyn Museum, 173–74, 186–90, 218, 337
 Canada, 228–29
 Frankfurt, 282, 283–85, 288
 Houston, 164–69, 173, 174, 263, 303
 London, 249, 259, 282, 288, 293, 352
 San Francisco Museum of Modern Art, 144, 151, 158, 165, 345
 Scotland, 249–50
grassroots support for, 145, 192, 217, 317–18, 392
Heritage Floor, 131, 132, 138, *139*, 144, 147, 152, 163, 282
lighting, 147–50, 161
online curriculum, 378, 390
permanent housing for, 146, 147, 156, 159, 295, 314
 Brooklyn Museum, 2, 380–82, *381*, 386
 TTF and, 320, 338–39, 362
 UDC debacle/congressional debate, 307–9, 314–20, 338, 360
plates and place settings, *119*, 144, 169, 296, 381
runners, 135–36, 144, 164, 169, *170*, 172, 188, 381, 396
studio potlucks, 141–42, 203
women chosen for, 131
 See also Hammer Museum; *International Honor Quilt*
Dobbins, Norm and Ruth, 383
domes, 40–42, *40*, 45, 49, 50, 52
dry ice, 388–39
Duke University, 374
Dunn, Mary Maples, 362–63

End, The, 266, 384–86, *385*, *386*

Female Divine, The, 396, 396–98, *396*, *397*
Feminist Art, 84, 91, 113, 173, 307, 320, 353, 360, 380
 exhibitions, 97, 386–87
 history, 81–82, 83, 112, 364

principles of, 3, 57, 69–70, 146
Sackler Center for, 295, 378, 380
Feminist Art Program, 70–71, 92, 98, 113,
141, 156, 208
CalArts' attitude toward, 109–12
See also *Womanhouse*
Ferus Gallery, 29, 30, 41
Fineberg, Donald, 292, 297, 302
fireworks, 115, 388–90, 393
archive, 393, 395, 399
pyrotechnics training, 46–47, 49, 390
Flesh Gardens, 58, 73
Fragments from the Delta of Venus, 368, *369*
Francis, Sam, 94–94
Frankel, Dextra, 50, 96–98, 301
Fresno Fans, 58, 73–75, *74–75*, 96, 240
Fresno State College, 56, 57–72, 109–10, 113
all-female environment, 57–58, 110–11
Cuntleaders, 67–68, *68*
studio, 61, 65
weekend rap session, 71, 98
See also Feminist Art Program

Gelon, Diane, 131–32, *132*, 192, 195, 196, 207,
287
Dinner Party, 131–33, *132*, 141, 144, 145,
154, 158
TTF, 145, 154, 192
See also *Dinner Party*: exhibition venues
Gerhard, Jane, 192, 195, 392
Gerowitz, Jerry, 20–21, 32, 173, 183
death of, 21–22, 23, 25, 27, 257
surname, 49–50
Getty, 362. See also Pacific Standard Time
Gilliam, Ken, 137–38, 141, 143, 147–50, 161, 167
glass, 368, 383–87
See also *Holocaust Project: Rainbow Shabbat*
Gomez, Bob, 313, 323, 325
Graphicstudio, 366–68
Great Ladies, 115, *116*, 120, 125, 248
Grinstein, Elyse and Stanley, 94, 242, 308,
346, 358, 395, *395*
Grode, Susan, 145, 186, 308–9, 315, 317

Hamilton, Stephen, 175, 222, 239, 243, 256
Birth Project, 222, 226, 229, 242, 246
illness, 286, 313
Hammer Museum, 190, 320, 339, 353, 356,
359, 395

Hamrol, Lloyd, 19, 26, 27
marital infidelities and breakup with JC,
125–26, 127, 137–38, 160–61
relationship with JC, 32–33, 34, 35, 39, 48,
56
Hanart Gallery, 370
hand series, 383–84
Harp, Holly, 247, 324
Harper, Paula, 98, 156, 183, 242
head series, 384, *384*
Heaven Is for White Men Only, 248
Hibma, Karin, 179–80, 181
Hill, Susan, 133, 134–36, 163, 164, 167, 173,
192, 288
Holocaust Project, 265–97
Arbeit Macht Frei, 324–25, 326
audiences for, 273–74, 327–28, 330
book, 266, 267, 271, 332, 343, 357, 359
Double Jeopardy, 274, 313, 322–23,
322–23
exhibition, 266, 273–74
audio tour, 266, 327–28, 337
reviews, 343–50, 352, 358
tour, 1, 296, 334, 341–42, *342–46*, 353,
358
video, 266, 337
Fall, The, 274, 290–91, 352, 358
Four Questions, 334–36, *335*
Im/Balance of Power, 313, 325
Legacy of the Holocaust, 330–32
painting/photo combines, 273, 274, 293,
322–23
preparation for
research, 268–70, 283, 288–90, *290*, 295,
324–25
Shoah viewing, 264, 265, 267, 268, 275,
336, 344
Rainbow Shabbat, 274, 305, *306*, 313,
323–24, 326–27, 330, *344*
Vetruvian Man?, 235
Hopkins, Henry, 314, 382–83
See also Hammer Museum; San Francisco
Museum of Modern Art
Hopps, Walter, 33–34
Hughes, Robert, 188–89, *190*, 357

ICA Miami, 392–93
Indiana University, 371–74, 379
In My Mother's House, 24, 31

International Honor Quilt, 165–66, *166*, 218,
 303–4, 338
Isolde, Anne, 144

Jack Glenn Gallery, 50, *53*
Jacobson, Manuel, 13–14, 219
Johnson, Ken, 379
Jones, Amelia, 190–91, 320, 353, 359, 363
Judaism, 10–12, 252, 264, 387
 tikkun olam, 12, 274, 380
 Vilna Gaon, 11–12, 290, *290*
 See also *Holocaust Project*

Kahlo, Frida, 82, 176, 201–2, 213
Keyes, Judye, 147, 156, 159
Kitty City, 373
Kraft, Jim, 250, 304, 336
Kramer, Hilton, 1, 188–89, 190, 347
Kuperstein, Isaiah, 283, 285, 288–89, 327,
 345, 362

Lacy, Suzanne, 72, 152
Landfall Press, 366
Leibovitz, Annie, 159, 160, 292, 294
Leon, Vicki, 368, 370
Let It All Hang Out, 248
Levin, Gail, 383, 386, 388
LewAllen Galleries, 383
Lippard, Lucy, 173–74, 319, 343
*Looking at Los Lunas Hill from the West Late in
 the Afternoon*, 366
Lucie-Smith, Edward, 364–65, 380

Maddy, Dorothy, 323–24, 325
minimalism, 32, 34–35, 37, 74
Miriam Glass, 387
Movable Cylinders, 38
Muchnic, Suzanne, 156
Mudd, Harvey, 258–29, 264, 265, 289
My Accident, 281–82, *281*
Myers, Juliet, 156, 255, 286, 288, 296,
 303–7

National Museum of Women in the Arts
 (NMWA), 2, 308, 314, 390, 394
 End, The, 384
 importance of, 213, 214
 JC survey show, 380
needlework, 181–82, 195, 386, 387

See also *Birth Project; Dinner Party, The;
 Female Divine, The; Resolutions*
Nelson, Rolf, 29, 35, 50, 71, 392
Nevada Museum of Art, 393, 394–95, 399
New Orleans Museum of Art, 380
New York Times, The, 1, 2, 51, *53*, 209, 316, 393
 reviews, 1, 188, 352, 379, 382–83
Nin, Anaïs, 84, 92–93
 illness, 126
 influence on JC, 93, 107, 120–22, 126–27,
 340–42, 368
Nyehaus, 388

Pacific Standard Time, 31–32, 388–89, *390*, 391
Palevsky, Joan, 145
Pasadena Lifesavers, 43–45, *44–45*, 49, 50, 69, 83
Penn State University, 109, 390, 391, 394–95
plastics, 35, 37, 115, 118
Pomona College Museum of Art, 389
PowerPlay, 238, 242, 249, 254, 264, 268, 303
 Crippled by the Need to Control, 237, *237*, 241
 Disfigured by Power 4, *241*
 Driving the World to Destruction, 3, 260
 exhibitions, 276, 286, 287, 392
 In the Shadow of the Handgun, 244, *245*
 Maleheads, 240, 251–52, 319
 Rainbow Man, 246, *247*, 249, 251
 reliefs, 238, 280, 291, *291*
Prismacolor pencils, 73, 120, 122

Rainbow Pickett, 32–34, *33*
Raven, Arlene, 113, 116, 126, 348
Red Flag, 94–96, *95*, 106
Reincarnation Triptych, 86
Rejection Quintet, 120, *121*, 122–23, *124*
Resolutions, 351–52, *351*, *354*, 357–58, 379, 380
Retrospective in a Box, 366
Rohatyn, Jeanne Greenberg, 392
Rosen, Arleen and Howard, 151, 186, 187,
 218–20, 253–54, *254*, 295, 324, 329,
 343
Rosen, Howard, 11, 191, 277, 278–79, 298–99,
 342

Sackler, Elizabeth, 295, 378, 380–82, *381*
San Francisco Museum of Modern Art, 144,
 151, 158, 165, 183, 345
Schapiro, Miriam, 52, 68–69, 77, 84, 96–97
 Conference for Women Artists, 98

Feminist Art Program, 69–71, 92, 98
rupture with JC, 79, 111–12
slide talks with JC, 78–79, 96
See also *Womanhouse*
Schlesinger Library, 362–64, 383, 390, 394
Scholder, Fritz and Romona, 247, 251,
 256–60, 261, 263, 277
Silinsky, Mim, 118, 119
Silverman, Jessica, 392
Skuro, Leonard, 130, 136–37, 141, 143, 147
Sky Flesh, 76
Smith, Roberta, 382–83
smoke, 45–47, 390, 399
Souza, Chris, 389–90, 393
Spertus Museum. See *Holocaust Project*:
 exhibition: tour
sprayed paintings, 43, 115, 118, 120, 228, 240,
 248, 335
 See also *Flesh Gardens; Fresno Fans*
spray painting, 30, 31–32, 118, 241, 358
Stewart, Marilyn, 378
Stockwell, Dean, 242–43, 259

Taylor, MaryRoss (MR), 162, 164, 195, 217,
 233, 234, 242
 Canyon Road house, 193, 236, 240,
 245–46, 250, 328
 Dinner Party, 164–65, 169, 286, 317, 363
 TTF, 286, 303, 304, 363, 391
 See also *Birth Project*
teaching
 pedagogy, 60–61, 72, 198, 373–74, 377, 390
 residencies, 371–77
 return to, 64, 72, 371, 378–79, 380
 See also Feminist Art Program; Fresno
 State College; *Womanhouse*
10 Part Cylinders, 35–36, 37
Thinking About Trees, 357, 357–58
Through the Flower (book), 4, 133–34, 145, 152,
 211
 Nin's influence on, 93
 publication/editions of, 1, 134, 140,
 233–34, 301
Through the Flower (painting), 78, 145, 216
Through the Flower (TFF; nonprofit)
 art-education award, 391
 Art Space, 393–95
 chartering of, 145–46, 186, 308
 library, 216–17, 361–62

See also *Birth Project; Dinner Party, The*
UCLA. *See* Chicago, Judy: college and
 graduate school; Hammer Museum
UNC–Chapel Hill, 374
Unified Arts, 250, 259, 336
University of the District of Columbia
 (UDC). See *Dinner Party, The*:
 permanent housing for

Vanderbilt University, 376–77
Village Voice, 188
 "Planet Holocaust," 343–50, 358
Voices from the Song of Songs, 367, 367

watercolor, 365–66, 368, 373
Weaver, Bill, 384, 386
Webb, Janet, 242–43, 246
Werner, Mindy, 356
Western Kentucky University, 109, 374–75, 375
Wilding, Faith, 104, 105, 106
Woe/Man, 280
Wolf, Amy, 248
Womanhouse, 98–113, 101, 213, 374–75
 documentary, 109, 141
 Menstruation Bathroom, 102–3, 103
 performances, 103–6, 105, 108, 236
Woman's Building, 114–17, 123, 204, 211,
 324
 Feminist Studio Workshop, 113, 116, 117,
 316
 Grandview Gallery, 115, 116
 Womanspace, 98, 103
Womanspace Journal, 77, 79
Woodman, Donald, 260–64, 262, 279, 280,
 327, 333, 335, 400
 collaborations with JC, 287, 292, 390,
 396–98
 family, 263, 275–76, 283, 287, 313, 334–35,
 339, 342
 relationship with JC, 264, 275–76, 277–80,
 279, 325–28, 327, 336, 361, 371, 383,
 400, 400
 TTF, 393
 See also Belen Hotel; *Holocaust Project*;
 teaching: residencies
Woolf, Virginia, 85, 88, 90–91, 259, 268
Wylder, Viki Thompson, 228, 379, 380

Youdelman, Nancy, 63, 110

ACKNOWLEDGMENTS

Over the years, many people have commented on my frequent collaborations, as if it were unusual. This has always puzzled me because there are many instances in which work is dependent upon the efforts of numerous individuals. For instance, in the art world, most prints are created via collaboration between artist and printer, both of whom are supported by a network of others. Similarly, in publishing, books are dependent upon a disparate group of partners, beginning with an agent who places one's manuscript. In my case, Joan Brookbank—with whom I've had the pleasure of previous collaborations—was able to find the perfect publisher, Thames & Hudson. There were several publishing houses interested in my book but when Joan mentioned this one, I jumped at the opportunity. I am thrilled that they are publishing not only this book but the catalog for my first retrospective at the de Young Museum in San Francisco. Joan's efforts were aided by my intellectual-property lawyer, Ben Allison, so thanks to both of them.

I am grateful to everyone at Thames & Hudson for their support, especially my editor, Elizabeth Keene, who has steered this author around many hurdles, including the significant changes in thinking about race and gender that have taken place since I first penned *Through the Flower* and *Beyond the Flower*, the two autobiographies that comprised the starting point for this new volume. *The Flowering* might be viewed as the summation of my life, a process that began when my mentor, the diarist Anaïs Nin, first suggested that I put pen to paper. But neither she nor I ever imagined that I would end up publishing fifteen books.

The process of combining and editing my two previous autobiographies, providing me with the basis to expand upon them and also to pick up where I left off in 1996, fell to my beloved and long-time editor

Mindy Werner, with whom I have worked since the early 1990s when she was pregnant with her first child. Mindy has never failed to push me while expressing confidence that I could indeed improve upon my writing, something that I often doubted. She and I first started working together when she was at Viking Penguin at which time I also met my publicist, Ron Longe, who faced innumerable obstacles in his efforts to promote the many books we have worked on together, including the hostility of some powerful art critics, an animosity that has only recently (and happily) subsided.

In terms of the nuts and bolts of "making" this publication, I must commend the designer, Anne DeMarinis, whose lively design helped to bring my story to life. Closer to home, there is my wonderful husband, photographer Donald Woodman, with whom I have collaborated many times. As I have often remarked, he is the most competent person I have ever known and I must confess to having become very spoiled by that. His own photos—along with those whose insufficiencies have been compensated for by his incredible digital skills—have guaranteed that my work has been properly reproduced. Aiding him is our terrific photo assistant, Apolo Gomez (who is himself a talented photographer). His persistence in ferreting out some of the historic images in the book is unparalleled; he even discovered some gems about which I had totally forgotten. And then there is our remarkable studio manager, Megan Schultz, whose attention to detail fortunately compensates for my own utter lack of facility in this area. If this book is a success, it is because of the talents, hard work, and abiding commitment of our "team," one I am truly fortunate to have.